AMATEUR MOVIE MAKING

AMATEUR MOVIE MAKING

Aesthetics of the Everyday in New England Film, 1915–1960

Edited by Martha J. McNamara and Karan Sheldon

Foreword by Alice T. Friedman

With contributions by Dino Everett

Indiana University Press

This book is a publication of

Indiana University Press
Office of Scholarly Publishing
Herman B Wells Library 350
1320 East 10th Street
Bloomington, Indiana 47405 USA

iupress.indiana.edu

Manufactured in the United States of America

Library of Congress Cataloging-in-Publication Data

Names: McNamara, Martha J. editor. | Sheldon, Karan editor. | Northeast Historic Film (Organization)
Title: Amateur movie making : aesthetics of the everyday in New England film, 1915-1960 / edited by Martha J. McNamara and Karan Sheldon ; foreword by Alice T. Friedman ; with contributions by Dino Everett.
Description: Bloomington : Indiana University Press, 2017. | Covers films produced in New England between 1915-1960 and held in the collections of the repository, Northeast Historic Film. | Includes bibliographical references and index. | Description based on print version record and CIP data provided by publisher; resource not viewed.
Identifiers: LCCN 2016055001 (print) | LCCN 2017009242 (ebook) | ISBN 9780253026446 (ebook) | ISBN 9780253026163 (pbk. : alk. paper) | ISBN 9780253025623 (hardcover : alk. paper)
Subjects: LCSH: Amateur films—New England—History—20th century. | Cinematography—New England—History—20th century.
Classification: LCC TR896 (ebook) | LCC TR896 .A43 2017 (print) | DDC 777.0974—dc23
LC record available at https://lccn.loc.gov/2016055001

1 2 3 4 5 22 21 20 19 18 17

Contents

Accessing Moving Images

To view moving images related to each essay, visit www.oldfilm.org/amm

Northeast Historic Film offers access to reference copies of the films discussed in *Amateur Movie Making: Aesthetics of the Everyday in New England Film*. Unless otherwise noted, original films are housed in the collections of Northeast Historic Film, Bucksport, Maine.

In addition to the digital video online, copies of most of these works are available in other forms for teaching and exhibition. For more information, contact Northeast Historic Film technical services, 207-469-0924, or nhf@oldfilm.org.

Foreword

For historians, and no doubt for many other people as well, the opportunity to actually see worlds long past through the eyes of contemporaries is the stuff of fantasy—something longed for, perhaps, but hardly imaginable. We toil away in archives, reading through letters, inventories, and descriptions of people and places, and we peer at paintings, maps, plans, and old photographs that offer tantalizing glimpses of the way things looked to observers and storytellers in past years, decades, or even centuries before our own. Thus the survival and diligent preservation of amateur films and home movies, and the scholarly attention given to them by the essays in this collection, are an incomparable gift—accomplishments to be not only supported but also celebrated. Amateur films offer not simply historical "facts" and images from the past, but also stories, narratives, and representations—often tantalizingly brief—of the ideas, values, and dreams of the people who made them. They open up new vistas, enabling us to see the world through long-ago lenses and look through eyes now closed by the passage of time. Through them, loss and absence are magically transformed into animated presence, no matter how fragmentary and brief the view. The study of this medium—as historical artifact, new technology, work of visual art, or dramatic narrative—is indeed rich with possibilities.

It is therefore a particular pleasure for the Grace Slack McNeil Program for Studies in American Art at Wellesley College to have been a part of this project since its inception. Thanks to Karan Sheldon, cofounder of Northeast Historic Film, and Martha J. McNamara, director of the New England Arts and Architecture Program at Wellesley College, students of the rich textual and cinematic materials offered by this volume and the accompanying website can not only have access to a wide range of significant examples of the genre, but will also benefit from the careful analysis, personal reflections, and new methodologies offered here. These represent the very best work to date in this area of study.

This volume brings together the research of distinguished historians and scholars from a variety of fields, and the essays in this collection cover a wide range of subjects, from preservation, to technologies of production, to the complex analysis of cultural and artistic meanings embedded in the films themselves. Focusing our attention on everyday events and objects, presenting us with the look and "feel" of landscapes, families, work, play, and comedic mise-en-scène, the amateur films studied here open up a vast array of topics and questions, not only about the material culture of the past, but about the medium itself and its

capacities for documentation and narrative invention. Issues of privacy and public consumption are inherent in this investigation. So too are questions about gender identity, sexuality, social class, and even humor; indeed, whatever categories and concerns we might find in contemporary social and material culture can be found here. It is thus particularly gratifying that the editors of this volume have seized upon this opportunity for interdisciplinary collaboration, bringing together scholars whose cutting-edge strategies of criticism and analysis offer a foundational collection of diverse perspectives on which students, scholars, and media artists can build.

Casting light on the relatively new subject of amateur films and home movies through high-quality scholarship, personal reflections, and technical expertise is an endeavor that would no doubt have pleased Robert L. McNeil, founder of the chair and the program at Wellesley College that bear his name. A collector of eighteenth- and nineteenth-century American furniture, a student of American painting and architecture, a scientist and an entrepreneur, McNeil was passionate about the need to experiment and innovate through dedicated research, teaching, and public education. His mandate to us was to seek out new perspectives and analyses, look for new avenues of inquiry and new technologies of dissemination, and break new ground in the study of American art. Home movies, like snapshots, photo albums, and other forms of popular visual culture, though long neglected by historians of art and society, clearly represent an exciting new area of research and a vast and still-unexplored treasure trove of original materials worthy of care, preservation, and close examination. Thanks to the commitment of Raina Polivka, Janice Frisch, and the Indiana University Press, this project brings us exciting new scholarship and a range of case studies in a rich and lively format worthy of its subject. This is a significant accomplishment on many levels, and one for which we should all be grateful.

<div style="text-align: right;">

Alice T. Friedman
Grace Slack McNeil Professor of the History of American Art
Wellesley College

</div>

Alice Friedman is the Grace Slack McNeil Professor of the History of American Art at Wellesley College. She is the author of *Women and the Making of the Modern House: A Social and Architectural History* and *American Glamour and the Evolution of Modern Architecture*, and is currently working on a book about domesticity, privacy, and public image-making since 1900.

Acknowledgments

MANY TALENTED, RESOURCEFUL, enthusiastic, and hard-working people have helped us get this exciting study of New England's amateur film and filmmakers to press. First and foremost, we are deeply indebted to the volume's authors, who have inspired us with the creativity and scholarly rigor they brought to material that is often shorn from its original contexts and relentlessly quotidian in its content and form. This volume has been a rich and rewarding collaborative endeavor across time and space, and we have appreciated every moment of the shared adventure.

No serious analysis of amateur film could be undertaken without the vision and passion of moving image collection donors—the people who entrust their films to repositories where they can be shared, studied, preserved, interpreted, and appreciated. These donors have recognized the value of moving images produced and viewed by ordinary people; their foresight has helped to create a new way of interpreting and disseminating twentieth-century creativity. Similarly, repositories that collect amateur film, like Northeast Historic Film in Bucksport, Maine, have played a pivotal role in bringing this understudied cultural expression to a broader audience.

Amateur Movie Making: Aesthetics of the Everyday in New England Film, 1915–1960 could not have appeared without the hard work of many people associated with Northeast Historic Film. Many thanks to Brook Ewing Minner, former executive director of Northeast Historic Film, and to founding executive director, David S. Weiss, whose leadership and deep commitment made the moving image archive a reality. We are particularly grateful for the work of Joe Gardner, who handled the original film for the project, documenting its physical characteristics, providing scholars with reference copies, and creating the many illustrations and digital moving images that accompany the volume. He was ably assisted by Karin Carlson and Amber Bertin. As this publication got underway, collection management was handled by Gemma Perretta Scott, with the assistance of Brian Graney and Katrina Dixon. Accessibility of the collections has been supported with funding awarded by the Cataloging Hidden Special Collections and Archives program of the Council on Library and Information Resources, with the support of the Andrew W. Mellon Foundation. Thanks also to Northeast Historic Film's Theater, Distribution, Membership Manager Jane Donnell, and Business Manager Andrea Foster, preceded by Barbara Manning. The board of directors of Northeast Historic Film has supported the work of this volume from the beginning.

Thanks to all who have served on the board, and especially founding board member Pam Wintle.

Special thanks as well to Alice T. Friedman, Grace Slack McNeil Professor of the History of American Art at Wellesley College, whose enthusiasm for this project and understanding of its goals was backed up with significant material support from the Barra Foundation through the Grace Slack McNeil Program for Studies in American Art at Wellesley College. For their behind-the-scenes activities that helped produce this volume, we would also like to thank Dennis Doros, Raye Farr, Andrea Leigh, and Donna Ross.

This work had its origins in an exhibition concept focused on the artifact and moving image collections of Northeast Historic Film. Libby Bischof and Justin Wolff were the first to engage wholeheartedly with that project and were joined in preparing our earliest concept documents and outreach by Sarah Ruddy, with support from the Golden Rule Foundation. A daylong screening with museum curators in 2012 helped to identify the need for a print volume focused on regional amateur film. Thanks to the following for their attendance, thoughtful commentary, and enthusiasm: Henry Adams, Steve Bromage, Liz Coffey, Susan Danly, Sian Evans, Michael Grillo, Erik Jorgensen, Michael Komanecky, Judy McGeorge, Rob Nanovic, Mark Neumann, Sarah Ruddy, Michael Simon, Earle Shettleworth Jr., Toni Treadway, Tricia Welsch, David Williams, and Steve Wurtzler. Darryl Czuchra, Josh Povec, and Phil Yates helped to create and record that successful event.

Much of the scholarship in this volume builds on conversations fostered by the Northeast Historic Film Symposium, an annual gathering devoted to amateur film and home movies. Participants have included Jan-Christopher Horak, Sue Howard, Alan Kattelle, Heather Norris Nicholson, William S. O'Farrell, Rick Prelinger, Eric Schwartz, and Patricia Zimmermann.

We are also grateful to our acquiring editor at Indiana University Press, Raina Polivka, and to the careful and insightful anonymous readers she engaged for the volume. Thank you to the press's editorial and production team: Raina's successor, Janice Frisch, Dan Pyle, Shannon Brown, Melissa Dalton, Rachel Rosolina, and Kate Schramm. They cheerfully tackled the complications of multiple publication platforms and the integration of moving images. The accompanying web access, hosted by Northeast Historic Film, was built by Ian Smithdahl, Brass Nine Design, Inc.

Finally, Martha is particularly grateful for her family's patience while she stole time away from weekends and summer vacations to pull this volume together. Thanks to Jim Bordewick and Nora and Colin McNamara-Bordewick for their interest in the world of amateur film, their love of New England, and their tolerance of a somewhat absent-minded professor. Karan sends thankful wishes. May all beings be well, and especially these ones: Robert Jones, Jennifer Sheldon, Catherine Weiss, and Martin Weiss.

AMATEUR MOVIE MAKING

Introduction

Martha J. McNamara and Karan Sheldon

In 1940, Amateur Cinema League member Olin Potter Geer brought his camera, loaded with 16mm Kodachrome film, to an Esso gas station in Boothbay Harbor, Maine. There, Geer shot a tightly edited, one-minute movie that, in just six shots, captures the mid-twentieth-century's absorption with color, sheen and polish, and automobiles—in short, modernity. The film's establishing shot is a landscape of gas station, commercial signage, a New England clapboard house, attendants at the pumps, and a woman striding across the station lot. Next, a close-up celebrates a 1936 Buick convertible in all its polished glory; two trim and efficient uniformed gas-station workers in frame-filling pride turn toward the camera, and the pump numbers tick over. Gassed up, the car, with no visible driver, leaves the station, passes between two cars, rounds a corner, and drives out of the frame into an enclosing backdrop of trees, an orange Gulf sign on the right. Deeply saturated color and the midday full-sunshine summer light give the film energy, flash, and sparkle. The brilliant blue sky, red-and-yellow awnings on the house with a picket fence, white-painted curb, red-lettered Esso signs, pendant red lights on poles, the red trim on the woman's saddle shoes, the workers' blue uniforms, and the navy car all exemplify the richness of Kodachrome, which so superbly retains saturated color, reflections, and fine-grained details. But the movie's attraction for us goes well beyond its evocative shine. The entire film is impelled by the technology of mobility—the car, the gas pumps, the road—all found in a New England traditional landscape. This is the everyday petroleum-powered life, and it is gorgeous.[1]

This short 16mm film is an upbeat celebration of American modernity at midcentury. But to a viewer today, Geer's *Esso* film might also evoke melancholy, with the imminence of World War II, vehicles of yesteryear, the consequences of our petrochemical dependence, people now long gone, or the existence and extinction of Kodachrome. Although capturing a brief moment of an ordinary day in rural New England, Geer's film remains open to many different readings. Not only can it elicit respect for the filmmaker's skill with color stock and his 16mm camera, but it can also evoke admiration for his ability to suggest a range of emotions, including delight, wonder, familiarity, and wistfulness. Geer's *Esso* is not simply a celebration of American modernity; instead, the film is a visual

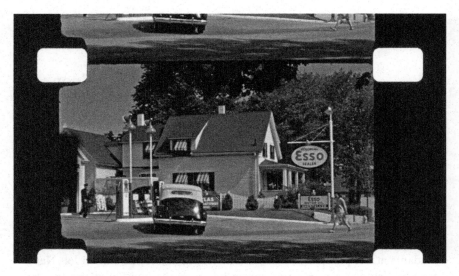

Fig. 0.1 Olin Potter Geer filmed the Esso station in Boothbay Harbor, Maine, in 1940. From 16mm film. Blanche Geer, PhD, Memorial Collection, Northeast Historic Film. [Accession 1005, Reel 30]

poem, the evocation of a time and place in its most detailed specificity, maximizing the potential of Kodachrome film, the filmmaker's discerning eye, and the brilliance of New England summer light.

Geer's film puts to rest the commonplace that amateur films or home movies are lacking in aesthetic value—that they are typified by shaky, out-of-focus images depicting family vacations and kids' birthday parties. Instead, early twentieth-century films made by nonprofessional filmmakers using small motion picture cameras were often complex, artfully constructed, and aesthetically compelling works of art. Training their lenses on the local and the ordinary, vernacular cinematographers in the photochemical era—roughly from the first decades of the twentieth century through the early 1960s—captured a beauty in the everyday and lyrically communicated their experience of place and time. This volume takes these filmmakers and their films seriously. The authors—cultural and art historians, archivists and technology specialists, media-studies scholars, writers, artists, and filmmakers—approach the study of amateur film from a variety of disciplinary perspectives; they are all interested in examining the visual aesthetics of these moving images, as well as placing them in their social, political, and historical contexts. Most importantly, each views these films as creative and compelling testaments to the lives of ordinary people.

There has been surprisingly little attention paid to American home movies and amateur films in the scholarship on vernacular visual expressions. And yet

interest in snapshot and everyday photography has recently surged. The discovery, exhibition, and publication of the work of street photographer Vivian Maier is an example of curatorial and scholarly focus on vernacular photography that began with the work of Barbara Norfleet in the late 1970s.[2]

The literature of home movies and amateur film has begun to build, however, constructed on a foundation laid by Patricia R. Zimmermann in *Reel Families: A Social History of Amateur Film*. Subsequently, *Mining the Home Movie: Excavations in History and Memories*, edited by Karen L. Ishizuka and Patricia R. Zimmermann, brought an international scholarly perspective to home movies made across the globe, from Mexico to New Zealand. More recently, Janna Jones, in *The Past Is a Moving Picture: Preserving the Twentieth Century on Film*, has drawn attention to challenges inherent in the film-archiving project, while Charles Tepperman's *Amateur Cinema: The Rise of North American Moviemaking, 1923–1960* illuminates the breadth and reach of amateur cinema in the United States and Canada. In the British Isles, long home to comprehensive audiovisual archives, scholars have also begun to turn their attention to amateur film. Recent work includes Ryan Shand and Ian Craven, eds., *Small-Gauge Storytelling: Discovering the Amateur Fiction Film*; Ian Craven, ed., *Movies on Home Ground, Explorations in Amateur Cinema*; Heather Norris Nicholson, *Amateur Film: Meaning and Practice, 1927–1977*; and Laura Rascaroli, Gwenda Young, Barry Monahan, eds., *Amateur Filmmaking: The Home Movie, the Archive, the Web*. Paralleling these print publications, moving image archivists and curators have been engaged in programming work to promote recognition of amateur film's importance to visual culture. For instance, the nonprofit Center for Home Movies and its international Home Movie Day, the Orphan Film Symposium (1999–present), and Northeast Historic Film's annual symposium held in Bucksport, Maine, since 2000 have all advanced scholarship and awareness of the issues surrounding nontheatrical film.

This body of scholarship and increasing public engagement, however, has not resolved the difficulties of choosing a single definitional term that will do justice to the complex array of moving images under discussion in this volume. The big-tent phrases "moving images" and "time-based media" are too broad to convey the singularity and intimacy of these films. Other choices—"vernacular film," "amateur film," "personal film," and "home movies"—have all been used to describe various forms of nontheatrical, nonprofessional filmmaking. Although "vernacular film" has resonance for a book structured around the significance of place and the strength of local attachment, it is not yet a generally accepted term for moving images. Similarly, "personal film" implies a single-author, single-viewer experience and does not adequately capture the collaborative production processes of many of these images, nor the collective viewing context in which they were screened. "Home movies" or "amateur film" seem to provide the best

descriptors for the films under study here, but what is the difference between a "home movie" and an "amateur film"? The answer we propose is that all home moves are amateur film, but not all amateur films are home movies. "Home movies" are essentially domestic moving images meant to be screened for a small audience of friends and family, whereas "amateur film" connotes nonprofessional productions often intended for a wider audience.[3]

A working method of sorting home movies from amateur films was presented at a 2010 Center for Home Movies meeting at the Library of Congress. Albert Steg clarified the primary differences, with the following working definitions:

> Home Movies are "home made" motion pictures created by individuals primarily for an intended audience of family members and friends within the immediate circle of the home.
>
> The following factors make it likely that a Home Movie designation is appropriate: (1) The subject matter includes family members, family events, and family activities. (2) The films were manipulated, edited, screened, and stored in a home setting. (3) The film materials are original reversal projection materials. (4) The film stock is a popular consumer gauge (9.5mm, 16mm, 8mm, Super8).
>
> "Amateur Film" would take in non-professional film production that aims for a wider audience in settings such as film-making classes, film festivals, or local broadcast, or by means of mechanical reproduction in the form of multiple prints or copies made available to a public outside of the film maker's immediate circle of friends and family.
>
> The following factors make it likely that an Amateur Film designation is appropriate: (1) The film is a composite work making use of multiple elements in the final print. (2) Multiple copies were struck in order to reach a wider public. (3) The film was screened at film festivals or public events. (4) The film was created in the context of a filmmaking course or made use of film editing equipment outside of the home.[4]

The essays in this volume—looking at both home movies and amateur film—focus on a specific time and place. The time is the photochemical era; the place is New England, that part of North America arrayed against the Atlantic Ocean and Canada. Alexander Forbes, a 28mm film enthusiast, shot the earliest film in these essays in 1915 on an island off the coast of Massachusetts; and Charles Norman Shay of Indian Island, Maine, filmed the most recent reels on 8mm Kodachrome in 1962. These and the other films explored in this volume are historically informative as well as aesthetically engaging, revealing the quotidian and remarkable aspects of life from distinct points of view. All are original works, edited by their makers in camera or at the editing table, possessing integrity of vision and sensibility. Not only do they document place, time, individuals, and experience, these works are imaginative, creative, and beautiful.

This volume also recognizes, however, that when home movies leave the domestic realm and enter a repository—library, museum, moving image archive—to be exposed to the scrutiny of scholarship, something is lost. The intimacy of the films, their connections to these people, their special places and cherished events, and particularly the context of projection and viewing, cannot easily be reconstituted in the archive. To counter that loss, the scholarly essays here are juxtaposed with a series of personal reflections on films written by individuals with close connections to the filmmakers. Shorter in length and more informal in prose style, these essays help reanimate the private contexts of individual home movies before they were recast as objects of study and artifacts of public history housed in an archive. Viewing moving images from the perspectives of both creative expression and personal association, these reflections serve as a bridge between the scholarly development of aesthetic theories about personal film and the intimate experience of personal films in art and life.

In addition to reanimating the personal experience of amateur film, this volume also invites thoughtful consideration of photochemical works just as the enabling technology has come to an end. There are few other art forms for which the artists' materials are no longer available. For moving images, while some photochemical substitutes remain, it is impossible to shoot 28mm film, or 8mm Kodachrome, or create works on many of the reversal stocks that 8mm and 16mm filmmakers used. Throughout the volume, then, an understanding of amateur filmmaking's material culture—reversal film, color stocks, changeable lenses, the question of equipment portability—helps to contextualize the films and the technologies that made them possible. The development of amateur film gauges (28mm film in 1912; 16mm in 1923; 8mm in 1932) and personal-sized cameras and projectors between 1915 and 1960, shaped the attitudes, perspectives, and abilities of amateur film creators. Kodachrome, for instance, the carrier for O. P. Geer's work and that of Charles Norman Shay, was a color reversal film stock made available to home movie makers in 1935 and last manufactured in 2010. It was not the first home color product, but it was highly valued for its intensity and has a remarkably stable chemistry enabling it to retain its brilliant colors. In addition to color, other parameters of filmmaking—reel length, titling, editing equipment, and trick film techniques particular to photochemical technology—enhanced the form's effectiveness as an expressive medium.

A fundamental point is that the cellulose acetate that we call "film," despite its susceptibility to damage, is an irreplaceable, paradoxically robust, fixed, and tangible medium that can be remarkably long lived, particularly when compared to digital media, which require perpetual migrations. Film is for the most part stable in cold storage, and may retain its qualities for decades, or even centuries. Justin Wolff's essay on Alexander Forbes provides an introduction to 28mm, the

home film stock that preceded the better-known amateur film gauge of 16mm, and reminds us that home movies were shot and screened over one hundred years ago. Forbes's films are bookended in this volume by those of Charles Norman Shay in the 1960s, just before the advent of home video, because, as Karen Gracy notes, there are many differences between shooting film and contemporary digital production—notably that film cannot be erased intentionally or accidentally, as can analog and digital video. This span of years, from the turn of the twentieth century to the 1960s, is the photochemical era of filmmaking, and because it is now past, we must pay attention to the physical objects that it produced and not merely settle for their digital surrogates.[5]

In order to view photochemical works, digital copies are typically made from the original translucent ribbons. These scans, even at high resolution, are only rough representations of highly complex objects and are often played back with compromises to size of display and aspect ratio, frame rate, light source, and other qualities inhering in the photochemical object and its display. Digital surrogates are also usually limited to the image itself and therefore neglect the information found on the film outside the image frame, such as date and camera codes, perforation patterns, and optical soundtracks. In order to reveal examples of that information, the image scans in this volume are printed edge to edge. In addition, each essay is accompanied by technical notes written by University of Southern California film archivist Dino Everett, which provide a thorough understanding of the materiality of amateur film production by using data that appear outside the image, such as number and type of physical splices, and film stock identification.

While time and technology are important lenses through which to view these films, a tight focus on place allows consideration of these films as regional expressions. New England's mythologized past has provided rich fodder for writers, poets, painters, sculptors, and photographers since the middle of the nineteenth century. Recently, the role of these cultural expressions in the "re-creation" of New England and its past has been the subject of some path-breaking scholarship in cultural history and regional identity.[6] This volume allows the same scholarly perspective on regionalism to be brought to home movies and amateur film that has been accorded the writings of Sarah Orne Jewett or Carolyn Chute, and the paintings of Fitz Henry Lane or Marsden Hartley.

The regional emphasis of this volume is possible because the films under scrutiny are drawn from the collections of Northeast Historic Film, a moving image archive and study center established to collect, preserve, and interpret the moving images of northern New England. Since 1986, NHF has acquired nontheatrical moving images, building a collection perhaps unparalleled in its regional depth and its strength in home movies and amateur film. Through its study center, annual scholarly symposium, the William S. O'Farrell Fellowship,

and publications, NHF is known for providing resources to advance the study of twentieth-century personal filmmaking. In 2013 the archive was awarded the highest honor of the Association of Moving Image Archivists, the Silver Light Award, for leadership in the field.

Focusing this volume on Northeast Historic Film's holdings gives the authors the benefits of curated moving image collections, but also presents the challenge of working with an archive that has been constructed—as they all are—within the inescapable constraints of time and money. Although NHF has been lauded for its commitment to home movies and amateur film, the organization's collecting aspirations and the scope of its holdings are not always perfectly aligned. Film collecting and preservation can take place day-to-day only within the parameters of both cultural expectations and the resources available to hold the archival sand pile together. For example, the predominant film creators (by number) in this volume are white, male, and extravagantly privileged. It would be a mistake to conclude that the smaller number of filmmakers who are women or people of color or working class, indicates that Northeast Historic Film, or the essay authors in this volume, prefer (or seek out) films only from an elite white male demographic. To be clear, Northeast Historic Film has a very large corpus of moving images, but the formation of those holdings is avowedly accidental and ongoing. Northeast Historic Film has developed ties with individual and family donors and their communities—but these relationships have not emerged from an established "school" or market, or from a pipeline of donor-institutional agreements. Today we still do not know what else lies out there for discovery. This field is being built as we go along, and that requires intellectual agility, optimism, and a far greater financial commitment.[7]

The next generation of archivists and scholars will be able to remake the landscape of archived amateur film only if resources are brought to bear on collection and preservation. The 8mm films of Anna B. Harris (1876–1979) are a case in point. Harris, believed to be an African American woman from Conowingo, Maryland, died in Manchester, Vermont, where she had lived for forty years, filming mostly Kodachrome between 1949 and 1958. Her thirty-seven surviving reels, which arrived in Kodak-yellow film boxes that telegraph a delightful personality through brief notations such as "Fishing in high heels," are now safeguarded at Northeast Historic Film. They depict a rural New England world populated by people of color in a resort town during the mid-twentieth century. Harris and her community are not part of the archival and interpretive record of Manchester, Vermont. Moreover, the films came via eBay, rather than from her family, making their historical and creative context difficult to reconstruct. Research has begun on the work of this filmmaker by networking with church and family friends, jump-started in part by the African American Home Movie Archive, initiated as a student project in New York University's Moving Image

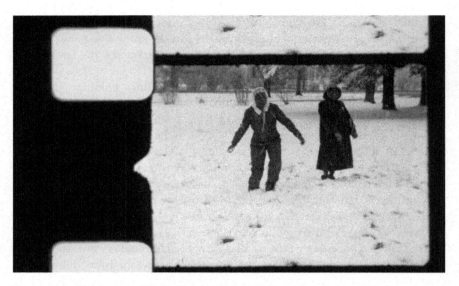

Fig. 0.2 Anna Harris wrote "Clytie, Holiday House, Self, Snow" on the 8mm film box, 1950. Scenes of Anna (on the right) shot with her camera were likely taken by people who appear with her by the Holiday House in Manchester, Vermont. From 8mm film. Anna B. Harris Collection, Northeast Historic Film. [Accession 2420, Reel 15]

Archiving and Preservation program.[8] Anna Harris's New England is one that can be recovered through attention to amateur film and home movies that lie undiscovered in an unknown number of attics, basements, closets, and storage units, or uncataloged and unopened on library or museum shelves. There are vastly more films out there than we know.

By focusing on one region (New England), archive (Northeast Historic Film), and form (amateur film and home movies), the essays in this volume map common themes within several dozen films. In order to bring some coherence to the volume for the reader who moves seriatim from introduction to index, we have grouped the essays into sections that provide a sense of orderly movement across and through the varied terrain of New England's amateur film. And while all of the essays are mindful of the technology used to create amateur film, archivist Dino Everett's technical notes—identifying camera, film stock, and editing practices for the films—give depth and intricacy to the authors' interpretations.

Beginning with "Locating Contexts: Archive, Material, History, Place," the first essays establish the various contexts in which to view amateur film. Karan Sheldon's overview of the thirty years of Northeast Historic Film's activities grounds the essays in the materiality and practice of collecting, and introduces

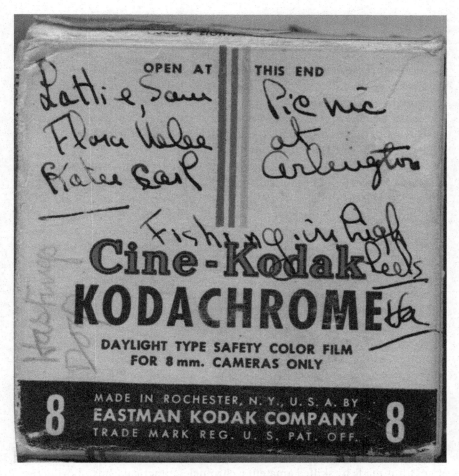

Fig. 0.3 Reel 1 notations, "Fishing in high heels," and "Picnic at Arlington" [Vermont], along with names of those filmed, are written on one of thirty-seven 8mm film boxes sent between Kodak and Anna B. Harris of Manchester, Vermont. Anna B. Harris Collection, Northeast Historic Film.

themes that will reappear throughout the volume: region, socioeconomic class, aesthetic beauty, historical context and value, and technology. Dino Everett's "The Technologies of Home Movies and Amateur Film" synthesizes complex historical data on amateur filmmaking into a narrative of technological innovations and dead ends; international competition and industrial intrigue; and the industry's goal of putting sophisticated, easy-to-operate, affordable filmmaking and projecting equipment into the hands of ordinary people.

Libby Bischof's essay pulls back from a focus on the archive and its material objects to provide the historical context for a region undergoing vast change as modernity, with its technological, socioeconomic, and cultural revolutions, transformed the everyday life and aspirations of New England's inhabitants. Establishing the aesthetic context for viewing amateur film is Justin Wolff's essay on the 28mm films of Alexander Forbes, a physician, engineer, geographer, and artist. Wolff reads the films with Forbes's scientific orientation in mind, but perhaps more importantly, points us to the choices made by the filmmaker to achieve aesthetically compelling results.

Context—archival, material, historic, and aesthetic—therefore roots these analyses of amateur film and leads to the volume's second section, "Creative Choices: Recovering Value in Amateur Film," which demonstrates the extraordinary variety of moving images under discussion and the range of values associated with them. Filmmaker Whit Stillman, writing about his grandfather's home movies, perceptively draws our attention to the difficulties faced by filmmakers (of any generation) in determining what to capture from the confusion of the world. He writes, "The key decision—the choice of subject—sounds simple but, extrapolating from the many cases of talented people who have made poor ones, is not." Examining the filmmaker's choice of what to film is the closest contextual read we can give these objects and possibly the most satisfying.

Next, Karen Gracy interrogates the position of home movies vis-à-vis the motion picture industry and argues that, just as home movies have been stereotyped as to their subject matter and technological sophistication, the perception of their value as cultural artifacts has also been straitjacketed. She encourages scholars to "read against the grain" to reveal the multiplicity of values inherent in home movies in order to broaden the films' reach and impact. Charles Tepperman's essay on Hiram Percy Maxim and the Amateur Cinema League affirms Gracy's call for revaluing by drawing our attention to the variety of films made by skilled amateurs: chronicles, practical films, short fiction, experimental, trick films, and poetic form, and the sophistication with which many amateurs (like Maxim) approached their work. Rounding out this selection of essays on the multiplicity of amateur film is Martha McNamara's close study of the comedies produced by landscape architect Sidney Shurcliff and his friends during the early years of the Great Depression. McNamara explores, in particular, the attention Shurcliff lavishes on the marsh landscape of Boston's North Shore, interpreting his lyrical depictions as a stabilizing force in what are otherwise zany, high-energy, somewhat out-of-control Keystone Kops–like comedies.

The volume's third section, "Everyday Lives: Home and Work in Amateur Film," turns toward the quotidian: amateur film's emphasis on daily life. It begins

with Jennifer Neptune's evocative exploration of the life and work of Charles Norman Shay—Penobscot tribal elder, veteran, emigrant, homecomer, cultural memorializer, husband, and father—and his images of Penobscot life in the early twentieth century. Next, Cyrus Pinkham's films provide an opportunity to interrogate everyday family life of the late 1930s through the lens of a young gay filmmaker. Christopher Castiglia and Christopher Reed note that Pinkham deploys Hollywood-style aesthetics in his depiction of family members transformed into actors by his scripting, filming, and editing. Filmmaking provided Pinkham a mode of self-expression that is at once nostalgic and glamorous, that could "delicately balance the competing claims of home and movie." Finally, Brian Jacobson explores the everyday of the workplace through films made by Charles B. Hinds and Henry Sturgis Dennison. Jacobson reveals that the "Boss's Film" is often as much about the application of scientific management principles as it is about what happens on the factory floor. While nominally placing workers at the center of their films, these bosses were also clearly making a case for a work world dominated by efficient business practices overseen by individuals who positioned themselves as capable, enlightened, modern, and benevolent factory owners.

The last section of essays, "Families: Private and Public," explores the ways in which personal filmmaking addresses the complex meanings of family and privacy. Images of family are, of course, a mainstay of home movies, but writer Martha White beautifully reveals that for her grandfather, writer and essayist E. B. White, filmmaking was a means of catching time and threading together the experiences of generations past, present, and future. White reflects on the ways that her grandfather's films capture the inheritances—physical, intellectual, artistic—looping through her family from grandfather to great-grandchildren and drawing a web of relationships whose timelessness is made visible by film. Shifting to the question of privacy, archivist Melissa Dollman asks whether we have a right to control images of our loved ones or ourselves when they move from private hands to public settings. She examines the concept of privacy as it relates to amateur film, asking about the ethics of collecting, preserving, and presenting images of people who may or may not have granted their consent. Are home movies by nature private, or do they leave privacy behind when they move from home to archive?

In the final essay, Mark Neumann and Janna Jones explore how amateur filmmakers Elizabeth Woodman Wright and Archie Stewart narrativized their lives through amateur cinema. While the world Wright commits to film is one of rural domesticity for her family at their summer retreat from urban life in western Maine, Stewart's is a "narrative of masculine adventure." In both cases, the camera afforded Wright and Stewart the opportunity to construct alternate identities, away from home, but within the protected confines of camera, film, and projector.

Amateur Movie Making deploys different modes of writing—the scholarly essay, the personal reflection, and the technical exegesis—to explore and celebrate an extraordinarily diverse range of moving images, from films of the factory floor, to madcap comedies, to family narratives. By fixing on a particular place at a particular time, the essays in this volume are able to investigate thoroughly and precisely the elements that constitute amateur filmmaking practice. Together, these authors and these essays illuminate the engaging, sometimes frustratingly complex, and often beautiful world of amateur film in early twentieth-century New England.

Technical Notes: Olin Potter Geer, *Esso Station, Boothbay Harbor, Maine* (1940) and Anna Harris, *Clytie, Holiday House, Self, Snow* (1950)

> *Esso Station, Boothbay Harbor, Maine*, 1940. Olin Potter Geer.
> Blanche Geer, PhD, Memorial Collection, Accession 1005, Reel 30.
> Gauge: 16mm. Stock: Kodak Safety Film (Kodachrome).
> Length: 18 ft. Splices: zero within gas station scene.
> Overall reel length: 20 ft.
> Date code: 1939 (Kodachrome).
> Camera code: Bell & Howell Filmo 141.

> *Clytie, Holiday House, Self, Snow*, 1950. Anna Harris.
> Anna B. Harris Collection, Accession 2420, Reel 15.
> Gauge: 8mm. Stock: Kodak Safety Film (B&W reversal).
> Length: 50 ft. Splices: one, the standard splice at 25 ft.
> Overall reel length: 50 ft.
> Date code: 1949.
> Camera code: Keystone Eight Model B-8 f-3.5.

Martha J. McNamara is Director of the New England Arts and Architecture Program in the Department of Art at Wellesley College, where she specializes in vernacular architecture, landscape history, and material culture studies of New England. McNamara is author of *From Tavern to Courthouse: Architecture and Ritual in American Law, 1658–1860* and editor with Georgia Barnhill of *New Views of New England: Studies in Material and Visual Culture, 1680–1830*.

Karan Sheldon is Cofounder of northern New England's moving image archive, Northeast Historic Film, recipient of the Silver Light Award from the Association of Moving Image Archivists. She has curated screenings including You Work, We'll Watch and Exceptional Amateur Films and given annual lectures in Regional and Nontraditional Moving Image Archiving for the L. Jeffrey Selznick School of Film Preservation, Rochester, New York.

Notes

1. Midcentury landscapes of mobility also fascinated American painter Edward Hopper, who featured gas stations in his paintings *Gas,* 1940 (Museum of Modern Art, New York), *Portrait of Orleans,* 1950 (Fine Arts Museums of San Francisco), and *Four Lane Road,* 1956 (private collection).

2. John Maloof, ed., *Vivian Maier: Street Photographer* (Brooklyn: Power House Books, 2011); Richard Cahan and Michael Williams, *Vivian Maier: Out of the Shadows* (Chicago: City-Files, 2012); Barbara P. Norfleet, *The Champion Pig: Great Moments in Everyday Life* (Boston: D. R. Godine, 1979). Other recent studies of vernacular still photography include Sarah Greenough and Diane Waggoner, et al., *The Art of the American Snapshot, 1888–1978: From the Collection of Robert E. Jackson* (Washington, DC: National Gallery of Art, 2007); Catherine Zuromskis, *Snapshot Photography: The Lives of Images* (Cambridge, MA: MIT Press, 2013).

3. For further discussion of these terms see Patricia R. Zimmermann, "The Home Movie Movement: Excavations, Artifacts, Minings," in *Mining the Home Movie: Excavations in Histories and Memories,* eds. Karen L. Ishizuka and Patricia R. Zimmermann (Berkeley: University of California Press, 2008), 1–28.

4. *The Center for Home Movies 2010 Digitization and Access Summit Final Report,* (January 2011), accessed May 26, 2015, http://www.centerforhomemovies.org/Home_Movie_Summit_Final_Report.pdf. See also Center for Home Movies, "Home Movie Terminology," and associated web pages, accessed August 11, 2015, http://www.centerforhomemovies.org/home-movie-terminology/, and Martha Yee, *Moving Image Materials: Genre Terms* (Washington, DC: Cataloging Distribution Service, Library of Congress, 1988).

5. Jean-Louis Bigourdan, et al., eds., *Film Forever: the Home Film Preservation Guide,* chapter 2, "Film Specifics: Stocks and Soundtracks," accessed May 26, 2015, http://www.filmforever.org/chap2.html; Giovanna Fossati, *From Grain to Pixel: The Archival Life of Film in Transition* (Amsterdam: Amsterdam University Press, 2009).

6. Dona Brown, *Inventing New England: Regional Tourism in the Nineteenth Century* (Washington, DC: Smithsonian Institution, 1995); William H. Truettner and Roger B. Stein, eds., *Picturing Old New England: Image and Memory* (New Haven, CT: Yale University Press, 1999); Joseph A. Conforti, *Imagining New England: Explorations of Regional Identity from the Pilgrims to the Mid-Twentieth Century* (Chapel Hill: University of North Carolina Press, 2001); Julia B. Rosenbaum, *Visions of Belonging: New England Art and the Making of American Identity* (Ithaca, NY: Cornell University Press, 2006).

7. Film scholar Patricia R. Zimmermann draws attention to this issue in her essay "Cinéma amateur et démocratie," *Communications,* no. 68 (1999): 281–92.

8. Home Movie Registry, African American Home Movie Archive, produced by Jasmyn Castro while a student in New York University's Moving Image Archiving and Preservation MA program, 2014, accessed August 18, 2015, http://aahma.org/registry/. Manchester Historical Society's Shawn Harrington located Anna B. Harris's obituary in the *Manchester Journal,* May 3, 1979, personal e-mail, May 18, 2015.

PART I

LOCATING CONTEXTS: ARCHIVE, MATERIAL, HISTORY, PLACE

1 A Place for Moving Images: Thirty Years of Northeast Historic Film

Karan Sheldon

> Although they use as their *material* the *vocabularies* of established languages (those of television, newspapers, the supermarket or city planning), although they remain within the framework of prescribed *syntaxes* (the temporal modes of schedules, paradigmatic organizations of places, etc.), these "traverses" remain heterogeneous to the systems they infiltrate and in which they sketch out the guileful ruses of *different* interests and desires. They circulate, come and go, overflow and drift over an imposed terrain, like the snowy waves of the sea slipping in among the rocks and defiles of an established order.
>
> —Michel de Certeau, *The Practice of Everyday Life*

How are we to understand twentieth-century films made by regular people in light of their qualities of experimentation, the continuities and shifts in individual and family-based entertainments, and the intermingling of personal expression and popular culture? The collaborative creativity among women, men, and children in personal films has been largely unrecognized, imperiling the survival of home movies and amateur film in museums, libraries, archives, and other repositories.

This essay calls attention to challenges faced by the custodians of amateur films and home movies, recognizes scholars who have spoken on behalf of personal films, and comments on issues in institutions promoting humanities and arts endeavors that have stood in the way of fuller recognition of these creative works.

Personal films contain images of lives and landscapes, of gestures, colors, and interactions that survive only on these original reels of celluloid. Michel de Certeau's phrase identifying consumers as "poets of their own acts" might describe the creators of home movies and amateur films as they moved in their worlds and framed particular visions. Becoming acquainted with these films as intentional works, despite their largely hidden flow in private spaces, "slipping in among the rocks and defiles of an established order," may change our

understanding of visual media. My argument derives from the experience of a moving image archive that has concentrated on collecting and sharing home movies and amateur film. Northeast Historic Film has a regional collecting mandate, northern New England, that has functioned as a filter, organizing criterion, and intellectual ground. The film examples are rooted in twentieth-century New England, inviting comparison among works made in this place within the span of five decades. Each personal film is both as common as the everyday and is also the sole instance, reflecting private lives, creative notions, engagement with photochemical and mechanical technologies and the culture of its moment.

The *Journal of Film and Video* in 1986 published a special issue on home movies and amateur filmmaking. Fred Camper's "Some Notes on the Home Movie" captured two concepts that seem no less important today to those concerned with personal film. Camper's points are that home movies have been little understood, and archives for their care are necessary: "It would be presumptuous to offer anything but the most preliminary of taxonomies of the home movie. What is needed is first of all an archival source, in which all type and manner of home movies are collected and preserved. Then scholars could go about the work of screening, studying, [and] evaluating. My primary goal here is to assert that such a work should be done, especially now, when families are increasingly transferring their home movies to video. There is always the danger that this aspect of our cinematic heritage may be lost." The same year as the special issue of the *Journal of Film and Video*, 1986, Northeast Historic Film was founded with a mission to preserve and make moving images of northern New England accessible.[1]

Camper identifies the motivating anxiety of loss when facing audiovisual technology's shift from photochemistry to video; he states that the transition to videotape should provoke public and scholarly interest in finding and discussing home movies. While in the 1980s many regional archives understood that families transferring reels of film to videotape, usually VHS, and discarding the originals was a problem (Northeast Historic Film distributed notices to commercial transfer shops requesting that the originals of newly transferred materials not be thrown out), a related insight concerns the impulse to meet transience by visually securing the disappearing object. Camper stated:

> It is often remarked that important phenomena, both natural and man-made, are often appreciated only at the moment of their demise. In our nation's recent history, the celebration, by artists, of the spiritual values of our wilderness emerged largely in the mid-nineteenth century, during the period when that wilderness was being rapidly destroyed. In a certain sense there seems something almost inevitable about this pattern; that which always existed, or so it seems, tends to be taken for granted. Perhaps the demise of the home-movie as a dominant form, as a result of home video, will awaken us all to an appreciation of what is surely a major aspect of American folk-art.[2]

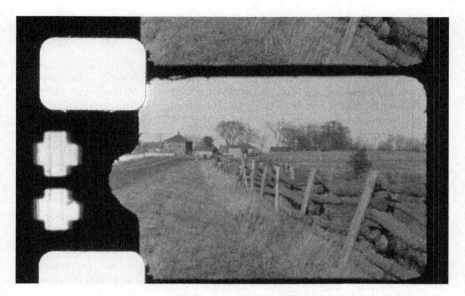

Fig. 1.1 Milton Dowe, *Just Fences*, 1938–1940. From 8mm film. Palermo Historical Society Collection, Northeast Historic Film. [Accession 2310, Reel 7]

Imminent demise is the theme of some of the better-known personal films in Northeast Historic Film's custody. The works read as explicitly elegiac, intended as cinematic records of loss by their creators. A 16mm film of the logging industry was made in 1930 by Alfred Ames and Howard Kane, entitled *From Stump to Ship*. Ames's script, read aloud when he presented the silent film in the 1930s, begins, "Knowing that the long lumber industry in Maine was a thing of the past, in 1930 I purchased a moving picture camera to make a record of the long lumber operations on the river." Another film capturing evanescence and making an explicit point about that intent is the 8mm work by Milton Dowe, *Just Fences* (1938–1940), a short visual catalog of split-rail and other fence types in the landscape with the on-screen title, "Soon these will decay and be forgotten." When exhibited to the public in the late twentieth and early twenty-first century, the pleasure expressed by some viewers may result from their own wish to pay tribute to lost things. The filmmakers' abilities to create narratives that speak to evanescence align with desires to transmit to posterity a message about fragility and survival. The habits of elegy connect personal films with other expressive forms.[3]

Gemma Perretta Scott, in 2010 the Northeast Historic Film collections manager responsible for the Milton Dowe 8mm films in the Palermo Historical Society Collection and part of a cataloging project focusing on work life, presented

Just Fences at the Society for Cinema and Media Studies annual conference. In the project blog on March 25, 2010, she calls attention to Dowe's aesthetic intent and echoes Camper's invocation of folk art:

> Below is a clip I showed from NHF's Palermo Historical Society Collection by amateur filmmaker and [then] future Palermo historian Milton Dowe. Dowe's films left behind a legacy of his tribe and the surrounding community, but their significance is underscored by an artistic value worthy of recognition. Just as Fine Arts has sub-genres of folk art, naïve art, and recently outsider art for describing works by Grandma Moses, Henri Rousseau, and Henry Darger, so do amateur works by filmmakers like Milton Dowe belong in a sub-category of Amateur film described by the quality of their technical achievement and the artistic intent of the creator.[4]

One motivation to create personal films is the capacity to document changing landscapes, people, and activities; the family film as record of how we will have been. However, the contemporary impetus for preservation of noncanonical works, I would argue, has been too much driven by what the film was thought to be about, often the record of a disappearing something, as opposed to consideration of these works as personal or group art-making.

A further complexity of longing for the indexical trace is that the approbation won when specific elegiac pieces are recognized (named to the National Film Registry by the Librarian of Congress, or screened to favorable comment at conferences, or shared via the Internet) does not necessarily draw other works along with it. Praise for a few personal films, useful in building audiences and appreciation, may not help bring attention to those films, with a no-less-engrossing gestalt, that stand outside the established and expected shape of nontheatrical films. An example of an expressive and coherent work that exemplifies this challenge is Arthur Race's 16mm film of a drunken men's excursion in 1930. The film has unity of time, place, and action; delivers portraits of the participants and their relationships; plays with mood—including suspenseful ladder descents; narrativizes the trajectory of alcohol consumption and its results; and caresses texture in objects such as rags, driftwood, and island granite. The film exposes participants' fun and provokes viewers with the playful depiction of one man draping seaweed on another's bare buttocks. These qualities are in addition to value as documentation of a white-collar homosocial excursion in the 1930s (the maker was a New England hotel manager with a professional interest in the repeal of Prohibition), and as a record of the coastal landscape of the era and its use.

What are ways to render intelligible twentieth-century films such as this one, carefully made by amateurs? We start by acknowledging that Race's *Heron Island* and tens of thousands of works may never be seen and studied. Perhaps they were meant to be enjoyed only by the participants (or maybe only by the

Fig. 1.2 Men's picnic, by Arthur Libby Race, *Heron Island*, circa 1930. From 16mm film. Arthur Libby Race Collection, Northeast Historic Film. [Accession 1154, Reel 9]

person behind the camera). Before 1980 in the United States, film and media studies largely focused on Hollywood film, early film, and well-known avant-garde works. In an art-historical context, the recognition of items and classes of work as art has a great deal to do with what has been bought and sold, as stated by Abigail Solomon-Godeau in regard to twentieth-century photographs: "The institutions and discourses that collectively function to construct the object 'art' are allied to the material determinations of the marketplace, which themselves establish and confirm the commodity status of the work of art." There has been almost a century-long avoidance of amateur film and home movies by art critics, at least in part as the result of a classification problem. If personal films are those works that exist in what Richard Chalfen in *Snapshot Versions of Life* (1987) called the "home mode," or have been invisible, like Arthur Race's *Heron Island*, then perhaps personal moving image works did not qualify for more nuanced consideration or valuation because they were produced and consumed far from any market. Films made in everyday circumstances, even if the creators demonstrate creative imagination, care, skill, and intentionality, were outside an art market-place, lacked institutional scaffolding and cachet, and have largely been left out of critical discourse.[5]

Yet within the field of film archiving, by the late 1990s the diversity and power of personal filmmaking was more apparent to those who collected and cared for it. Jan-Christopher Horak reported on a 1997 International Federation

of Film Archives/Fédération Internationale des Archives du Film gathering in Cartagena, Colombia:

> The symposium's most important revelation was that amateur films, far from being just home movies, define a cinema almost as rich in form as professional cinema, and potentially as sophisticated, even if the gauges in question are sub-standard. At least four general directions in amateurism were visible in Cartagena: ethnographic/travel films, documentary, familial "home movies" and avant-garde films. After a few days' proceedings, it also became clear that these genres are not mutually exclusive, but rather intertwined: familial narratives become documents of history, documentary images are fictionalized, all of them inscribed by the subjectivity of their makers, by the desire of the audience.[6]

Before the digital era, the inaccessibility of personal moving images contributed to the larger failure of public and critical attention. The works, when made, had been mostly intended for screening among family and friends and were almost always original reversal film; thus each exists only as a unique object. Yet personal still photochemical prints—coming to be known as snapshots and vernacular photographs, also unduplicated unique objects recognized for their material qualities—steadily gained status through exhibition in art museums. *Private Realms of Light: Amateur Photography in Canada, 1839–1940* (1984) had a substantial catalog; *Snapshots: The Photography of Everyday Life, 1888 to the Present*, appeared at the San Francisco Museum of Modern Art in 1998; *Other Pictures: Vernacular Photographs from the Thomas Walther Collection* was exhibited at the Metropolitan Museum of Art (2000), also with a catalog; *In the Vernacular: Everyday Photographs from the Rodger Kingston Collection* was shown at the Boston University Art Gallery (2004–2005); and *The Art of the American Snapshot, 1888–1978: From the Collection of Robert E. Jackson* was hung at the National Gallery of Art (2007), while *Accidental Mysteries: Extraordinary Photographs from the John and Teenuh Foster Collection*, had eight exhibition sites (2007–2008).

Most of these exhibitions were made up of unattributed photographs, a result of snapshot collecting practices. This is exemplified in communications from an exhibition at the Museum of Fine Arts, Boston, in 2015–2016, which foregrounds image sources in its web promotion: "'Unfinished Stories' celebrates a century of snapshots from the Peter J. Cohen Collection of amateur photographs. An avid collector, Cohen rescued more than 50,000 lost, discarded, or disowned personal photographs, culled from flea markets, antique shops, galleries, eBay, and private dealers." According to Sarah Greenough in her introduction to *The Art of the American Snapshot*, "Curators, too, have recognized that some snapshots, once they are removed from the personal narratives that impelled their creation and endowed them with their original meanings, are immensely satisfying visual

objects, worthy of careful scrutiny." Do vernacular still photographs enter the fine-art space with anonymity for their unknown creators in some sense providing cover for curators and critics, who don't have to wrestle with details of the photographers' existence? As I argue below, to bring personal films into transdisciplinary discussion and careful curatorial inclusion, it is necessary to come to terms with the materiality of film (the skills and choices of 16mm and 8mm nonprofessional creators who handled the photochemical reels), along with acquiring scaled-up resources for documenting and preserving films in the context of the individual creator's work. I propose that personal films may be recognized in an art-historical context even without a veil of anonymous creatorship. Media critics, scholars, and philosophers of art will, in the future, be more likely to contend with moving image art of the everyday.[7]

Solomon-Godeau identifies strategies of appropriation and pastiche in postmodernist photography. The attention to appropriation as highest-value use for amateur films and home movies, more welcome than the works in their unreused form, is in a curious relationship to the "as is" exhibition of vernacular still photographs in art museums. Appropriated, reworked amateur film and home movies seemed until now more highly valued than the original works, for example in the selection of *Found Footage: Cinema Exposed* as the topic of the first exhibition at the EYE Film Institute, The Netherlands, in 2012. The exhibition included Bruce Conner, Gustav Deutsch, and others, curated to demonstrate "the fascination of artists and experimental filmmakers for working with found films and film fragments, to which they give a new, original twist." At the end of the photochemical era, I propose that we consider films made for intimate audiences as expressive works of art without always having to invite contemporary filmmakers to refashion and obscure them.[8]

We start by asking why the original unappropriated amateur works are not enjoying more widespread critical consideration. Perhaps the simplest answers are that these works, when made, were not intended for a connoisseurs' market, and that small-gauge film was disadvantaged as a medium by the expense (or poor quality) of duplication, by projection challenges, and by the fragility of the materials as they aged.

The interaction of scholars and curators with moving images relies on access to the audiovisual materials. To consider films for study, teaching, and exhibition, works must be brought to light and made safe for discussion. If the films are previously unknown, the potential users must be intellectually oriented toward discovery and situated in institutions friendly to engagement with unrecognized works. One challenge of discussing amateur film and home movies is inertia: traditional academic values and interests sometimes move slowly, and personal film is unfamiliar. Andrew Lampert, curator of collections at Anthology Film Archives in New York, says of attempting to interest researchers in noncanonical

work, "Academia is this closed loop, where people write about what's already been written about." Artistic and professional excellence in film are subjective qualities more easily matched to known names and recognized genres of film than to unknown film works by individuals expressing themselves in creative modes that at the end of the twentieth century were just beginning to be written about in Europe and North America. Scholars who take this leap are generating a literature around the art and intentionality of works not firmly planted in recognizable pastures of avant-garde or documentary media, and this, I believe, is an essential turn for personal films.[9]

Finding Funding for History

I suggest there are three elements that determine the health of audiovisual archives: (1) survival through technological shifts, (2) negotiation of perceived value of holdings and the actual remunerative market for those holdings (appraisal), and (3) tactical communications leading to funder appreciation of collections' intellectual, cultural, and monetary value. The continued existence of analog moving images, and particularly personal moving images, is dependent on these three factors. In the United States, funding for moving image preservation has had two main federal sources and a small cohort of philanthropic entities providing sub-survival-level resources. On the earned-income side in the late 1980s and 1990s there was a public market for copies of personal films on hard media (VHS and DVD) and commercial stock footage (for illustrative use in documentaries, short clips in commercials, and in some feature films). The perceived value of nontheatrical moving image content, including home movies, in education and the public sphere was enhanced by state-mandated regional and ethnic studies and by high-profile museums such as the Japanese American National Museum (opened 1992) and the United States Holocaust Memorial Museum (opened 1993). These institutions used personal moving images as an integral part of their public programs.

Andrew Lampert at Anthology Film Archives describes his institution's "cellar's worth of discarded films from deceased laboratories, widows, dumpsters, from the street, from every nook and cranny." All organizations must choose what to keep and show while seeking financial support, as Lampert says: "One generally has to raise federal, public, or state funding. Or you have to find private foundations and individual funders. So to do this, you generally have to argue a value for a film in order to fight for its long-term preservation. I understand that process, it's clear to me, but what really intrigues me are the films that we unknowingly let slip through our fingers. Not just Anthology, everybody."[10]

The competition for arts and culture funding is bound by institutional definitions of intellectual acceptability, definitions of "quality," and shared understanding of value. A path to funding for film preservation and access is created

by making a case that builds on proven precedents while offering new insights and experiences. Northeast Historic Film's first such negotiations were around the 16mm amateur film *From Stump to Ship*, undertaken by the founders in 1985 with the University of Maine. The film had been donated, along with a script, to the university by a family member of Alfred Ames (1866–1950), the primary filmmaker. The 1930 film had landed in the office of David C. Smith, a history professor who published on Maine history, geology, H. G. Wells, and other topics. Smith handed film cans to a staff member from the university's public information office, Henry Nevison, who contacted the director of the Maine Humanities Council, thinking the council might be a source of funds to copy the film and make it accessible. Janna Jones describes the journey in "From Forgotten Film to a Film Archive: The Curious History of *From Stump to Ship*." Selecting the Maine Humanities Council, a state affiliate of the National Endowment for the Humanities, as a funding source was closely connected with how archival non-fiction film was seen at the time. The humanities sponsorship, an imprimatur essential to Northeast Historic Film's existence for its first decade, tracked closely with expectations of film indexicality: the perceived value of a film document as a record of the past. This orientation was buttressed by the prevailing under-standing of nonfiction film as documentary, the use of film in construction of historical narratives, and the negotiation of corporate and educational interests. Documentary film production, PBS-style broadcast, and use in classroom teach-ing were practices supported by a cohort of filmmakers and historians; the tele-vision compilation documentary form (archival footage and talking heads) was a National Endowment for the Humanities–grant staple. What falls outside this negotiation for *From Stump to Ship*, and more broadly for the status of nonthe-atrical film, is an understanding of the variety of films made by regular people. There was and still is resistance to investigating the range of personal films and pursuing how the reels might be understood as creative works, not just as record-ings of the past. As the photochemical era recedes further into the past, it may be possible to expect a more lively appreciation of amateur creativity; however, this will require access to more works—and to understand them, accompanying knowledge of their photochemical attributes.[11]

In the 1980s, the popularity of VHS videotape greatly expanded the home and educational markets for regional archival audiovisual materials. Videos were acquired by individuals and institutions for enjoyment—and also prompted by the requirement for educational materials to support local and regional stud-ies. In New England there was a traditionally practiced and legally mandated curriculum, as expressed in 1983 state legislation: "Maine studies. A course in the history, including the Constitution of Maine, Maine geography and the natural, industrial and economic resources of Maine and Maine's cultural and ethnic heritage shall be taught in at least one grade from grade 6 to grade 12,

in all schools, both public and private." That law was probably instrumental in driving purchases by schools and libraries of VHS videotapes, and later DVDs, from Northeast Historic Film, income that helped underwrite staff lines and supported the operating costs of the archive. Distribution of personal films packaged for classroom use had several outcomes: there was newly earned income for the archive, teachers became accustomed to using archival media in instruction, and students were exposed to home movies and amateur film presented as historical evidence early in their classroom experience.[12]

What is Artistic Excellence?

Northeast Historic Film, around the time it was founded as an independent media archive in 1986, investigated the grant guidelines of the National Endowment for the Arts (NEA). Becoming a self-supporting organization required finding funding for works that were not easy to label as history. The National Endowment for the Arts' establishing legislation focused on advancement of professional excellence, as in "projects and productions, which have substantial national or international artistic and cultural significance, giving emphasis to American creativity and cultural diversity and to the maintenance and encouragement of professional excellence." Grant requests would be rejected if they did not conform to the agency's ideas of artistic excellence: "Artistic excellence and artistic merit are the criteria by which applications are judged, taking into consideration general standards of decency and respect for the diverse beliefs and values of the American public." The NEA, with the American Film Institute, in 1984 established the National Center for Film and Television Preservation, which administered the American Film Institute/National Endowment for the Arts Film Preservation Program. The grant guidelines for the AFI/NEA Film Preservation Program noted that a limited number of grants would be awarded to film archives to support the laboratory costs of preserving American films of the highest artistic excellence, and that "applicants must raise a minimum of two nonfederal dollars for every dollar that is awarded by the Arts Endowment, and must have plans to exhibit the film(s) after they are preserved." Applicants were asked for a description that included "the film's significance as a 20th century artwork."[13]

The AFI/NEA annual round of film-preservation grants was largely directed to a half-dozen major film-preservation programs. Northeast Historic Film was awarded $1,000 in 1988 toward laboratory work on about four thousand feet of 35mm nitrate film shot by Maine news cinematographer Daniel Maher between 1924 and 1933. Also in 1988, another NEA program, Expansion Arts, regranting through the Maine Community Foundation, awarded $3,000 toward preservation of *Movie Queen, Lubec*, a 16mm film by an itinerant filmmaker, Margaret Cram. Northeast Historic Film offered the Maher and Cram film preservation

projects as examples of interesting nontheatrical work, and in that role these films helped advance awareness among funders, and the reviewers who served the funding process, of regional creators in a national context.[14]

Northeast Historic Film set out to establish itself as an entity that was suitable for tax-exempt status in the eyes of the Internal Revenue Service in order to be eligible for grant funding. To become an independent not-for-profit organization and thus qualify for most kinds of grant funding, an applicant must express educational and charitable bona fides under IRS rules. Northeast Historic Film's initial application prompted thirteen questions in return from the IRS regional office. Northeast Historic Film replied by comparing the moving image archive to a public library:

> Just like the public library serves the reading public, NHF services public organizations and individuals. In fact, NHF serves the broadest possible public: not just readers, but listeners and watchers, too. Historical film is of particular interest and relevance to students at all levels in the fields of history, sociology, anthropology, film and media, and to the elderly, who can relate to past events shown in motion picture[s] . . . A bookstore, which must select stock with an eye to what sells in a particular community today in order to make money and stay in business, uses very different selection criteria from a library, which chooses books that are of interest to its users and will be preserved for posterity. NHF selects preservation and access projects—not like the bookstore to make money through "best sellers" and "popular" titles—but like the library, for lasting value and interest to the public over the long term.[15]

The invocation of the public library, found in nearly every community, and the emphasis on history, past events, and "lasting value," likely spoke a reassuring language to the IRS readers. Tax-exempt status was awarded in 1987.[16]

Shortly after NHF's founding, donations of moving image materials arrived, including more 1930s silent 16mm films: a portrait of the town of Cherryfield, Maine, in 1938, valued by the local historical society, which identified all individuals shown in it; an amateur film of cutting and storing ice near Portland, Maine, in 1943; and essayist E. B. White's family films and projector. To their new custodians' eyes, these works were compellingly shot and edited, and although the Cherryfield piece had sustained water damage, its overall visual quality ensured that the emulsion degradation did not detract from the audience experience. The visible trauma to the reversal film presented the opportunity to discuss film's paradoxically robust fragility, while the framing and gaze prompted conversations about Depression-era still photography. (See fig. 1.3)

A museum exhibition called *Home Movies* took place in 2000 in New York City. Two elements of the show—a screening series and a gallery installation—guided its creation, potentially clearing the way for home movies in fine art museums, yet not speaking for the broad range of personal films, since screenings were

Fig. 1.3 Lester Bridgham, *Cherryfield 1938*. Water damage to the emulsion at the surviving head of the reel. From 16mm film. Cherryfield-Narraguagus Historical Society, Northeast Historic Film. [Accession 1194, Reel 1]

of home movies by professional filmmakers and celebrities, not unknown makers, and the installation was not a home movie but a work by Ken Jacobs, a celebrated experimental filmmaker. *Home Movies*, the installation at the Museum of Modern Art (MoMA), was mounted in April 2000 accompanied by a screening series from MoMA's collections. The installation opened with an 8mm short by Ken Jacobs called *Baby Advances*, projected as a loop on a 1953 Bolex 8mm projector. Jacobs, a filmmaker and teacher (with a retrospective at MoMA in 1996 and the 2013 exhibition *Carte Blanche: Ken Jacobs*), is known for exploiting mechanical and visual intersections, so installing the 8mm projector with a film loop was congruent with his work and appropriate for the *Home Movies* show. With recognition of the distinctive character of projected film, presentations of personal films in the future will sometimes choose traditional projectors with film looping mechanisms as curators become more committed to the photochemical experience in gallery spaces.

The MoMA *Home Movies* curators, Jytte Jensen and Anne Morra of the Department of Film, noted in the show's press release that "the defining components of a home movie seem to be covered by notions linked to the intimate sphere: immediacy, familiarity, authenticity, accessibility, and artlessness." MoMA's public presentation of home movies naturally reflected the collecting practices of the Department of Film: Douglas Fairbanks, Mary Pickford, D. W.

and Evelyn Griffith, among others. The press release characterized the 16mm era of home movie making as primarily a period dominated by wealthy socialites and celebrities, with a later shift to 8mm modest-income users with inward focus:

> Although home movies by professional filmmakers existed from the birth of the medium, it was the introduction of 16mm film stock and camera in 1923 that provided the amateur filmmaker with the technology to document various domestic events. Nevertheless, economic forces prohibited the wide consumption of this gauge of film, and its use was generally confined to the affluent. Typically these home movies are not the filmic records of the average family, but rather they illustrate the "private" lives of very public people or the celebrated friends of the moviemaker. From the early 1920s, home movie documents of the socialite and celebrity proliferated throughout the world . . .
>
> In 1932, 8mm film and cameras were introduced into the nonprofessional filmmaking market. Affordable, lightweight cameras, reliable film stock and workhorse projectors all permitted the amateur filmmaker of modest economic means to realize his/her auteurist potential. With the advent of the newly formulated small-gauge film now in the hands of pure amateurs, the obvious subject of the lens would be turned inward to focus on a more closed and private environment.[17]

The decade that followed the MoMA show revealed the diversity of 16mm creatorship with evidence that people of relatively modest means used 16mm film and editing equipment, examples being Everett Johnson (1912–1988), who made a short film of ice harvesting in 1943 because he lived near a pond, and the young Cyrus Pinkham (1915–1989). Following the invention of 8mm film, works by regular people such as Milton Dowe (1912–2001) of Palermo, Maine, were not restricted to the purely closed and private environment. Dowe's approximately 7,900 feet of 8mm film included the previously discussed *Just Fences*, trick films including a knife-throwing gag film made with W. J. Roach, *Is Seeing Believing*, and with Virginia Wescott Dowe, *Remote Control*, a stop-motion production.[18]

The MoMA exhibition press release from April 2000 includes a statement regarding the dissemination of consumer cameras and an aesthetic judgment of the resulting home movies: "The spread of movie technology beyond those already professionally familiar with the medium had marked stylistic ramifications. Generally speaking, the home movie came to be recognized by the amateurish quality of the camerawork." This statement highlights a circularity of thought accorded the visual qualities of personal films in a period that preceded access to immense numbers of personal works in museums and archives (and YouTube and the Internet Archive). This definition of "amateurishness" could discount the creators' knowledge and opinions acquired by them as astute observers (consumers) of theatrical film forms, the role of instructional publications and sharing with peers, and the value of originality.[19]

Advocacy

A close look at personal films then known shows a spectrum of creative camera work, mise-en-scène, and editorial control. Archivists assessed the content of amateur reels in their custody, recognizing dramas, travel and adventure, trick films, comedies, industrial process films, instructional films, and poetic works. Individual curators and scholars organized to raise the visibility of these works within and outside their institutions. Anne Morra, cocurator of the MoMA show *Home Movies*, attended an archivists' roundtable on small gauge film in Los Angeles, California, in 2000, where she recounted the rapid shift in MoMA's opinions about home movies. According to minutes of the meeting, "Morra described the low priority often given to this format in terms of funding and collecting. For example, initially her institution was hesitant to support the *Home Movies* exhibition. Later the director of the museum highlighted its success." The small gauge roundtable was an organizing and advocacy effort launched by members of the Association of Moving Image Archivists to address the status of non-35mm (small gauge) film. The group was convened as the Small Gauge Film Preservation Task Force in 2000 to discuss preservation of 8mm, Super 8, and 9.5mm film, including appraisal and selection (how to identify films of significance); long-range plans, including funding for preservation; and identification of technical challenges to help ensure that laboratories and archives invested in small-gauge infrastructure. This meeting led to a small-gauge-themed Association of Moving Image Archivists conference in Portland, Oregon, in 2001.[20]

The convening body, AMIA, had been founded in 1991 as a forum for individuals interested in film and video preservation. The first AMIA conference, held in New York City, was attended by 140 people and included a plenary session on amateur film. Northeast Historic Film organized the panel cochaired by Stephen Gong, associate director of the American Film Institute's National Center for Film and Video Preservation, with panelists Pamela Wintle (Human Studies Film Archives at the Smithsonian Institution), Micheline Morriset (National Archives of Canada), and Karen Ishizuka (Japanese American National Museum). The session, called "Home Movies and Amateur Footage," showed and discussed video transfers of nonfiction amateur film, highlighting the significance of personal films, an interjection of nontheatrical film into a body then largely concerned with nitrate, fiction film, and television collections. Patricia Zimmermann (Ithaca College), at the last minute unable to attend, sent a statement that read in part, "Of course, amateur film must never be seen as an isolated phenomenon; it is always operating in tandem with commercial filmmaking, mass culture, the commodification of leisure time, the dissemination of technology, and localized interests."[21]

Regional moving image archives collaborated through the Association of Moving Image Archivists on a screening at the annual conference in Montreal in 1999. "The Richness of the Regions, Projecting a Global Picture of the 20th Century," curated by Maryann Gomes of the Northwest Film Archive in Manchester, United Kingdom, included *Captain Rowsell's Norwich*, an amateur film from the East Anglian Film Archive by an American airman presented by Patrick Russell, and *Mississippi Baptism* (Rosedale, Mississippi), Emma Knowlton Lytle Collection 8mm Kodachrome, part of the Southern Media Archive's project, *Picturing Home: Family Movies as Local History*, presented by Karen Glynn. Gomes (1954–2002), the first leader of a nonnational archives to achieve recognition by FIAF, the Fédération Internationale des Archives du Film, was a flag-carrier for the diversity of nontheatrical film in that international body.

Advocacy for particular genres within amateur work, such as home dramas or experimental and trick reels, led to focused screenings building on the increasing access to archival collections, and engaging interested scholars. Fiction films by individuals and families became the subject of Northeast Historic Film's 2005 symposium, Amateur Fiction Films. Dramatic films were a significant portion of UK cine-club production, according to Heather Norris Nicholson. She says that in the 1930s, "amateur fiction filmmaking seems an expression of cinematic form gaining greater acceptance as a respectable realm of activity beyond its popularist, Leftist and avant-garde circles."[22] Jan-Christopher Horak, mentioned above in connection with the Cartagena FIAF symposium, edited the anthology *Lovers of Cinema*, which includes an introduction, "History in the Gaps," and a chapter, "The First American Film Avant-Garde, 1919–1945," sensitive to the intersection of recognized avant-garde films and the amateur movement, in which he states, "In its earliest phases the American avant-garde movement cannot be separated from a history of amateur films." He noted the Amateur Cinema League's growth between 1926 and 1928 and the existence of amateurs and clubs throughout the United States.[23]

The establishment of the National Film Preservation Foundation (NFPF) in 2000 led to a competitive process for obtaining funds to pay laboratories to preserve films on film, in which a grant seeker made a case for its candidate film's cultural and artistic significance. In the NFPF grant rounds from 2000 through 2012, of 886 NFPF federal grants, at least 136 (15 percent) were for films identified by the repository as home movies or amateur films. Of 181 additional partnership grants, at least 24 (13 percent) were identified as home movies.[24]

The Librarian of Congress, recognizing films of historic, cultural, and artistic value, has since 1989 named these twelve amateur films and home movies to the National Film Registry, listed in the order of their stated dates of creation: *From Stump to Ship* (1930), *A Study in Reds* (1932), *Our Day* (1938), *Cologne: From the Diary of Ray and Esther* (1939), *Nicholas Brothers Family Home*

Movies (1930s–1940s), *The Augustas* (1930s–1950s), *Tacoma Narrows Bridge Collapse* (1940), *Topaz* (1945), *Disneyland Dream* (1956), *Zapruder Film* (1963), *Multiple Sidosis* (1966), and *Think of Me First as a Person* (1975). These titles represent somewhat less than 2 percent of the National Film Registry's total of 650 films as of 2015. In 2014, 16mm footage by Samuel Fuller under the title *V-E +1* (1945), was added to the registry, "the latest amateur title to be added to the list," according to the Center for Home Movies (December 2014). It is documentation of a Nazi concentration camp filmed while Fuller was in the infantry. The National Film Registry has existed under a single Librarian of Congress, James H. Billington. His successor, Carla Hayden, may play a role in new directions for the National Film Registry.[25]

Toward Aesthetic Exploration

Northeast Historic Film was founded to collect and make accessible moving images that gave pleasure to audiences. Metrics of success included audience size, press coverage, follow-up inquiries, sales of related materials such as DVDs, and invitations for speaking engagements and screenings. To reach urban and arts audiences, the organization carried out screenings at the Portland Museum of Art (Maine), starting in 2001 with the program Exceptional Amateur Films, which included the comedy drama *Mag the Hag* (1925) by Hiram Percy Maxim, founder of the Amateur Cinema League, starring his daughter as a young man; a comedy by the Hilda and Meyer Davis family, *Miss Olympia* (1931); and selections from Elizabeth Woodman Wright's reels of Paris, Maine (circa 1930), which were included in the National Film Preservation Foundation's *Treasures from American Film Archives*, a DVD boxed set of materials from eighteen archives released in 2000.

The title of the 2001 Portland Museum of Art screening, Exceptional Amateur Films, employed a mechanism that attempted to overcome possible audience preconceptions of amateur film and home movies. In the funding and exhibition environments of the early 2000s, declarations of exceptionalism seemed the safest course. The event, by underlining careful curatorial selection with the word "exceptional," meaning unusual or outstandingly good, framed the program as appropriate for the funder, the host institution, and the audience. But does "exceptional" imply that other personal films are not worth watching? By classifying things that we imagine as alike together, potentially denigrating all the others as the usual, the commonplace, and the dull, we perpetuate the general devaluation of a class of objects—where each work might instead deserve to be examined rather than prejudged.

Around 2000, a few media critics stretched to make an analogy on behalf of personal film to fine art, usually pastoral, as when film critic Jay Carr considers

Fig. 1.4 *Miss Olympia*, 1931. From 16mm film. Hilda and Meyer Davis Collection, Northeast Historic Film. [Accession 0284, Reel 25]

Elizabeth Woodman Wright's Paris, Maine, film in a review of the *Treasures from American Film Archives* DVD collection. He wrote, "In the contributions from Northeast Historic Film, the compositions in frame after frame of seemingly offhand footage of workers plowing and removing rocks from a field in 1930 are more urgently composed than many a more celebrated pastoral painting by the likes of Millet or Thomas Hart Benton."[26]

Northeast Historic Film quoted Carr in the press release for the Exceptional Amateur Films screening at the Portland Museum of Art, and in the event's film notes, said this of Wright:

> Elizabeth Wright was a careful recorder of rural life. She was not a member of the Amateur Cinema League. She did not create an obsessively ordered narrative structure with intertitles. Instead, she captured views of the farm called Windy Ledge, in the summer orchard, at haying time, and around the barn, over a period of five years. Her style fits the subject beautifully. The film is peaceful and unusual for amateur footage, leisurely—befitting its subject.
>
> It is extraordinarily valuable for the personal point of view Wright brought to the work. We know from her son, Walter Woodman Wright, that she took care in preparing her filming, using a tripod, and capturing the passing of seasons, including the "last" birthday party of an elderly neighbor—year after year.

While the film includes world-renowned Maine fiddler Mellie Dunham (a much promoted "discovery" of Henry Ford's), the every day [sic] is the point of this amateur work.

There was not then anything remarkable about the daily farm activities: kids on a bench, the farm cat, Uncle El (Ellsworth Thayer) bringing in the hay. But today, the magic of these silent views is palpably present in a way that no other medium can convey.[27]

Reversal film from the hands and eyes of individuals, motivated by pleasure and the power of self-expression shared with intimates, has since been replaced by digital moving image media. Personal films allow us to experience a century of gestures, stories, framings of love, and incipient loss. Examining these works, which were never public commodities, we look at the contexts in which they were produced—their intersections with performative traditions, popular culture, socioeconomic settings, technological determinants. Seeing the films as they were originally made, we reflect on the barriers to preservation and presentation until this moment. Discovering the worlds that can be found in these representations of the vanished whole, it is not such a stretch to think of many personal Kodachrome and black-and-white films as works of art.

Technical Notes: Milton Dowe, *Just Fences* (1938–1940); Arthur Race, *Heron Island* (circa 1930)

Milton Dowe's *Just Fences* and Arthur Race's *Heron Island* reflect the most common types of nonnarrative amateur film in terms of their technical production: the edited film and the point-and-shoot linear film. As film became more affordable, the attention that amateur filmmakers put into making each film tended to decrease. This explains why Super 8 films (a film format that began to be available in 1965) are often nothing more than long reels consisting of multiple, unedited fifty-foot rolls spliced end to end, whereas many 16mm films of the 1920s and 1930s will contain specially made titles and careful editing choices. In these examples, however, the reverse is true: Dowe's 8mm film is edited, whereas Race's 16mm film is entirely linear.

Both the Dowe and Race films seem to be made using the fixed-focus lenses that came standard on most early cameras. These lenses relieved the amateur from worrying about focusing on the subject as long as the subject was a certain distance from the camera (usually around five feet). Everything near or far would remain in focus unless it came too close to the lens, which can be seen briefly in the Race film when subjects come right up to the camera and go slightly out of focus.

Heron Island records a linear version of events unfolding before the camera. It was shot handheld and features no editing other than splicing four

one-hundred-foot rolls end to end onto a four-hundred-foot projection reel. This splicing could sometimes be requested from the lab that processed the film. A fuzzy edge around the frame caused by dirt in the camera gate at the time of shooting points to a user who was either unaware or uninterested in the need to clean the inside of the camera before each new roll was shot. This could indicate that the filmmaker was primarily interested in documenting a moment in time rather than making a perfect film, or that the amateur was someone with the financial means to acquire the latest gadgets, but not deeply committed to the art of filmmaking.

Dowe's *Just Fences*, however, while also shot handheld, reveals a couple of technical considerations suggestive of an early enthusiast who cared about the process and potential artistry of making films. *Just Fences*'s frame has a clean edge despite the fact that any dirt in the camera gate would be much more noticeable because 8mm frames were half the size. Next, the main title appears to be carved into wood, showing that the filmmaker (or a friend) was willing to devote the time to creating something that might have no other use beyond titling this roughly six-foot film. Finally, the secondary title, "Soon these will decay and be forgotten," appears to be typed on white paper. This provides a clean, aesthetically polished look. Race, on the other hand, like most point-and-shoot filmmakers, avoided all titles and instead filmed whatever existing signage he found along the way.

There were two main types of equipment that filmmakers could use to create titles: the homemade vertical and the manufactured horizontal stands. Based on the titling in *Just Fences*, it seems likely that Dowe used a vertical stand that allowed him to arrange a title on the floor and shoot it from a set position directly above. These were often referred to as "animation stands" because they were used for most predigital animation. The horizontal stand was usually a small cradle attached to the camera with a slot for pieces of hand-drawn paper or boards on which one could place specially made letters. The horizontal stand often required a separate lens attachment to photograph an image set only inches away, whereas the homemade kind could be designed to match the focal length of the amateur's existing lens.

Just Fences, 1938–1940. Milton Dowe.
Palermo Historical Society Collection, Accession 2310, Reel 7 excerpt.
Gauge: 8mm. Stock: Kodak Safety Film (B&W reversal).
Length: 6 ft. Splices: five.
Overall reel length: 200 ft.
Date codes: 1939 for intertitles; 1938 and 1940 for fence footage.
Camera code: Ciné-Kodak Eight Model 60 f-1.9.

Other info: The titles are homemade and have the same camera code as the rest of the film. This selection is one of many edited pieces with titles in the overall 200 ft. reel.

Heron Island, circa 1930. Arthur Libby Race.
Arthur Libby Race Collection, Accession 1154, Reel 9.
Gauge: 16mm. Stock: Kodak Safety Film (B&W reversal).
Length: 400 ft. Splices: three, all diagonal, roughly one every one hundred feet. This reel appears to be four 100 ft. reels spliced together with no editing.
Overall reel length: 400 ft.
Date code: 1930.
Camera code: Bell & Howell Filmo 70-D.

Karan Sheldon is Cofounder of northern New England's moving image archive, Northeast Historic Film, recipient of the Silver Light Award from the Association of Moving Image Archivists. She has curated screenings including You Work, We'll Watch and Exceptional Amateur Films and given annual lectures in Regional and Nontraditional Moving Image Archiving for the L. Jeffrey Selznick School of Film Preservation, Rochester, New York.

Notes

1. Fred Camper, "Some Notes on the Home Movie," *Journal of Film and Video* 38, no. 3/4 (Summer–Fall 1986), 10.
2. Ibid.
3. *From Stump to Ship* (1930), 16mm film, Fogler Library Collection, Northeast Historic Film, Bucksport, Maine; *Just Fences* (1938–1940), Milton Dowe, Palermo Historical Society Collection, Northeast Historic Film, Bucksport, Maine.
4. Gemma Perretta, "The Intrigue and Accessibility of Amateur and Home Movie Collections," accessed September 3, 2013, http://nhftreasures.blogspot.com/2010/03/intrigue-and-accessibility-of-amateur.html.
5. Caroline Frick, *Saving Cinema: The Politics of Preservation* (New York: Oxford University Press, 2010); Janna Jones, *The Past is a Moving Picture: Preserving the Twentieth Century on Film* (Gainesville: University Press of Florida, 2012); Abigail Solomon-Godeau, *Photography at the Dock: Essays on Photographic History, Institutions, and Practices* (Minneapolis: University of Minnesota Press, 1991), 124; Richard Chalfen, *Snapshot Versions of Life* (Bowling Green, Ohio: Bowling Green State University Popular Press, 1987).
6. "Substandard" is a term used for film gauges such as 16mm and 8mm, smaller than standard professional 35mm film. Jan-Christopher Horak, "Out of the Attic: Archiving Amateur Film," *Journal of Film Preservation* 56 (1998): 50–51.

7. *Unfinished Stories: Snapshots from the Peter J. Cohen Collection*, Museum of Fine Arts, Boston, July 11, 2015–February 21, 2016, accessed July 28, 2015, http://www.mfa.org/exhibitions /unfinished-stories; Sarah Greenough, Diane Waggoner, Sarah Kennel, and Matthew S. Witkovsky, eds., *The Art of the American Snapshot, 1888–1978: From the Collection of Robert E. Jackson.* (Washington, DC: National Gallery of Art, 2007), 3.

8. Marente Bloemheuvel, Giovanna Fossati, Jaap Guldemond, eds., *Found Footage: Cinema Exposed* (Amsterdam: Amsterdam University Press: EYE Film Institute Netherlands, 2012), accessed September 3, 2013, http://www.eyefilm.nl/en/expositie/found-footage /found-footage-cinema-exposed.

9. Joel Schlemowitz, "Unessential Cinema: An Interview with Andrew Lampert," *The Moving Image* 12 no. 1 (2012), 108; Ian Craven, ed., *Movies on Home Ground: Explorations in Home Cinema* (Newcastle upon Tyne: Cambridge Scholars, 2009); Laura Rascaroli, Gwenda Young, Barry Monahan, eds., *Amateur Filmmaking: The Home Movie, the Archive, the Web* (London: Bloomsbury Academic, 2014).

10. Schlemowitz, 108.

11. Janna Jones, "From Forgotten Film to a Film Archive: The Curious History of *From Stump to Ship*," *Film History* 15, no. 2 (2003), 193–202.

12. Laws of the State of Maine as passed by the One Hundred and Eleventh Legislature, 1983, Chapter 859, §4706 (page 4318) "An Act to Implement the Recommendations of the Commission on the Status of Education in Maine," accessed July 28, 2015, http://lldc.mainelegislature .org/Open/Laws/1983/1983_PL_c859.pdf, via the Maine State Law and Legislative Reference Library.

13. National Endowment for the Arts, US Code Title 20, Section 954, accessed July 17, 2015, http://www.gpo.gov/fdsys/pkg/USCODE-2011-title20/pdf/USCODE-2011-title20-chap26 -subchapI-sec954.pdf; AFI-NEA film preservation grants are described in Annette Melville and Scott Simmon, eds., *Film Preservation 1993 A Study of the Current State of American Film Preservation: Report of the Librarian of Congress.* (Washington, DC: National Film Preservation Board of the Library of Congress, 1993), accessed July 17, 2015, http://www.loc.gov /programs/national-film-preservation-board/preservation-research/film-preservation-study /current-state-of-american-film-preservation-study/.

14. See Sarah Ziebell Mann, "American Moving Image Preservation 1967–1987." Master of Library and Information Science thesis, University of Texas at Austin, 2000.

15. Northeast Historic Film, institutional archives, IRS Form 1023 Follow-up, July 1987, 4–6.

16. Letter from Internal Revenue Service, Department of the Treasury, to Northeast Historic Film, October 18, 1993, accessed July 17, 2015, http://oldfilm.org/sites/default/files/NHF%20 IRS%20Letter.pdf.

17. "Four-Month Series At MoMA Explores The History And Influence Of Home Movies," The Museum of Modern Art, New York, press release, April 17, 2000, accessed July 19, 2015, http://press.moma.org/wp-content/press-archives/PRESS_RELEASE_ARCHIVE/home _mov.pdf.

18. Everett Johnson Collection, Northeast Historic Film, Bucksport, Maine; Cyrus Pinkham Collection, Northeast Historic Film, Bucksport, Maine; Milton Dowe's films in the Palermo Historical Society Collection, Bucksport, Maine.

19. Ibid., The Museum of Modern Art.

20. Association of Moving Image Archivists, "Minutes, Roundtable on Small Gauge Film," June 17–18, 2000, Sony Pictures Studio, Culver City, CA, accessed September 3, 2013, http://www.amianet.org/groups/committees/smallgauge/documents/minutes/Roundtable _mins_00.pdf.

21. Patricia Zimmermann, fax message to author, November 6, 1991.

22. Heather Norris Nicholson, *Amateur Film: Meaning and Practice, 1927–1977* (Manchester: Manchester University Press, 2012), 40.

23. Jan-Christopher Horak, ed., *Lovers of Cinema: The First American Film Avant-Garde, 1919–1945* (Madison: University of Wisconsin Press, 1995), 18.

24. National Film Preservation Foundation, Awarded Grants, accessed July 19, 2015, http://www.filmpreservation.org/nfpf-grants/awarded-grants.

25. Library of Congress, Complete National Film Registry Listing, accessed July 19, 2015, http://www.loc.gov/programs/national-film-preservation-board/film-registry/complete -national-film-registry-listing/; Donna Ross, e-mail to author, May 21, 2015, regarding selections; "Samuel Fuller's amateur film *V-E+1*, added to National Film Registry," Center for Home Movies undated post, accessed July 28, 2015, http://www.centerforhomemovies.org /samuel-fullers-amateur-film-v-e-1-added-to-national-film-registry/#more-11986.

26. Jay Carr, *Boston Globe*, December 17, 2000.

27. Exceptional Amateur Films, screening notes in event files, 2001, Northeast Historic Film.

2 The Technologies of Home Movies and Amateur Film

Dino Everett

Amateur filmmaking was made possible by factories producing miles of photochemical emulsion laid on base, mechanical cameras for exposing the film, and home projectors to showcase the artists' work. This chain of production, distribution, and marketing of home movie technology has now largely become extinct. To understand the end product of amateur filmmaking—movies that now occupy moving image archives as well as closets, attics, and basements—we need to understand the material objects that filmmakers used to produce and present their moving images. This essay is an overview of home movie equipment used in North America from 1912 to the early 1960s. Technical notes written to accompany each of the essays in this volume provide specific details concerning cameras and film stock particular to the films under discussion, but this essay pulls back to provide the broader context of amateur film technology.

While professional movies were almost always shot on 35mm film, home movie makers usually favored smaller film formats because of portability, cost, and ease of use. These are described as "small gauge," or, in the United Kingdom, "substandard" films. Also, most home movies during this period were shot on silent black-and-white film, but in the 1930s, amateur filmmakers had options for recording and playing back synchronized sound, and color film became available.

28mm Film for Home Shows

The 28mm film format was the first to be produced specifically with the amateur film market in mind. The standard film for cinema projection was 35mm nitrate, a flammable film stock that was largely considered unsafe for home use. Eastman Kodak Company (Kodak) produced a nonflammable diacetate film stock as early as 1906, but the commercial industry was unimpressed with its visual quality. In 1911, the French company Pathé released a 28mm film format that was designed to bring nonflammable, commercial-quality movies to the home movie enthusiast. Pathé envisioned that members of the public would build personal library collections of commercial films as well as shoot original film on home cameras. While the positive 28mm print used for projection was nonflammable, the

Fig. 2.1 From left to right, samples of amateur film: 28mm, 16mm, and 8mm. The 28mm example, from Col. F. B. Richards's *Snow White* (1916), was originally shot on 28mm negative film in Blue Hill, Maine, and then copied to 28mm for home or club exhibition. The *Snow White* performance was outdoors at the Blue Hill Country Club and the film may have been shown there, too. The shadow 28mm perforations on the left (two per frame) are artifacts of the negative—and are not physically present in the 28mm print. The 16mm example is 1953 Kodachrome, *Stonington & Deer Isle* [Maine], by Walter V. Mitton. The 8mm black and white, circa 1942, is minor league baseball in Massachusetts, by Helen V. Bird.

28mm negative used in the camera was still combustible nitrate film stock. Pathé believed that the amateur would never project the nitrate film or keep the negative around the house once it had been exposed. Instead, the customer would buy negative rolls, shoot them, and send the rolls back to Pathé for processing. After a 28mm positive safety print was struck, the negative was recycled for its silver.[1]

Pathé marketed the 28mm home system along with musical cylinder and disc recordings, suggesting that the consumer could safely bring movies into the home and create a fully stocked entertainment parlor. The 28mm suite of

products was named the KOK, which was a phonetic transcription of the French name of the Pathé logo, a rooster (coq), as well as a compression of the word "Kodak." The original KOK projector was hand cranked and came in a number of variations. Some had electrical lighting, for instance, while many were powered by a dynamo device that simultaneously provided a charge to the lamp as the user cranked the film. Pathé also promoted the 28mm projector as a way of showing reduction prints of titles from the Pathé 35mm catalog.[2]

The Pathé 28mm camera was loosely based on Pathé's 35mm professional camera: it was leather covered, featured internal metal feed and take-up film chambers, and had a newly designed cranked-gear system. Within a year of its introduction, 28mm found its way to the United Kingdom under the name Pathéscope, and Willard B. Cook purchased the North American rights to the product and brought the format to the United States as Pathéscope. Cook set up shop in New York City, with a secondary office in Boston, Massachusetts. Pathéscope was marketed in the United States just as in France, with an emphasis on commercial films for home viewing, and the camera as a possible accessory. The entire suite of products was extremely costly and therefore available only to the very affluent.

Kodak's 16mm Film: A Reversal Stock

A little more than ten years after the introduction of 28mm, Kodak entered the nontheatrical film market with their new 16mm film product. In January 1923, Kodak released this amateur format with a public demonstration of the Ciné-Kodak 16mm system at East High School in Rochester, New York, and shipped it to dealers later that summer. Sixteen millimeter had been in development since 1900, when Kodak researcher John G. Capstaff began developing a process known as "reversal," which combined the negative and the positive print onto one strip of film. By eliminating the creation of separate negatives and prints, this reversal process halved the amount of film stock required, thereby saving money. An important characteristic of reversal 16mm is that the film exposed in the amateur filmmaker's camera is almost always the sole surviving print, since subsequent film copies of home movies were very rarely made. Reversal-process chemistry proved to be difficult at first, and Kodak engineers found that consistently achieving a good positive print was elusive. The process required that the film exposed by the customer be developed first as a negative and then put into a bleach bath and reexposed to light, which converted the negative to a positive. Capstaff realized that the second, bleaching bath had to be closely controlled to avoid an uneven print. One benefit of reversal was that developing the same piece of film through the negative and positive process reduced grain (small particles in the film emulsion), which created a sharper image. The reversal film process therefore ensured that picture quality would still be very good despite the smaller 16mm frame size.

Cameras: Kodak, Victor, and Bell & Howell

While Kodak launched the 16mm film market, two other companies also began developing 16mm products. Kodak shrewdly recognized that 16mm would succeed only if it achieved a critical mass in the market, and so they turned to other equipment manufacturers and encouraged them to produce 16mm cameras. They persuaded leaders in the 28mm home movie market to help promote 16mm. First they hired Willard B. Cook to run a new Kodascope library of rental films modeled on his Pathéscope enterprise. They also recruited moving picture equipment inventor Alexander Victor of Victor Animatograph Corporation in Davenport, Iowa, to adopt the 16mm format for his production line.[3]

The Ciné-Kodak Model A camera, in production from 1923 to 1930, was the industry standard for 16mm. Through features such as dials built into the back of the camera, the filmmaker could optimize camera control. One dial indicated the focus based on the subject's distance, from four feet up to one hundred feet; another controlled the shutter, enabling exposures between 3.5 and 16 f-stops; and a third monitored how much of the one-hundred-foot roll of film had been used. The fully accessorized camera came with a tilting-head tripod that allowed the amateur to tilt and pan the camera while cranking away. The camera cost $125 in 1923, and a camera with projector and splicer, tripod, and screen cost $335.[4]

Victor Animatograph Corporation produced a 16mm camera specifically marketed as an inexpensive device. It was simple to operate and affordable for moderate-income households, costing roughly one-third the price of the Ciné-Kodak. It featured a fixed-focus lens with a sure-shot finder—a square piece of glass that flipped up on top of the camera body and was used to center the subject being photographed. A third entry into the 16mm market was Bell & Howell, the Illinois camera manufacturer responsible for the 35mm motion picture camera most used for theatrical productions. Their Bell & Howell Filmo 70-A was in many ways the best of the first three 16mm cameras. Unlike the Kodak and Victor cameras, the Bell & Howell could be handheld during filming because it featured a spring-wound motor. The filmmaker, therefore, did not need a tripod, since a fully wound camera required merely the push of a button to advance the film. Portability proved very desirable, and it wasn't long before Kodak also sold an external motor-drive attachment for its camera. Another advantage amateurs had when using the Bell & Howell Filmo was an adjustable frame rate. "Frame rate" refers to the number of frames of film per second that passed by the camera gate. The original Filmo offered choices of eight frames per second (fps) or sixteen fps. Most projectors at the time were variable speed but were designed for an average of sixteen fps. Shooting a subject at sixteen fps and projecting at sixteen fps would provide smooth, lifelike motion, whereas shooting at eight fps and projecting at sixteen fps would result in a faster motion and could create humorous effects. With the release of the Model D in 1929, Bell & Howell Filmo

cameras offered a full range of frame-rate choices (eight, twelve, sixteen, twenty-four, thirty-two, forty-eight, sixty-four), allowing the user to create fast-motion and slow-motion effects.

All three companies' cameras used 16mm Kodak film stock. The film was purchased in one-hundred-foot rolls called "daylight reels," tightly wound on a solid black reel to be inserted into the camera. The protective black reel meant the film could be inserted in the camera under any lighting condition; only the end that was unspooled while loading the camera risked exposure. In the 1920s a one-hundred-foot roll of 16mm film cost roughly six dollars, including processing costs. Amateurs would shoot a roll of film, package it back into its original box, and mail it to Kodak for processing. The roll of developed film that was returned to the customer was the same roll that the amateur had shot. The laboratory developed that original length of reversal film into a print that could be edited or projected. Perhaps the prepayment system and the simplicity of returning the film to Kodak for processing explain why the 16mm format became so popular.

8mm Film and Cameras

Fewer than ten years after introducing the revolutionary 16mm film format, Kodak again reshaped the field of amateur filmmaking by launching the 8mm format. In July 1932, Kodak offered the Ciné-Kodak Eight Model 20 8mm camera that, at a cost of only $29.50 and with cheaper film processing, was priced well under its 16mm competitors. The camera used 16mm film stock to create what was called "double 8" film. The user ran the film through the camera exposing one half of the reel at a time, and then took out, flipped, and rethreaded the film to expose the other half of the reel. When the film was returned to Kodak, the laboratory sliced the film in half lengthwise and spliced the two lengths of film together. The customer received a fifty-foot length of 8mm film (two twenty-five-foot lengths joined), equal in screen time to the standard one hundred feet of 16mm film—at a fraction of the cost. With 8mm, home movie making became much more affordable and therefore accessible to a broader demographic.

Despite their smaller size and cheaper price, 8mm cameras retained a number of features that provided a variety of shooting options. The Ciné-Kodak Eight Model 20, for instance, had a flip-up viewfinder that doubled as a handle attached to the top of the body. The motor was spring-loaded, with a push-down and lock-in-place exposure button on the side of the camera. The only dial on the camera was the film-length counter on the same side as the exposure button. The Model 20 had a fixed-focus lens, which required subjects to be roughly five to seven feet away, depending on the exposure setting. Exposure selection instructions, affixed to the camera right under lens, indicate that the camera was marketed to the amateur, with Dull Days and Bright Days selection options, in addition to the f-stop markings of 3.5 to 16.

Bell & Howell supported 8mm with its Filmo 127-A Straight Eight camera, which was much more expensive than the Ciné-Kodak Eight Model 20 (at over fifty dollars), and sported more of the features common to 16mm Bell & Howell cameras. The Straight Eight used preslit 8mm film, instead of the double 8 used in the Ciné-Kodak. The film was supplied by Kodak, but then cut into thirty-foot reels by Bell & Howell. The format survived for a few years, only to be abandoned by Bell & Howell in 1935. The Swiss company Bolex, Victor, and others entered the 8mm market with cameras and projectors designed to project 8mm. 9.5mm, and 16mm from the same machine.

Color: Kodacolor

Kodak offered the first color motion picture film for amateurs, the short-lived Kodacolor, in 1928. Photochemical color processes can be divided into two categories: additive and subtractive. Subtractive methods (so called because they remove unwanted colors from the light beam) rely on complex and expensive processing that uses color dyes in the film emulsion. Additive methods, like Kodacolor, use black-and-white film in association with colored filters. This was a primary selling point of Kodacolor because customers could use their existing cameras and projectors and merely add red, blue, and green filters on both camera and projector to produce color.[5] Unfortunately, Kodacolor's requirement of a colored filter on the camera lens dimmed the light being captured and prohibited exposure adjustment: Kodacolor movies could be successfully shot only in bright sunshine, and the film produced tended to be dim. To help brighten the projected image, Kodak offered a special Kodacolor screen that was small (about two feet across), and coated with a silver surface.

Color: Kodachrome

The limitations of Kodacolor were not overcome until Kodak announced the invention of Kodachrome in a two-page advertisement in the May 1935 issue of the Amateur Cinema League periodical *Movie Makers*. An accompanying article by Dr. C. E. Kenneth Mees, vice president of Kodak, describes Kodachrome's multilayered emulsion. It contained three light-sensitive layers (red, green, and blue) and required a development process involving five chemical treatments across three different machines.[6] Now, anyone with a 16mm camera could buy a roll of Kodachrome film and shoot in color. In 1935, moviegoers could see Hollywood films in color, but these were produced using Technicolor—a film and process different from the color film available to amateurs.

Kodachrome was not perfect right out of the box. The first drawback was that it was a daylight-only process, requiring a bright-light environment in order to penetrate the relatively dense emulsion. Those filmmakers who had tried

Kodacolor were familiar with this light limitation. Kodachrome was somewhat of an improvement, however, because the film could be shot on overcast days, whereas Kodacolor really needed a cloudless sky. Processing Kodachrome was also expensive and offered only at the main Kodak plant in Rochester, New York.

Optical and Magnetic Sound

The amateur's ability to add sound to moving images began to develop in the mid-1930s. Optical processes for capturing sound while recording moving images had existed before that time, but the devices were costly and complicated and not widely used by the casual user. Optical sound is the registration of sound pulses as light and dark patterns, which are read by an "exciter lamp" in the projector and then amplified into audible sound. The magnetic recording of sound became available in the mid-1950s for 16mm and 8mm film. Much like audiotape, a magnetic sound stripe of ferrous oxide that could be encoded with sound signals and read by a sound head was added onto 16mm film outside the frame. The use of magnetic striping on the film allowed the amateur to add sound to their existing movies and later to capture the sound live while filming. The predominant use of 16mm magnetic-striped film was newsfilm, rather than home movies. In 1954, engineers began experimenting with the location for a magnetic stripe on 8mm film, finally deciding on a small stripe roughly 0.74mm wide, placed on the edge just outside the perforations. The stripe was adhered to the base side of the film and allowed for the recording of mono soundtracks to existing 8mm films.[7]

Projection

One of the joys of amateur filmmaking was sharing your images—and so home movie makers needed home projection equipment. Early projection was designed for reels of a maximum length of four hundred feet, and most lamps were in the 250-watt to 500-watt range. Often the manufacturers, such as Kodak and Bell & Howell, would release new projector models when they made technological advances in cameras. This was designed to encourage repeat business among true amateur-film enthusiasts. The biggest advances were, of course, a change in format, such as from 16mm to 8mm, or the introduction of sound. A home movie projector's low light output meant that the average screen had to be small, perhaps three or four feet wide, to ensure that the image was as bright as possible. Manufacturers attempted various solutions to improve screen reflectivity but ultimately stuck with three basic types: a silver screen that was used for Kodacolor; a screen with tiny glass spheres adhered to a background; and the standard white matte screen. Each had its benefits. The silver screen reflected light better, but the white matte helped reduce visual interference from the screen's

texture. The most important element of choosing a screen was that it was not too large for the projector's capabilities.

Date Codes and Camera Codes

Kodak, the main producer of film stock in the United States, included edge codes on the film marking the year the stock was manufactured. These codes indicate the date of manufacture, not when the film was exposed, but a reel could not have been shot before the year of its date code. Similarly, motion picture cameras used by amateurs left specific edge markings on the film stock that signaled what brand and type of camera was used to produce the footage.[8]

Dino Everett is Archivist for the University of Southern California Hugh M. Hefner Moving Image Archive, where he oversees the school's media assets, including the Herbert E. Farmer Motion Picture Technology Collection. He facilitates collaboration between the film artist and archive communities and promotes the use of archival films and equipment to illustrate that cinematic history is more than content alone.

Notes

1. For more information on 28mm film, see the technical notes accompanying Justin Wolff's "A Strange Familiarity: Alexander Forbes and the Aesthetics of Amateur Film" in this volume. The flammable nitrate negative was not discussed in trade journals or marketing literature at the time, but film archivists have discovered unused nitrate negatives in 28mm cameras donated with film collections. At the University of Southern California Hugh M. Hefner Moving Image Archive, I found an entire roll of unused 28mm nitrate negative stock inside one of the three 28mm cameras in the collection.

2. The 35mm prints that were reduced to 28mm for home showing had a change of aspect ratio. The aspect ratio measures the image frame's proportion of width to height. Early silent 35mm films had a 1.33:1 (referred to as "full" aperture) aspect ratio, whereas later 35mm sound films had a 1.37:1 (referred to as "sound" or "Academy" aperture) aspect ratio. The 28mm home format had an aspect ratio of 1.36:1, whereas 8mm utilized 1.33:1. On the other hand, 16mm used a 1.37:1 aspect ratio on the actual film itself, but when projected became 1.33:1. This confusion can lead to mistakes in film preservation when 16mm source material is enlarged to full aperture, causing some of the image to be cut off. A preservation print from a 16mm film should be enlarged to a 1.37:1 sound aperture to achieve the best and most accurate results. Often, when an original photochemical reel is digitized, an incorrect aspect ratio is chosen, losing some of the original composition.

3. Victor's company had released a 28mm projector, and at one point he had attempted to standardize 28mm as the official safety film format through the Society of Motion Picture Engineers (SMPE), of which he and Willard B. Cook were active board members.

4. Alan D. Kattelle, *Home Movies: A History of the American Industry, 1897–1979* (Nashua, NH: Transition, 2000), Appendix 6.

5. For more information on Kodacolor, see the technical notes accompanying Justin Wolff's "A Strange Familiarity" in this volume.

6. C. E. Kenneth Mees, "Presenting Kodachrome," *Movie Makers*, May 1935, 197, 220–21.

7. For more information on an amateur's use of optical sound, see the technical notes for Karen F. Gracy, "Midway between Secular and Sacred: Consecrating the Home Movie as a Cultural Heritage Object" in this volume.

8. Kattelle, *Home Movies*, Appendix 11: Identification Marks Used in Substandard Motion Picture Cameras, reproduces camera codes.

3 A Region Apart: Representations of Maine and Northern New England in Personal Film, 1920–1940

Libby Bischof

There is no time when the Maine landscape does not present some new and striking scene.

—*Maine: A Guide "Down East,"* 1937

Introduction

In 1930, Harrie B. Coe, general secretary of the Maine Publicity Bureau, filmed a series of promotional vignettes designed to promote Maine to those who might pay the state a visit for a vacation. The resulting short films take viewers on an abbreviated tour of Maine, emphasizing the burgeoning tourism industry as well as some of the state's more traditional industrial and agricultural labor practices. As the film loops through the projector, the viewer is transported from the lime quarries in Rockland to the sardine industry in Eastport before getting a glimpse into the labor required to "harvest a blueberry pie"—from raking the berries to canning them. From the blueberry barrens, the film brings the viewer to pastoral Bowdoinham to witness sheep farming before finally lingering on the recreational pleasures of Maine's rocky coastline and northern lakes. Frame by frame, tourists are shown swimming, fishing, and exploring inviting vistas on foot and in automobiles. The last intertitle of Coe's silent promotional film attempts to entice viewers by noting "Only a few of Maine's Manifold Attractions have been shown—come and see them all."[1] While Coe's publicity film invites viewers to come and see Maine and engage in a process of discovery, it also invites them to consume. Ideally the viewer would consume the blueberries and sardines on display (an intertitle informs the viewer that the small fish are "ready to place between two crackers with a little lemon juice added"), but they are also invited to consume the landscape by traveling from town to town in their automobiles and taking in the scenery, as well as by participating in various leisure and sporting activities.

The film's trajectory mirrors, in many ways, the economic history of Maine—putting agriculture and natural-resource industries on display, and emphasizing the primacy of manual labor, before finally settling into tourism, which was Maine's fastest growing industry by 1930. According to a chapter Coe wrote on the tourist industry in his five-volume *Maine—A History*, published in 1928, over one million vacationers came to Maine in 1925, and that same year it was "conservatively estimated that the tourist industry is worth $100,000,000 to the State each year—new money brought into the State."[2] He continued, "All that the tourist takes away from the State with him is renewed health and pleasant memories, leaving the State's assets of invigorating climate, pure water and air, the beauties of an unrivalled [sic] seacoast, the gleam and glisten of myriad lakes and streams, and the grandeur of towering forests to be sold to the tourist over and over again year after year."[3] Coe's film, like his prose, was designed to sell Maine, which meant selling the state's natural assets and guaranteeing those assets would be there for visitors to enjoy year after year.

Coe's 1930 promotional film was just one more way the Maine Publicity Bureau—founded in January 1922 by hotelier Hiram Ricker of Poland Spring and a group of like-minded men—attempted to reach a growing audience of urban dwellers eager for respite. As Coe explains, the new publicity organization was established to "maintain and operate a bureau and offices for the purpose of acquiring and disseminating information concerning the business interests of the State of Maine including the facilities and accommodations therein for travel and transportation whether for business or recreation; to act as advertising and publicity agent for the aforesaid purposes; to buy, print, sell, publish and deal in papers, books, magazines and other publications."[4] Coe, as general secretary of the bureau, crafted promotional materials including brochures, advertisements, and guide books; worked with Maine hoteliers, railroads, restaurants, and other interested businesses; and corresponded with thousands of visitors. These promotional materials that he and others created—in print and on film—attempted to draw more visitors to Maine, and in so doing touted Maine's unique landscape, attractions, and residents as something different from the rest of the United States.

Coe, and those who advertised Maine in the 1920s and 1930s, were not alone in emphasizing the region's unique natural features. New England regionalist writers, from Sarah Orne Jewett at the turn of the century, to Robert Frost and the lesser-known Ruth Moore in the 1930s and 1940s, have long portrayed northern New England as a place, and indeed a region, apart—a frontier landscape of rocky coasts, forests, mountains, hardscrabble farms, rustic outposts, and traditional villages—replete with self-sufficient, dependable residents with strong independent streaks. Such images of Maine and northern New England, perpetuated by nineteenth- and early-twentieth-century realist and regionalist

writers and visual artists such as Jewett, Frost, Winslow Homer, Eastman Johnson, Chansonetta Stanley Emmons, and many others, perpetuated the region's distinct sense of place, composed of seemingly timeless natural landscapes and more traditional ways of life, to a regional and national audience.

As historian Joseph Conforti tells us, "From the Colonial era to the present, New England's shifting identity has rested on selective representations of the regional landscape."[5] Such selective representations, on view in promotional materials for tourists, in the novels of regionalist writers, and in the paintings and photographs of native and visiting artists, are also present in the home movies and personal films of amateur filmmakers working in northern New England between 1920 and 1940. These personal films, often short and created as part of larger personal and historical collections, evoke for the viewer a sense of nostalgia and wonder, and an understanding of the past as it was being lived in the moment by those caught on film. For historians, the films are documents not only of the lives and pursuits of their subjects—they also capture lived experience in particular times and particular places.

As cultural historian and critic Raymond Williams described in his 1961 essay "The Analysis of Culture," it is precisely the lived experiences of a particular time and place that constantly elude historians. He explained, "The most difficult thing to get hold of, in studying any past period, is this felt sense of the quality of life at a particular place and time: a sense of the ways in which the particular activities combined into a way of living."[6] While no medium can ever bring us back fully into the past, personal films can bring us closer to a holistic vision of the past than other forms of documentation. In the hands of the personal filmmaker, the camera captures landscapes, scenery, home life, material culture, traditional labor practices, clothing, interpersonal relations, regional tropes and styles, and most important, life being lived. Precisely because of their ability to capture and record slices of the past, personal films should be elevated on par with other primary sources such as written documents and photographs.

This essay interprets a selection of personal films and home movies drawn from the collections of Northeast Historic Film (NHF) that depict the labor practices, landscapes, homesteads, leisurely pursuits, and family gatherings of residents and visitors to the region. Images of regional landscapes in these films of the 1920s and 1930s both reinforce and challenge commonly accepted regional tropes and archetypes portrayed in other media. Personal films are compelling historical sources that reveal the daily lives and the lived experiences of ordinary men, women, and children in Maine and elsewhere in northern New England. This chapter analyzes three personal films: the Hiram Historical Society's blueberry-farming footage shot by Raymond C. Cotton in the 1930s; *Cherryfield, 1938,* a short documentary of a small rural Maine town; and Chute Homestead footage of local parades and the Civilian Conservation Corps (CCC) working

in Bridgton, Maine, during the Great Depression.[7] These films were selected for both their aesthetic and their historic value. Frame after frame, they reveal both forgotten and familiar visions of northern New England, while simultaneously providing viewers an entrée into the daily lives, rituals, and ordinary landscapes of small-town life in rural areas of Maine. Within these films, the often tenuous coexistence of rural traditions and modern innovations found throughout the state of Maine are on display for viewers. They show a region and its people in flux, attempting to hold on to an agrarian past while simultaneously coping with the economic uncertainty of the Depression years. In order to understand these films, as well as those who made and preserved them, we must first grasp something of the mid-twentieth-century history of the region and its inhabitants.

Maine in the Mid-Twentieth Century

Despite an increase in tourism, northern New England in the 1920s and 1930s was experiencing profound economic instability in other natural-resource industries. For Maine, which had separated from Massachusetts just a century earlier in 1820, the years following the Civil War witnessed significant shifts in agriculture, fishing, lumbering, and industrial practices while tourism, a new industry for the state, quickly became Maine's leading source of revenue. The state experienced significant out-migration after the Civil War, as returning soldiers took advantage of the Homestead Act and traveled west for new opportunities and more fertile soil, and as the opening of the Transcontinental Railroad in 1869 reoriented the nation's transportation networks from north/south to east/west. Despite the presence and growth of paper and textile mills, canning and shoe factories, and other industries, in 1930, 60 percent of Maine's eight hundred thousand residents still lived in rural areas.[8] The allegiances of these residents were to their families and extended kin, their local towns, and their immediate communities—less so to the state and the nation at large. Hard work, a respect for tradition and continuity, and deep-seated beliefs in independence and self-sufficiency persisted as the defining qualities of rural Mainers. As historian Richard Judd reminds us, in Maine during this era, "the bonds between the rural citizens and their natural world were moral as well as economic. Their culture was rooted in long-standing patterns of common use of a familiar landscape . . . Maine rural trades characteristically involved direct manipulation of raw nature in open settings, with little technological mediation between human effort and the land itself."[9] Understanding the abiding attachment of rural Mainers to the landscapes and waterways that sustained their existence is essential to understanding their work patterns, their social lives, and their cultural productions.

As Maine approached the mid-twentieth century, however, relationships to the land were changing. Historians Richard Wescott and David Vail argue that

"despite a modest return to the land during the Great Depression, there were 35 percent fewer farms in the state in 1940 than in 1910. Of the 39,000 farms that survived on the eve of the Second World War, about half were specialized commercial farms. Only a few thousand traditional small, full-time general farms survived; about 20,000 general farms had become part-time operations. The erosion of farming had a profound impact upon rural towns."[10] The 1930s, then, represented a period of transition, particularly as rural Mainers shifted labor patterns that had often been in place for generations. Beyond deep ties to the land, many who resided in rural northern New England harbored a distrust of outsiders, including land speculators, out-of-state capital investors, and the federal government. As a result, Maine's experiences during the Great Depression years differed from other states that were more reliant upon and more open to receiving New Deal funds and programs. In 1933, Lorena Hickok, a roving reporter and chief investigator for the Federal Emergency Relief Administration, and a keen observer of local life, described in detail the Maine people she visited with throughout the state: "The majority of the people—and the ruling class—are of course typical 'down East Yankees.' Proud, reserved, independent. Shrewd, but honest. Endowed with all the good solid virtues on which this nation was founded. Pretty much untouched by the moral and intellectual by-products of the American 'bigger and better' madness. Apt to be pretty intolerant of those who fail to live up to their standards. And, above all, thrifty."[11]

While Hickok lauded some of the virtues she perceived in Maine residents, she found that the very qualities that set Mainers apart also predisposed them to shun most federal relief, even though the need for such assistance was certainly widespread throughout the state in the 1930s. In the same report, she further observed: "A 'Maine-ite,' being the type of person that he is, would almost starve rather than ask for help. In fact, his fellow citizens would expect it of him. It is considered a disgrace in Maine to be 'on the town'. . . . They won't ask for help, and it can't very well be forced on them. And this attitude is quite general among the Yankee population."[12] One element of Mainers' resistance to federal help stemmed from the fact that, long before the Great Depression hit the nation, northern New England had been locked in a cycle of economic downturns. Rural Maine residents, used to scarcity and well schooled in thrift, weathered the nation's economic downturn as they had weathered their own economic challenges for years. Change in the form of federal intervention was not easily forced upon northern New England, and indeed, three years after Hickok's visit, Maine and Vermont were the only states to vote for Franklin Roosevelt's Republican challenger Alf Landon during the 1936 election.

During the years of the Great Depression, then, fierce independence and relative isolation characterized northern New England. While Maine may have modernized with new roads, increased access to electricity, expanded Rural Free

Delivery, and new technology such as automobiles, radios, and movie theaters, more intangible social and cultural changes came slowly, when they came at all.[13] A by-product of this relative isolation was that the persistence of Maine's rural communities and traditions—sleepy towns, agricultural fairs, grange halls, Fourth of July picnics, and town meetings—attracted legions of tourists and seasonal residents from New England, New York, Chicago, Philadelphia, and other urban areas in the 1920s and 1930s. For these visitors Maine's seemingly pristine landscapes and traditional folkways stood in stark contrast to crowded urban areas and the increasingly fast pace of modern life. Maine was billed by its promoters, including railroad executives, hoteliers, sport enthusiasts, and state government agencies led by men like Harrie B. Coe, as a place apart from the rest of nation, and even the rest of New England. Tourist literature consistently promoted a preindustrial image of the state, touted the healthful benefits of the climate, the diverse landscape (lakes, mountains, the ocean, inland farming communities), and encouraged interactions with native residents.[14] George H. Lewis, who refers to this phenomenon as the creation of the "Maine Myth," writes:

> To outsiders, then, Maine became beautiful when it came to stand for the essence of a romanticized regional lifestyle that many felt had been lost in this century. This image of Maine and its people is an invented one, developed by "romantic tourists and publishers" to fill significant social and economic needs. The invention of Maine transformed a potentially negative image. It recognized regional backwardness because it had to, but cleverly played it under a positive sign. . . . Small local communities, lacking modern goods and services and dependent upon limited natural resources, were re-imagined as unspoiled havens of authenticity in an artificial world.[15]

In the Depression era, many Americans sought solace in the seemingly stable qualities of Yankee thrift and ingenuity and believed that Mainers "were able to weather the economic storm of the Depression better than many."[16] Authenticity in a world of urban artifice proved to be attractive bait for would-be tourists and their tourist dollars. Regional backwardness, however, was often the by-product as well as the hallmark of a traditional existence in which people depended on the land and their local communities for subsistence. It also resulted from the waning of Maine's natural-resource industries such as lumbering, granite quarrying, and ice harvesting. While still plentiful in Maine, the demand for natural resources was lessened by the development of new products and technologies such as steel, concrete, and electric refrigeration.

While all three of the films featured in this essay were shot in Maine during the Great Depression, the despair and poverty of that era—so evident in many thousands of Farm Security Administration (FSA) photographs taken elsewhere in the nation—are not really showcased in any of them, save the mere presence

of the Civilian Conservation Corps in Bridgton. Perhaps this is because, as historian Richard Condon argues, "however distressed some areas of the state might have been, Mainers generally weathered the Great Depression better than urban workers in the big cities of the East and the Midwest." This is mostly because "rural Mainers proved to be, as their grandparents had been, hard-working, self-reliant, neighborly, and adaptable."[17] These very qualities are on display in each of the films in this chapter, from Cotton's intimate look at blueberry farming to the citizens of Cherryfield who beam with civic pride, and the glimpses of CCC workers in their camp at Bridgton.

Blueberry Harvesting in Hiram, Maine

In 1938, Raymond C. Cotton (1904–1998), local grocery store owner, blueberry farmer, amateur historian, town clerk, and member of the nascent Hiram, Maine, fire department, shot an 8mm film detailing the multiseasonal process of blueberry farming and harvesting. Part of a larger set of amateur films that comprise the Hiram Historical Society Collection at Northeast Historic Film, Cotton's ten-minute color film of the life cycle of the blueberry, which he titled *Raymond C. Cotton Presents Field of Blue: The Story of Maine's Blueberry Industry*, draws the viewer into the world of the small, tart Maine blueberries and those who grow and harvest them.

Hiram, a small town in the mountains of western Maine, was first settled in the 1780s, and incorporated as a town in 1814. Early settlers farmed the rocky land, primarily harvesting wheat and hay and raising sheep. As a result of the town's location on the Saco River, manufacturing fueled by waterpower became increasingly important to Hiram's livelihood in the nineteenth century, as evidenced by the construction of sawmills, gristmills, and other small factories. Despite the presence of these industries, Hiram was (and remains), like many towns in northern New England, predominantly rural.

According to the collection description at Northeast Historic Film, the Raymond Cotton home movies "offer a glimpse into family and community life. Community events include raccoon hunting, the 1938 Memorial Day parade, and efforts to clean up the damage from the 1938 hurricane that struck New England. With a keen eye for work processes, Cotton documented the training and development of the Hiram Fire Department, the ice harvesting process, river drivers running logs on a river, and Maine blueberry farming practice by season."[18] Cotton's sharply observant eye was developed from a young age. Before he began working with moving images, he honed his vision with a still camera. In one of his three brief published histories of Hiram, Cotton reveals relatively little about himself—aside from his sense of humor and affinity for poetry—but mentions an early venture with the camera as he attempted to document the damage to Hiram's roads wrought by the great rainstorm of July 1915. Cotton displays his

sense of humor and his camera work in his account of the storm when he reveals to his readers, "At that time your historian was ten years old. I took out my No. 2 Brownie camera and went to photograph the damage. I found the water had cut great gashes six to ten feet deep in the road. Happily, I blew a whole roll of film. It was too bad that the light was so bad in those gulches because, like the road, my film was a total washout."[19] If we take this quote at face value, Cotton, who clearly self-identified as a historian, had been visually documenting the history and major events of the town of Hiram for twenty years before he made his 1938 blueberry film.

Wild blueberries are indigenous to Maine and are most prevalent in the Down East region of the state, including Lincoln, Knox, Waldo, Hancock, and Washington counties. They exist, however, in pockets throughout the state, including Hiram, which is located in Oxford County. In 1938, when Cotton shot *Field of Blue*, the commercial harvesting of blueberries was a nearly century-old practice. Native Americans originally harvested the berries and burned the barrens to encourage growth.[20] In the colonial era, and through the late-nineteenth century, blueberry fields were considered open to the public for picking and general use. Maine pioneered the canning of blueberries in the 1840s, and the privatization of barrens by the 1870s, along with harvesting innovations such as Abijah Tabbot's metal blueberry rake in 1882, began to make the industry more profitable.[21] When Cotton filmed his barrens in 1938, the annual Maine wild blueberry harvest reached about eight million pounds—a relatively average harvest for the decade. Production increased in the 1940s (except in the last years of World War II), along with the price, and as a whole the industry continued to grow through the late-twentieth century. The largest harvests have occurred in the twenty-first century: eighty-seven million pounds of wild blueberries were harvested in 2013.[22]

In the 1930s, blueberries were a staple Maine crop—sold fresh in state and shipped out of state in canned form. They were also, as evidenced by their presence in Coe's promotional film of 1930, a natural resource and an industry intended to be synonymous with Maine. As someone who harvested wild blueberries, Cotton was intimately familiar with the process of preparing the land, cultivating the berries, and picking them for market. Immediately evident in Cotton's film is that blueberry growing in the 1930s was time-consuming and required both hard manual labor and a great deal of patience and persistence. Like other natural-resource industries in Maine, blueberry farming was in a period of transition in the 1930s, as growers, like Cotton, tried out new techniques for increasing crop yields.

Throughout the film, Cotton showcases traditional farming techniques such as cutting weeds with a scythe, hauling supplies with a horse and cart, and harvesting the berries by hand, as well as new technology like machines for facilitating a controlled burn and fertilizing the crop.

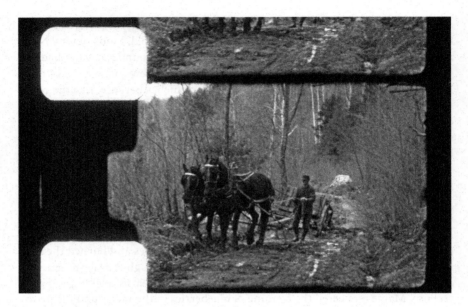

Fig. 3.1 Traveling to the blueberry barren, *Field of Blue*, 1938. From 8mm film. Raymond Cotton, Hiram Historical Society Collection, Northeast Historic Film. [Accession 2122, Reel 2]

The juxtaposition of traditional and modern farming techniques might appear particularly striking to a viewer from outside of northern New England, but this melding of old and new is central to understanding Maine in the 1930s. Historian Richard Condon argues:

> The rural people of Maine lived in two worlds in 1930. The first, passing for half a century but far from gone, was a world of nearly self-sufficient farm and village families. Ethnically and religiously homogenous, modestly schooled, isolated, and independent-minded, most of Maine's earlier rural families had little direct experience with distant markets and federal agencies. In the newer world, which had advanced rapidly during the 1920s, there were fewer but more specialized farms. Farmers who adjusted profited; others clung to the old ways and found themselves farming part time or not at all. Life changed as modern transportation, communication, and service networks reached out into rural America.[23]

Survival meant adaptability, but almost never a complete abandonment of tried-and-true techniques. Modern innovations were adopted only when they were clearly more efficient and affordable than traditional ways. Furthermore, modern innovation did not always mean a significant reduction in physical labor.

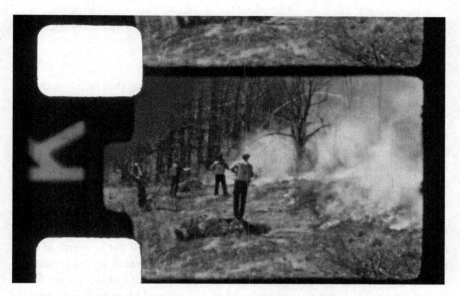

Fig 3.2 Burning the field, *Field of Blue*, 1938. From 8mm film. Raymond Cotton, Hiram Historical Society Collection, Northeast Historic Film. [Accession 2122, Reel 2]

Cotton's film records the manual labor required to clear, plant, and harvest blueberries despite the advent of new technology. *Field of Blue* provides important visual evidence regarding the simultaneous existence of tradition and innovation in 1930s rural Maine. It is also interesting to think about the role of the movie camera in this larger narrative: the camera is yet another technological innovation that transforms Cotton's traditional storytelling.

To demonstrate the labor-intensive nature of blueberry cultivation to his viewers, Cotton chose to film the entire process of preparing a crop for harvest, beginning with preparation of a new field in August, two years before any berries could be harvested. Cotton was heavily invested in conveying a sense of time passing to the viewer, which he accomplished by placing intertitles throughout the film. They appear in the following order:

AUGUST Bushes and weeds are cut
OCTOBER Hay is spread for fuel
APRIL Brings travel trouble
And burning time
JULY New bushes and WEEDS
After the August weeding
The following MAY brings the bloom

JULY DUSTING
AUGUST AGAIN AND HARVEST TIME
OFF TO MARKET[24]

Cotton carefully constructed his intertitles; the scenes that follow each one are literal representations of the activities described in the title. For example, in "OCTOBER Hay is spread for fuel," the viewer looks on as a cart packed high with hay is unloaded by a group of men who carefully and methodically lay the hay over the ground they prepared in August. The hay facilitated the burning of the fields showcased in April. After the intertitle "AUGUST AGAIN AND HARVEST TIME," the viewer is confronted with long camera pans of wild Maine blueberries, including extreme close-ups of the fruit where the viewer is clearly able to tell that these are the small, tart Maine blueberries growing close to the ground. These shots, some of the most aesthetically pleasing in the film, are the payoff for both the farmer and the viewer (as well as the eventual consumers). The viewer has watched brush-ridden land be cleared, burned, planted, and weeded, and is finally, after an eight-minute investment (insignificant when compared with the two-year investment by Cotton and his laborers) treated to the bloom! Cotton's use of color film adds to the visual interest of the narrative, especially in the scenes where the fields are in flames and, toward the end, when the screen is constantly awash in lovely hues of purple and blue. In his film, Cotton sees the beauty both in the labor and the literal fruits of the labor.

After immersing the viewer in the glory of ripening blueberries, Cotton turns to the workers in the blueberry barrens. Men and boys in various stages of dress and undress simultaneously harvest cordoned-off areas of the fields. The film provides an effective visual explanation of how blueberries were harvested in the 1930s—by hand, with blueberry rakes. The hunched figures hovering over the ripe berries make it clear that the work is arduous and monotonous, and requires a great deal of care and attention as crushed blueberries would not sell well. Cotton shows the blueberry pickers raking the fields in strips and then carefully emptying the rake's harvest into larger wooden buckets. These buckets are then weighed and recorded before being skillfully poured into larger wooden boxes, the last stage of the process Cotton documented—"OFF TO MARKET."

Even though the majority of Cotton's film is meant to showcase the blueberry industry in Maine and convey the multistep process of cultivating the berries for harvest, there are small elements of the personal that make the film even more engaging. For example, when Cotton documented the August weeding, he included brief and endearing shots of a young girl "helping" to weed. She is clearly aware of the camera as she raises a weed she has pulled and smiles directly into the lens. Even in the midst of an otherwise serious documentary, Cotton has included elements that we tend to associate with the home movie—children,

sentimentality, and humor. Rather than view this decision as an aberration, we should instead understand it as a testament to how closely land, labor, and family were bound together in rural Maine. An accurate history of the region must include a discussion of the land as well as the people who inhabit and work the land. That is what Cotton—farmer, town clerk, store owner, filmmaker, and family man—has bequeathed to us in *Field of Blue*.

Cherryfield, 1938

Cherryfield, a small town in Down East Maine, was incorporated in 1816 and touts itself these days as the Blueberry Capital of the World. Located on the Narraguagus River, in the nineteenth century the town was an active wooden-ship-building community. As the "age of sail" shifted to the "age of steam," the town's survival depended on diversifying the economy, which resulted in a growing dependence on the cultivation and harvesting of blueberries.

In 1938, the height of the Great Depression, many citizens of Cherryfield participated in the creation of a six-minute collective town portrait, shot in 16mm black-and-white film by Lester Bridgham. Filmed in the spring, when snow melts to mud, the motion picture celebrates the small community by showcasing local businesses and residents, as well as picturesque scenes of rivers, schools, farms, and churches. Unlike some personal films, where a lack of documentation makes it difficult to identify people, places, and events beyond what can be derived from the film's visual cues, *Cherryfield, 1938* has been thoroughly documented. When the Cherryfield-Narraguagus Historical Society (CNHS) gave the original film to Northeast Historic Film for preservation, they provided a detailed list of people and places in order of appearance in the film. The list was compiled in 1988, fifty years after the original filming, by members of CNHS with help from town residents. One of the hallmarks of Northeast Historic Film's archival practice is the careful attention they pay to context, provenance, and historical detail when building their collections. Because so much additional data on the makers and subjects of many personal films in NHF's collections have been recorded, the historian's task of analyzing and interpreting the film in its original context is made that much easier.

The Cherryfield film is the most self-consciously modern of the films explored in this essay. The title's inclusion of "1938" signals that the film is an up-to-date depiction of the 1930s, as do the clothing and hairstyles, shop-window advertisements, gas stations, and other symbols of modernity. Whereas some of the other films showcase agricultural activities or processes that could have been filmed anytime after the invention of the motion picture camera in 1895, the very first shot of *Cherryfield, 1938*, is a prominent sign that reads "Cherryfield Motor/Ford/800 Yds. On Route 1/Ellsworth, Bangor/We Service All Cars/

Lubrication," indicating the ready availability of car sales and a service station—perhaps intended for tourists traveling along Coastal Route 1. This initial shot signifies to the viewer both the film's location and its relation to the larger cities of Ellsworth and Bangor. Bridgham then turns his camera on the town's defining natural features and former industrial prowess when he showcases the Stillwater Dam and Mill on the Narraguagus River, built in 1836, and the site of a formerly busy stave-and-shingle mill. The Milbridge Historical Society reports that at one time, "this mill was so productive that it required two million board feet of lumber a year, more than 50 hands, and 12–15 teams."[25] Once a hub of industry for the town, in the 1938 film the mill buildings and stray boards appear as relics of a bygone time, as much a signifier of the town's past as the Ford sign is of the town's present. The film then unfolds with shots of town residents at the railroad station, before featuring employees of the Ford Garage and other local businesses such as Spencer Moore's Paint Shop, Percy Wakefield's Shop, and the A. L. Stewart and Son's office. As Bridgham turns the camera on each storefront, a local townsperson associated with the business appears in front of their workplace. Although the film is silent, it is clear to the viewer that active banter is taking place between the film's creator and the subjects, who smile, say a few words, and often chuckle in the general direction of the camera. The remainder of the short film intersperses shots of landmarks like dams, churches, and historic houses, with storefronts, people, and a visit to the local schools—both the grammar school and Cherryfield Academy. Viewers get the sense that they are touring a town where the landmarks are as central to the town's identity as its people. The film is rich in civic pride.

If *Cherryfield, 1938* is interpreted as a composite snapshot of the small town in a particular year of its history, without additional context it would be difficult to place the town in the midst of the economic crisis of the Great Depression. Stores are open, advertisements for food, drink, and other consumer goods line the windows; the people appear cheerful and gainfully employed. Townspeople of all ages are featured throughout the film, from infants in prams to the elderly. Bridgham's town portrait also makes clear that Cherryfield takes particular pride in the education of its children—a good deal of the film showcases the students and teachers of both schools. However, like most rural Maine towns, vestiges of the past remain, and Bridgham does not neglect traditional customs, or seem to value them any less. Although he features cars, trucks, and auto-repair shops, he also records men driving a hay wagon into town, as well as a young boy wrangling a pair of small steers in the film's final shot. Like Cotton's film, Bridgham's portrait of Cherryfield reveals to the modern viewer one of the most important aspects of early-twentieth century Maine life: the coexistence of traditional practices and modern conveniences.

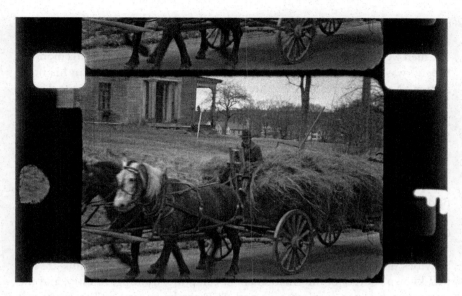

Fig. 3.3 Hay wagon filmed by Lester Bridgham, *Cherryfield, 1938*. From 16mm film. Cherryfield-Narraguagus Historical Society, Northeast Historic Film. [Accession 1194, Reel 1]

We may not know much about Bridgham, but his film suggests that he was a skilled and thoughtful documentarian, and, given the reactions of his subjects to being filmed, an engaging presence. In *Cherryfield, 1938*, he provides the viewer with a strong sense of life in a vibrant rural community where modernity has entered, and seemingly taken root, in the form of transportation and advertising. The trajectory of the film is worth exploring more closely, however. Bridgham begins with showcasing the modern, and ends with scenes of a young boy wrangling a pair of steers, hitching them to a cart, and driving the cart around pastureland, clearly a nod to the town's rural identity—both past and present. This is what these personal films do better than any other primary sources created in Maine during this era: they present to the viewer the coexistence of the rural and the modern, the traditional and the innovative—a juxtaposition that remained a commonplace of life in northern New England longer than in other regions of the United States.

The New Deal Comes to Maine—The Civilian Conservation Corps in Bridgton

The Civilian Conservation Corps (CCC), a work-relief program established as part of President Roosevelt's New Deal during the Great Depression, began in 1933 and ran until 1942. Over the life of the program, the CCC employed upward

of three million young men throughout the country to work on environmental and landscape-conservation projects, particularly in national and state forests. The men were paid thirty dollars per month; twenty-five dollars of this monthly stipend was sent home to their families. As Neil Maher explains in his book *Nature's New Deal*, these workers transformed the American landscape during the Great Depression by "planting 2 billion trees, slowing soil erosion on 40 million acres of farmland, and developing 800 new state parks."[26] According to the Maine State Archives, there were twenty-eight CCC camps in Maine over the life of the program.[27] The camps were supervised by a variety of state and federal agencies, including the National Park Service, the US Forest Service, the US Army, and the Maine Forest Service. A CCC camp in the western Maine town of Bridgton operated from July 1935 to May 1941 and was run by the Maine Forest Service's Forest Protection Division. The young men who worked at the Bridgton Camp focused on insect and disease control in Maine trees.[28]

While there are many photographs and oral histories documenting the activities of those who worked for the CCC in Maine, personal films are less well-known sources of information about camp life, training, forestry, and the interaction between local citizens and CCC workers. In the thirty-eight-reel Chute Homestead home movies, part of the Naples Historical Society Collection housed at Northeast Historic Film, a few moments of Reel 26 are devoted to CCC training and camp life at the Bridgton outpost. While the CCC footage, interspersed among extensive documentation of parades, home life, and civic life, may seem a bit of an anomaly at first, it becomes clear that the CCC camp was of tremendous local interest and an important part of local life during the Depression years (Bridgton and Naples are a few miles apart).

The Chute Homestead, founded in 1910 on a two-hundred-acre farm in Naples, Maine, was a resort located on Long Lake, where guests engaged in outdoor activities like boating, hiking, swimming, and fishing. Many of the Chute Homestead home movies feature life at the resort, including comical shots of guests setting out on the lake in a bathtub fitted with an outboard motor. According to the collection description at NHF:

> James Chute was active in local politics and helped develop the summer tourism industry in his area. He served as town treasurer for Naples, as a director of the Maine Publicity Bureau, and was a member of the Democratic State Committee. His son, Philip Chute, was born in Naples in 1920. Philip Chute began college at the School of Forest Resources at the University of Maine in Orono in 1940, then enlisted in the Army in 1942. This is the same year that his father, James Chute, passed away. Philip Chute took over the family business and added more cottages to the Chute Homestead. Philip Chute served as town selectman, was a Scoutmaster, and co-founded the Lakes Environmental Association to protect the lakes region around Naples.[29]

Both James and Philip Chute documented life on the family homestead and in the surrounding communities. While not every film reel can be definitively attributed to one man or the other, it is likely that Philip Chute shot some of the CCC footage given his education in forestry at the University of Maine at Orono in the early 1940s.

As Maher argues, "By introducing conservation to nearby communities, Corps camps were also bringing the New Deal home to local residents."[30] Even Mainers, who were by and large reluctant to accept any federal aid, enthusiastically welcomed the CCC. As Condon notes, the CCC was the New Deal relief program "first in the hearts of Maine people."[31] The CCC appealed to Mainers because it provided young men the opportunity to work and improve the landscape. In Chute's film, a frame of the camp entrance in winter reveals the formality of the CCC camps and their quasi-military organization. Even through the snowstorm, residential barracks are clearly visible in the distance, and subsequent frames document the barracks as well as the regimented nature of camp life as lines of young uniformed men load into the back of trucks to be ushered off to a day's work. When viewing the CCC footage, one wonders if visiting the local camps was a common occurrence, or if the Chutes sought special permission to film on-site. The federal government also photographed life in the camps, as well as the landscape improvements CCC workers made and the state parks they created. Images of camps and work sites around the country can be found in the Farm Security Administration and Office of War Information collections at the Library of Congress.

Additional CCC footage on this reel includes workers training in various tree-climbing techniques. These scenes are compelling to watch due to the added level of danger as men scale tall trees and then use rappelling techniques to swing back down to the ground below. Similar documentation of tree-climbing techniques practiced by the Bridgton CCC workers exists in photographs, and a comparison of the moving and still images demonstrates the helpful ways in which both media can provide interpretive context for viewers. While this still image of a CCC tree climber is impressive, conveying to the viewer an element of danger, it ultimately does not satisfy the viewer's curiosity, or answer some crucial questions: What is the climber doing in the tree? How did he get up there? And perhaps more important, how will he get down? The Chute Homestead films, however, give viewers a richer understanding of what occurred outside the still frame of the photograph. The Chutes filmed CCC workers training to climb trees—some climbed the trunk up into the higher branches, while others climbed up and rappelled down the tall trees using a pulley system. (See figure 3.5)

As the generation of men who served with the CCC are passing away, both forms of visual documentation preserve details of the relief work of the Great Depression era, as well as the federal government's involvement, albeit limited, in local Maine communities. The fact that this footage exists as an amateur film,

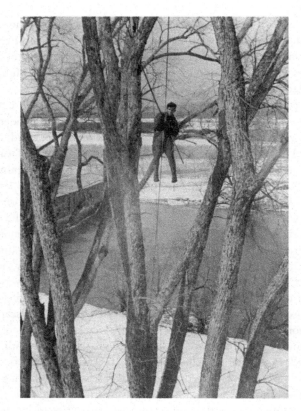

Fig. 3.4 Civilian Conservation Corps tree climber, Bridgton, Maine. Courtesy Maine Conservation Corps/AmeriCorps, Maine Dept. of Agriculture, Conservation, and Forestry, Bureau of Parks and Lands.

as opposed to a government or "official" film, is also testament to the community interest in the activities of the CCC, who were doing what many Mainers considered useful and honorable labor in exchange for a fair monthly wage. Additionally, the inclusion of this informative documentary footage of a New Deal relief organization within a larger collection of films about leisure activities at a local Maine resort signifies the importance of the CCC to the local community, as well as, particularly in Maine, the coexistence of a growing tourist economy with New Deal relief agencies.

Conclusion

When viewing and analyzing personal films, it is important to consider, as Patricia Zimmermann reminds us in *Reel Families*, "however visually primitive home

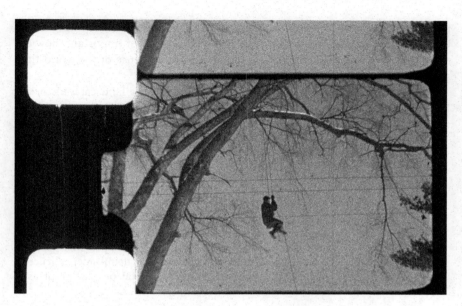

Fig. 3.5 Philip Chute, Chute Homestead home movies. From 8mm film. Naples Historical Society Collection, Northeast Historic Film. [Accession 1612, Reel 26]

movies may appear textually, their historical and discursive structures present much more complexity."[32] The same is true of Maine and the region. However the landscape and inhabitants may appear on film, their lives were rich, complex, and full of all the nuances inherent in living in a time and place where the traditional and the modern coexisted. Each of the films discussed in this chapter showcases the piecemeal ways in which change came to Maine and northern New England in the first decades of the twentieth century. Those who view these personal films must also keep in mind that the films, in addition to documenting activities and places—such as labor practices, vacation spots, towns and their people—were also vehicles of personal expression. As the viewer regards the film, he or she sees what the person holding the camera wanted the viewer to see—particular moments, particular places, and particular people. As the historian studies what is inside the frame for clues to the lived experiences of the past, he or she must also piece together what was outside the frame. These films, like any useful historical source, invite new questions and new ways of thinking about the past: How did Mainers reconcile the decline of traditional natural-resource industries with the state's increased dependence on revenue from tourists? Why did traditional practices persist in Maine longer than other regions? When Mainers chose to adopt or welcome a new technology or innovation, what

prompted them to do so? Were filmmakers self-consciously documenting traditional practices for historical purposes? And perhaps most important, how do these films represent the filmmakers' attempt to make sense of the world that surrounded them?

In his collection of essays *Landscape and Images*, the landscape historian John Stilgoe reminds his readers of the power of personal expression as it relates to rural landscapes:

> Rural landscape remains the greatest triumph of landscape planning, but not planning by government employed planners. Instead the concatenation of farms, woodlots, small towns, and roads reflects a fundamental United States belief in personal physical expression. Sometimes individual personal expressions coalesce in similar ways, particularly in the context of recreation and other shared experience, creating the landscapes that attract tourists, advertising experts, and, especially, retirees, homeschoolers, and the wealthy. Individual expression involves the shaping of space to produce personal goods (especially crops), microclimate, and privacy, but also demi-independence from utility grid and other communal networks coastal people accept as norms.[33]

Like the rural landscapes whose image they capture, these films function as physical personal expressions insofar as they represent an intentional shaping of space. Understanding the intention of the filmmaker is, whenever possible, as essential as working to understand what he or she succeeded in communicating to the viewer. Personal films shot in northern New England in the 1930s provide historians and other viewers with a rich trove of visual, cultural, and social experiences not fully attainable in other media. These films remind viewers of the sometimes tenuous coexistence of tourism and agricultural labor in rural northern New England, as well as the compelling ways in which modernity and tradition commingled here in the 1920s, 1930s, and 1940s, particularly as traditions such as full-time family farming were on the decline. They are underutilized and frequently overlooked sources that should be brought out of storage, out of the archives, and into classrooms, essays, conference presentations, and screening rooms.

Technical Notes: Lester Bridgham, *Cherryfield, 1938*; Raymond Cotton, *Field of Blue: the Story of Maine's Blueberry Industry* (1938)

The *Cherryfield, 1938* reel of 16mm film displays a common form of deterioration caused by exposure to moisture, perhaps when stored in substandard conditions. Film is essentially a clear plastic base with chemicals (known as the emulsion) adhering to the base. When exposed to moisture over time, the emulsion dissolves and erodes from the base, effectively washing the image away. Looking closely at *Cherryfield*, it is evident that the water affected the edges most, and in

one section it probably penetrated the whole reel at a single entry point, causing a rhythmic appearance and disappearance of damage.

Raymond Cotton's film, *Field of Blue: The Story of Maine's Blueberry Industry*, was shot on 8mm film, the film gauge released in 1932 as a lower-cost alternative to 16mm. Cotton made the film between 1937 and 1938 using both black-and-white and the newly introduced Kodachrome film. Offered first in 1935 for 16mm, and the following year for 8mm, Kodachrome was arguably the single best advancement in film stock for the amateur because, unlike earlier more limited color technologies, it used the full spectrum of color.

Kodachrome film technology was extremely complex: a reversal film with multiple layers of emulsion. Processing involved taking a single roll through twenty-eight different steps. By 1938, Kodak could provide better color representation and faster processing time, but Kodachrome was still a dense emulsion requiring a great deal of light to capture the image. Like *Field of Blue*, edited reels could contain both Kodachrome and black-and-white reversal film, with the latter used when faster film was needed for shooting at dusk or on overcast days. Despite Kodachrome's limitations, it is possible that more home movies were shot on it than any other film stock.

Cherryfield, 1938. Lester Bridgham.
Cherryfield-Narraguagus Historical Society Collection, Accession 1194, Reel 1.
Gauge: 16mm. Stock: Kodak Safety Film (B&W reversal) for live action, Kodak Safety Positive (B&W print) for intertitles, AGFA Safety (B&W print) for "The End" leader.
Length: 230 ft. Splices: Twenty-nine. Many appear to have been made where damaged frames may have been cut out. Cement and tape splices, probably from different eras.
Overall reel length: 230 ft.
Date code: 1937.
Camera code: Ciné-Kodak Model E f-3.5.
Other info: Severe water damage, washed-away image, creasing, and perforation damage repaired with tape throughout. The first appearance of intertitles far into film indicates that the beginning of the film may be missing.

Raymond C. Cotton Presents Field of Blue: The Story of Maine's Blueberry Industry, 1938. Raymond Cotton.
Hiram Historical Society Collection, Accession 2122, Reel 2 excerpt.
Gauge: 8mm. Stock: Kodak Safety Film (Kodachrome), Kodak Safety Film (B&W reversal).

Length: 150 ft. Splices: Thirty-five. Additional splices in overall reel. Most splices redone by NHF during processing in the 2000s, according to inspection notes.
Overall reel length: 250 ft.
Date codes: 1938 for live action and intertitles; 1937 for live action.
Camera code: Ciné-Kodak Eight Model 20 f-13.5.
Other info: After "Off to Market" intertitle and brief color shot of loading blueberries into truck, there seems to be more field-burning footage, perhaps tacked on because it was extra/left over. This has all been included in the length for this selection. Then the film continues to logging and parade footage.

Libby Bischof is Associate Professor of History at the University of Southern Maine, where she specializes in Maine history and the history of photography. Bischof is author, with Susan Danly, of *Maine Moderns: Art In Seguinland, 1900–1940*; and, with Earle G. Shettleworth Jr. and Susan Danly, of *Maine Photography: A History, 1840–2015*.

Notes

1. Harrie B. Coe Collection, Northeast Historic Film, Bucksport, Maine.
2. Harrie B. Coe, ed. *Maine—A History,* Volume I (New York: Lewis Historical Publishing, 1928), 449.
3. Ibid., 449–50.
4. Ibid., 444.
5. Joseph Conforti, "Regional Identity and New England Landscapes," in *A Landscape History of New England*, eds. Blake Harrison and Richard Judd (Cambridge, MA: MIT Press, 2011), 17.
6. Raymond Williams, *The Long Revolution*, (Peterborough, Ontario: Broadview, 2001), 63.
7. Raymond C. Cotton, *Raymond C. Cotton Presents Field of Blue: The Story of Maine's Blueberry Industry*, 1938, Hiram Historical Society Collection, Northeast Historic Film; Lester Bridgham, *Cherryfield, 1938*, Cherryfield-Narraguagus Historical Society Collection, Northeast Historic Film; James C. Chute and Philip Chute, Chute Homestead home movies, 1930–1965, Naples Historical Society Collection, Northeast Historic Film.
8. "Maine History Online: 1920–1945: The Countryside at Midcentury," Maine Historical Society, accessed November 2, 2014, https://www.mainememory.net/sitebuilder/site/907/page/1318/display. For more information on Maine in this era, see Richard Condon, "Maine in Depression and War, 1929–1945," in *Maine: The Pine Tree State from Prehistory to the Present*, eds. Richard Judd and Joel Eastman (Orono: University of Maine Press, 1995).
9. Richard Judd, "Reshaping Maine's Landscape: Rural Culture, Tourism, and Conservation, 1890–1929," *Journal of Forest History* 32, no. 4 (October 1988): 181.
10. Richard Wescott and David Vail, "The Transformation of Farming in Maine, 1940–1985," *Maine Historical Society Quarterly* 28, no. 2 (1988): 68.

11. Quoted in *One Third of a Nation: Lorena Hickok Reports on the Great Depression*, eds. Richard Lowitt and Maurine Beasley (Champaign: University of Illinois Press, 2000), 34. These observations are contained in a report letter written to Harry Hopkins, September 21–29, 1933.

12. Lowitt and Beasley, 35.

13. "Maine History Online: 1920–1945: The Countryside at Midcentury," Maine Historical Society, accessed November 2, 2014, https://www.mainememory.net/sitebuilder/site/907/page/1318/display. See also: *Modern Times in Maine and America, 1890–1930*, DVD. Bucksport, Maine: Northeast Historic Film, 2007.

14. Judd, "Reshaping Maine's Landscape," 184.

15. George H. Lewis, "The Maine That Never Was: The Construction of Popular Myth in Regional Culture," *Journal of American Culture* 16, no. 2 (June 1993): 93.

16. Lewis, 96.

17. Richard H. Condon, "Living in Two Worlds: Rural Maine in 1930," *Maine Historical Society Quarterly* 25, no. 2 (Fall 1985): 80.

18. "Summary: Hiram Historical Society Collection, 1937–1976," Northeast Historic Film, accessed June 27, 2013, http://oldfilm.org/collection/index.php/Detail/Collection/Show/collection_id/373.

19. Raymond C. Cotton, *Hog Reaves, Field Drivers, and Tything Men: The Birth Pains of the Town of Hiram* (Hiram, ME: Hiram Historical Society, 1983), 22.

20. For more on the practice of burning blueberry barrens by the Wabanaki, see Kerry Hardy, *Notes on a Lost Flute: A Field Guide to the Wabanaki* (Rockport, ME: Down East Books, 2009), 75–77.

21. Candace Kanes, "Blueberries to Potatoes: Farming in Maine," The Maine Memory Network, accessed October 20, 2014, https://www.mainememory.net/sitebuilder/site/161/page/420/display. For more on the history of the blueberry and blueberry production in Maine, see James L. Warren, *Maine Blueberry Industry History, 1865–2003: An Anthology* (Brewer, ME: by the author, 2004).

22. David Yarborough, "Wild Blueberry Crop Statistics, 1924–2012," University of Maine Cooperative Extension, accessed September 13, 2013, http://umaine.edu/blueberries/factsheets/statistics-2/statistics/.

23. Condon, "Living in Two Worlds: Rural Maine in 1930," 58.

24. Cotton, *Field of Blue: The Story of Maine's Blueberry Industry*, 1938.

25. Terry Hussey, "Harriman tells historians about Mills and Dams of the Narraguagus," Milbridge Historical Society, accessed September 19, 2013, http://www.milbridgehistoricalsociety.org/previous/narraguagus.html.

26. Neil M. Maher, *Nature's New Deal: The Civilian Conservation Corps and the Roots of the American Environmental Movement* (Oxford, UK: Oxford University Press, 2008), 3–4.

27. "CCC Camps in Maine 1933–1942," Maine State Archives, accessed August 1, 2015, http://www.maine.gov/sos/arc/ccc/camps.html.

28. "New CCC Arrivals, Bridgton, 1935," Maine Memory Network, accessed September 1, 2013, http://www.mainememory.net/artifact/26859/enlarge. For more information on the CCC in Maine, see Jon A. Schlenker, *In the Public Interest: The Civilian Conservation Corps in Maine* (Augusta: University of Maine at Augusta Press, 1988).

29. "Bibliographic/Historical Notes," Naples Historical Society Collection, Northeast Historic Film, accessed September 17, 2013, http://oldfilm.org/collection/index.php/Detail/Collection/Show/collection_id/420.

30. Maher, 149.

31. Condon, "Maine in Depression and War, 1929–1945," 516–17.

32. Patricia R. Zimmermann, *Reel Families: A Social History of Amateur Film* (Bloomington: Indiana University Press, 1995), ix.

33. John Stilgoe, *Landscape and Images* (Charlottesville: University of Virginia Press, 2005), 5.

4 A Strange Familiarity: Alexander Forbes and the Aesthetics of Amateur Film

Justin Wolff

IN 1915, ALEXANDER Forbes, a thirty-three-year-old Harvard physiologist, filmed the annual sheep drive on Naushon Island, a bucolic retreat off Cape Cod, Massachusetts, that his family had owned for over seventy years. Though narrow and just seven miles long, Naushon is the largest of the Elizabeth Islands, an archipelago of sixteen ledges and landmasses in Buzzards Bay. By any measure it is an exceptionally charming and privileged island. Viewed on a dry day from Martha's Vineyard, which lies four miles to the southeast, Naushon shows "hillsides furrowed with valleys" and a "sun-bleached concave . . . cliffs of pale yellow clay and sand."[1] Unlike its neighbors, which were denuded long ago, the island is also home to virgin beech and oak trees; the old forests stand in rolling pastures where sheep have grazed for centuries. Forbes's film depicts a Naushon ritual almost as old as the pastures, the annual roundup of sheep for shearing. It shows men on horseback in open fields, dogs chasing sheep, and sheep trotting to and fro. On first impression, it evokes a familiar pastoralism.

Wampanoag Indians hunted, fished, and planted on the Elizabeth Islands free from interference until 1602, when the English explorer Bartholomew Gosnold claimed the islands for the British Crown. In 1654 Thomas Mayhew Sr., a Puritan trader and shipbuilder, bought Nantucket, Martha's Vineyard, and the right to settle on the Elizabeth Islands. His family sold Naushon in 1682 to Wait Winthrop—grandson of John Winthrop, the first governor of Massachusetts— and then, in 1730, James Bowdoin, a wealthy Boston merchant, purchased the island.[2]

From the time Bowdoin acquired it to the present day, Naushon has been a "country gentleman's demesne." Bowdoin's male heirs, so "that they might have a park after the manner of the nobility of England," stocked it with deer, game birds, and prairie fowl.[3] They also parceled the land into farms, which they leased to tenants who raised cattle and planted small vegetable gardens. But Naushon's pastures, being too hilly and rocky to plow, proved best suited to the several

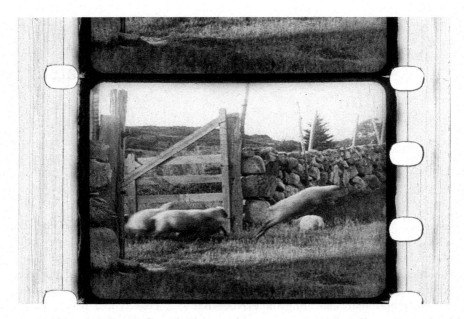

Fig. 4.1 Sheep drive on Naushon Island, Massachusetts, 1915. From 28mm film. Irving Forbes Collection, Northeast Historic Film. [Accession 1902, Reel 18]

hundred sheep the Winthrops had introduced, and by 1780 the farmers' principal business was selling lamb, mutton, and wool to ships anchored in Tarpaulin Cove. The flock was decimated during the War of 1812, but in the decades that followed, during the "merino craze" in New England, the Bowdoins restocked the island, at "huge expense," with two thousand of the Spanish sheep.[4]

In 1842 John Murray Forbes and William Swain purchased Naushon from the Bowdoin family. Forbes, who later bought Swain's share, lived in Milton, Massachusetts; he had made a fortune in the China trade and would amass even greater wealth as a railroad magnate. An avid sailor, Forbes admired the island's "position between the mild waters of the Bay and the Sound [and] its two sheltered harbors" and judged it a "perfect summer home." But he also noticed Naushon's "broad breezy sheep downs" and valued it, as the Bowdoins had before him, as an estate where he and his descendants could perform the custodial duties expected of gentlemen landowners.[5]

* * *

This essay examines the life, career, and filmmaking of John Murray Forbes's grandson, Alexander Forbes (1882–1965), and its broadest aim is to introduce

Fig. 4.2 Alexander Forbes, 1918. Alexander Forbes Papers (H MS c22), Harvard Medical Library, Francis A. Countway Library of Medicine, Boston, Massachusetts, box 126, folder 2603.

readers to his intrepid mind and entertaining, artful films. The movies, dating from 1915 to 1953, depict his family gardening, dancing, skating, camping, horseback riding, and vacationing on Naushon and their Wyoming ranch. The collection also includes films of Forbes's sailboat cruises and survey expeditions to the northern tip of Labrador.[6]

Rather than summarize every reel in the collection, this essay analyzes just a few of Forbes's films in order to propose and ponder several approaches that contemporary viewers can take to appraise the historical and aesthetic value of his movies. Any viewer, casual or otherwise, can enjoy any of his films on their own merit, for they feature places and doings that are simply beautiful—aerial shots of Devils Tower in Wyoming, for example, or steady footage of a schooner, its rail cutting through Atlantic waves, close-hauled to the wind—and that excite in us

joyful recognition of intimate family rituals, such as young girls improvising a ballet and children playing in the snow.

But this essay in particular examines Forbes and his work in the context of his family's social status; his amateur interests in electronics, photography, and filmmaking; his professional specialization in electrophysiology; and ideas about the aesthetics of personal films. Therefore, it explores ways to make sense of the films *objectively*, for history's sake, as well as *subjectively*, so as to relate them to our own consciousness. To these ends, several propositions are woven throughout this chapter. As the emphasis changes, the various claims ebb and flow, but they are intended to work together with the broader purpose here, which is to consider how we might experience the many facets of Forbes's films.

First, we can appreciate his films for their pure historical value, especially the insights they provide about his family's social privilege. Second, Forbes's filmmaking defies common assumptions about supposed distinctions between *professional* specialization and *amateur* pursuits. His endeavors—in the laboratory and in the field—to document fleeting phenomena and map broader knowledge using mechanically recorded data demonstrate his disregard for disciplinary boundaries. Third, all amateur films from the period can be seen as emblematic of broader cultural developments, specifically the dialectic between national identity and regional character. Finally, by considering the movies in the context of phenomenological analyses of film aesthetics, we come to see them as strangely familiar—as both ineffable and meaningful to the here and now. As a scientist Forbes was interested in technologies that detected impulses and topographies hidden from view; as an amateur filmmaker, he used motion picture cameras to disclose the strangeness permeating the familiar world. His films are rich documents that open up historical knowledge as well as epistemologies of consciousness.

* * *

John Murray Forbes's first child, William Hathaway Forbes, was born in 1840. After fighting in the American Civil War, William married Edith Emerson, the daughter of Ralph Waldo Emerson, and worked for Bell Telephone Company, serving as president from 1879 to 1887. The couple's eighth child, Alexander, was born in 1882; he attended Milton Academy, graduated from Harvard College in 1904 (Franklin Delano Roosevelt was a classmate), and received an MD from Harvard Medical School in 1910.[7]

Alexander spent his summers on Naushon in the "Stone House," a fifty-three-room home built for his father by the architect William Ralph Emerson. The Milton and Naushon houses were Edith's domain, "from the back porch to the outer edge of the front veranda," but beyond that, "whether on land or water, her husband had complete authority." Insistent that his children be self-reliant,

William taught them to "meet with coolness the dangers incident to handling a boat at sea, a horse, an axe, and a gun," and though he'd let the boys sail out of the harbor, he'd stand "on the veranda with a spyglass watching the manoeuvres intently." He also passed on to them "not inconsiderable knowledge of practical devices and ingenious arts," which made an especially deep impression on Alexander.[8]

An equally influential figure in Alexander's life was his grandfather, who died in 1898. Believing that hard work, especially on his properties, built character, John Forbes obliged his children and grandchildren, even his guests, to toil alongside him. "He spared no pains," one of Alexander's cousins recalls, "to improve the pastures, drain the swamps . . . build stone walls, and plant thousands of . . . trees to help prevent erosion of the bare hillsides." He was especially proud of Naushon's game and livestock. During his first trip to England, for instance, he described the deer and sheep at Windsor Park as "smaller than our deer and tamer than [our] sheep," and he took very seriously the annual deer hunts and sheep drives, which he supervised from horseback. Though these events served practical purposes, one of his daughters, recalling their pageantry, portrays them as exactingly orchestrated "arrangements" that impressed upon Forbes's family, friends, and farmhands the nobility of his proprietorship.[9]

John Murray Forbes's descendants inherited his appreciation for land, livestock, and their cultivation. In 1898, the year he died, three of his grandsons, including Alexander, purchased Beckton Stock Farm, a ranch at the foot of the Big Horn Mountains in Wyoming. The brothers bred Clydesdale horses and, in 1931, acquired a flock of Rambouillet sheep reputed to be the "finest in America, if not in the world." One paper reported that a "staid and aristocratic old Boston family has 'invaded' the west . . . and has built up one of the finest purebred livestock ranches in the nation." All the while the Forbes family continued tending to Naushon. To this day, sheep and Scottish highland cows graze the island's pastures, and John Forbes's descendants "ride there, caring deeply for their beautiful, unspoiled heritage."[10]

Seen in the context of his family's identification with patrician stewardship, Alexander Forbes's film of the 1915 Naushon sheep drive, which seems at first conventionally pastoral, appears instead to be working at something more: it both *documents* the prestige associated with genteel farming, evident in the coordinated herding of sheep, and *produces* a different kind of prestige, one characterized by leisure. Only the fortunate have the luxury of abstaining from labor in order to represent it, not to mention the time and means to sit in a salon and watch these representations play out. Moreover, only the cultured are inclined to enjoy the remembering of their work. The sheep-drive film, it's important to note, is not an exception: for instance, Forbes's films of Wyoming, dating from the 1930s, portray ranchers stacking and bundling hay. While Naushon Island,

Beckton Stock Farm, and the cattle and sheep that lived there signified the family's material wealth, the films representing the upkeep of these assets, which were presumably viewed afterward for entertainment, transformed work into amusement.

Considering that most Forbes men were recreational ranchers, insofar as they were professionals dedicated to esteemed careers and farmed only when on holiday, and considering that Alexander was a hobbyist filmmaker, the concept of amateurism further illuminates their particular brand of social privilege. Between 1880 and 1920, the film historian Patricia Zimmermann notes, "amateurism" was "clearly identified with upper- and middle-class leisure." "The amateur's versatility," she adds, demonstrated "mental agility, personal freedom, and daring," traits commonly ascribed to Alexander Forbes.[11] Reputed to be as "at ease in the White House as in an Eskimo hut in Labrador," he excelled in every arena. Wallace Fenn, Forbes's biographer, describes him as "every inch a gentleman, loyal to his many friends, considerate of others, quiet and self-controlled but confident and decisive in action," and Edgar Douglas Adrian—Britain's most eminent neurophysiologist—memorialized him as a "knight from the age of chivalry, skilled in manly pastimes."[12] A younger cousin, John Forbes Perkins Jr., also remarked on Forbes's impressive persona:

> I realized after he died that I had never really understood how different he was from the confident, swashbuckling prototype of an adventurer on the one hand, and the absent-minded professor, which he somewhat resembled, on the other. His love of living was a love of simple things, like the sea or the mountains, and his apparent absentmindedness—the result of preoccupation with important matters—concealed a cool-headed clarity of thinking and acting which enabled him to fly a plane for over a thousand hours without a major mishap, and to sail his boats for tens of thousands of miles with very few groundings.[13]

Like other members of his family, Forbes was an avid outdoorsman and regularly sought adventure on his travels. In a gap year between high school and college he visited the family ranch in Wyoming; worked in an electrochemical mill in Rumford Falls, Maine; traveled along the Pacific Coast; and spent a summer in Switzerland, France, Holland, England, and Scotland. After college and before medical school he spent a full year in Wyoming, this time in a cabin on Lake Solitude, far up in the Big Horn Mountains, where he "engaged in a combination of work outdoors, chopping wood and shooting elk, and indoors, studying chemistry and astronomy."[14]

Forbes also flew planes, skied, rode horses, hunted, and, between 1914 and 1932, "with a canoe or kayak . . . made fifteen trips down the rushing water and the hemlock-lined gorges of the Westfield River" in western Massachusetts. He

was particularly fond of sailing and often cruised between Naushon and his cottage on Harbor Island, Maine, and in 1933 he and an amateur crew sailed his schooner *Ramah* from New England to Naples, Italy. In a book about the adventure, Samuel Eliot Morison, a rear admiral and eminent maritime historian, describes Forbes as "one of the most versatile men of our era."[15] As he had studied photography at Milton Academy, three times receiving an honorable mention for landscape and marine photographs, it's not surprising that Forbes took up filmmaking in 1915, when it was seen as a prestigious amateur hobby.

Significantly, Forbes shot his 1915 films, including that of the Naushon sheep drive, with a 28mm Pathéscope camera, a product marketed to wealthy amateurs. The French firm Pathé Frères patented the KOK Cine-Projector in 1911 and introduced its companion KOK Cine-Camera a year later.[16] According to Anke Mebold and Charles Tepperman's history of 28mm film, Pathé Frères, hoping that its projector would "capitalize on affluent audiences . . . hesitant to venture into the theatres," marketed it as a "cinématographe de salon"—the "salon" being what Pathé identified as a "venue for . . . literate and high-class films" intended to elevate "the cinema's fare to meet upper-class tastes."[17]

The American entrepreneur Willard B. Cook purchased the rights to produce and market Pathé's machines in the United States and, after establishing the Pathéscope Company of America in 1913, sold them as the New Premier Pathéscope projector and camera.[18] The equipment was prohibitively expensive: the camera and projector together cost $400 (equivalent to over $6,000 in 2015 dollars). Cook, therefore, had no choice but to market the system as an elite product, and in June 1914, when he unveiled the equipment to America-bound passengers onboard the glamorous ocean liner *Vaterland*, he "invited many of the more prominent passengers . . . to a private exhibition of the Pathéscope [projector] in the luxurious Imperial suite."[19]

By 1915 the Pathéscope Company of America was boasting that "although new to America, Pathéscopes already grace many of the finest homes" and "among the Royal Pathéscope patrons are the Czar of Russia, the King of Belgium, the King of Spain, the King of Italy, the King of Siam and the Sultan of Morocco." A 1920 Pathéscope advertisement listed the names of some of its American clients, including Vincent Astor, H. O. Havemeyer, Mrs. Alfred G. Vanderbilt, and "four of the Du Ponts."[20] When Forbes acquired his Pathéscope equipment, therefore, he both confirmed his own prestige and reinforced the exclusivity of a brand.

* * *

With regards to filmmaking, amateurism was more than a social signifier; it also required a degree of technical proficiency that imbued a film's aesthetic attributes

Fig. 4.3 Advertisement for the New Premier Pathéscope Projector, Pathéscope Company of America, 1920. Courtesy Grahame Newnham.

in unpredictable ways. Forbes was a novice filmmaker using a new camera when he shot the Naushon sheep drive, but the film, while abruptly cut, is hardly incompetent. To film one sequence, for instance, he positioned himself perfectly: slightly downhill from and just inside an open wooden gate, but far enough away from the gate to show some of the stone wall to which it's anchored. The vantage

point gives the sequence a double effect: the square frame of the gate and the horizontal wall stabilize the composition, fixing within the moving image a scene of quaint rusticity, but the impression suddenly vanishes as horses and sheep funnel through the gate, their gallops and gambols quickening downhill. The frenetic blur of downward-sloping motion and jump cuts discompose the frame and estrange the pastoral picture.

Such oppositions are fundamental to our experience of historical home movies, which represent something recognizable, the quotidian, in idiosyncratic ways. Every familiar moment in a historical home movie is suspended in emulsion deteriorated by time and imprinted by its maker's spontaneous choices, quirky aesthetics, and degree of technical skill; recording equipment (cameras, lenses, and films), techniques of mechanical operation (crank speeds and frame rates), film editing (cuts and splices), and projection machines (again, crank speeds) render the familiar deeply strange.

Another of Forbes's early movies, for instance, shows his schooner *Black Duck* sailing near Mount Desert Island, Maine.[21] The film was taken on a blustery day and demonstrates one of the technical challenges he faced when filming at sea. First we see a close-up shot of a dinghy being towed behind the boat; the camera bounces up and down, indicating that Forbes is holding it in his hands as *Black Duck* bounces through the waves. The film then cuts (the camera now rigged on a gimbal) to a steady, forward-facing view of the boat's bow slicing through the chop. The effect is dizzying.

Remarkably, the disarray inherent to personal films comprises their greatest advantage, for, as if by alchemy, their incoherence can clarify the nature of our own experiences. "I have seen many curious, and not a few near-magical moments in . . . home movies," Fred Camper observes. In personal films, he adds, the "oddly out-of-place" produces an "admixture . . . like nothing else in cinema, with its peculiar filmic incongruities, inconsistencies of point-of-view, and with the way in which its accidents seem to in fact reveal something not quite specifiable about the subject-matter."[22] Whether or not it is unique to personal films, phenomenological epistemologies describe this effect as precisely what characterizes our knowing of things in immediate experience. What we know when immersed in experience is aleatory—the experience is unfolding and "not quite specifiable" because the knowledge is prereflective. After we disclose and reflect experience, it settles into familiar narrative forms and loses its ineffability. Personal films are instrumental insofar as our experience of their digressive unfolding occasions the recovery of our first impressions of the world.

The historian, sociologist, and critic Lewis Mumford makes similar points about the value of film in *Technics and Civilization*. Distrustful of shallow representations of experience, Mumford prefers motion pictures that get "dramatic

effect through their interpretation of an immediate experience and through a heightened delight in actuality." He continues:

> Today, in the motion picture, which symbolizes our actual perceptions and feelings, time and space are not merely co-ordinated on their own axis, but in relation to an observer who himself, by his position, partly determines the picture, and who is no longer fixed but is likewise capable of motion. The moving picture, with its close-ups and its synoptic views, with its shifting events and its ever-present camera eye, with its spatial forms always shown through time, with its capacity for representing objects that interpenetrate, and for placing distant environments in immediate juxtaposition—as happens in instantaneous communication—with its ability, finally, to represent subjective elements, distortions, hallucinations, it is today the only art that can represent with any degree of concreteness the emergent world-view.[23]

It's necessary to clarify that such attitudes about the instrumentality of film are not predicated on claims that they depict the world as it really is. They don't disclose reality, or even represent it; they remind us, rather, that reality is lived. According to Vivian Sobchack, an advocate for phenomenological approaches to film, the "realism" of film is not "a predication of the world as 'real' in some abstractly objective sense, some disembodied sense. That is, this sense of realism does not make a truth claim about *World*, but rather makes it about *perceptive experience* of the world."[24]

* * *

Coherence, according to Zimmermann, is precisely what amateur filmmakers avoided. She shows how technical specialization, a key attribute of modern capitalism, increased social distinctions and minimized dissent and difference, whereas amateurism satisfied personal needs. "The symbiotic relationship between professionalism and amateurism mitigates the split between work and freedom," she writes. "The professional embodied the logic of scientized work, while the amateur constituted spontaneity."[25] "Amateurism," according to Zimmermann, "emerged . . . as the cultural inversion to the development of economic professionalization," and "the amateur's spontaneity and lack of purpose momentarily interrupted the control of social and labor relations" by giving significance to the private just as bureaucratic standardization was seizing control of our schedules and dismissing the idiosyncrasies of our parochial and familial habits.[26]

It's tempting to conclude that Forbes was precisely the sort of man who sought in the spontaneity of amateurism an escape from arduous professional specialization. We have considered his filmmaking as signifying prestige and as dramatizing distinctions between patrician stewardship and manual labor. It would be narrow-minded, though, to imply that privilege alone defined Forbes and that Zimmermann's categories, as useful as they are, are anything more than

conceptual frames. In fact, Forbes, who was a creative professional specialist and unusually industrious amateur, collapsed the distinctions between the two modes of production.

As a medical student, Forbes so easily grasped the intricacies of laboratory systems and was such an expert operator of electrophysiological equipment that immediately after he graduated in 1910, Harvard Medical School invited him to serve as an instructor in the Department of Physiology. He accepted the offer but quickly negotiated a two-year leave to study with the esteemed neurologist Charles Sherrington at the University of Liverpool. Forbes returned to Cambridge with new knowledge and state-of-the-art laboratory technology, including Boston's first Einthoven string galvanometer—a six-hundred-pound instrument that produced the earliest electrocardiograms. He went on to achieve remarkable professional success, rising through the academic ranks at Harvard and publishing prodigiously on diverse topics. When Forbes began his career, electrophysiology was a nascent science, but it progressed rapidly in large part because of his technical brilliance and disregard for disciplinary boundaries.

Forbes's greatest contributions to the field involved amplifying the recording capabilities of devices used to detect electrical currents in the nervous system. One major accomplishment came early in his career, shortly after his World War I service. In 1917 he took a leave of absence from Harvard and enlisted in the navy. There, as a radio officer, Forbes maintained communications electronics and supervised the installation of radio direction finders on destroyers. He viewed his navy fieldwork and laboratory research as complementary and insisted that academic scientists were as instrumental to national security as tactical strategists. Historians substantiate Forbes's claim, and in recent years several scholars have portrayed him as an exemplary "scientific military gentleman" who parlayed his wartime research and amateur experiments into breakthrough discoveries with broad applications.[27]

Radio officers, according to Forbes, fixated almost exclusively on one mission: improving signal amplification. Electrophysiologists, it so happened, were equally obsessed with the same objective, and so, once back at Harvard, Forbes set about devising methods for magnifying the sensitivity of string galvanometers, thus "preparing the ground for one of the milestones of nerve physiology."[28] The string galvanometer had a vexing shortcoming: it was sluggish and incapable of recording rapid cardiac events. Forbes's idea was to experiment with new vacuum tubes that he had learned about in the service. Knowing that the tubes enhanced radio signals with minimal distortion, he used them to construct a new amplifier, or what he called an "electron tube." When, in 1919, Forbes finally put the amplifier into a circuit with a nerve and a string galvanometer, he found that it "multiplied a tiny action potential an unprecedented fifty times in size."[29]

Forbes was lauded for his discovery and, over the next several years, published many papers based on data collected using the new amplifier.[30] One historian,

however, argues that Forbes's most significant contribution to neurophysiology wasn't his application of communications technology to signal amplification but, rather, his espousal of a radical theory that envisioned the nervous system as a holistic system: "In Forbes's eyes, the nervous system itself *was* an elegant and efficient marvel of communications technology, the function of which is to transmit messages, signals, and, more generally, information about the environment from the peripheral nervous system to the brain."[31] It's apparent, then, that Forbes was an intuitively interdisciplinary scientist who traversed boundaries between laboratory protocol, experimental fieldwork, and theory. Moreover, in order to achieve in each of these areas he saw no distinctions between the techniques and habits of mind supposedly particular to professionalism and amateurism.

Cameras were integral components of the data detection networks that Forbes operated in his laboratory as he continued to innovate techniques for amplifying and recording nervous-system action currents. To produce high-quality electrocardiograms, for instance, Forbes constantly fiddled with the string galvanometer's silver-coated quartz filaments, electromagnets, and photographic plates. He reported on his photographic experiments in many published papers, including one that explained how he had tweaked a photographic mechanism in order to obtain an electrocardiogram from an elephant.[32] At the same time, however, Forbes was constantly manipulating the cameras, films, and chemicals that he used to make his home movies. His correspondence with Kodak technicians, which lasted for close to forty years, demonstrates that he experimented with his amateur equipment just as assiduously as he did with his laboratory technologies.[33]

In addition to making movies at home and electrocardiograms in his laboratory, Forbes used cameras to develop new charts and maps for maritime navigators. "Everything pertaining to ships fascinates me," Forbes remarked, "especially the theory and practice of navigation," and according to one authority, "with sextant and dead reckoning few professionals [were] his equal."[34] In the early 1930s Forbes was able to apply virtually all of his skills—as a sailor, navigator, engineer, and photographer and filmmaker—to a single objective when he joined an expedition to chart territories in northeastern Canada.

Forbes had planned a recreational cruise to Labrador for the summer of 1931, but a chance encounter with Dr. Wilfred Grenfell, an English doctor and medical missionary in Newfoundland and Labrador, resulted in a new purpose for the trip. After Grenfell explained to Forbes that the region was inadequately charted, they devised the Forbes-Grenfell Northern Labrador Expedition to survey the coast and Torngat Mountains up to Cape Chidley on Labrador's northern tip. Before departing, Forbes learned that Osborn Maitland Miller, a surveyor at the American Geographical Society, had recently developed a new photographic technique for aerial mapping. The assumed advantage of Miller's

photogrammetric method, called "planetabling from the air," was that it would produce very accurate contour maps. But Miller's system was brand new, and Forbes took it upon himself to test and refine it in the field.[35]

First, though, Forbes had to navigate the heavy currents of the Labrador Sea, wait for weather safe enough for flying, set up the aerial cameras and mount them on airplanes, and then develop clear photographs. For the latter purpose, the team set up a darkroom fed by a brook; because the water was too cold for the chemical solutions, they also built a coal stove to heat the water. Only then could Forbes set his mind to mastering Miller's method, which required precise trigonometry and lots of trial and error. The process, Forbes explains, "requires that three or more easily identified, already established points be imaged in the photograph" and then "analysis of angular measurements extracted from the photograph in either a photogoniometer or a single-eyepiece oblique plotter."[36] The hard work paid off: in addition to producing accurate topographical maps of the Torngat Mountains and charts that opened the region to aerial and ocean navigation, Forbes shot over five hundred "of the finest black-and-white low-level oblique air photographs of glacial landforms ever acquired."[37]

Forbes also shot motion pictures during the original 1931 survey and a second expedition to Cape Chidley in 1935. One film, titled *Flight Over Northern Labrador, August 1935*, documents the trip from St. Mary's River to Nain, the northernmost permanent settlement in the province.[38] Forbes held the camera rather than mounting it so that he could quickly move it from one side of the plane to the other; the film, therefore, cuts between rocky coastline and offshore icebergs. In Forbes's official account of the surveys, he mentions taking advantage of the effects afforded by the Kodachrome motion picture film he had obtained. The color film, he explains, helped us "locate shoals by differentiating the dark brown of submerged kelp-covered rocks from the blue of deep water."[39]

In 1941, Forbes reenlisted in the navy as a lieutenant commander, where he was assigned to participate in various projects that required his expertise in electrophysiology, photography, and filmmaking. In *Quest for a Northern Air Route*, a book about his activities during World War II, Forbes writes, "The trail led to many strange places and arenas where the talisman of oblique photogrammetry . . . might solve some urgent problem of war." First, he returned to Canada to scout for potential airstrips; in 1942 he traveled to the Pacific to chart water depth using aerial photographs; and in early 1945 he was in the Caribbean using photogrammetric data to analyze the effectiveness of smokescreens. "At last, the war over," he writes, "the trail led to the heart of the Crossroads project."[40]

The two nuclear weapon tests at Bikini Atoll in July 1946 were known as Operation Crossroads. Responsibility for recording the blasts, including photographically, fell to the Wave Motion Section, a cohort of hydrographic scientists

that included Forbes as a "group leader."[41] In this capacity he advised the section about how best to position, program, and coordinate the automatic cameras that, suspended from huge towers on Bikini Island, shot over fifty thousand stills and 1.5 million feet of movie film during the tests. "I looked down on Bikini Lagoon," Forbes recalls, "and watched while a mass . . . no larger than a man's head released the energy that threw millions of tons of water high into the air, atomized the ship from which it was suspended, and sank a battleship before the great cloud of foam, spray, and fog had cleared away."[42]

Again, to understand properly Forbes's filmmaking we must remember how easily he applied his professional and amateur practices to a single holistic enterprise: the detection and preservation of ephemeral information. Ultimately Forbes's professional legacy rests less on what he contributed to pure scientific knowledge than on the improvements he devised for recording technologies used in electrophysiology. However, his achievements in the laboratory were made possible by his constant tinkering with military electronics and the photographic equipment he used for pleasure. In 1925 Forbes's friend and colleague Edgar Adrian sent him a letter remarking on precisely this aspect of their work: "The amazing thing," Adrian wrote, "is that we have to become histologists, micro-dissectors and even psychologists as well as electricians, plumbers, mechanics and photographers."[43]

* * *

During the 1920s, as the principles of industrial capitalism expanded into the private sphere, and as scientists like Alexander Forbes exposed previously unimaginable magnitudes of reality, many Americans grew anxious about the scale of modernity, feeling that "modern time had become speeding and unstoppable . . . [and] that the rapid pace of social and economic change was rapidly robbing modern people of the capacity to produce their own culture."[44] In response, a regionalist sensibility trickled down from elite cultural circles to the broader public. Lewis Mumford, for instance, was a passionate advocate of localism: "The region," he writes, "provides a common background: the air we breathe, the water we drink, the food we eat, the landscape we see, the accumulation of experience and custom peculiar to the setting, tend to unify the inhabitants."[45] He urged Americans to "start immediately in your own region and locale to lay the basis for the renewal of life" and preferred what he called "definite, verifiable, localized knowledge."[46]

In turn, manufacturers of film technologies and their commercial and cultural associates—critics, charities, amateur clubs, publishers of educational pamphlets and popular magazines—encouraged the public to record and preserve every aspect of the American scene. The introduction of 16mm film in 1923, "an American rebuff to the dominance of Pathé's home and nontheatrical business,"

intensified this localization of amateur filmmaking.[47] Film historian Haidee Wasson explains how amateur film products brought the allure of urban instantaneity into discrete spaces. The purpose, she argues, wasn't to expand domestic spheres or make them replicate cosmopolitan spheres; rather, like collecting books or listening to recorded music, amateur film offered families a way to "rein in the world."[48] Wasson's conclusion, much like Zimmermann's, is that amateur filmmaking came to embody "ambivalence toward modernity's rationalized systems."[49]

It is not my intention to deny these claims about film. However, every rule has an exception, and in this instance Alexander Forbes's filmmaking emerges, yet again, as strange. We have seen evidence that Forbes, in both his professional and amateur guises, did not share in this broader ambivalence about techno-rationalism. He was, instead, a devoted technologist and a systematic thinker. Moreover, even though Forbes acquired a popular 16mm product, a Bell & Howell Filmo 57 projector, he was hardly the kind of middlebrow consumer targeted by 16mm purveyors. It's hard to imagine that his wife, Charlotte, tried to "domesticate" his bravado filmmaking or that Forbes thought of himself as a regional amateur. His filmmaking, we have seen, served laboratory science and national interests during wartime, while his home movies document a privileged domesticity and remarkable adventures: flights over uninhabited landscapes, cruises in the Aegean, and ranch life in wild Wyoming—just the sort of highbrow adventures that Bell & Howell happened to feature on the cover of their monthly magazine *Filmo Topics*.[50] So as much as theories about amateur film practice may open up the field to political and cultural discourses, sociohistorical interpretations alone cannot make his films or filmmaking more familiar.

Nevertheless, I want to conclude by proposing a means for understanding Forbes's films, or some of them anyway, as embedded in our collective consciousness of experience. In fact, what makes some of his films familiar to us is that they share with every other amateur film a degree of strangeness. In *The Story of Utopias*, published in 1922, Mumford considers the role of aesthetics in the regionalist renewal he advocates. "Art in its social setting," he writes, "is neither a personal cathartic for the artist, nor a salve to quiet the itching vanity of the community, it is essentially a means by which people who have had a strange diversity of experiences have their activities emotionally [fit] into patterns and molds which they are able to share pretty completely with each other."[51]

Though the rewards of a contextual analysis of Forbes's filmmaking are manifold—they allow us, for instance, to appreciate the rarity of a life as rich as Forbes's, to see his filmmaking as a manifestation of a broader urge to record mechanically any phenomenon that registers, and to consider amateur filmmaking as part of a large discussion about national versus regional Americas—they are not the same rewards we enjoy while a film plays before us. These rewards,

Fig. 4.4 Cover of Bell & Howell's *Filmo Topics*, August 1931. Forbes owned a Filmo 57 16mm projector. The projector and this journal (the latter not from Forbes) are in the collections of Northeast Historic Film.

by contrast, are more immanent; they are, as Mumford might agree, visceral. We should not, however, deflect or disallow them. We should seek to recover and know them, for "what else is a film," one historian asks, "if not 'an expression of experience by experience'?"[52]

Consider, for instance, Forbes's 1932 reel-length film of two young girls danc-ing in front of a Milton home.[53] The movie, I think, is particularly gorgeous and, owing to its "accidents," poignant. The subject matter is certainly common: the reel shows two girls, perhaps twelve years old, performing several choreographed dances. In one dance they wear kimonos and, moving synchronously on tiptoe, affect a schoolgirl Orientalism. In another they wear white gossamer dresses and prance, balletically and joyously, on a lawn fringed with flowerbeds. Both

Fig. 4.5 Girls dancing in Milton, Massachusetts, Kodacolor film, 1932, by Alexander Forbes. From 16mm film. Irving Forbes Collection, Northeast Historic Film. [Accession 2241, Reel 6]

the grassy garden and the girls' joyful pride are simply beautiful. The origins of the film's poignancy, however, are harder to identify, though some of it, at least, is generated by an incongruity—that of observing unabashed zeal unleashed within the confines of a small fenced yard.

Personal films resist narratives because they are contingent on experiences we can never recover. Sobchack remarks that "the constitutive activity of spectatorial consciousness" increases when one watches a home movie. When we know very little, if anything at all, about a film (as is the case with Forbes's film of dancing girls), then we are more likely to look engagingly *through* the screen, rather than passively *at* it, and to meet there something of our own lives. The phenomenology of Maurice Merleau-Ponty provides the foundation for such claims: "The movies," he says, "are peculiarly suited to make manifest the union of mind and body, mind and world, and the expression of one in the other." As Sobchack has it, "the film lives out before us a perceptual life expressed as kin to our own."[54] Film, and particularly personal film, discloses perception as a living process, thus allowing us to perceive the world more self-consciously.

The cultural historian Mary Ann Doane develops an interpretation of motion pictures that emphasizes what they disclose about time. "The early cinema," she argues, "gives the spectator the opportunity of witnessing the ceaseless

production of meaning *out of* contingency." "Contingency," she adds, "appears to offer a vast reservoir of freedom and free play." Motion pictures, by cataloging everything—the home, the street, spectacles—"promoted the sense that contingency, and hence the filmable, have no limit."[55] Though Doane's focus is early cinema, her observations are well suited to amateur film. Because edits constitute in motion pictures the contingency that we also experience in modernity's real time, and because the amateur's cuts may be unsystematic, we can say that amateur films are especially able to orient us to actual experience. As Christian Metz puts it, "Because movement is never material but is always visual, to reproduce its appearance is to duplicate its reality. . . . It is not sufficient to say that film is more 'living,' more 'animated' than still photography, or even that filmed objects are more 'materialised.' In the cinema the impression of reality is also the reality of impression, the real presence of motion."[56]

To experience historical amateur films like Forbes's—to sense the impressions left by their contingencies and motions—is to feel melancholy. The nostalgia induced by old still photographs has been well documented: Roland Barthes identifies a "that-has-been" clinging to them; Susan Sontag proposes that "all photographs are *memento mori*"; and Jay Prosser, seeing through the "myth that photographs bring back memories," detects in them "not the presence of the past but the pastness of the present."[57] The pinch of melancholy we experience while watching amateur films originates in loss. Doane speaks of the "pretense that the cinema replicates time perfectly, without loss." With early films especially, she explains, "the fact of [their] own finitude—the limits imposed by both the frame and the length of the reel—resulted in the necessity of conceiving the event simultaneously in terms of structure, as a unit of time, as not simply a happening, but a significant happening that nevertheless remained tinged by the contingent, by the unassimilable." "In contrast to the security and certainty of the irreversible flow of time incarnated in the projector's relentless forward movement," she concludes, "there is an intolerable instability in the image's representation of temporality (where one might be led to expect, in fact, a grounding referentiality)."[58]

So as we watch a film, our desire for total preservation through technology is frustrated, thus heightening our anxiety about memory's imperfection and obliging us to reckon with the fact that our own mechanisms for remembering are deeply flawed. The experience of watching a film, which is always moving away from what it has just revealed, intensifies the melancholy we feel when passing through real time. This quality of moving images is rendered exquisitely in Forbes's film of the dancing girls. We don't know the dancing girls, and we don't know the story their dances told then or tell now, but we do undergo a compound experience as we watch them dance. First we sense their having passed away into history; then we sense our own passing beyond the time when we, too, danced

before the camera. That the reel ends with the girls opening the gate to the garden fence and running away from the camera deepens our consciousness of these endings.

Technical Notes: Alexander Forbes, *Sheep on Naushon Island* (1915) and Girls Dancing Excerpt (1932)

Alexander Forbes's 28mm films demonstrate that he was an ideal customer for Pathé's early venture into the amateur-film market. Pathé's unique 28mm product—a suite of film, camera, and projection equipment—was designed not only to bring the cinema into the home by countering the danger of projecting flammable 35mm nitrate film, but also to break Pathé's longstanding reliance on Kodak for film stock. The 28mm safety diacetate film was entirely Pathé's creation, and because it had a dimension close to 35mm, they opted for an unusual perforation design in order to differentiate their product: one perforation per frame on one side of the film, and three perforations on the other. Standard 35mm film featured four perforations per side of a frame.

Pathé produced only one 28mm camera: the Pathé KOK (sold in the United States as the Pathéscope). Released in 1912, it was a slightly modified version of their existing 35mm professional motion picture camera, which featured two internal metal film magazines. In the KOK, the magazines were spring-loaded instead of the earlier twist-off design, and the belt drive was simplified to rotate only the take-up reel, which in turn simplified the internal film path. This design, however, also made creating in-camera effects more difficult—with no way to crank the film backward, it wasn't possible to produce special effects such as double exposures or dissolves.

The KOK's technology allowed extended filming, as the camera's magazines held over three hundred feet of film, which would run approximately ten to fifteen minutes (depending on how fast the projector was cranked). A single crank propelled the film eight frames through the gate area, resulting in a general speed of sixteen frames per second, which was slightly slower than the 35mm model. Shot framing was done via a small squared scope that flipped up on the top of the camera body. The KOK had a fixed-focus, f/4.5, 45mm, anastigmatic lens (having a fixed focal point from the center of the lens to its outer edges). The gate area had rounded corners instead of the hard ninety-degree corners of some 35mm projectors, and this gives all 28mm home movies a framed look that differs slightly from other home movies. The advantage of the fixed-focus lens was that it reduced focusing mistakes on the part of the amateur, as long as the filmmaker did not try and shoot the subject any closer than roughly ten to fifteen feet. In the Forbes film, for instance, when the sheep run by they are all in focus, but the leaves directly in front of the camera are not sharp because they are too close to it.

The film of the two girls dancing was shot on 16mm film using the color process known as Kodacolor (manufactured from 1928 to 1935), which used

black-and-white film stock to produce color images. The Kodacolor process relied upon placing a red/green/blue filter on the camera lens, separating the different colors and capturing the image on millions of tiny lenticules at different physical layers of the emulsion. The lenticules contained different levels of sensitivity so that when the image passed through the red filter, reds would be registered on the red-sensitive layer, greens on the green-sensitive layer, and so on. Those lenticules can be easily detected as ridges running down the film, giving it a corrugated appearance. Processed film, when held up to the light, would still read as black and white, but using the same type of red/green/blue filter on the projector lens produced a color image when the film was projected. This technology could result in image distortion during projection. If the blue filter, for instance, was damaged or obstructed, the projected color would appear distorted because the lenticules containing the blue information could not be read correctly by only the red and green filters. Similarly, if the projector filter were attached upside down (with the red and blue filters positioned opposite to their correct location) the colors would be visible, but would not be accurately represented. Last, if the film were projected with the emulsion facing the light source instead of the filters, the image would appear on the screen as black and white. Because of the complexity of Kodacolor's technology, it is very difficult to transfer the film accurately, and so most Kodacolor can now be viewed only in black and white.

Sheep on Naushon Island, 1915. Alexander Forbes.
Irving Forbes Collection, Accession 1902, Reel 18.
Gauge: 28mm. Stock: B&W print. From original can label: "The Pathéscope Co. of America, Inc., New York Non-Inflammable Film."
Length: 250 feet. Splices: six, (five cement splices and one tape repair splice).
Overall reel length: 250 ft.
Date codes: none.
Camera code: none.
Other info: Not sure if the camera original negative that this print came from was 28mm or 35mm. There are examples of both in the Forbes Collection. On can: "Naushon Sheep drives, June & Sept 1915, A. Forbes."

Girls Dancing Excerpt, 1932. Alexander Forbes.
Irving Forbes Collection, Accession 2241, Reel 6.
Gauge: 16mm. Stock: Kodak Safety Film (Kodacolor).
Length: 40 ft. Splices: zero.
Overall reel length: 50 ft.
Date code: 1929.
Camera code: Victor.
Other info: There is similar dancing-girls footage (from same day?) on Reel 3 in this collection, on Kodacolor stock as well. According to NHF

inspection notes, the box for Reel 3 was dated 1930. The box for this reel (Reel 6) was dated 1932.

Justin Wolff is Associate Professor of Art History at the University of Maine. He has published essays and criticism on American art and visual culture. His books include *Richard Caton Woodville: American Painter, Artful Dodger* and *Thomas Hart Benton: A Life.*

Notes

1. Walter Teller, *Cape Cod and the Offshore Islands* (Englewood Cliffs, NJ: Prentice-Hall, 1970), 143.

2. For the early history of Naushon Island see Alice Forbes Howland, *A Brief History of Naushon* (Cuttyhunk, MA.: Cuttyhunk Historical Society, 1983) and Amelia Forbes Emerson, *Early History of Naushon Island* (Boston: Thomas Todd, 1935).

3. Charles Edward Banks, *The History of Martha's Vineyard, Dukes County, Massachusetts*, vol. 2 (Boston: G. H. Dean, 1911), 19.

4. Jennifer Stone Gaines, "Woolens Industry," *Spritsail* 21, no. 1 (Winter 2007): 34.

5. Edward Waldo Emerson, "John Murray Forbes," *The Atlantic Monthly* 84 (September 1899), 387.

6. Alexander Forbes's films were donated to Northeast Historic Film by his son. See the Irving Forbes Collection, Northeast Historic Film, Bucksport, Maine. Detailed collection records and annotations are available at Northeast Historic Film's website, accessed September 16, 2014, http://oldfilm.org/collection/index.php/Detail/Collection/Show/collection_id/426.

7. For Alexander Forbes's biography see Wallace O. Fenn, *Alexander Forbes, 1882–1965* (Washington, DC: National Academy of Sciences, 1969). The principal archive of Forbes's papers is held by Harvard Medical School: Alexander Forbes Papers, 1827, 1835, 1848–1978 (inclusive), 1910–1946 (bulk), H MS c22, Harvard Medical Library, Francis A. Countway Library of Medicine, Boston. Also see Forbes Family Papers, Massachusetts Historical Society, Boston.

8. Arthur S. Pier, *Forbes: Telephone Pioneer* (New York: Dodd, Mead, 1953), 64–67.

9. Howland, *A Brief History of Naushon*, 10; John Murray Forbes to William and Malcolm Forbes, May 17, 1855, in *Letters and Recollections of John Murray Forbes*, ed. Sarah Forbes Hughes (Boston: Houghton Mifflin, 1899), 141; and Hughes, "Introduction," *Letters and Recollections of John Murray Forbes*, 23. For another brief description of the annual "sheepings" on Naushon, see "Society," *The Kerrville (Texas) Times* (September 19, 1957), 3.

10. "Beckton Stock Farm Near Sheridan Famed for Blooded Strains," *Billings Gazette* (July 30, 1933), 4. In 1939 Alexander's nephew, Waldo Emerson Forbes, moved to the ranch permanently to develop new cattle breeds, including the Red Angus (Howland, *A Brief History of Naushon*, 10).

11. Fenn, *Alexander Forbes*, 115, and Patricia Zimmermann, *Reel Families: A Social History of Amateur Film* (Bloomington: Indiana University Press, 1995), 7–8.

12. Fenn, *Alexander Forbes*, 130; 114; E. D. Adrian, "Alexander Forbes," *Electroencephalography and Clinical Neurophysiology* 19, no. 2 (August 1, 1965): 110.

13. Dr. John F. Perkins Jr., quoted in Fenn, *Alexander Forbes*, 114–15.

14. Fenn, *Alexander Forbes*, 115–16.

15. Ibid., 121. Also see Alexander Forbes, "Twenty years on the Westfield River," *Appalachia* (June 1937), 310–26. Samuel Eliot Morison, *Spring Tides* (Boston: Houghton Mifflin, 1965), 67.

16. "KOK" refers to Pathé Frères's rooster logo. The principal attraction of the 28mm KOK system was its safety for home projection. Although the negative film, made of nitrate, was combustible, the positive film that ran through the projector was nonflammable—unlike 35mm nitrate film—and in 1918 the Society for Motion Picture Engineers adopted 28mm as the industry's "safety standard." According to one historian, Forbes purchased a Pathéscope camera and projector in 1915. See Dwight Swanson, "Up from the Basement: Reviving and Preserving Alexander Forbes's 28mm Home Movies." Paper delivered at the Summer Film Symposium at Northeast Historic Film, Bucksport, Maine, August 8–9, 2003. Reprinted by Northeast Historic Film, accessed August 20, 2014, http://oldfilm.org/content/reviving-and -preserving-alexander-forbess-28mm-home-movies. The projector is in the Irving Forbes Collection.

17. Anke Mebold and Charles Tepperman, "Resurrecting the Lost History of 28mm Film in North America," *Film History* 15, no. 2 (2003): 140.

18. One expert reported that the New Premier Pathéscope projector "proved to be more practical in many respects than its French counterpart." See Austin C. Lescarboura, *The Cinema Handbook* (New York: Scientific American Publishing, 1921), 411. See also Anthony Slide, *Before Video: A History of the Non-Theatrical Film* (New York: Greenwood, 1992), 35–36.

19. "Pathéscope Entertains on Board the 'Vaterland,'" *The Talking Machine World* (June 15, 1914), 11.

20. *The Pathéscope: Announcing the First Complete, Safe, and Thoroughly Practical Equipment for Taking and Presenting Motion Pictures in the Home, the School or the Church* (New York: Pathéscope Company of America, 1915), 9. For the Pathéscope advertisement listing wealthy clients, see *House & Garden* 38, no. 2 (August 1920): 70. Also see Mebold and Tepperman, "Resurrecting the Lost History of 28mm Film," 143.

21. Identifier: 1902.0013.02. Irving Forbes Collection, Northeast Historic Film, Bucksport, Maine.

22. Fred Camper, "Some Notes on the Home Movie," *Journal of Film and Video* 38, nos. 3/4 (Summer-Fall 1986): 11–12.

23. Lewis Mumford, *Technics and Civilization* (New York: Harcourt, Brace, 1934), 341–42.

24. Vivian Carol Sobchack, *The Address of the Eye: A Phenomenology of Film Experience* (Princeton, NJ: Princeton University Press, 1992), 181.

25. Zimmermann, *Reel Families*, 6, 9.

26. Ibid., 7.

27. For a discussion of the "scientific military gentleman," see Steven A. Walton, "Mathematical Instruments and the Creation of the Scientific Military Gentleman," in *Instrumental in War: Science, Research, and Instruments: Between Knowledge and the World*, ed. Steven A. Walton (Boston: Brill, 2005), 17–46. For analysis of Forbes's military research and its later applications, see Stanley Finger, *Minds Behind the Brain: A History of the Pioneers and Their Discoveries* (New York: Oxford University Press, 2004), 240–44; Justin Garson, "Alexander Forbes, Walter Cannon, and Science-Based Literature," in *Literature, Neurology, and Neuroscience: Historical and Literary Connections*, volume 205 of *Progress in Brain Research*, eds. Anne Stiles, Stanley Finger, and Francois Boller (New York: Elsevier, 2013): 241–56; and Joseph H. Spear, "Cumulative Change in Scientific Production: Research Technologies and the Structuring of New Knowledge," *Perspectives on Science* 12, no. 1 (2004): 76.

28. Garson, "Alexander Forbes, Walter Cannon, and Science-Based Literature," 243. Forbes's obsession with signal amplification was so intense that he published a novel about a heroic navy radio officer. Though a peculiar book, it offers interesting insights into Forbes's mind. See Alexander Forbes, *The Radio Gunner: A Fable of the Navy* (Boston: The Riverside Press Cambridge; Houghton Mifflin, 1924). For more on *The Radio Gunner*, see Garson, "Alexander

Forbes, Walter Cannon, and Science-Based Literature." Also see Alexander Forbes, "Radio Compass Officer in Time of War," *The Open Road* 4, no. 5 (May 1922): 62.

29. Finger, *Minds Behind the Brain*, 244.

30. See, for instance, Alexander Forbes and Catharine Thacher, "Amplification of Action Currents With the Electron Tube In Recording With the String Galvanometer," *American Journal of Physiology* 52, no. 3 (July 1920): 409–71.

31. Garson, "Alexander Forbes, Walter Cannon, and Science-Based Literature," 250. Forbes proposed his theory in several publications. See, for example, Alexander Forbes, "The Interpretation of Spinal Reflexes in Terms of Present Knowledge of Nerve Conduction," *Physiological Reviews* 2, no. 3 (July 1922): 361, and Forbes, *The Radio Gunner*, 30.

32. Alexander Forbes, Stanley Cobb, and McKeen Cattell, "An Electrocardiogram and an Electromyogram in an Elephant," *American Journal of Physiology* 55, no. 3 (April 1921): 385–89. Also see Alexander Forbes, Hallowell Davis, and John H. Emerson, "An Amplifier, String Galvanometer and Photographic Camera Designed for the Study of Action Currents in Nerve," *Review of Scientific Instruments* 2, no. 1 (January 1931): 1–15.

33. Forbes corresponded with Kodak from 1911 to 1950. See Alexander Forbes Papers, Box 58, Folders 1734–37, Harvard Medical Library, Francis A. Countway Library of Medicine, Boston.

34. Forbes quoted in Fenn, *Alexander Forbes*, 123, and Samuel Eliot Morison quoted in ibid., 122. Also see Alexander Forbes, *Offshore Navigation in its Simplest Form, for All Who Sail the Oceans Out of Sight of Land* (Boston: Eastern Science Supply Company, 1935).

35. O. M. Miller, "Planetabling from the Air: An Approximate Method of Plotting from Oblique Aerial Photographs," *Geographical Review* 21, no. 2 (April 1931): 201–12.

36. Alexander Forbes, "A Flight to Cape Chidley, 1935," *Geographical Review* 26, no. 1 (January 1936): 54.

37. Jack D. Ives, *Land Beyond: A Memoir* (Fairbanks: University of Alaska Press, 2010), 6. In chronological order, the publications resulting from the survey are Alexander Forbes, "Surveying in Northern Labrador," *The Geographical Review* 22, no. 1 (January 1932): 30–60; Alexander Forbes, "A Flight to Cape Chidley, 1935," *Geographical Review* 26, no. 1 (January 1936): 48–58; Alexander Forbes, *Navigational Notes on the Labrador Coast* (New York: American Geographical Society, 1938); and Alexander Forbes, O. M. Miller, N. E. Odell, and Ernst C. Abbe, *Northernmost Labrador, Mapped from the Air* (New York: American Geographical Society, 1938). For his contributions to the advancement of geography, the American Geographical Society awarded Forbes the Charles P. Daly Medal in 1932.

38. Identifier: 2533.0010. Irving Forbes Collection, Northeast Historic Film, Bucksport, Maine.

39. Forbes, et al., *Northernmost Labrador, Mapped from the Air*, 136.

40. Alexander Forbes, *Quest for a Northern Air Route* (Cambridge: Harvard University Press, 1953), 137. In the spring of 1941, Forbes was sent to Squantum Naval Air Station, south of Boston, to participate in groundbreaking research on electroencephalography (EEG) data collected from navy pilots, but by May he was back in Newfoundland, helping to identify sites for military airstrips. For more on Forbes's EEG research see Kenton Kroker, "Washouts: Electroencephalography, Epilepsy and Emotions in the Selection of American Aviators During the Second World War," in *Instrumental in War*, 301–38. For more on Forbes's other activities during World War II see Lincoln R. Thiesmeyer and John E. Burchard, *Combat Scientists: Science in World War II* (Boston: Little, Brown, 1947), 125–26.

41. William A. Shurcliff, *Bombs at Bikini: The Official Report of Operation Crossroads* (New York: W. H. Wise, 1947), 148.

42. Forbes, *Quest for a Northern Air Route*, 137.

43. Adrian to Forbes, November 19, 1925, Alexander Forbes Papers, Box 1, Folder 2, Harvard Medical Library, Francis A. Countway Library of Medicine, Boston.

44. J. M. Mancini, "'Messin' with the Furniture Man': Early Country Music, Regional Culture, and the Search for an Anthological Modernism," *American Literary History* 16, no. 2 (Summer 2004): 226.

45. Lewis Mumford, "Regional Planning," [1931], in *The Lewis Mumford Reader*, ed. Donald L. Miller (Athens: University of Georgia Press, 1995), 211.

46. Donald L. Miller, *Lewis Mumford: A Life* (New York: Grove, 1989), 166. Lewis Mumford, *The Story of Utopias* (New York: Boni and Liveright, 1922), 281.

47. Haidee Wasson, "Electric Homes! Automatic Movies! Efficient Entertainment!: 16mm and Cinema's Domestication in the 1920s," *Cinema Journal* 48, no. 4 (Summer 2009): 6.

48. Ibid., 21.

49. Ibid., 2. On antimodernism, see T. Jackson Lears, *No Place of Grace: Antimodernism and the Transformation of American Culture, 1880–1920* (New York: Pantheon, 1981). Also see Ryan Shand, "Theorizing Amateur Cinema: Limitations and Possibilities," *The Moving Image* 8, no. 2 (Fall 2008): 42.

50. See, for example, the *Filmo Topics* covers for January 1931, April 1931, and August 1931.

51. Mumford, *The Story of Utopias*, 293.

52. Sobchack, *The Address of the Eye*, 3. Here Sobchack quotes Maurice Merleau-Ponty, who writes, "In a sense the whole of philosophy, as Husserl says, consists in restoring a power to signify, a birth of meaning, or a wild meaning, an expression of experience by experience, which in particular clarifies the special domain of language." See Maurice Merleau-Ponty, *The Visible and the Invisible*, ed. Claude Lefort, trans. Alphonso Lingus (Evanston, IL: Northwestern University Press, 1968), 155.

53. Identifier: 2241.0006. Irving Forbes Collection, Northeast Historic Film, Bucksport, Maine.

54. Vivian Sobchack, "Toward a Phenomenology of Nonfictional Film Experience," in *Collecting Visible Evidence*, eds. Jane M. Gaines and Michael Renov (Minneapolis: University of Minnesota Press, 1999), 244; Maurice Merleau-Ponty, "The Film and the New Psychology," in *Sense and Non-Sense*, trans. Hubert L. Dreyfus and Patricia Allen Dreyfus (Evanston, IL: Northwestern University Press, 1964), 58; Sobchack, *The Address of the Eye*, 122. For another take on how we experience images, see Dominic Lopes, *Sight and Sensibility: Evaluating Pictures* (New York: Oxford University Press, 2005).

55. Mary Ann Doane, *The Emergence of Cinematic Time: Modernity, Contingency, the Archive* (Cambridge: Harvard University Press, 2002), 181, 11, 230.

56. Christian Metz, *Film Language: A Semiotics of the Cinema* (Oxford, UK: Oxford University Press, 1974), 9.

57. Roland Barthes, *Camera Lucida: Reflections on Photography*. Translated by Richard Howard (New York: Hill and Wang, 1981), 77; Susan Sontag, *On Photography* (New York: Picador, 1977), 15; and Jay Prosser, *Light in the Dark Room: Photography and Loss* (Minneapolis: University of Minnesota Press, 2005), 1.

58. Doane, *The Emergence of Cinematic Time*, 62, 141.

PART II

CREATIVE CHOICES: RECOVERING VALUE IN AMATEUR FILM

1 The Task at Hand: The Films of Ernest Stillman

Whit Stillman

IN CINEMA, ONE decision is vastly more important than all the others. So many filmmakers lavish enormous talent and resources on misconceived projects, unsuited to the medium, with much hard work and creativity poured into the sand. The key decision—the choice of subject—sounds simple but, extrapolating from the many cases of talented people who have made poor ones, it is not. The best subject has visual interest and the sort of physicality the camera can capture better than words, the potential for beauty and dramatic tension, while being well explorable by the means at hand. And it must have the fascination and emotional resonance that will keep the filmmaker drawn in and inspired.

The striking quality of Ernest Stillman's films in Northeast Historic Film's collections, as well as others elsewhere, is how well suited the choices of subject were to him and the silent 16mm camera he had at hand.

We have been asked to draw personal connections with our forebears' films; in my case these are not very apparent. I never knew my grandfather, who died before I was born. As children it was the apparatus of his filmmaking we knew, not the content: a film-editing deck and a silent 16mm projector on which we would watch Felix the Cat cartoons and World War II documentaries. My brother would usually operate the projector; perhaps this had some influence on him as, when he was suspended from Harvard in the 1960s for his political activities, he became a film teaching assistant at MIT and a film projectionist (among other things, helping the manager of Cambridge's Orson Welles Cinema splice together old Warner Brothers cartoons to create the feature *Bugs Bunny Superstar*) before going on to train in medicine as our grandfather had done.

My father also had a photographic bent, which he exercised recording family events with a magnificent Rolleiflex camera; if I recall correctly, you would peer over its top and see a beautiful image upside down on its ground glass.

I never had their affinity for cameras and photography; instead, I approached filmmaking as a failed writer, deciding in college that without the solitary stamina to be a novelist I might do something in film and television. There was the same question of finding good subjects that my grandfather faced: only three

Fig. R1.1 Head title, circa 1930. From 16mm film. Ernest G. Stillman Collection, Northeast Historic Film. [Accession 1289, Reel 7]

periods of my own experience had potential as film stories, and after making those, I struggled to find books or historical subjects to adapt, which brings me to the one odd personal connection with Ernest Stillman's films. A few years back, while staying in New York's Chelsea neighborhood on a house- and dog-sitting assignment, the dog and I chanced upon the delivery of boxes of ice-packed fresh fish to a fish shop that looked like it had survived from one of the *Godfather* films. There was something fascinating about seeing these denizens of wild nature deposited directly on an urban avenue. What a wonderful visually and thematically rich film I thought it would make to follow the capture of fish from the sea, via all the steps, to the shop counter. Or even just, as in this case, to the pavement outside the shop. The sea and its creatures are fascinating and ideal for cinema: they neither take nor need direction. Fish work for cheap and, with a bed of ice, for long hours; fish never request first-class travel for their companion, publicist, and hair and makeup team: fish glisten beautifully without any hair or makeup work at all—no artificial glitter needed. Fish and fish processing is a subject of such visual strength that it could even be intertwined with the fictional human storylines that supply the filler in commercial cinema without losing its fascination. The idea seemed very strong.

It was a pleasant comeuppance to discover that ninety years before, my grandfather had had the same idea, and while such "ideas" can come fast and

cheap, he shot and executed a film on the subject with great patience and austere beauty.

Much of the little I know about my grandfather is reflected in his films. He was very shy, which he overcame by dedicating himself to worthy endeavors, losing himself in his projects. He grew up essentially an orphan, but one with living parents. His father, a banking rival of J. P. Morgan, exiled his wife to Europe after they separated when Ernest was an infant. Ernest was raised by the household staff, and family legend has it that his childhood best friend was—a pig. To his shyness I owe my name: Harvard College had alphabetical classroom seating in his days; "Stillman, Ernest" and "Whitney, Mark" were seated next to each other and became friends; Mark introduced Ernest to his younger sister; she and Ernest married.

Ernest went on to study medicine and became a research doctor at the Rockefeller Institute in New York. There he always felt more comfortable among the workmen than he did among his fellow doctors. Though affectionately regarded, his eccentricities earned him a place in the institute's official history:

> Ernest G. Stillman, who joined the hospital staff in 1915 and remained until his death in 1949 at the age of sixty-five, devoted himself to studying experimental pneumococcus infections in mice and rabbits. An independently wealthy man of non-conformist temperament, Stillman . . . added variety to the life of the hospital by mild eccentricities and by divagations unusual in research men. He was, for example, an honorary medical officer of the New York City fire department and chief of the fire company in the . . . village where he lived. He would not take lunch in the doctors' dining room, but brought his own dinner pail and ate with the head painter and other friends on the service staff. Once in his later years Stillman enlivened a social function at the Institute, on a night of driving rain, by taking his post at the main entrance, dressed in yellow oilskins, and directing automobile traffic as guests came and went. (George W. Corner. *A History of the Rockefeller Institute 1901–1953 Origins and Growth*. New York: Rockefeller University Press, 1965)

This last anecdote particularly suggests someone uncomfortable in conventional social situations who yearns for the physical world of activity and problem solving, parallel to his lifelong fascination with firefighting and camaraderie with firefighters. (The major cache of his films were related to firefighting. Together they are considered the largest such collection in the world, and are housed in the Prelinger Archives at the Library of Congress. It is said he would arrive at fires with his medical bag in one hand and his camera in the other; he invented a flashlight designed for firefighters, as well as smoke-ejection equipment, both used by the Fire Department of New York, where he was made an honorary battalion chief and deputy chief.)

Ernest had been in the army medical corps in World War I and, like most of his generation, was profoundly affected by the devastating Spanish Influenza

Fig. R1.2 Fishing off Southwest Harbor, Maine, circa 1928. From 16mm film. Ernest G. Stillman Collection, Northeast Historic Film. [Accession 1289, Reel 7]

epidemic. His medical research was toward finding a cure; then, the discovery of sulfa drugs in the late 1930s seemed to render his research vain, but in subsequent decades it was found again to be useful. For the lab mice and rabbits he used in his research, he arranged a bucolic retirement on his small Cornwall-on-Hudson farm. When he gardened he dressed like a hobo, alarming visitors. His major endeavor was forestry, and he established the Black Rock Forest as a teaching forest, affiliated initially with Harvard (which the late George W. S. Trow recounted in a brilliant article for the *New Yorker* [June 11, 1984], later published as a book).

Ernest's love for the Hudson Highlands, the center for nearly all his activities, is seen in one of his earliest and best films, *Cornwall, N.Y., Memorial Day Celebration 1920* (https://archive.org/details/cornwall_ny_celebration). The secret behind the films he later made showing life along the coast of Maine was simple: he did not want to be there. His wife, Mildred Whitney, a writer and poet, had fallen in love with the Maine coast and wanted to spend time there with their children during the summer. It was not just any part of the Maine coast but the stretch between Northeast and Seal Harbors on Mt. Desert Island, the high ground of the sort of resort social life that Ernest would have found off-putting despite the beautiful surroundings. Removed from the Hudson Highlands and all the projects he cared about, in a resort area where the interests were leisure class, he was a fish out of water. So he plunged into filming with his 16mm camera the magnificent physical world surrounding the small, seasonal, "social" one.

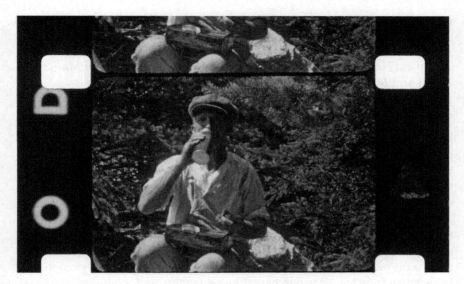

Fig. R1.3 Construction of Berry Cliff, 1930. Summer home of Ernest and Mildred Stillman, worker on break. From 16mm film. Ernest G. Stillman Collection, Northeast Historic Film. [Accession 1289, Reel 15]

His greatest subject was the craft of Maine commercial fishing, especially thriving in those years. Few aspects of our world can be so well portrayed on film as that of pulling fish from the sea and their subsequent preparation and transporting. The greatest of American filmmakers, John Ford, was a Maine native ("John Feeney" during his formative years in Portland; he and his elder brother changed their names to Ford when they went Hollywood), and in Ernest Stillman's elegant short *Fishing for the Sacred Cod in Maine*, there seems a Fordian quality, a reverence for the natural world and the men who harvest its fruits, with an austere black-and-white cinematography; spare, diagonal compositions; and elegant pacing (music needed): one thinks of Ford's *Seas Beneath* and *The Long Voyage Home*. In these films, as in the chronicling of the construction of the house he had built for his family at "Berry Cliff," near the boundary between Northeast and Seal Harbors, there is also a feeling for the fellowship of constructive work. These are three-dimensional, physical projects that lend themselves to representation on film, rich compositions, and objective interest. Raised by workmen, Ernest was always interested in and admiring of those dedicated to other crafts and trades. And these provided great subjects for his 16mm camera.

As a shy and somewhat awkward man—his childhood nickname was "Moxie," derived from "lummox" (a reference to his large build)—it would be easy to say that he hid behind his camera. But in fact he was using it as a link to

subjects with which he had an intellectual or emotional bond: the lush beauties of nature or the camaraderie of individuals.

Technical Notes: Ernest Stillman, *Fishing for the Sacred Cod in Maine* (1928) and *Building Berry Cliff* (1930)

The reels shot by Ernest Stillman exemplify the flexibility of Bell & Howell Filmo cameras and demonstrate why they became popular. The camera's portability and handheld design (enabled by its spring-wound motor) allowed Stillman to get close to the action whether he was documenting the building of a house or ocean fishing. In one scene of *Building Berry Cliff*, he appears to be standing on the beams of the house frame; another shot is a close-up of the jackhammer.

The titles in *Fishing for the Sacred Cod in Maine* film were made at Kodak. The amateur could send title text to Kodak, who would return positive film with the titles for the user to edit into the production. Kodak began providing this service in 1924, when it was proven the format was a success, and charged roughly three cents per word with a minimum charge of one dollar. This service relieved the amateur from having to purchase titling apparatus, and resulted in consistent titling.

There is a scene in *Building Berry Cliff* where the Bell & Howell Filmo 70-D's limitations provide an aesthetically interesting sequence. The shaky shot of the man sitting and eating next to the window is in soft focus and overexposed. By shooting directly into the sunlight coming through the window, Stillman frames the man's head as a silhouette. The bright sunlight in the background and the absence of a filter on the camera (which might have corrected the exposure) results in an image that seems to glow. The camera was also positioned too close to the man to remain in focus. Fortunately, such mistakes when shooting photo-chemical film can produce memorable and beautiful shots.

Building Berry Cliff contains very few cement splices, indicating that Stillman created most of the edits in camera. He shot the movie in a linear fashion in order to capture the construction process. In-camera editing can work well for this type of documentation film, but it can also give the film an unpolished quality—often a compelling attribute of amateur film.

Fishing for the Sacred Cod in Maine, 1928. Ernest Stillman.
Ernest G. Stillman Collection, Accession 1289, Reel 7.
Gauge: 16mm. Stock: Kodak Safety Film (B&W print) for intertitles; Kodak Safety Film (B&W reversal) for live action.
Length: 400 ft. Splices: Fifty-seven. Mostly original diagonal, but many straight replacements.
Overall reel length: 400 ft.

Date codes: 1928 for intertitles; 1926, 1927 and 1928 for live action.
Camera code: Bell & Howell Filmo 70-D.
Other info: Date codes are mixed throughout. Intertitles typical of kind ordered from Kodak. Brown discoloration in a few frames.

Building Berry Cliff, 1930. Ernest Stillman.
Ernest G. Stillman Collection, Accession 1289, Reels 14–15.
Gauge: 16mm. Stock: Kodak Safety Film (B&W reversal).
Length: Reel 14, 160 ft. Reel 15, 430 ft. Splices: Reel 14, three; Reel 15, eight; mostly original diagonal splices.
Overall Reel Length: Reel 14, 160 ft. Reel 15, 430 ft.
Date codes: Reel 14, 1930; Reel 15, 1929 and 1930.
Camera code: Bell & Howell Filmo 70-D.

Whit Stillman is a filmmaker and directed the Academy Award–nominated *Metropolitan*, as well as *Damsels in Distress*, *The Last Days of Disco*, and *Barcelona*. He has also written novels based on his films *Love & Friendship* and *The Last Days of Disco*.

5 Midway between Secular and Sacred: Consecrating the Home Movie as a Cultural Heritage Object

Karen F. Gracy

ONCE THOUGHT OF primarily as a tool to record family life, the home movie has become rehabilitated from its prosaic origins. Only a few decades ago, these films were marginalized as pedestrian documents, devoid of value outside of the personal and familial spheres in which they were created. Archivists, cultural historians, curators, and artists now argue that they be recognized as important historical records, sociocultural documents, and works of art. For these home movie enthusiasts, such films are particularly prized for their functions as reflective documents of personal, familial, and cultural identity. Home movies serve as contextual markers for community structures and values, often serving as the material record of how filmmakers defined and interacted with their world.

Despite newfound recognition and an accompanying resurgence of interest, home movies still occupy a peculiar position in the cultural heritage hierarchy—found midway between the categories of disregarded personal memento and celebrated cultural artifact. Unlike folk art or snapshots, which have been embraced by curators and the cultural elite and thereby have entered the museum sphere reborn as vernacular art, home movies have thus far trod a very different path to cultural relevance.

Assessing the Home Movie Form

Home movies provide critical clues to understanding how people represented themselves and their worlds in the twentieth century. Current scholarly approaches to home movies tend to privilege the personal, familial, or documentary aspects over other potential values. Given this preference for assessing home movies within a historical context, they are primarily valued as evidence of events in the lives of their creators or subjects. Other potential values can lie buried below the surface, however, concealed from most viewers or scholars by the familial or documentary contexts in which home movies are deeply embedded.

How does one fully assess the importance of these films, bringing forth and exploring their inherent multiplicity of values? While knowledge of the life of a film's creator and the context of its creation and use provides one important approach for reading a home movie, this attention to historical value can also be a hindrance to using new critical frameworks and, because it easily produces a dominant narrative, may mask other potential readings.

In order to move beyond the automatic foregrounding of historical value, scholars and archivists must first question the degree to which home movies may be used as authentic, reliable representations of people, places, and events. Ultimately, one must assess the truth-value of such films. Are they purely evidential in nature, creating genuine records of a place, time, and community long past? French film scholar Roger Odin has noted the problematic nature of using home movies and other amateur footage as truth statements: "Reading a home movie does not summon the documentarist mode of reading but the *private one*. . . . Home movie images function less as representations than as *index* inviting the family to *return to a past already lived*. The home movie does not communicate. Instead it invites us to use a double process of *remembering*."[1] Using home movies as historical evidence, therefore, risks naïveté and a lack of critical distance.

Approaches from other disciplines such as art history, cultural studies, and sociology may sometimes prove to be more fruitful avenues for exploring the value of these films, and could provide a richer, more complete understanding of home movies than historical methods alone. This essay illustrates the potential of such approaches by applying relevant sociocultural theory to specific home movie case studies.

First, the sociocultural value of home movies will be examined using Pierre Bourdieu's concept of the "field of cultural production," as well as recent theories on the social utility of vernacular photographs. Second, a critical examination of two film collections—the Archie Stewart Collection and the Sterling Collection, found in the moving image archives of Northeast Historic Film—will reveal the social utility and aesthetic values of home movies. Each of these approaches demonstrates new ways of reading and appreciating these films beyond standard interpretations of their value as domestic narratives or historical documents. Comparing the merits of exploring the evidentiary nature of home movies with the potential rewards of seeing them as tabulae rasae for new meanings and aesthetic interpretations opens up promising avenues for critical analysis. In conclusion, the essay offers suggestions for how cultural heritage communities may continue to reassess and reevaluate home movies as objects worthy of collection and interpretation.

A critical approach to the analysis of a home movie must often read "against the grain," resisting the established function of the form as purely a record to be taken at face value. Reading against the grain is the practice of "critically reading historical documents through fragmentary traces that illuminate unintended or contradictory evidence, usually buried within records created to document

entirely different actions."[2] To read contrarily, scholars must tease out those other aspects of the home movie—such as the filmmaker's socioeconomic status, the film's materiality or morphology, and its aesthetics or narrativity—that lie underneath the dominant discourses of familial and regional documentation.

Scholars and viewers must also be aware of the modality of personal film—that is, the ways in which it is has been used and viewed by amateur filmmakers and how it differs in important ways from digital modalities of illustration and narrative. Although digital capture technologies have largely replaced the home movie and analog home video as the preferred mode of creative expression, photochemical film still holds a cachet for filmmakers, both amateur and professional, because of its aesthetic qualities. Film cannot be erased or written over once exposed, and thus provides certain boundaries and limitations that shape the creative processes of shooting and editing. Also, the cost of using film poses restrictions on spontaneity and requires the filmmaker to think before shooting; in comparison, the ease of recording video on digital video devices encourages a different type of creativity that privileges quick reactions, sometimes at the expense of focus or technique. Each modality, both film and digital, has its advantages and disadvantages; the danger lies in assessing the value of one using the strengths of the other as a critical framework. Film's advantages and limitations cannot be fairly compared to more recent moving image technologies such as analog videotape and digital media. Approaches that are used in the assessment of the value of home movies must honor the product's form and function.

Through different readings and with careful attention to the spectrum of possibilities provided by the medium of small-gauge motion picture film, home movie enthusiasts may begin to break down those arbitrary categorizations that separate and segregate these materials from other forms and genres of moving images. These alternative approaches provide the framework for the further exploration of the multiplicity of values embedded in home movies.

Home Movies and the Field of Cultural Production

Home movies are part of a larger social economy of cultural heritage that sociologist Pierre Bourdieu refers to as the "field of cultural production," one in which heritage objects are markers of both monetary and symbolic value. In this domain, individuals and institutions create, distribute, and exhibit cultural objects for various purposes, both commercial and noncommercial.[3] Bourdieu writes, "It is the field of production, understood as the system of objective relations between these agents or institutions and as the site of the struggles for the monopoly of the power to consecrate, in which the value of works of art and belief in that value are continuously generated."[4]

In the case of film and other types of moving images, the motion picture industry tended to dominate the field, controlling the monetary valuation of such objects through its near monopoly on production, distribution, and exhibition of commercial moving images to bourgeois audiences. In turn, the dominated fraction of the field (i.e., those who engage in noncommercial forms of expression) engineered its own system of valuation for the moving images that it creates and consumes—one that largely repudiated economic considerations. This disavowal of economic interest led to the development of many cultural heritage objects standing in contrast to the typical Hollywood product.

Avant-garde and amateur filmmaking of various types and genres, including home movies and video shared with family and friends, digital shorts distributed on YouTube or other video-sharing sites, and experimental works using various analog and digital media are just some of the examples of moving images created and distributed outside of the commercial motion picture and television industry. These works span the spectrum of potential audiences, from the intimate portraits and artwork meant to be seen by a close circle of family, friends, or colleagues, to those aimed at the largest possible audience by open distribution through social media and other outlets.

To distinguish among the vast array of moving images created as acts of communication or creativity in the commercial (dominant) and noncommercial (dominated) fraction of the field, Bourdieu argues that participants in the field engage in a process of cultural consecration. Creators and consumers together create categories of value to establish what fits the definitions of art, history, and culture.

In the Bourdieuvian field of cultural production, avant-garde films tend to top the hierarchy of consecration, being acknowledged primarily by intellectuals for their importance as works of art. Independent films and documentaries also tend to be recognized for their social and cultural values, given that many of them find currency as political statements, artistic expressions, or historical narratives. Commercially made, widely distributed films are often seen as middlebrow, since their ability to make a profit for the producers is usually of primary importance, and the filmmaker's aim is usually to entertain or educate. Critical assessment enhances the level of consecration that an individual work or genre receives, and the highest level of consecration is often reserved for those films that few have ever seen, outside of an elite circle of filmmakers who disavow any commercial intentions for their work.[5]

Home movies have often been considered to be on the far end of the spectrum when compared to highbrow genres such as experimental film. Typically, the audience for such films has been very small, often consisting of only family and friends of the filmmaker. Because the value of home movies is defined primarily by individuals who have little economic influence on the field, the

conventions of the form developed independently from or in opposition to economic imperatives. Most have received little critical acknowledgment and are stereotyped as having a "low-art" aesthetic that emphasizes traditional family values and narrative conventions over experimentation with content and form, the use of abstraction, or the deployment of ambiguous meanings.[6]

In comparison to more self-consciously artistic works, home movies have often seemed prosaic and secular, rarely being considered suitable for the rarefied domain of those heritage institutions whose purpose is to sanctify the status of cultural objects. While museums and archives have often championed noncommercial genres such as avant-garde film and documentaries, it has been rare to see that level of acclaim for most home movies.[7] While film preservationists have been celebrating the cultural importance of Hollywood, European, and other more mainstream films since the establishment of the first archives in the 1930s, the accolades for home movies have come more slowly. The National Film Registry—a project created in 1989 by the United States National Film Preservation Board (NFPB) of the Library of Congress—recognizes films with cultural, historical, or aesthetic significance. Yet of the 650 titles listed on the registry since the NFPB's inception, only a dozen are amateur films.[8] Despite their ubiquity in private spheres, it is still rare to see home movies garner as much public and critical attention as more commercial or culturally consecrated films have received.

Home Movies Find a Place in Cultural Heritage Institutions

In spite of home movies' seemingly low status in the field of cultural production—valued as neither art nor commercial product—they are now beginning to be discovered, acquired, and celebrated by some cultural heritage institutions. More likely to be found in archival collections than in museums, home movies are often labeled as documents or records first, and social artifacts or works of art second. They are often consolidated within the larger grouping of amateur and small-gauge filmmaking, and can sometimes be difficult to distinguish from these other films (particularly when the creator of the films also engaged in other forms of amateur filmmaking like travelogues).

Yet few cultural institutions other than media archives have actively collected home movies, because many museum curators and archivists lack a complete understanding of the films' value. They often perceive that difficulties in preserving and documenting small-gauge film may outweigh the advantages of adding them to collections. Unlike photographic prints, home movies require specialized viewing equipment and projectors. Thus amateur film has been more difficult to assess. Condition of the film also affects accessibility and therefore evaluation—the film must be undamaged and not too shrunken in order to be duplicated successfully for exhibition.

In spite of the limitations that make home movies a difficult form to manage, preserve, and exhibit, important collections have been established, and there is growing awareness of the significance of these cultural objects. Pioneering archivists working with regional and community-based collections at organizations such as Northeast Historic Film and the Japanese American National Museum, as well as archivists involved with the Center for Home Movies, have made great strides in preserving films and making surrogates of home movies more accessible via Internet distribution. The inclusion of home movies and other amateur films in DVD sets, such as the well-regarded *Treasures from American Film Archives* series (compiled by the National Film Preservation Foundation and distributed by Image Entertainment), has also furthered awareness of the value of these films as cultural heritage objects.[9] These sets attempt to raise the status of home movies by placing them on the same level as other valued forms and genres, such as feature films, documentaries, avant-garde, and experimental films, and situating them in the canon with works by well-known directors and artists such as John Huston, Cecil B. DeMille, Stan Brakhage, and Shirley Clarke.

The slow transformation of home movies from prosaic and largely unremarkable private documents to works worthy of consecration as cultural heritage objects parallels the change in attitudes toward other vernacular forms of expression. The snapshot, for instance, recently rebranded as vernacular photography, can serve as a point of comparison to home movies' trajectory from living-room entertainment to museum artifact.

Home movies have the potential to become museum artifacts by ceasing to have primary value as familial communication documents or historical evidence. By entering the museum, they become accessible objects of contemplation and open to multiple interpretations beyond the original context of their creation and the intentionality of their creator. In the reflective space of the museum, one finds the home movie at a critical juncture in its transition from purely private document or evidential record to cultural heritage object.

In the Vernacular: Home Movies as a Tool for Expression and Interaction

While museums have largely embraced vernacular still photography as a legitimate form, home movies have been slower to enter the museum and archival realms. In archival communities, continued preference for text-based or still-photograph forms of evidence might stand in the way of greater appreciation of home movies' value as historic and cultural documents.

In spite of this seeming prejudice, the new attitude toward home movies that has emerged over the last thirty years is traceable to two emerging phenomena. First, there is the developing trend in curatorial practice to recognize and valorize vernacular art forms, of which home movies may be considered a part.[10]

Second, the ascendancy of digital modes of creation and communication has prompted a nostalgic turn to reconsider our analog selves, including societal uses of moving images to express identity and record impressions and details of daily life as evidenced by phenomena such as vlogging (i.e., video blogging) and the use of cameras in smartphones to provide on-the-scene documentation of events as they unfold.

Beginning in the 1990s, artists, cultural studies scholars, and museum professionals began to recognize the artistic and historical value of amateur photography, identifying it as a vernacular form of self-representation worthy of study. Amateur photography's worth has often eluded art historians, due to what art historian Geoffrey Batchen has called its "idiosyncratic morphologies."[11] Snapshots often defy categorization as part of a particular Western style or genre. "They muck up the familiar story of great masters and transcendent aesthetic achievements, and disrupt its smooth European-American prejudice. In short, vernaculars are photography's *parergon*, the part of its history that has been pushed to the margins (or beyond them to oblivion) precisely in order to delimit what is and is not proper to this history's enterprise."[12] Batchen argues that a material culture approach to the study of vernacular forms of expression, wherein the structure and physical qualities of the object and the uses to which the object has been put, may be the more appropriate approach for analysis.

Batchen's suggestions have been influential on a number of photography scholars and historians. In their introductory essay to the volume accompanying the 2005 Boston University Art Gallery exhibition *In the Vernacular: Photography of the Everyday*, art historians Stacey McCarroll Cutshaw and Ross Barrett argue that the visual content of photographs, including aesthetic decisions, are key cues of amateur photographs' social functions.[13] They suggest four particular functions of vernacular expressions, which they used as organizational principles for the gallery exhibition: archive, proof, surrogate, and yardstick. When a photograph is used to archive, it means that the photographer aims to "preserve, systematize, and save visual information" in the private or public spheres. A photograph can also serve as proof, or evidence of claims, experiences, and authentication of phenomena, which most closely relates to its indexical properties. Third, a photograph might be a surrogate—"a substitute or stand-in for experience"—representing people, places, or events that the person taking the snapshot wants to remember. Last, photographs can serve as yardsticks—standards of measure or judgment that allow someone to assess the object depicted according to a perceived standard, such as when a photograph shows the size of a fish caught by an angler or the height of a person compared to the monument in front of which he or she is standing. While their categories are neither definitive nor exhaustive, Cutshaw and Barrett's framework offers a model for approaching the study of vernacular expression from a perspective that foregrounds the use value of this material.[14]

How do the approaches of material historians such as Batchen or Cutshaw and Barrett impact the assessment of the value of amateur or vernacular moving images, such as home movies? Because home movies share many characteristics with snapshots in terms of their social utility, these categories offer insights into how moving image scholars and archivists might analyze the functions of such media.

Several cinema scholars have attempted to draw interest to the study of home movies over the last few decades by highlighting their importance to moving image history and their value as cultural objects. Thirty years ago, the *Journal of Film and Video* devoted a special issue to the form. In his essay "Some Notes on Home Movies," artist and writer Fred Camper noted, "The history of cinema has seen the creation of far greater numbers of home movies than of any other type of film."[15] Yet, despite the hundreds of thousands of home movies created since the invention of cinema, the form has received relatively little critical attention when compared to the analysis of the products of Hollywood and national cinemas.

This critical focus on the creation of canons of important films, television, and other media drawn primarily from works created for highbrow and middle-brow audiences tends to produce a "normative framework" for thinking about moving images that marginalizes those works that diverge from those privileged genres and types. When assessed through that normative framework for media valuation, home movies tend to not measure up and thus are less likely to achieve cultural consecration as artistic works or historical documents.[16] Instead, film scholar Chuck Kleinhans argues for the importance of understanding circumstances of creation and use: "The internal and non-contextual analysis so common in aesthetic film analysis cannot deal with the full experience of my aunt's home movies. In the family setting they are always accompanied by commentary about the film, the people, and the past. The family audience has an elaborate foreknowledge of the people/actor depicted, and this knowledge is part of the pleasure of recognition in experiencing the work."[17]

In contrast to Kleinhans's emphasis on the social utility of home movies, art historian Patricia Erens argues for the development of a critical framework for understanding the aesthetics of the form. She notes that these films are characterized by "the degree of revealed self-awareness on the part of the participants," as well as the tendency of filmmakers to make "mistakes," by which Erens means "events which were not planned by the photographer (i.e., light flares, the appearance of sprocket holes, black outs, shakey camera movements, over- and under-exposed lighting and out-of-focus shots) and techniques which are not common practice in commercial feature filmmaking (i.e., jump cuts, swish pans, lack of establishing shots, tilt shots, repeated pans from left to right or right to left and back again, casual framing, correcting focus during a shot, jerky zooms, and uneven lighting)."[18]

In some respects, this characterization of the aesthetics of home movies is, in fact, a stereotype that reifies the distinction between professional and amateur. Many of these so-called mistakes of home movies can also be defining characteristics of avant-garde cinema; curator Bruce Posner, who compiled the touring program and DVD set *Unseen Cinema: Early American Avant-Garde Film, 1894–1941*, included several home movie selections.[19] Clearly, he considered home movies and amateur films to be part of the culture of experimentation that fostered the avant-garde movement. Film historian Patricia Zimmermann also notes, "Most amateur films problematize oppositions between professional and amateur, dominant and emergent, national/international and local. Amateur films push questions of artistry—if defined as authorial genius and intervention into visual codes—to the sidelines. Analysis requires situating these films as historical formations rather than reified objects. How can historiography account for shifting relations between aesthetic, discursive, social, political, economic, and technological formations?" In summary, it is shortsighted to create ontological categories that are too rigid and do not allow for reassessment or recategorization through the reading of films using new frameworks beyond historical interpretation such as aesthetics or sociocultural theories.[20]

A Multiplicity of Values: Case Studies from the Collections of Northeast Historic Film

Northeast Historic Film, located in Bucksport, Maine, has been a leader in collecting the moving image record of New England since 1986. Over the course of its history, the archive has acquired numerous home movie collections that provide the basis for further exploring concepts of value in amateur cinema. Examples drawn from two of the archive's collections provide further illustrations of the social utility and aesthetic flexibility of the home movie.

The Archie Stewart Collection

The amateur films of Thomas Archibald (Archie) Stewart (1902–1998), are imbued with self-consciousness, humor, and an obsession with the technical details of filmmaking. A resident of Newburgh, New York, Stewart was in the automobile business, operating the Broadway Garage, where Buicks and Pontiacs were sold and serviced. Stewart was deeply interested in the equipment and techniques of filmmaking and was a member of the Amateur Cinema League. He can be characterized as an early adopter, given that he obtained his first camera in 1926—only a few years after Kodak's introduction of the 16mm amateur film gauge to the American consumer. By 1935, he had purchased a sound camera and immediately began to experiment with its capabilities to record narration and wild sound.

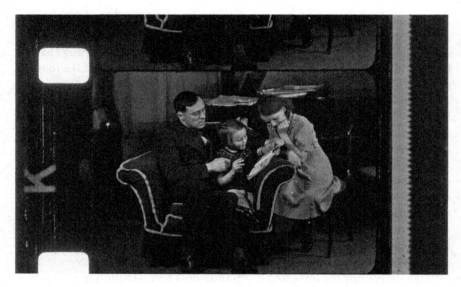

Fig. 5.1 Ann Stewart reads a story to her father, Archie, and sister, Mary. From 16mm film. Archie Stewart Collection, Northeast Historic Film. [Accession 1108, Reel 66]

The Archie Stewart Collection consists of almost seventy thousand feet of film, or over thirty hours of footage. Together, these many rolls comprise an engaging record of family life and pastimes from the 1930s through the 1980s. His family, including wife, Mary Louise; daughters Mary and Ann; and dog, Patsey, feature prominently in his films. Many scenes focus on moments of leisure, such as piano playing, dancing, family vacations, and other diversions.

While some reels feature what we might now consider the highly ritualized subjects of home movies, such as birthdays and Christmas mornings, other scenes are obviously carefully composed vignettes. In one example, Archie asks Ann to tell him a story while they sit in a comfortable chair. Mary looks over Ann's shoulder. He prompts Ann frequently as she slowly sounds out the words. In a later reel, Archie asks Ann to read to him again, this time with Patsey, the dog, as another audience member. Ann's reading skills have improved quite a bit since the last time, and she can successfully read the story without as much prompting from her father. In these related records, the viewer sees how the films are used as a kind of yardstick for measuring Ann's progress.

The Stewarts were a family of means, even during the height of the Depression. Birthday and Christmas celebrations were bountiful and often boisterous. Several reels of richly hued Kodachrome showcase a family vacation to Miami Beach for the Christmas holidays. In another scene that subtly conveys privileged economic status, eight little girls in party dresses sing "The Good Ship Lollipop"

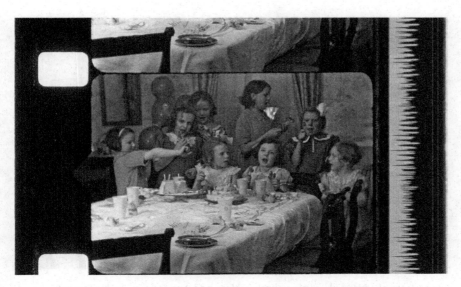

Fig. 5.2 Birthday party for Ann Stewart, with optical sound visible on right side of frame. From 16mm film. Archie Stewart Collection, Northeast Historic Film. [Accession 1108, Reel 66]

while brandishing lollipops at a birthday party for Ann.[21] During those harsh times, to be able to hold such a celebration with a decorated cake, balloons, and various party favors and table settings points to the family's material comfort. Using a motion picture camera to record such details—the ownership of the camera itself being a sign of economic prosperity—Stewart has provided proof of such status.

In Stewart's films, daughters Mary and Ann are well aware of their status as cinematic subjects, helping Archie create charming stories for the camera. In figure 5.3, the sisters are having a mock tea party, with the dog, Patsey, outfitted in a dress and kerchief, waiting for tea to be poured and biscuits to be served. The scene is not complete without hearing the daughters' comical tea party conversations, as they pretend to be friends or neighbors exchanging social niceties. Here, the camera provides a document of their playacting, as they reenact social rituals that they have no doubt witnessed many times before.

In addition to Stewart's focus on documenting (or sometimes engineering) amusing moments of family life, his films and their soundtracks reveal an avid interest in the technical aspects of filmmaking. His narration of each film often includes mentions of the camera settings, and the lens and film stock chosen to capture the scene, and he often revisits a subject in order to capture it using different technical parameters. For example, in a shot of water, taken from the top of a hill in San Francisco, he narrates as he adjusts his equipment: "Exposure

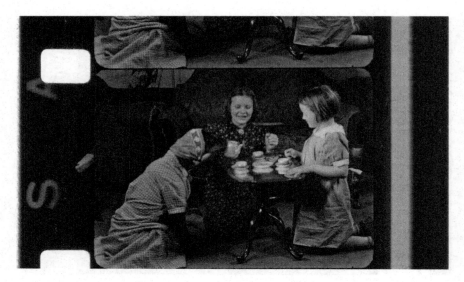

Fig. 5.3 Tea party attended by Patsey the dog, Mary, and Ann Stewart. Archie Stewart Collection, Northeast Historic Film. [Accession 1108, Reel 66]

F-11, made with ordinary lens. Same picture, same stock, only this time with a telephoto lens attached. . . . Now, we've placed a hood over the telescope lens, and we'll see if it takes away the objectionable fog I've been getting on all these telescopic pictures." Here, Stewart makes a playful pun on the word "fog," which could mean a hazy effect on the film or the atmospheric fog for which San Francisco is famous.

Throughout Stewart's films, he investigates the social and aesthetic boundaries of the medium. While his subject matter is usually his family, they often serve as subjects in a larger investigation to explore the capabilities of the film medium as a narrative device or tool of experimentation. Charles Tepperman has called this genre of amateur filmmaking, which focuses on family, local events, and travel, "chronicle films." While most amateurs produced films that could be categorized as chronicles, he distinguished advanced amateur filmmakers as those who "developed a significant relationship between their everyday lives and the new aesthetic and technological means of communications provided by the movie camera."[22] A purely historical approach might recognize the importance of Stewart's films primarily for their value as chronicles of a middle-class family's life and travels in the 1930s. Yet Stewart's films also provide insights to how an inquisitive amateur explored and exploited the modalities of this new medium to make meaning of his world, and this indicates that Stewart's work was indeed more advanced than the average home moviemaker.

The Sterling Collection

The Sterling Collection provides the opportunity to consider further the potential of home movies as aesthetically pleasing objects of contemplation. Philip Sterling (1907–1989) was a writer and public-relations representative who worked in the radio and television industries from 1945 to 1965. His writing accomplishments included editing a bibliography on the literature of the motion picture (published by the Museum of Modern Art Film Library in 1941), and in later years, a biography of the environmentalist Rachel Carson and other books for young readers. He was married twice and had three children, Billy (born in 1931 by his first wife, Helen), Peter (born in 1941), and Anne (born in 1944). Philip married his second wife, Dorothy Dannenberg Sterling (1913–2008), in 1937. Dorothy was an accomplished writer of children's literature who wrote many acclaimed works of nonfiction, including biographies of historical African Americans that were some of the first juvenile literature written about those figures. Dorothy was the mother of Philip's second and third children, Peter and Anne.

It is unclear when or how the Sterlings acquired the 16mm motion picture camera that they used to shoot their family films, although there is evidence that Philip was familiar with the amateur filmmaking scene. In 1937, he reported in the *New York Times* about plans of the Motion Picture Producers and Distributors Association to cooperate with educators on the production and distribution of educational films using 16mm film. Sterling suggests that a side benefit of the development of distribution channels for educational films might be a similar distribution method for amateur films, thus dramatically increasing their audience. He notes that the 16mm gauge may be "about to transcend its recreational bounds and emerge as a serious instrument, primarily in the hands of education, but also in the service of cinematic art."[23] In this prediction, Sterling reveals his perception of the blurring boundaries between home movies and amateur filmmaking and also perhaps his own yearning to achieve recognition of "sixteen's" artistic potential.

The Sterlings' home movies came to Northeast Historic Film from daughter Anne Fausto-Sterling in 2012. The films are assembled in five reels and were shot between 1940 and 1945. They are not in any discernible order, arranged neither in exact chronological sequence nor strict topical categorization. The subject matter of these films is primarily familial, and at first glance appears to be rather pedestrian; scenes of beach vacations on Cape Cod, children's bath times, and crawling toddlers predominate the almost sixty minutes of silent black-and-white and color footage.

Given Sterling's interest in the artistic potential of 16mm, one might expect these films to be more overtly ambitious in their aesthetic, but they are not deliberately artistic or experimental in technique. There is no specific narrative, and

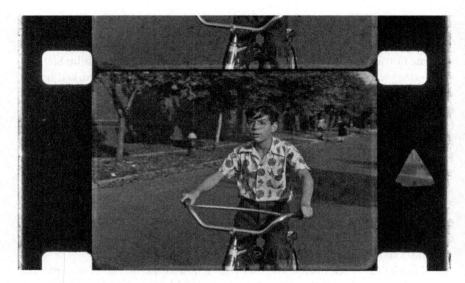

Fig. 5.4 Billy Sterling riding a bicycle. From 16mm film. Sterling Collection, Northeast Historic Film. [Accession 2629, Reel 1]

the chronological jumps provide no guiding explanation of events or importance. There is an unfinished quality to these films, as if the viewer was seeing a work in progress, a rough cut that was never brought to its final form. It is also not always clear who is behind the camera—for those scenes in which Philip is featured, clearly there is another operator, most likely Dorothy, who may also be the coconstructor of these works. In such situations when the filmmaker cannot be clearly defined, it is particularly difficult to assess authorial intentionality. Last, there is no evidence that the films were ever shown in a public venue—these films have seen light of day only in wake of their donation to Northeast Historic Film.

How might these films be assessed? While it is tempting to rely primarily on the context of their creation as an interpretive lens, what we know about those circumstances is minimal and may tempt the viewer to imbue certain shots with meanings and interpretations that are not based in evidence, or that foreground certain aspects or information at the expense of other qualities. These films are primarily personal expressions recorded on film. Given the limitations of a purely historical or biographical frame, a more overtly aesthetic approach can open up new avenues of appreciation. An analysis that establishes how these films evoke sensations and sentiment, for instance, may enrich our understanding of them and their creator(s). Among the many prosaic, familial scenes, viewers can find their moments of viewing pleasure, sometimes in unexpected places. The lack

of an overarching narrative or organizing principle, where shots are juxtaposed outside of the normal chronological sequence, creates a kind of flow where details that may have been unnoticed can emerge.

These films also seem to play with concepts of time by employing slow motion. While a more historical interpretation might suggest that the camera operator was experimenting with the camera speed, this slowing down forces us to focus on the subject of the shot and examine motion in more detail than we might have otherwise done. In the first sequence of images in Reel 1, the viewer sees several takes of a boy in glasses, approximately eleven years old, riding a bicycle toward the camera. After the first few takes, the speed of the shot is slowed, and the viewer gets a chance to look more closely at the boy and take in details such as his baseball-themed print shirt and his shiny bike with wide handlebars. In the background are pedestrians and the occasional car—we are in a suburban neighborhood.

Provenance notes accompanying the Sterling Collection confirm that the boy on the bicycle was Billy Sterling, Philip's son with his first wife, Helen Sterling.[24] No other footage exists of Billy, and he passed away at the age of sixteen, from complications related to heart surgery.[25] It is tempting to interpret the placement of this film, as the first sequence in the first reel, as having some kind of significance, particularly with the knowledge of Billy's premature death. Yet the viewer must be cautious not to indulge in such speculation, given how little is known about the overall structuring of these reels. Even without this knowledge, one can still appreciate the dynamism of the boy on his bicycle pedaling toward the camera, with a lock of hair across his forehead and a serious gaze that breaks into a grin as he passes by the camera.

Other moments when viewing pleasures intensify include a sequence in the second reel where an African American woman is bathing a baby boy (Peter Sterling) in a sink equipped with a hand pump. The images are rich with visual details, such as the pump handle in the foreground that serves as a kind of framing device, the bright sunshine that illuminates the scene, and Peter's wet, slippery skin as the woman first scrubs him as he sits down and then stands up. At one point, the woman peeks around the handle of the pump with a quick smile, acknowledging her participation in the bathing scene by making eye contact with the camera operator.

It is tantalizing to contemplate what few shreds of information we know about this scene: young Peter later became a Freedom Rider, riding the Illinois Central Railroad on May 30, 1961, from New Orleans to Jackson, Mississippi, in support of civil rights for African Americans. While this is certainly an important contextual detail, it also has the potential to create a dominant narrative around this film that might overshadow other potential readings of value, such as the aesthetic analysis detailed above. The woman in the sequence, Annette Smith

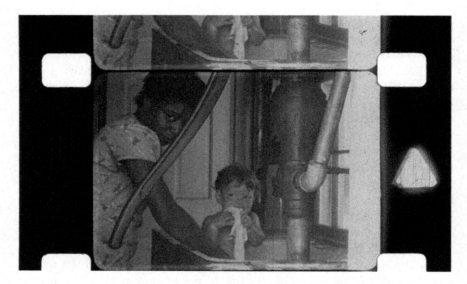

Fig. 5.5 Bath scene. Annette Smith Lee washing baby (Peter Sterling). From 16mm film. Sterling Collection, Northeast Historic Film. [Accession 2629, Reel 2]

Lee, who cared for Peter and his sister Anne from 1941 to around 1951, becomes woven into a larger story about relationships between whites and African Americans, rather than being a focal point in the contemplation of the film's artistic qualities.[26] Both readings have value—the trick is to trace both in the documentation and presentation of this sequence and draw a viewer's attention to each one's validity as an interpretation of the film.

In these brief examples from the Stewart and Sterling Collections, one finds compelling evidence of how home movies can be valued in fresh ways that do not rely primarily on their historical context. While information about the creator and his or her subjects will always enrich understanding of these films, it should not preclude or hinder other approaches to analysis that lead to new insights about their aesthetic qualities or sociocultural importance.

Reassessing the Home Movie Form: Suggestions for Curators, Archivists, and Viewers

Home movies can and should be more widely recognized, in addition to their documentary qualities, for their potential value as creative statements and sociocultural objects. While some scholars, artists, and consumers may continue to see home movies as rough and unpolished—in need of trimming, taming, or situating in tidy categories—others may begin to see in home movies the signs of a

work of art or communication in progress, unfolding in time and space and bearing the traces of stops and starts, experiments and tentative statements, which characterize such incipient expressions. Home movies give the viewer a unique perspective into that embryonic stage of creation, where creators learn the craft of expressing themselves through moving images. Using the analytic frameworks featured in this chapter, new audiences can consider the unique pleasures of home movies that relocate these films beyond the family or community for which they were made and make them a more valued part of cultural heritage.

Archivists and curators can contribute to reassessing this form through various institutional activities such as appraisal, documentation, and preservation. Archivists and curators should reconsider their approaches to appraisal of these films, moving beyond the provenance information that helps with initial contextualization to consider how creators may be exploring new ways of communicating and expressing themselves creatively. Cultural heritage professionals can recruit and cooperate with scholars, artists, and community stakeholders from various disciplines to provide new perspectives on the value of this material and evoke the multiplicity of values embedded in home movies. Documentation of home movies could also be enhanced by feeding the results of such reappraisals into finding aids and catalog records. Improved description and interpretive commentary on the value of home movies in archival and museum record-keeping systems will result in increased interest in the form and better integration of such films as objects of study in both the humanistic and scientific fields. Last, preservation work, in which home movies are often copied to newer stock or digitized, should respect and celebrate those aspects of home movies that define and characterize the form by resisting the urge to edit, condense, or subject film to cropping or processing techniques that alter the film's aesthetic qualities.

Through mindful reflection and action that considers the full spectrum of values found in these films, archivists and curators can more effectively advocate for the thorough integration of home movies into the cultural record. The lure of finding new audiences and new appreciation for home movies should provide incentive for this important work of improving the accessibility and appreciation of these films. Through such novel perspectives and recognition, home movies and other amateur films may someday enjoy the same degree of cultural relevance and consecration as our most noteworthy Hollywood movies.

Technical Notes: Archie Stewart, *Tea Party* (1937), and Philip Sterling, *Billy Sterling* (circa 1942)

Archie Stewart was an early adopter of motion picture technology, so it comes as no surprise that he purchased the first available sound camera—released for 16mm in 1935. The RCA Sound Camera (Type PR-25) was capable of shooting one

hundred feet of black-and-white film while recording sound on the same roll. The camera translated the sound into an optically written image on the edge of the film. Once developed, the film could be played back on a sound projector. RCA had introduced the first such projector five years earlier to project studio-made sound films.

When originally released, RCA configured the camera for "newsreel operation": a small microphone, "the autophone," capable of recording narration by the operator, was affixed to the rear of the camera. This placement also caused the microphone to record the sound of the camera's spring-loaded motor. To fix this problem, RCA released a secondary microphone, at additional cost, that greatly improved the sound quality.

Stewart captured the sound in the tea party footage by mounting an amplifier unit (Type PA-94) and battery box (Type PB-107) between the camera and tripod. He used a small headphone to monitor the sound transmitted by the microphone (Type PB-111) set up near the girls. Stewart could test the sound quality in his earpiece before starting the camera.

While the results must have been fascinating for early users such as Stewart, the tea party film illustrates that the sound was still not exceptional. Early optical sound technology suffered from a constant hum under the recorded dialogue. In later years, optical recording devices would be better shielded from the camera. Still, sound was a remarkable advancement for the amateur. Because this early RCA technology was short-lived, the sound reels in the Stewart Collection are rare and important.

The camera used by Philip Sterling was the Bell & Howell Filmo 70-D. Like the Ciné-Kodak, Bell & Howell constantly improved the Filmo 70's design in a series of different models. By the time the Model D was released in 1929, the camera included many unique features capable of generating effects such as slow motion in the sequence of Billy Sterling on a bicycle. Philip Sterling created the slow-motion scene by shooting it at a faster frame rate than would subsequently be used when projecting the film. The Filmo 70-D had a range of frame-rate speeds from eight frames per second (fps) to sixty-four fps. The sequence with Billy Sterling riding the bicycle was shot at thirty-two fps and was intended to be projected at eighteen fps.

Tea Party, 1937. Archie Stewart.
Archie Stewart Collection, Accession 1108, Reel 66.
Gauge: 16mm. Stock: Kodak Safety Film (B&W reversal), optical sound.
Length: 15 ft. Splices: zero within tea party scene, seventeen in overall reel.
Overall reel length: 625 ft.
Date codes: 1935 all B&W sections (tea party scene is only B&W). Overall reel includes 1936 and 1937 Kodachrome.

Camera code: RCA Sound Camera f-3.5.
Other info: Entire reel contains home movies with sound, covering 1936 to 1939, according to Stewart logbook. 1937 date for *Tea Party* probable, according to logbook. There is ink on soundtrack at splices, and the soundtrack is cut out of film for a few frames in many places (making the film width less than 16mm). Most color sections are faded.

Billy Sterling, circa 1942. Philip Sterling.
Sterling Collection, Accession 2629, Reel 1.
Gauge: 16mm. Stock: Kodak Safety Film (B&W reversal).
Length: 7 ft. Splices: two within bike sequence (tape splices).
Overall reel length: 30 ft.
Date code: 1942.
Camera code: Bell & Howell Filmo 70-D.
Other info: Followed by/spliced to Kodachrome stock with 1945 date code.

Karen F. Gracy is Associate Professor in the School of Library and Information Science at Kent State University. She is author of *Film Preservation: Competing Definitions of Value, Use, and Practice*. Other recent publications include research on the evolution of moving image preservation in cultural institutions for *Information & Culture: A Journal of History*, and professional attitudes toward digital distribution of archival moving images for *The American Archivist*.

Notes

1. Roger Odin, "Reflections on the Family Home Movie as Document," in *Mining the Home Movie: Excavations in Histories and Memories*, eds. Karen L. Ishizuka and Patricia R. Zimmermann (Berkeley: University of California Press, 2008), 259.
2. Timothy Wisniewski, "Framers of the Kept: Against the Grain Appraisal of Ephemeral Moving Images," *The Moving Image* 7, no. 2 (2007): 5.
3. Pierre Bourdieu, *The Field of Cultural Production* (New York: Columbia University Press, 1993), 115.
4. Ibid., 78.
5. For a further exploration of deploying the Bourdieuvian framework to understand how film is valued within the field of film preservation, see Karen F. Gracy, *Film Preservation: Competing Definition of Value, Use, and Practice* (Chicago: Society of American Archivists, 2007).
6. The high-art/low-art distinction has been argued most forcefully in Herbert Gans' *Popular Culture and High Culture*, rev. ed. (New York: Basic Books, 1999).
7. See Haidee Wasson, *Museum Movies: The Museum of Modern Art and the Birth of Art Cinema* (Berkeley: University of California Press, 2005), and Karan Sheldon, "A Place for Moving Images: Thirty Years of Northeast Historic Film," in this volume.
8. http://www.loc.gov/programs/national-film-preservation-board/film-registry/complete-national-film-registry-listing/, accessed July 6, 2015.

9. *Treasures from American Film Archives: 50 Preserved Films* (Chatsworth, CA: Image Entertainment, 2005). 4 DVDs.

10. An example of such critical reflection was a screening and discussion held at Northeast Historic Film in 2012 called Poets of Their Own Acts: Personal Film, 1916–1960. See https://www.academia.edu/10506605/Northeast_Historic_Film_hosts_discussion_of_home_movies_and_amateur_film, accessed March 5, 2015.

11. Geoffrey Batchen, *Each Wild Idea: Writing, Photography, History* (Cambridge, MA: MIT Press, 2002), 57.

12. Ibid., 57–58.

13. Stacey McCarroll Cutshaw and Ross Barrett, *In the Vernacular: Photography of the Everyday* (Boston: Boston University Art Gallery, 2008), 16.

14. Ibid., 16–22.

15. Fred Camper, "Some Notes on the Home Movie," *Journal of Film and Video* 38, no. 3/4 (1986): 9–14.

16. Chuck Kleinhans, "My Aunt Alice's Home Movies," *Journal of Film and Video* 38, no. 3/4 (1986): 25; see also Richard Chalfen's essay from the same issue, "Media Myopia and Genre-Centrism: The Case of Home Movies."

17. Ibid., 27.

18. Patricia Erens, "The Galler Home Movies: A Case Study," *Journal of Film and Video* 38, no. 3/4 (1986): 15–24.

19. *Unseen Cinema: Early American Avant-Garde Film, 1894–1941* (Chatsworth, CA: Image Entertainment, 2005). 7 DVDs.

20. Patricia R. Zimmermann, "Morphing History into Histories: From Amateur Film to the Archive of the Future," in *Mining the Home Movie*, eds. Ishizuka and Zimmermann, 277.

21. This song was made famous by Shirley Temple in the 1934 Hollywood film *Bright Eyes*.

22. Charles Tepperman, *Amateur Cinema: The Rise of North American Moviemaking, 1923–1960* (Berkeley: University California Press, 2014), 170.

23. Philip Sterling, "Sowing the 16mm Field: Hays Office Cultivation May Produce Harvest for the Amateur Experts," *New York Times*, July 25, 1937.

24. Billy Sterling was born in New York on October 8, 1931, and died in San Francisco County, California, on November 16, 1947. *California Death Index, 1940–1997*, http://vitals.rootsweb.ancestry.com/ca/death/search.cgi, accessed August 6, 2015.

25. Anne Fausto-Sterling, e-mail to Karan Sheldon, May 26, 2015.

26. Ibid.

6 "All the Wonderful Possibilities of Motion Pictures": Hiram Percy Maxim and the Aesthetics of Amateur Filmmaking

Charles Tepperman

> We amateur cinematographers see ourselves as a growing band of artisans who have been furnished with a new and wonderful tool with unplumbed possibilities. And yet, we only dimly sense these, as we grope about in the darkness of these early years, but we are deeply impressed by the potential possibilities of this new thing which can see, record and repeat what no words can, no matter how exquisitely chosen, what no printed page can, no matter how perfectly prepared, what no painting can, no matter how inspired and what no sculpture can, no matter how artistically executed. Can we be blamed for being thrilled over working out the destiny of amateur cinematography!
>
> —Hiram Percy Maxim, "The Sixth Year," *Movie Makers*, December 1931

DURING THE 1920s and 1930s, movie making proliferated far beyond Hollywood's production studios and movie theaters as amateurs took up 16mm and 8mm equipment to make their own movies. In 1926, shortly after the introduction of 16mm film in 1923, a group of ambitious amateurs banded together to form the Amateur Cinema League (ACL). This group was the brainchild of Hiram Percy Maxim, an inventor and avid radio and film amateur. At the heart of this effort was a set of utopian ideals that saw amateur cinema as a new art form and a new mode of communication that could connect people around the world, providing them with opportunities for self-expression not permitted by the commercial film industry. Over the course of the next decade, Hiram Percy Maxim spearheaded the ACL's investigation of the amateur medium's possibilities by articulating—in both his writing and film practice—the issues of film technique, form, and presentation that would set amateur film apart from commercial cinema, on the one hand, and mere home movies, on the other.

As Maxim's remarks above attest, this period involved "working out the destiny of amateur cinematography," and much of this was done in written form.[1] The Amateur Cinema League published a monthly magazine, *Amateur Movie Makers* (simply *Movie Makers* after 1928), that was rich in instructional content and encouragement. As the founder and first president of the ACL, Maxim was a regular contributor to the publication and played a significant role in shaping its mission. Maxim's writings (under his own name, and his pseudonym "Dr. Kinema") treated a range of issues in amateur cinema, from its broad artistic significance, to pragmatic approaches to solving technical issues in filmmaking. While advice for amateurs concerning film style and technique has often been understood as efforts to make their films conform to commercial cinema's rules and conventions, Maxim's articles demonstrate that there were other aesthetic options available to amateurs.[2] While a primary goal was simply to elevate the technical quality of amateur works above the rough, "snapshot" aesthetic of home movies, Maxim's advice encourages development of new methods for shaping narrative, nonfiction, and poetic materials. In some ways indebted to commercial film conventions, these approaches were pragmatic in their development and influenced by modernist aesthetics as well.

Advanced amateurs were also exploring the "destiny" of amateur cinema through their filmmaking. Maxim often reflected on his own films, and films by other amateurs, as a way of articulating the potential of the amateur field. He advocated for the improved and expanded circulation of amateur movies so that others could learn from exciting new works as well. Starting in 1930, *Movie Makers* held an annual competition for the "Ten Best" amateur movies of the year to reward such efforts. As the Ten Best competitions grew rapidly in scope and prestige, drawing film submissions from around the world, the ACL established a library of award-winning films that they circulated to amateur movie clubs around North America.[3] This library supported a growing culture of noncommercial film exhibition that sought out a space for film consumption between the domestic sphere of home movies and the commercial domain of Hollywood cinema. As president of the ACL, Maxim was excluded from the *Movie Makers* competitions, but his own films won prizes elsewhere and were circulated as part of the ACL library. Focusing on Hiram Percy Maxim's own writings and films, this essay traces a leading amateur's articulation of the terrain of artistic filmmaking. Maxim's writings and films demonstrate that the pathways for amateur cinema's aesthetic development didn't always lead to or from Hollywood.

A Practical Vision for Amateur Cinema

Maxim's biography helps frame his activities and preoccupations in amateur cinema. The son of one famous inventor (Hiram Stevens Maxim, who invented

the machine gun) and nephew of another (Hudson Maxim, who invented the explosive "Maximite"), Hiram Percy later recalled his unconventional childhood in a memoir about his eccentric father called *A Genius in the Family* (1936).[4] The memoir tells of Maxim Junior's childhood adventures at home in Brooklyn and on summer holidays at his grandparents' house in Wayne, Maine. These stories are characterized by Maxim Senior's experimental spirit and penchant for practical joking.[5] During this time, Maxim Senior worked as a successful inventor and engineer of gas, steam, and electrical machinery in New York, but he soon moved to Europe, where he experimented with flying machines and machine guns. He eventually settled in Britain, but the rest of his family, including twelve-year-old Hiram Percy, stayed behind in the United States.

Maxim Junior demonstrated a similar fascination with invention and pursued a career in experimental engineering, graduating from MIT in 1886 at the age of sixteen.[6] Maxim settled in Hartford, Connecticut, where he was a pioneer inventor of gasoline engines and automobiles at the end of the nineteenth century, and later invented gun silencers, industrial silencers, and air conditioners—all counterpoints to the industrial age's tendency to make everyday life louder and hotter. Balancing his eminently practical side, Maxim was also characterized as a bright-eyed dreamer of sorts. He nurtured his creative side through amateur theatricals and writing clubs. A regular theatergoer through the 1920s, Maxim published frequent newspaper columns, memoirs, and even a book about astronomy that speculated on the possibility of extraterrestrial life. Though politically independent himself, Maxim's wife, Josephine, was the daughter of a former governor of Maryland; she was active in the women's suffrage movement and a participant in local and state politics. Maxim was also a natural organizer, first exercising this skill on a large scale when he founded the Amateur Radio Relay League (ARRL) in 1914. When Maxim helped found the Amateur Cinema League in 1926, he was already a well-established inventor and organizer.

Throughout his life, Maxim contributed articles on a range of topics (usually relating to technology and modern life) to newspapers and magazines, but he was especially closely tied to the magazines associated with the two amateur organizations he helped found: the Amateur Radio Relay League's *QST* and the Amateur Cinema League's *Movie Makers*. To *QST*, Maxim contributed both regular, signed editorials and pseudonymous articles that offered down-to-earth advice. He played a similar role in *Movie Makers*, where his editorials as president of the ACL provided a broad vision for the amateur film movement, while the articles he signed as Dr. Kinema (whose true identity was revealed only after Maxim's death) addressed the more practical challenges of moviemaking. Overall, Maxim's writings about cinema range from lofty considerations of the amateur's position in the development of film art and matters concerning the development of

a community of amateurs, to technical issues of film exhibition and pragmatic approaches to improving film technique and presentation.

Maxim was presented as a visionary, almost seer-like, figure in the profiles of him that appeared in *Movie Makers*. This was a consequence of his status as founder of the ACL and spokesman of the amateur film "movement," but it also reflected his background as somebody who had a capacity for technological invention and the sensitivity for artistic appreciation and creation.[7] Maxim's earliest writings about amateur cinema announced his linked goals for the Amateur Cinema League: to explore the possibilities of amateur film art and to develop a network of amateur filmmakers and viewers. His broader prognostications for amateur filmmaking also linked these objectives. Even though he saw filmmaking itself as an individual activity (in its filming and editing), he believed that its true significance resided in the social activity of sharing one's films with others. "When we analyze amateur cinematography," Maxim wrote, "we find it a very much broader affair than appears on the surface. Instead of its being a form of light individual amusement, it really is an entirely new method of communication."[8] Among Maxim's loftiest goals for amateur moviemaking was its humanist potential for exchanging personal experience across the globe, in effect becoming a powerful tool of international understanding and peace. Maxim would continue to espouse this idealistic view of amateur cinema in his writings, proposing an antidote to the harsh realities of political and economic struggle that emerged in the 1930s.[9]

The success of Maxim's idealistic vision for amateur cinema, however, relied upon the amateurs developing technical and stylistic proficiency in their filmmaking. Maxim's writings as Dr. Kinema were practically oriented toward these goals and less philosophical in their orientation than his editorials. In the first years of *Amateur Movie Makers*, Dr. Kinema was responsible for the magazine's technical column, "The Clinic," which solicited questions from readers and aggregated filming advice from a variety of different sources. For example, the January 1927 column commented on the value of close-ups (you can't have too many in your films) and the need for a cross-fading device for amateur filmers, while also encouraging amateurs to use titles in their films.[10] Later columns treated common amateur problems and in this way provided an ongoing technical commentary for amateurs seeking to improve their filming and editing.[11] Dr. Kinema also authored longer articles about specific technical or creative issues. For example, "The Perils of Panoraming" is a good example of Maxim's funny but blunt condemnation of common faults among amateurs. He presented familiar advice against panning the camera too much when filming: "My friend is a dear fellow, but he nearly killed me with a plague of panoramas . . . He developed the characteristics of a fireman. He used his camera on the same basis that a fireman would use a hose. He squirted at everything."[12] Other articles address the need

for basic editing and titling of amateur films. For instance, Dr. Kinema points out the ease of making simple titles in amateur films or of purchasing them from advertised title makers. Dr. Kinema takes the mystery out of this task by describing how he goes about writing the titles for his own films and notes wryly, "The improvement that titles make in a film is beyond words."[13] Dr. Kinema's articles had a down-to-earth, self-deprecating quality, which made helpful advice approachable, not intimidating.

Dr. Kinema also pleaded with amateurs to edit their films ruthlessly and present only the most compelling images to their audience. Beyond providing purely technical advice, Dr. Kinema probes more deeply, asking: "What is it that constitutes an interesting film? Is it marvelous photography? Is it composition? Is it absorbing plot? Is it the dramatic? Is it the unexpected? Is it the artistic? I analyzed each of these in terms of my own family and friends. . . . It was not any single one of the things mentioned."[14] Rather than considering this in a purely abstract manner, Dr. Kinema responded practically:

> I thus reviewed the ingredients of an interesting amateur film. When I had reached this stage, I decided that there was no use theorizing any longer. The thing to do was to try an experiment and find out what the actual results would be. This required taking radical steps . . . Yonder stand over forty humidor cans . . . In every one of those humidor cans lie buried any number of permanently interesting bits . . . So, I thought, why not take out those interesting bits and build a reel out of them, and call it a News Reel?[15]

Dr. Kinema reports that after producing such a reel, it proved to be his most popular film with audiences.[16] His commentary is striking, however, because his answers to amateur problems did not lie in applying editing or scenario solutions from commercial cinema; rather, he moved from observation to practical experimentation and arrived at a distinctly amateur approach to producing a film that was still polished and interesting.

Issues of film exhibition and presentation presented another frequent theme of Dr. Kinema's articles, as he encouraged amateurs to gather in larger groups but also provided tips for moving from domestic parlor screenings to more quasi-public movie club presentations.[17] In an article on this topic, Dr. Kinema writes, "I have made up my mind that projecting is lagging behind exposing. In several instances lately I have seen perfectly good pictures ruined by deficient projecting. The trouble is a poor lens, with the blurry focus that a poor lens always gives, insufficient light, a bad screen, and trying to get too large a picture on the screen."[18] Here, it was not the skill of the amateur that was deficient so much as the home projection technology that had not yet been adapted for larger audiences. Also, amateurs were provided with advice about the kinds of films that could be expected to appeal to such audiences (i.e., those made up of both friends and nonfriends) and

how best to organize the material for a public audience.[19] At issue here were the changes needed to shift nonprofessional filmmaking from a primarily domestic and private activity (in the form of "home movies") to a more collective and public one. This involved developing skills related to both the selection and organization through editing and narration of film material and its exhibition. Supporting the ACL's goal of circulating motion pictures among amateurs, *Amateur Movie Makers* established a column called "Swaps," which permitted amateurs to list films they were willing to share with others. Maxim's films appear among the first of these.[20] Through his practical articles and actions, Maxim advanced specific goals of improving film organization, presentation, and technique, thereby reinforcing his broader objectives of artistic development and communication for the ACL.

The ACL also encouraged amateurs to organize and participate in movie contests. Maxim felt that these stimulated the development of amateur film technique and also further enhanced the public interest in amateur movies. In 1928, he argued that there was an emerging preference among a "discerning public" for advanced amateur films over professional ones.[21] Here again, we find him looking elsewhere than Hollywood for a guide to the development of an amateur film aesthetic. In 1930, Maxim argued that there was something distinctive about the amateur film that was emerging, as amateurs discovered their own brand of "showmanship" quite apart from commercial cinema: "I believe that we amateurs are going to evolve a type of film that will be utterly above the frivolous. It will not be pure entertainment. It will not be dry as dust informative. It will be intensely pleasurable to view, will contain worth while [sic] information and will be really uplifting and, as such, very much worth while [sic]."[22] For Maxim, the key lay in finding the worthwhile, thoughtful images in mundane, everyday material.[23] Ever the pragmatist, Maxim saw competitions as an opportunity for amateurs to improve their efforts and compare their results. He observed as much in his columns as Dr. Kinema. One of these from 1931 reported on a competition between New York, New Jersey, and Connecticut amateurs in which his own film had placed second. What struck him as most significant about the contest was the opportunity it provided for amateurs to discuss the films and the results and refine their sense of amateur film art. He writes, "The one topic of conversation among these amateurs today is whether a motion picture *must* have motion first, last and always or whether continuity of sequences is more important . . . I heard one group wrangle over whether *Sunsets*, the film that got third prize, was or was not cinematic." To Dr. Kinema, these award-winning films represented the best of what advanced moviemaking was achieving: nondramatic works with accomplished technique, good photography, and strong continuity. He discusses each of the three prize-winning films in turn, noting that the first-place film, *Poetry of Nature*, "probably won because it had more striking scenes in it than any other, because those scenes were so arranged that things got better and better and more

and more interesting as the film went on and built up the thought in every one's [*sic*] mind that there would be a regular knockout at the end, which there was." Dr. Kinema finds that the second film, his own (unacknowledged) *The Sea*, was strong in many similar ways, but "the idea did not have quite the heft in it that *Poetry of Nature* had, nor was it quite as specific."[24] Dr. Kinema provides a frank assessment of amateur practice and results as he explores the characteristics of amateur film expression while it is developing and uses the film competition as a moment for reflecting on these possibilities. Of course, it was also an opportunity for Maxim to reflect on his own filmmaking practice.

Maxim the Filmmaker

Maxim's forays into film production actually predated the arrival of 16mm film and the founding of the Amateur Cinema League by several years. His infatuation with the movies dated back to the nickelodeon era (1905–1913). During the 1910s, Maxim was a member of a small "writing club" where he produced a number of short works and screenplays, allegedly on the wager that "anyone could do it."[25] His efforts were rewarded when one of his screenplays was produced by Fox as *A Virgin Paradise* in 1921, starring Pearl White. According to Maxim, the film "started out to be an example of the tremendous amount one must learn in order to keep one's place in modern civilization. A young woman of the best ancestry grows up in savagery and has to learn *everything*."[26] The film presents a conflict between the natural world and civilization—one of Maxim's recurring preoccupations. Another of Maxim's screenplays, which was not produced, explored the inverse of this scenario: a society woman having to learn the practical dimension of everyday survival when social order breaks down.[27] Maxim would often return to this juxtaposition of natural forces and civilization. As an engineer, he was clearly a proponent of technology, but his position was not without ambivalence as he also pointed out the costs of modernization (including the affective and physiological costs as suggested by his fascination with sound suppression). During a trip to California in the early 1920s, Maxim visited Hollywood to see how professional films were made. These forays into the professional filmmaking world may have set Maxim apart from more typical amateurs (there were clearly lots of other ways he was set apart from them, too), but he doesn't seem to have aspired to produce additional commercial films, instead turning with enthusiasm to amateur movie making once the equipment and 16mm format were available.

Filmmaking by serious amateurs, such as those who were active members of the ACL, generally falls into four modes of production: chronicle films (records of family and travel), practical films (made for business or educational purposes), photoplays (short fictional works), and experimental films (that explored new aesthetic possibilities of the medium).[28] While few amateurs worked in all of

these modes, Maxim explored each in some form.[29] His work is varied in both content and style and allows us to understand the variety of self-conscious modes of film production in which amateurs engaged. His films also provide a rich set of texts for considering the aesthetic dimensions of amateur filmmaking, which diverged from commercial film style and was premised instead on clarity of subject and richness of theme. Maxim's sophistication as a filmmaker grew over the years; although they are unpolished in many places, Maxim's reels are almost all edited and titled in some form. In 1931, Maxim wrote (as Dr. Kinema) an article that sketched the trajectory of his own work as a filmmaker, suggesting what he believed to be the natural evolution for most curious filmmakers.[30] Beginning with chronicle films (shots of family and friends, miscellaneous shots of interesting sights, and travel films), Maxim then advanced to the photoplay and eventually experimented with both trick photography and poetic forms of filmmaking that used editing to evoke complex moods and metaphors. Although Maxim didn't make films that were specifically for business or educational use, many of his chronicle films touched on aspects of his working life (especially transportation technology) and were thus examples of the practical mode as well.

The majority of reels in Maxim's collection could be categorized as chronicle films, but within this larger mode Maxim distinguished several subcategories of his activity. His first phase of filmmaking, Maxim wrote, reflected a fascination with taking films of himself and friends.[31] The earliest of these, produced in 1924, introduces the filmmaker's family, friends, and maid in front of the family house and car. Like many amateur films, Maxim's begin by delineating the domestic space and group, but he does so in a relatively polished and self-aware way. The film begins with title cards that establish the function of the reel—"Josephine and I present OURSELVES and OUR FRIENDS"—and specify its date, location, and the names of people shown. The Maxim family is shown in long shot as a group, and then approaching the camera in pairs before returning to the group. The action is clearly choreographed, with the family members laughing as they read from a page, and Josephine ("Mother") directs the action on screen. An intertitle remarks, "I show them how," and Maxim himself appears with the group; he takes Josephine by the arm, and the pair walks closer to pose for the camera. The reel includes several similarly self-conscious and humorous gestures, which simultaneously illustrate the carefully choreographed organization of the film and also the good-natured (even self-mocking) attitude toward its production.

Subsequent family films include records of family trips and intimate portraits with loved ones (in medium shot). Maxim's family films include special events like his daughter Percy's wedding in 1926. Shot in the Maxim backyard, this footage is rough compared to Maxim's usual work, including amateur faux pas like canted angles and rapid panning. At the end of the reel is appended a short (tongue in cheek) scene of the Maxims enthusiastically packing their daughter's

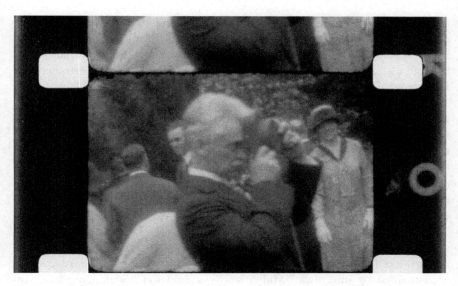

Fig. 6.1 Hiram Percy Maxim at his daughter Percy's wedding in 1926. From 16mm film. Hiram Percy Maxim Collection, Northeast Historic Film. [Accession 1521, Reel 11]

belongings for shipment, and Hiram Percy is shown sawing wooden slats to crate the stuff up! While mostly a rough record (with titles added), the reel is given additional narrative structure through the inclusion of this concluding scene. Maxim chronicled the redevelopment of "Bill Hill," an old farmhouse that his family purchased as a country home in 1924. This reel collects footage from when the farm was first purchased, and then follows with images of its improvements. "This is the way it looked when we bought it. Note how it changed as the months passed," an intertitle notes. In this way, the reel demonstrates the film's status as an edited work, not only because of the intertitles, but because it compiles footage taken at different moments into a chronological process of restoration. Perhaps Maxim's most literal chronicle was his series titled "Log of the Sea Gull," which recorded trips on his motorboat. In several reels, taken across a number of years, these films record Maxim's movements on the boat with his family.

Beyond his family chronicles, Maxim photographed his local surroundings. He wrote in 1931, "As we all know, there came a day when it became deadly boring to look at pictures of ourself, our family, and our friends. A higher intellectual plane was yearned for. Then was born the great class of miscellaneous shots. Tennis, yachting, golf, dogs, horses, fires, fishing, accidents, floods, storms—everything just out of the ordinary was filmed. . . . Thousands of miscellaneous scenes came into being . . . I took mine and cataloged them and built several volumes of *Here and There*."[32] Much like the "News Reel" he had previously attempted, Reel 19 of

Maxim's collection was one of his *Here and There* volumes, which compiled a pot-pourri of interesting views including the Hartford airfield, Bremen transatlantic flyers expected at Brainard Field, and "a queer view of Connecticut capital" seen through his parlor window in the distance at the same scale as the telephone in foreground.

"Then came a day," Maxim wrote, "when this sort of miscellaneous stuff became banal. Something more hefty was wanted . . . Then was born the travel film."[33] Maxim described travel films—another subcategory of the chronicle mode—as a major occupation of amateurs, and transportation is a primary theme of Maxim's own films. His collection records various car trips, including one from Connecticut to Maryland (via Princeton and Delaware) that observes technological details of the roads (making it a practical film as well), ferries, and different kinds of cars. Maxim's travel filmmaking culminated in his *European Trip* (1925), which includes three edited and titled reels. The film contains shots of the ship the family travelled on (the *Mauretania*), capturing both significant actions, like the ship's departure from New York harbor, and expressive shots accompanied by intertitles: "Mid-Atlantic—a cold wet and lonely place." In France and England, footage includes significant attractions, friends and business associates, and again, expressive or representative shots, such as "Paris street scenes taken through Lobby windows" and "Paris Traffic." In some of these street scenes, Maxim is seen walking and posing on the street alongside traffic. Maxim believed travelogue films to be reflections of the maker's best characteristics. In one article, Dr. Kinema contrasted the travelogue made by the "nervous man," who doesn't know what to cut out of his films, with one by a more "charming man," whose films focus less on continuity than "just a suggestion of the travel idea, and with a very clearly defined dramatic effect throughout . . . This last man evidently places beauty as his outstanding aim. He sees the beautiful."[34] For Maxim, the ability to produce artistic films is the product of neither an overdeveloped attention to technique and continuity, nor a broader artistic education. Rather, amateur cinema permits one who has a desire to create something beautiful to do so with only basic technical and practical skill.

Running parallel to the development of the chronicle film, Maxim wrote in 1931, "has been the amateur photoplay, built on the same foundation as professional pictures."[35] It appears that Maxim produced only a single photoplay, *Mag the Hag* (1925). This collaboration with Maxim's nineteen-year-old daughter, Percy, and two of her school friends presents a send-up of a Hollywood melodrama: an aristocratic boy (played by Percy) can make a good match with his simple country girl sweetheart only after she has been transformed into a stylish flapper by a magical talisman (provided by the titular character). The film uses rudimentary staging and intertitles to convey the story. The most dramatic moments of the film, however, rely on trick editing whereby the talisman appears

Fig. 6.2 *Mag the Hag*, 1925. The talisman appears to transform objects and eventually people before our eyes. From 16mm film. Hiram Percy Maxim Collection, Northeast Historic Film. [Accession 1521, Reel 7]

to transform objects and eventually people before our eyes. The film has some charming and surprising elements, but the action drags, and it was perhaps this quality that caused Maxim to respond so critically to it himself: although he noted that good amateur photoplays had been produced, many "including our own were perfectly terrible." For Maxim, the photoplay's requirements hewed to Hollywood filmmaking more closely than any other mode of amateur work. And he notes, "Longer amateur photoplays required actors and a production staff that could only be managed by a club or a group similar in essentials to a club. . . . And so, while the production of longer photoplays still commands the attention of some of us, the majority of amateurs cast about for some other channel."[36] Maxim was ultimately less interested in amateur forms that mimicked commercial cinema than those that charted a distinct course.[37]

To discover this course, Maxim and many other amateurs experimented with new visual effects and structures for the cinema, and in this they saw themselves as helping to develop new trajectories of film language. First this was seen in terms of tricks that the camera could achieve: "In casting about for some other outlet," Maxim wrote, "many of us took up trick pictures. Perfectly extraordinary magic was displayed; utterly impossible actions were shown: strings of beads and neck furs became animated in serpent like manner; titles arranged and wrote themselves right there before your eyes."[38] Maxim's own trick films experimented

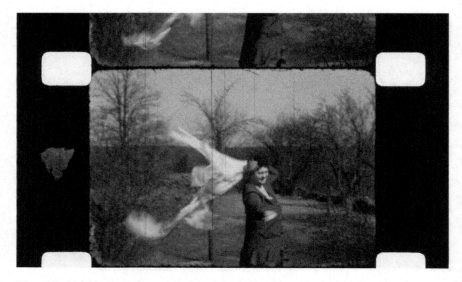

Fig. 6.3 One of the most effective of Maxim's trick films shows Josephine and then Percy Maxim performing a scarf dance in reverse, 1930. From 16mm film. Hiram Percy Maxim Collection, Northeast Historic Film. [Accession 1597, Reel 75]

with reverse action and strange dance-like motions produced by simple trick photography. In one trick film of Hartford, Connecticut, the title announces that it is "certainly not to be classed among the backward cities . . . and yet," only to reveal a street shot of people and cars moving backward. The reverse motion continues, showing us busy crowds, sidewalks, and a mechanical shovel in reverse motion: a worker unshoveling sand, the mechanical shovel undigging, and so on. This sequence concludes with a short sketch of girls taking a fur stole from a car; shown in reverse, it seems to wrap itself around their necks. One of the most effective of Maxim's trick films shows Josephine and her daughter Percy performing a scarf dance in reverse. Dr. Kinema discussed this film when contemplating the viability of more "unnatural" effects, experiments, and trick shots in a movie contest:

> Is there not a form of the unnatural that is beautiful, interesting and which cannot possibly be shown by anything but cinematography? I have in mind a certain scarf dance which I made myself. In a light breeze the lady gracefully sweeps the scarf about her in the manner affected by scarf dancers. I took the scene with the camera upside down. When projected at a little slower speed than the speed at which it was taken, the effect is a scarf dance that is stunning. However, beautiful as it really is, it is unnatural for no earthly scarf could do the things that this scarf does. I fully expect to try this sort of stuff on the judges next season and let them decide whether or not the beautiful but unnatural will also rate a prize.[39]

It isn't known if Maxim won any prizes for this film, but in this kind of trick reel the amateur explores a new kind of cinematic beauty that Maxim felt was an important discovery. "Like the travel film," Maxim writes, "this class of film has persisted . . . They seem to possess something that promises to be permanent."[40]

Connecting trick photography to more advanced artistic experimentation was the idea of "the cinematic," or filmmaking that explored the unique characteristics of the motion picture medium. Nonfiction films that organized photographically superior shots in a poetic way to develop an idea or theme (such as "the sea" or "winter") provided a new avenue for experimentation in film expression. Maxim wrote, "The next phase became sort of a complex of the best that had gone before. We started making films that were nondramatic but which possessed something in the way of narrative. The tendency seemed to be toward a poetic form of narrative. It was here that continuity of idea throughout the film began to be recognized as imperative. The appearance of a poetic atmosphere was also highly desired. These new departures took all manner of form."[41] Maxim produced a handful of films—those of which he was most proud—in this poetic form. In particular, Dr. Kinema discusses "a film entitled *Summer*," which is probably Maxim's own *Summer in Connecticut*: "This showed summer emerging from a moist spring, the warm and soft weeks of midsummer with their grassy meadows and flowers, ending with the fading away of summer into the cold and somber autumn." Dr. Kinema remarks on another of his own films: "One person selected the Sea as his theme, presenting its moods and mysteries in a poetic sort of way." *The Sea* was Maxim's most lauded poetic film, winning third prize in the nondramatic category of *Photoplay*'s 1929 Amateur Movie Contest.[42] It also placed second in the tri-state contest Dr. Kinema discussed earlier. His own assessment of the film emphasizes its thematic organization:

> This [film] had an idea, but it was not as definite as that of *Poetry of Nature*. It could be seen that the maker of this film sat himself down and got together all his best marine shots, catalogued them, built up an idea around them and then strung together those that best fitted the purpose. He made an interesting film of it all right and it was just a hair more of a parade of pretty shots than the other. He paraded a lot of beautiful views of the sea and showed how stately a thing is a ship sailing through the water and how moody and menacing and mysterious is the sea always, but how you love it just the same. And you agreed with him.[43]

This kind of film compiled thematically linked images in order to generate a poetic montage of a specific theme or subject. In doing so, Maxim aligned amateur work more closely with emerging avant-garde films than with Hollywood's scenario-driven films.

Fig. 6.4 *The Sea* was Maxim's most lauded poetic film, winning third prize in the nondramatic category of the *Photoplay* 1929 Amateur Movie Contest. Hiram Percy Maxim Collection, Northeast Historic Film. [Accession 1521, Reel 9]

Indeed, Maxim viewed the avant-garde "city symphony" film as closely related to these poetic works. City symphony films organized images of a specific urban locale in expressive and metaphorical terms through editing. Originating in the films of Charles Sheeler (*Manhatta*, 1921), Robert Flaherty (*Twenty-Four Dollar Island*, 1927), and Walter Ruttman (*Berlin: Symphony of a Great City*, 1927), the model of the city symphony was taken up by amateurs in the 1930s.[44] Evidently editing took a more prominent and pragmatic role in these amateur films than the planning of a scenario. In an article about his desire to make a film about New England, Dr. Kinema wrote about his failed attempt to follow a complex continuity script and execute a film as planned, instead opting to take the best shots he could and organize them thematically afterward. After shelving his complex script, Dr. Kinema explained: "I shot the best scenes that I could find and put my trust in a kind of providence when it came to consideration of how I was to tie them together. . . . I worked out sequences of three or four shots of the same subject so that the audience would understand why I felt that particular subject worth filming at all and so that they could see its beauty as I saw it."[45] This produced a hodgepodge of footage, but after examining it closely, Dr. Kinema was able to discern a thematic link between the images, which became the abovementioned *Summer in Connecticut*: "I wrote these titles with the sole view of helping to tie the picture together and emphasize the

Fig. 6.5 *Winter in Connecticut*, circa 1928. This film presents a mix of poetic and personal material: some impersonal nature views and poetic intertitles, but also shots of people and their winter activities. From 16mm film. Hiram Percy Maxim Collection, Northeast Historic Film. [Accession 1521, Reel 8]

theme. At the end, in order to make an excuse for some sunset shots of which I was particularly proud, I used a title about the early twilight of cool October bringing the summer's end."[46] Here we find a clear demonstration of pragmatic approaches overruling a theory of careful planning and scripting. "Other than first making a more ambitious plan than was practical," Dr. Kinema writes, "I had tried to write too literal directions for my picture making and these were useless in a summer's filming, for I could not foresee the exact shots that I might be able to get or those I would accidentally miss. Hence I finally followed a general idea, doing the best I could to make each sequence beautiful and entertaining."[47] The outcome of this film is more loosely thematic than originally planned but also more in keeping with the realities of amateur filming, which typically dictate opportunistic filming over the preplanned and staged filming of commercial cinema.

In a similar vein, Maxim's winter film, *Winter in Connecticut*, presented a mix of poetic and personal material: the film includes some impersonal nature views with poetic intertitles but also shots of Maxim's family and their winter activities. Maxim felt that poetic experiments with cinema were some of the most advanced developments of amateur filmmaking. He wrote, "This movement has produced by far the most interesting and worth while [*sic*] films that the amateur

as a class has made to date."⁴⁸ With respect to future directions, Maxim felt that this poetic form would continue to evolve, perhaps resulting in fable-like semi-narratives. Maxim closed his reflection on the evolution of amateur filmmaking by pointing toward the accomplishments and future possibilities of the amateur moviemaker:

> To close this screed, our tendency in amateur moving pictures is distinctly evident, now that we are able to gaze back over several years and to note the different phases we have passed through. This tendency is toward something that is different from anything that ever has been done before. It is literary in character and it is artistic in the sense that pictures enter into it. It is not yet sufficiently well defined to enable one to accurately describe it but it is very real and it is reasonable to assume that, in a few more years, it will be clearly disclosed. Is it insanity or hyperoptimism to believe that some day amateur cinematography will hold a high place in modern art?⁴⁹

Maxim's remarks map a novel aesthetic terrain for amateur cinema. Amateurs were part of an artistic vanguard to the extent that they diverged from commercial cinema's production practices and narrative forms and instead explored the new creative possibilities of cinema. While Maxim's version of "modern art" may not have corresponded to the more abstract terrain of modernist painting, it nevertheless articulated a kind of "pure cinema" that explored light, movement, and theme rather than story and love interest.⁵⁰ As one profile of Maxim suggested, "He likes to depict nature and thinks it well for the amateur photographer to pick some similar field and devote himself to it, rather than to encroach on the well-developed field of the better-prepared professional producer."⁵¹

Although it was distinct from commercial cinema, Maxim didn't view abstract modernism (for example an "ultra-modern amateur film screened before an ultra smart group"⁵²) as the authentic alternative to Hollywood's professional filmmaking. These ultramodern films seem "morbid and "unwholesome" and not "worthy of the tools we have at our disposal," Dr. Kinema writes. "The super-terrible and the weird and the unnatural are interesting. There is no gainsaying it . . . But the interest seems to me to be the wrong kind of interest."⁵³ Here, Maxim might have been alluding to the recent success of films such as James Sibley Watson and Melville Webber's *The Fall of the House of Usher* (1928), which circulated in amateur circles during the months before he wrote this.⁵⁴ While Watson and Webber's film presented a cubist-inspired and darkly fragmented vision of Edgar Allen Poe's story, Dr. Kinema proposed a different direction for amateurs. "There is another kind of interest," he wrote, "one which carries with it approval, sympathy and respect. That's the kind of interest we amateurs ought to find a way to create." Here, Dr. Kinema voices a preference for a more realist approach that found interest in one's surroundings:

There are intensely interesting things going on all about us. Animal close ups are absorbingly interesting. Children are interesting when you get them young enough. Nature, awakening in the Spring and going to sleep in the Winter can be made marvelously beautiful and of great interest. The good old ocean is a dandy actor, with all his moods and tempers. Strong wind creates dramatic situations that are of commanding interest. And all of them are wholesome and natural. It seems to me that they reek with possibilities. So—is it not some masterpiece along this line that we amateurs are really aiming at, if we get down to brass tacks?[55]

Rather than encouraging the kind of radical experimentation associated with filmmakers like Watson and Webber, Maxim instead allied the amateur with a more realist approach. While such an attitude might seem to be at odds with a modernist avant-garde—and there is perhaps even a current of romanticism running through it—the kind of filmmaking Maxim proposed was still modern in important respects. While it eschewed abstraction in favor of realism, it was still organized around principles of fragmentation and montage; in contrast to the narrative-based commercial cinema, Maxim's cinema was poetic and associational in structure.

In discussing his own filmmaking, Maxim expressed a desire to sweep aside complex technique and artistic posturing in favor of a pragmatic approach to filmmaking that developed a compelling idea in visual terms. By 1930, he was articulating the specific character of amateur film art as a new kind of beauty of the everyday: "These films are bringing into our homes ideas of interest and beauty that have never before entered. They are disclosing interest and beauty inherent in things that we did not think possessed them . . . I have seen an amateur film of a locomotive that revealed a dynamic beauty that I did not know existed. A film of some kittens playing unfolded a form of beauty and comedy that the world has overlooked. Several scenic films made by amateurs are powerfully dramatic. Certain amateur studies in motion have opened up undreamed beauty."[56] While realist, rather than abstract, in its orientation, this character is still modern in its nonnarrative character and its reliance on the technology of motion pictures to reveal such "undreamed beauty."[57] It was precisely the tension between modernity and the natural world that captivated Maxim. The themes that interested Maxim the most were those that framed the relationship between nature and technology: "I am most interested in working out pictures that depict the drama of natural things: the stupendous power of nature and the struggle of intelligence to successfully battle against it; the sea—and the struggles of physically weak but mentally powerful man in overcoming its fury; Winter with its death-dealing cold and mysterious silence, deep snows and invigorating hardships. I really like to depict the struggle of man and beast against nature."[58] Similarly, it was the amateur's task to develop a new filmic vocabulary that diverged

from both the commercial and "ultra-modern," but used a modern technology of cinema to explore age-old dramas and themes.

* * *

Hiram Percy Maxim died suddenly during a long rail journey in 1936. His death was greeted with shock and dismay by the writers in *Movie Makers*, who noted his great contribution to amateur film as an organizer, a thinker, and a filmmaker. The ACL's managing director noted, "Above all else, Hiram Percy Maxim was world minded. His sympathies were never narrowly national and it was his persistent ideal that the two human activities he served so devotedly—amateur movies and amateur radio—should provide a practical method, for he was always practically inspired, to unite men of good will into a richer fellowship without regard to where they might abide."[59] Arthur Gale, on the other hand, noted Maxim's own accomplishments as a filmmaker: "His film, *The Sea*, was one of the first carefully planned artistic efforts to be produced on 16mm film purely for personal satisfaction . . . Early he determined that motion and cinematic qualities were the paramount considerations in his chosen medium of self-expression and he was one of the earliest amateurs to base his scenic filming on the art of the cinema rather than on still photography."[60] Moreover, Gale pointed out that Maxim believed amateurs could accomplish something that was distinct from professional filmmakers. In his obituary of Maxim, Gale wrote, "Our Amateur Cinema League, by systematically organizing cinematography, can hasten the day when all the wonderful possibilities of the motion picture can be made available to mankind. The professional screen can never do it. Its workers have that awful spectre, the Box Office, chained around their necks. We amateurs do not have to consider the box office. We are free to do anything—everything that brains, money and enthusiasm can produce—and these three things can turn the world upside down."[61]

In Maxim's activities we find several distinct but overlapping preoccupations, including explorations with new technologies and the counterpoint to technological modernity in silence and poetry; he also championed the individual filmmaker while demonstrating a strong commitment to community. His writing and films reflected an effort to chart a new course of amateur cinema, one that was both practical and poetic and as fascinated with nature as it was enabled by modern technology.

Technical Notes: Hiram Percy Maxim, *The Sea* (circa 1929) and *Scarf Dance* (1930)

Many amateur filmmakers experimented with trick photography. Just like the trick films of early French filmmaker George Méliès, the amateur often learned

(sometimes by accident) that manipulating certain aspects of the filmmaking process could result in pleasurable deceptions for the audience. For instance, a character could be made to disappear simply by stopping a shot, removing the subject, and starting to film again. Hiram Percy Maxim was not immune to this type of playfulness, as evidenced in his *Scarf Dance* film from 1930. *Scarf Dance* is a fascinating use of a simple trick: shooting in reverse, which made the action become slightly unnatural looking. Maxim achieved this reverse effect merely by filming with the camera upside down so that the film passed by the lens from end to start. Because Maxim's Bell & Howell Filmo camera propelled the film vertically, he could reverse the movement only by flipping the camera upside down, thereby exposing the film from bottom to top or in reverse.

By the time Hiram Percy Maxim made his award-winning film *The Sea*, he was knowledgeable about the most recent advancements in amateur cinema technology due to his work with the *Movie Makers* magazine and the Amateur Cinema League. Lenses had become faster, with a number of companies making an f/1.5 lens available for Maxim's camera, a Bell & Howell Filmo, and this is one of the reasons he was able to achieve the sunset shot in *The Sea*. Another technological advance was the use of various colored filters that when coupled with the faster lens could help improve contrast in black-and-white film. The most common was a yellow filter, which increased the contrast between clouds and sky by neutralizing the blue component of sunlight. Similarly, red increases contrast even further, rendering the sky black, and neutral (or gray) filters could be used to avoid overexposure.

The Sea, circa 1929. Hiram Percy Maxim.
Hiram Percy Maxim Collection, Accession 1521, Reel 9.
Gauge: 16mm. Stock: Kodak Safety Positive (B&W print) for "Member Amateur Cinema League, Inc." leader and "The End" leader; Kodak Safety Film (B&W reversal) for live action; Gevaert Belgium Safety Film (B&W print) for intertitles.
Overall reel length: 250 ft. Splices: fifty-nine, mostly original diagonal, some later replacements.
Date codes: 1934 for ACL leader; 1926, 1927, 1928 for live action; 1929 for live action and "The End" leader. No date code for intertitles.
Camera code: Bell & Howell Filmo 70-D (reversal only).
Other info: Date codes mixed throughout. "Bass Rocks" and "Gloucester Harbor" from original can information list in collection folder.

Scarf Dance, 1930. Hiram Percy Maxim.
Hiram Percy Maxim Collection, Accession 1597, Reel 75.
Gauge: 16mm. Stock: Kodak Safety Film (B&W reversal).

Length: 40 feet. Splices: zero within *Scarf Dance* section. Many in overall reel.
Overall reel length: 400 ft.
Date code: 1930.
Camera code: Bell & Howell Filmo 70-D.
Other info: Part of a large compilation reel that starts with the title card "Here and There." The compilation reel has a mix of date codes, color and B&W, and camera original/dupe.

Charles Tepperman is Associate Professor in the Department of Communication, Media and Film at the University of Calgary. Tepperman has published articles on early cinema in Canada and on nontheatrical film culture and technology. He is author of *Amateur Cinema: The Rise of North American Moviemaking, 1923–1960*.

Notes

1. Hiram Percy Maxim, "The Sixth Year," *Movie Makers*, Dec. 1931, 655. *Movie Makers* is available through the Media History Digital Library and can be accessed through http://mediahistoryproject.org.
2. See for example Patricia R. Zimmermann, *Reel Families: A Social History of Amateur Film* (Bloomington: Indiana University Press, 1995).
3. For a complete list of the ACL Ten Best winners, see Alan D. Kattelle's "The Amateur Cinema League and Its Films," *Film History* 15, no. 2: 238–251. Only a small percentage of these award-winning films are known to have survived; see Charles Tepperman, *Amateur Cinema: The Rise of North American Moviemaking, 1923–1960* (Berkeley: University of California Press, 2015); the Amateur Movie Database at http://www.amateurcinema.org. The ACL film library was likely dissolved when the organization was folded into the Photographic Society of America in 1954.
4. This book was later adapted into the Hollywood film *So Goes My Love* (1946), with Don Ameche playing Maxim Senior.
5. Hiram Percy Maxim, *A Genius in the Family* (New York: Harper & Brothers, 1936).
6. For general biographical information see Alice Clink Schumacher, *Hiram Percy Maxim* (Greenville, NH: Ham Radio Publishing Group, 1970), 74–75; Dorothy Rowden, "Colored Home Movies by Radio?" *Amateur Movie Makers* (hereafter *AMM*), Dec. 1926, 24; Katherine M. Comstock, "Hiram Percy Maxim—Inventor and Fan; First of a Series of Portraits of Leaders of the Amateur Cinema League," *Movie Makers* (hereafter *MM*), June 1928, 396–7; Roy W. Winton, "Farewell to the Chief," *MM*, March 1936, 105; Arthur Gale, "Hiram Percy Maxim," (Obituary), *MM*, March 1936, 107.
7. Dorothy Rowden, "Colored Home Movies by Radio?" *AMM*, Dec. 1926, 24: "Mr. Maxim also believes that the day is not far distant when amateur movie makers will be exchanging films with the same ease and enjoyment as the amateur radio operator now communicates with his distant friends."
8. Hiram Percy Maxim, "Amateur Cinema League: A Close Up," *AMM*, Dec. 1926, 7.
9. H. P. Maxim, "Here to stay: A Greeting from the President of the ACL," *MM*, Dec. 1932, 535.

10. Dr. Kinema, "The Clinic," *AMM*, Jan. 1927, 11.

11. For example, the June 1927 issue includes a list of "Clinical Cautions" with do's and don'ts of amateur filmmaking; Dr. Kinema, "The Clinic," *AMM*, June 1927, 28.

12. Dr. Kinema, "The Perils of Panoraming," *AMM*, May 1927, 32.

13. Dr. Kinema, "A Plea for Titles," *AMM*, Aug. 1927, 15.

14. Dr. Kinema, "Cutting the High Spots," *MM*, March 1929, 149.

15. Ibid, 150.

16. Dr. Kinema often treated subjects like travel filmmaking in a similar vein, arguing that the key to success there as well was ruthless editing. See Dr. Kinema, "Some Comments on Going Abroad," *MM*, Aug. 1930, 473.

17. Dr. Kinema, "Trouble—A Grand an' Glorious Feelin'," *AMM*, Dec. 1926, 14, 16.

18. Dr. Kinema, "Bettering Projection," *AMM*, June 1927, 12.

19. Dr. Kinema, "Trouble—Don't hang up your film," *AMM*, Jan. 1927, 16.

20. "Swaps: Our Amateur Film Exchange," *AMM*, Dec. 1926, 25. This exchange was later replaced by the ACL's circulating library of films.

21. Hiram Percy Maxim, Editorial, *MM*, Dec. 1929, 783.

22. Dr. Kinema, "Showmanship," *MM*, Oct. 1930, 609.

23. After Maxim's death, his family created an award for the top amateur film of the year that memorialized his contributions to amateur cinema and acknowledged the centrality of competition for amateur filmmaking. "Let the best win," *MM*, May 1937, 211.

24. Dr. Kinema, "Blue Ribbon Films," *MM*, June 1931, 313.

25. Schumacher, *Hiram Percy Maxim*, 74–75. Some of these scripts are preserved in the Maxim Collection, RG 69:12, Connecticut State Archives, Hartford, CT (hereafter CSA).

26. Comstock, "Hiram Percy Maxim—Inventor and Fan," 396. No extant prints of this film have been located by the author.

27. Hiram Percy Maxim, "Law and Order," Maxim Collection, RG 69:12, CSA.

28. These four modes of amateur filmmaking are explored in detail in Charles Tepperman, *Amateur Cinema: The Rise of North American Moviemaking, 1923–1960* (Berkeley: University of California Press, 2015).

29. The collection of Maxim's films held at Northeast Historic Film includes seventy-eight reels of 16mm film. His first films appear to date from 1924, and his final films were made in 1935.

30. Dr. Kinema "Where Are We Bound?" *MM*, Oct. 1931, 530.

31. Ibid.

32. Ibid.

33. Ibid.

34. Dr. Kinema, "Movies as Mirrors," *MM*, July 1927, 16.

35. Dr. Kinema, "Where Are We Bound?"

36. Ibid.

37. As Kristin Thompson points out, there were indeed many traces of avant-garde filmmaking to be found in Hollywood films during the 1920s, and *Movie Makers* followed the films that displayed such qualities with great interest. Nevertheless, amateur discourse repeatedly articulated amateur filmmaking as distinct in key respects: its freedom from a profit motive; its smaller scale of production; and a greater opportunity for formal experimentation. See Kristin Thompson, "The Limits of Experimentation in Hollywood," in *Lovers of Cinema: The First American Film Avant-Garde, 1919–1945*, ed. Jan-Christopher Horak (Madison: University of Wisconsin Press, 1995); and Tepperman, *Amateur Cinema*.

38. Dr. Kinema, "Where Are We Bound?" 560.

39. Dr. Kinema, "Blue Ribbon Films," 333.

40. Dr. Kinema, "Where Are We Bound?" 560.

41. Ibid.

42. "The Amateur Movie Contest Prizes," *Photoplay*, Nov. 1929, 67.

43. Dr. Kinema, "Blue Ribbon Films," 313.

44. Dr. Kinema, "Where Are We Bound?" See also my essay on Leslie Thatcher's amateur city symphony of Toronto, *Another Day* (1934), "Uncovering Canada's Amateur Film Tradition: Leslie Thatcher's Films and Contexts," in *Cinephemera: Archives, Ephemeral Cinema, and New Screen Histories in Canada*, eds. Zoë Druick and Gerda Cammaer (Montreal: McGill-Queen's University Press, 2014): 39–58.

45. Dr. Kinema, "Building Plots to Fit the Shots," *MM*, March 1931, 135.

46. Ibid.

47. Ibid.

48. Dr. Kinema, "Where Are We Bound?" 560.

49. Ibid, 561.

50. In this respect, Maxim's words parallel the calls for an avant-garde of visual, not narrative, cinema made by Germain Dulac at about the same time: Germaine Dulac, "From "Visual and Anti-Visual Films,"" (1928) in *The Avant-Garde Film*, ed. P. Adams Sitney (New York: Anthology Film Archives, 1987).

51. Comstock, "Hiram Percy Maxim—Inventor and Fan," *MM*, 396–7.

52. Dr. Kinema, "Getting Down to Brass Tacks," *MM*, June 1929, 371.

53. Ibid., 421.

54. Several articles about *The Fall of the House of Usher*, including one by J. S. Watson, appeared in *Movie Makers* during this period, and there was interest in the film among amateurs. There was also an ongoing discussion about the appropriate dimensions of an amateur avant-garde during this period. For more about this, see Tepperman, *Amateur Cinema*, especially chapter 7, "'The Amateur Takes Leadership': Amateur Film, Experimentation, and the Aesthetic Vanguard." For more about Watson and Webber, and other amateur experimental filmmakers see Horak, ed., *Lovers of Cinema*.

55. Dr. Kinema, "Getting Down to Brass Tacks," 421.

56. Hiram Percy Maxim, Editorial, *MM*, Dec. 1930, 753.

57. Here, again, Maxim echoes some discussions among French filmmakers and critics over the preceding decade, who sought new ways of describing the cinema's revelatory powers. See *French Film Theory and Criticism, vol. 1: 1907–1929*, ed. Richard Abel (Princeton, NJ: Princeton University Press, 1988), especially Abel's essay "*Photogénie* and Company" and essays by Louis Delluc ("Beauty in Cinema"), Jean Epstein ("Magnification" and "On Certain Characteristics of *Photogénie*"), and Louis Aragon ("On Décor").

58. Comstock, "Hiram Percy Maxim, Inventor and Fan," 396–7.

59. Roy W. Winton, "Farewell to the Chief," *MM*, March 1936, 105.

60. Arthur Gale, "Hiram Percy Maxim," *MM*, March 1936, 107, 132.

61. Ibid.

7 Comedic Counterpoise: Landscape and Laughs in the Films of Sidney N. Shurcliff

Martha J. McNamara

THE SCENES ARE beautifully shot and utterly bucolic: salt marshes extending to the horizon snaked with slow-moving rivers, tree-lined country lanes leading to gracious estates, and wind-swept beaches rising to grass-topped dunes. It's the early 1930s, and the coastal landscape north of Boston outside the town of Ipswich, Massachusetts, couldn't be more quiet, pastoral, and timeless—except, that is, for the incursion of automobiles careening across the landscape, sailing off cliffs, sinking into rivers, and crashing spectacularly into trees, stone walls, and each other. No sound is needed to conjure the squeal of automobile tires, the screech and bang of crumpling metal, the shouts of people dodging out of the way, and the crack of gunshots as kidnappers, jewel thieves, bootleggers, and a "highly efficient, motorized" police force in Model T and Model A Fords, Chevy touring cars, and MG sports cars wreak havoc on the New England landscape.

We also don't need sound to imagine the gales of laughter, wisecracks, in-jokes, and jovial teasing among the "Motormaulers," a group of young men and women who scripted, filmed, acted in, and screened a series of slapstick comedies produced between 1930 and 1937. Leading the group were the self-styled "joyful idiots" Alan Bemis, Edward "Ned" Dane, John H. Marshall, and Sidney Nichols Shurcliff. Friends at Harvard College, they shared a fascination with automobiles and had access to resources that enabled them to produce amateur Keystone Kops–type films to entertain themselves, their families, and their friends. In all, the Motormaulers produced four silent black-and-white movies: *The Rise and Fall of Susan Lennox* (1930), *The Junkman's Holiday* (1932), *Rollo's Revenge or the Last of the Gotrocks*, (1933), and *Why do Oysters Perspire?: A Stark Drama of Stolen Pearls and Savage Revenge* (1937). The films are zany and hilarious. They no doubt provided a kind of comic relief similar to that which heartened Americans of all ages and social classes during the Great Depression and sent them in droves to movie palaces to see Charlie Chaplin, Harold Lloyd, Buster Keaton, and the movies of Mack Sennett's Keystone Film Company. But the Motormaulers' films

don't just depict vehicular high jinks; they also reveal a deep engagement with the New England countryside and, in particular, the salt marsh landscape of the Massachusetts coast.[1]

This incongruous juxtaposition of crashing cars and idyllic settings does not, by and large, derive from the aesthetic of Max Sennett's Keystone Kops films. Sennett's films and other slapstick comedies of the teens and twenties typically depicted buffoonery set in apartments, factories, amusement parks, city streets, and railroad tracks. The Motormaulers films, in contrast, celebrate the natural environment. They include lyrical pans and beautifully framed aerial shots of the Ipswich marshes, scenes shot across meadows and down country roads as well as views of more formally designed landscapes. In short, the films convey a deep, almost reverent, sense of place as much as a wacky comedic sensibility. This love of place and the impulse to give it such prominence is the work of the Motormaulers' "prime mover and inspiration," the landscape architect Sidney Shurcliff, who was the principal cameraman for three out of the four films as well as the series' scriptwriter, director, and editor.[2]

Shurcliff's homage to the New England coastal environment is not a surprise given his lifelong immersion—and that of members of his extended family—in the work of landscape architecture and urban planning. His father, Arthur Asahel Shurcliff, was one of the leading landscape architects of the early twentieth century and, having trained in the offices of Frederick Law Olmsted, a member of the first generation of American practitioners who identified themselves as professionals. A²S (as he called himself) founded his own firm in 1905 shortly after marrying his neighbor on Boston's Beacon Hill, Margaret Homer Nichols. Sidney Nichols Shurcliff, their first child, was born the next year in 1906 and was joined over the course of the next ten years by his five siblings.[3]

Soon after Sidney's arrival, Arthur and Margaret purchased land on Argilla Road in Ipswich, Massachusetts, thirty-five miles north of Boston. Here, in 1908, the Shurcliffs built a modest wood-frame house as the family's summer retreat. A summer community, primarily doctors from Boston, had been steadily growing along Argilla Road since the 1890s. Unlike the more affluent beachheads established in towns such as Beverly Farms and Manchester-by-the-Sea along Boston's "Gold Coast," Argilla Road was a group of well-off but not extraordinarily wealthy families. Ipswich's distance from Boston and the hardships posed by hot and humid summers shared with biting flies ensured that Argilla Road would not be everyone's cup of tea. The result was a tight-knit and extraordinarily social summer community that cheerfully "made do" with somewhat rustic conditions. Sidney Shurcliff, in his history of Argilla Road, noted that his parents' house occupied "a superb location" and "cost only $1,000 to complete," but it was lit only by kerosene and candles and had an intermittent water supply powered by a windmill with a gear mechanism installed by Arthur and

canvas sails sewn by Margaret. For the rest of their lives, the Shurcliffs continually altered the house and its landscape—an incessant, large-scale tinkering that embodied their shared passion for rural self-sufficiency, handcraftsmanship, and the area's natural beauty. In her study of Arthur Shurcliff, landscape historian Elizabeth Hope Cushing quotes younger son William Shurcliff's assessment of his father's goals for the home: "Above all, he tried to create a feeling of comfortable understanding—an enduring and growing fondness—of one's surroundings." For young Sidney and his brothers and sisters spending their childhood summers immersed in the area's dunes, hills, marshes, and beaches, Arthur and Margaret certainly achieved their goal: all had a lifelong attachment to and a deep understanding of the landscape and environment of Argilla Road.[4]

Sidney's Motormauler films clearly demonstrate his powerful affinity for the Ipswich landscape, as does his decision to build a house there on a lot that he purchased in 1932 adjacent to his parents. This love of the land, however, did not automatically translate into a keen interest to follow his father into landscape architecture. After graduating from Harvard College in 1927, Sidney immediately entered Harvard's graduate program in landscape architecture (a course of study that had been established by his father and Frederick Law Olmsted Jr. in 1900), but there is evidence to suggest that he was somewhat ambivalent about the choice and may have enrolled largely at his father's urging. Happily for Sidney, distraction came along in the guise of his Ipswich boyhood friend, Cornelius Crane—the scion of a Chicago family that had made a fortune in plumbing supplies. Between 1910 and 1918, Cornelius's father, Richard Teller Crane, had managed to purchase almost thirty-five hundred acres of land along Argilla Road, including a sweeping, almost four-mile-long white sand beach, acres of dunes, marshes, and farmland. Despite the enormous gap in wealth between the Cranes and their Argilla Road neighbors, the family fit right in with the lively summer community. Beginning in 1913, the Cranes turned to their Ipswich neighbor, Arthur Shurcliff, for ongoing landscape design projects at their expansive estate while Cornelius and Sidney became fast friends with their shared interests in airplanes, sailboats, hunting, and most of all, automobiles.[5]

Sidney Shurcliff loved cars with a passion that was perhaps matched only by his father's loathing of them. Arthur Shurcliff's dislike and even fear of riding in cars was legendary among his family, friends, and colleagues, and it's ironic, of course, that his professional practice largely centered on design work responding to the automobile's growing domination of the American landscape. But, as Elizabeth Hope Cushing points out, this personal antipathy toward cars did not keep him from designing landscapes that presciently, effectively, and thoughtfully accommodated the automobile. Perhaps he brought this same forbearance to his oldest son's preoccupation with the vehicles he so "utterly detested." Carefully preserved (perhaps by Arthur himself), in the Shurcliff family papers is a

Fig. 7.1 Fifteen-year-old Sidney's sketch of multiple automobile mishaps drawn in honor of his parents' wedding anniversary. Sidney N. Shurcliff, "To Father and Mother from Sidney on their Wedding Aniversary [*sic*] April 26, 1921," pencil sketch, Nichols Family, Additional Papers, Schlesinger Library, Radcliffe Institute for Advanced Study, Harvard University.

scrapbook of documents relating to Sidney, including almost two dozen crayon and pencil drawings of automobiles—most dated to the early 1920s. Largely depicting racing cars and Model A Fords, the sketches prefigure Sidney's talent as an architectural draftsman, but they also evidence a fascination with the humorous opportunities provided by images of improbable car crashes. Of the two dozen drawings, nearly half represent automobile mishaps: flat tires, getting stuck in the mud, being run off roads and bridges, and hitting trees and light poles. The funniest drawing is dedicated "To Father and Mother from Sidney on their Wedding Aniversary [*sic*] April 26, 1921" in which fifteen-year-old Sidney depicts an urban street corner (reminiscent of Beacon Hill) with no less than six different car accidents—each resulting in a significantly damaged automobile. Clearly, Sidney's interest in the comedic value of vehicular mayhem began when he was a teenager.[6]

It was a lucky break to have a friend like Cornelius Crane. Just halfway through that first year of graduate school, Cornelius told Sidney about his plan to sail around the world on a self-funded scientific expedition under the auspices of Chicago's Field Museum. Crane's 147-foot yacht, the *Illyria,* would travel through the Pacific with a captain and crew of eighteen, a team of scientists, and a group of Crane's friends to collect natural history specimens. Would Sidney like to join them? That same day, Sidney wrote excitedly to his parents, who were traveling in Europe, to ask for permission: "Cornelius showed me the model of his new boat which will be 190 feet [*sic*] overall and said that he is hoping to start next August in it with a large crew and several scientists to go around the world to investigate and collect fish and birds. Then he asked me to go with him. Think this over and see if you do not think it will be the opportunity of a life time for me."[7]

Arthur's surviving diaries and correspondence reveal no evidence of the family's deliberations about such an extraordinary adventure except to record various meetings between Cornelius and Sidney. With just a few hints of apprehension, Margaret and Arthur gave their approval, and expedition planning went ahead.[8]

There is no surviving correspondence between Cornelius and Sidney about preparations for the trip, so it is difficult to tell when and why Cornelius asked Sidney to document the expedition with still and moving images, but in his book about the voyage, published the year after his return, Sidney wrote self-deprecatingly, "Cornelius' fellow travelers were three Harvard men: Murry N. Fairbank, Charles R. Peavy and myself. I was semi-seriously appointed motion-picture photographer."[9] Early in the expedition planning, though, Cornelius (and perhaps Sidney as well) had been thinking about the commercial potential of any moving images of the trip. An undated document clarifying the expedition's mission and the rights and responsibilities of its members—crew, scientists and "the boys"—matter-of-factly states, "Cornelius has copyright on all movies and on written account [*sic*] of the trip." The document elaborates further on the division of any profits from the sale or screening of the films: "Movies will be taken with Cornelius' cameras at his expense. Sidney guarantees to be willing to work hard on the developing and taking of the movies. If the movies are successful and could be sold at a profit . . . and Sidney has done a substantial share of work in taking and developing, he will receive [. . .] ? per cent [*sic*] of the profits over and above cost."[10]

Given that Crane was eager to try to profit from expedition photography, it seems strange that he did not hire an experienced filmmaker. Sidney had owned a still camera as early as the age of fifteen, but there is no evidence that he had any training in shooting film before Cornelius's invitation. Arthur Shurcliff had used still photography in his landscape design practice, and an extensive collection of travel and family photographs surviving in the Shurcliff papers indicates

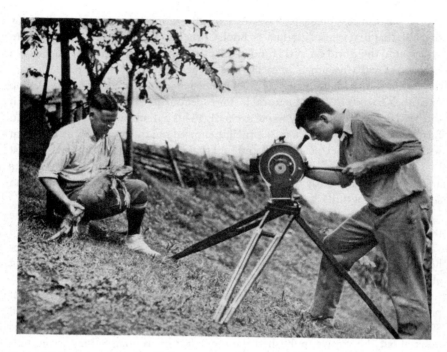

Fig. 7.2 Sidney using the 35mm Akeley camera to film scenes of the Crane Expedition's work in the Galapagos Islands. From Sidney N. Shurcliff, *Jungle Islands: The "Illyria" in the South Seas* (New York: G. P. Putnam's Sons, 1930), 42.

a strong family interest in photography, but they were not, by any means, home movie enthusiasts.[11]

There are hints, though, that Sidney was curious about filmmaking while in college. After graduation, he weighed the prospects of a career in film directing, and a tantalizing letter to Sidney from his father in August 1927 suggests that Arthur may have consulted local filmmakers for information about opportunities in the field of commercial movie making. Arthur wrote, "Mr. Dadmun says his ordinary price for taking moving pictures of families is at the rate of $1.00 a foot for the film. He says 60 feet of film would occupy one minute, in other words it would be at the rate of $60.00 a minute. He says five minutes would be enough for a whole family with all the fixings." Whatever his filmmaking aspirations, Sidney was an experienced still photographer who would have learned through assisting his father how to frame a shot for compelling effect. Perhaps he and Cornelius believed it would be only a short step from there to shooting film.[12]

Judging from the camera equipment he purchased for the expedition, Cornelius clearly did have high expectations for the quality of the photographic documentation. Official expedition cameras included a 35mm Akeley motion picture camera, two 35mm DeVry cameras, an underwater camera (brand unknown), and a Graflex still camera. Other expedition members, including the crew, brought their own still cameras—Leicas, Kodaks, and Graflexes—but the only motion picture cameras were those purchased by Cornelius. The Akeley was considered the finest camera available for expedition photography and was probably recommended to Crane by the Field Museum director because it had been invented by Carl Akeley, the Field's chief taxidermist from 1869 to 1909. The camera's innovation was a "freewheeling, damped-action, gyroscopic tripod head" that enabled the filmmaker to both pan and tilt using a single lever, rather than crank a different lever for each axis of movement. The Akeley's fluidity made it particularly desirable for explorers because it allowed the filmmaker to follow fast-moving animals in less than ideal conditions—an attribute, of course, that was also helpful for filming speeding cars. At the end of the Crane Pacific Expedition, Cornelius lent this very expensive camera to the Motormaulers for their first film.[13]

Sailing around the world on the *Illyria* was a somewhat life-changing experience for Cornelius and his friends. Not only was the adventure memorable, but many made subsequent life decisions that trace back to those eleven months at sea. Cornelius developed a lifelong interest in the Pacific, and particularly Tahiti, funding philanthropic activities and maintaining a residence there. Charles "Chuck" Peavy became an anthropologist, and Murry Fairbank participated in at least two more expeditions to Papua New Guinea before going on to work at Polaroid as head of the design group that developed the Land Camera.[14]

The trip's legacy for Sidney was threefold. First, he rediscovered his love for design and, consequently, confirmed his choice of landscape architecture as a profession. In his expedition journals he wrote beautifully about the places they visited, noting particularly the local architecture and the organization of towns and villages. Most revealing, though, on the three-thousand-mile, three-week passage from the Galapagos to Papeete in the Marquesas, Sidney turned to the drafting table: "Jan. 25th I have gotten out my Bristol board and drawing materials and have done a good many hours work drawing human figures, automobiles, and trees for landscape work and have been doing some reading in connections with landscaping. I find myself more interested in the field than when I left Boston and at times wish I was back there engaged in making a living. I intend to keep up the drawing in hope of getting fairly good before we get back."[15]

As with the others, the trip also kindled a lifelong love of travel for Sidney. In the 1950s, as president of the International Federation of Landscape Architects, he organized and participated in study trips that brought him around the world. Last, Sidney became a skilled filmmaker—under the most trying conditions—and

continued to make movies both for his own entertainment (Motormaulers) and commercially, until World War II returned him to the Pacific.[16]

Sidney must have worked quickly and diligently to master the technical challenges of filming with an Akeley camera. His younger sister recalled, a few years after Sidney's death, that Cornelius had hired "a Hollywood type" to teach him filmmaking. But it could just as easily been one of the many local filmmakers trying to break into "Hollywood-type" production. If the "Mr. Dadmun" to whom Arthur turned for advice on the business of filmmaking was Leon E. Dadmun, he potentially could have acted as Sidney's instructor. Since the early 1910s, Dadmun had been making commercial films and had developed "a specialty of . . . publicity films for a goodly number of New England's foremost manufacturers." In 1916, he founded the Atlas Film Company and opened a studio in Newton, Massachusetts, where he seems to have tried a bit of everything including comedies and, in the mid-1920s, feature films based on novels, but also advertised his services for the production of "Scientific and Educational Films." Ultimately more successful as a commercial still photographer, Dadmun also took the portrait photograph of Cornelius Crane sitting on the deck of the *Illyria* published in Sidney's book *Jungle Islands*.[17]

Wherever he acquired his training, Sidney was a quick study, and the Crane Pacific Expedition gave him plenty of time to tinker with the camera, film, and other accessories. The *Illyria* was equipped with a darkroom for developing still photographs, but moving images were developed at ports along the way or shipped back to Chicago for processing. Sidney had the first twenty-eight hundred feet of film developed "by a newsreel photographer" at Balboa, Panama, while passing through the Panama Canal. Filming took place almost every day and certainly every time the scientists went on a collecting trip. The results are often breathtaking. The footage includes beautifully framed shots, panoramic landscape views, close-ups of indigenous peoples, and some trick shots. To depict the passing of time, for instance, Sidney uses a wall calendar with the calendar days being torn away, while outtakes from the final film show him trying to superimpose the calendar over the faces of expedition members gathered around the *Illyria*'s dining table.[18]

Sidney also filmed scenes clearly scripted for comic effect, though they could be viewed now as culturally insensitive. One series of shots taken while traveling up the Sepik River in New Guinea depicts a ritual dance at Tambunum village. The elaborately costumed and masked dancer comes out in front of the main hall, dances in front of the camera, and suddenly two expedition members step out from behind the figure, flanking him and dancing in an inelegant mimicry of the native gestures. Sidney's journals also describe lighthearted moments caught on camera. While in the Marquesas, he writes, "We took a comic movie of Dr. Moss reclining on a palm divan while Cornelius knelt at his feet and Murry fanned

him with a palm leaf. At the same time, Chuck fed him cocoanut water." For Sidney, the Crane Pacific Expedition was the "opportunity of a lifetime" because it afforded him grand adventure, but it was also no less than a crash course in filmmaking.[19]

Cornelius brought the Crane Pacific Expedition rather unexpectedly to a halt on June 28, 1929. His reasons for abandoning the proposed itinerary are not entirely clear, but Sidney reported to his father that one of the scientists had decided to leave the ship to continue on to the Philippines and that Cornelius had gotten "a message from home that caused him to decide to foreshorten the trip." Cornelius may have been eager to return home to reunite with Cathalene Browning Parker, an American woman he met while the expedition was in Panama. They were married in New York on October 15, 1929, just a few weeks after Crane returned to the United States. When Sidney arrived home, he resumed his studies at Harvard's landscape architecture program, arriving just in time for the semester to begin on September 26.[20]

While diving back into his studies, however, Sidney did not leave the South Pacific far behind. He immediately turned to editing the expedition's thirty thousand feet of 35mm film and writing an account of the trip to be published the next summer by G. P. Putnam and Sons. In his room at a Harvard undergraduate social club known as the Speakers Club, he installed "complete movie editing equipment, including a Moviola viewer" and worked with a "paid undergraduate part-time helper nicknamed Bodie." His goals were no less than a commercially profitable adventure film and a best-selling book. In his memoir, *Roughing it at Roughwood*, Sidney describes that frantic fall of 1929: "Every week or so, after editing in preliminary form another thousand foot reel of film, I would run a show for my friends in the Speakers Club; their criticisms often being helpful in determining how Bodie should cut the film still further. Finally, by early spring, I had condensed the best of the 30,000 feet to 6,000 feet, having a projection time of 90 minutes."[21]

Sidney's first chance to show the final cut of his expedition film came via an invitation from his friend and future Motormauler coconspirator, Ned Dane. As boys, Ned and Sidney had developed a friendship that rested in part on a shared passion for all kinds of cars but particularly sports and racing cars. Ned was able to freely indulge that passion because his grandfather, Charles Pratt, had made a fortune in the oil business competing against and ultimately partnering with John D. Rockefeller. Ned was certain that his family, who were avid sailors, would thoroughly enjoy having Sidney join them for dinner and show his movie. Not missing a trick, Sidney accepted the invitation while also signaling his ambitions for the film: "'Well,' I said, 'I'd like to do that, but since I plan to go into the lecture business I think your family should know that my regular charge will be $100.00. However, I shall be glad to do it for nothing.' 'The family wants you next

Tuesday night,' [Ned] reported. 'They are inviting a few friends, and of course they prefer to pay the $100.00.'"[22]

With the film's splicing cement barely dry, *Jungle Islands* was already bringing in some cash. But Sidney (and possibly Cornelius) may have had bigger dreams for *Jungle Islands*. They may have hoped to replicate the phenomenal success achieved by other adventurers and filmmakers who had explored the South Pacific making movies and writing books about their exploits. In March of 1924, Boston's Symphony Hall hosted the Australian filmmaker Frank Hurley, who gave a lecture and showed his film of Papua New Guinea, *The Lost Tribe*. Martin and Osa Johnson's movies of their adventures in the South Pacific (some with Jack London) had also been wildly popular in the 1920s and 1930s, and a month-long *Boston Globe* series on the Johnsons, appearing just before the *Illyria* sailed, may have given Sidney and Cornelius some big ideas.

Jungle Islands' screening history after that evening at the Daneses' becomes murky. Sidney's parents and sister, Sarah, sent out engraved invitations to "the first showing" of the film on February 16, 1930, at Huntington Hall, the large lecture hall in MIT's School of Architecture building on Boylston Street. That may have been followed by other screenings, but Sidney may not have had time to market his film because he was desperately needed to work in his father's office. In March 1928, Arthur Shurcliff had landed the largest and perhaps most important job of his career. He had been hired to work for John D. Rockefeller on the restoration of Colonial Williamsburg, and work on the project had begun to accelerate. Sidney was needed, in particular, to conduct field research by "measur[ing] and photograph[ing] all the remaining colonial places within fifty miles of Williamsburg, then later, all within 100 miles." After completing only two years of the three-year degree in landscape architecture, Sidney left graduate school and spent the summer of 1930 researching the architecture and landscape of colonial Virginia. This work, combined with writing his book about the expedition, probably meant that Sidney's scheme to "go into the lecture business" with *Jungle Islands* had to be put on hold. Or perhaps Cornelius had other ideas for the movie. On February 5, 1931, Sidney shipped the reels to Chicago, having received word that the films were "wanted immediately" by Crane.[23]

Despite having to put aside *Jungle Islands* for Colonial Williamsburg, Sidney had clearly caught the amateur movie making bug. But as the nation's economy began its downward spiral in early 1930, what could replace the thrill of shooting film from atop the mast of a 147-foot ship in the South Seas or of filming an encounter with "cannibal tribes" of New Guinea? The answer it seems was shooting from the back of a car traveling at high speeds down country roads or from an airplane soaring over the Ipswich marshes and beach.

Moviemaking, cars, friends, and the New England landscape came together for Sidney in the Motormaulers Club. In early spring 1930, Sidney roused his

friends for some automotive pranks to be recorded on film. The cast and crew of this first Motormaulers expedition consisted of just four young men, all in their early twenties: Shurcliff, Dane, Alan Bemis, and John Marshall. In 1987, Alan Bemis recorded his memories of the films:

> My good friend Sid Shurcliff got a hold of me and he said he'd discovered a wonderful place to crack up automobiles. There's a place up near Concord [NH] where they'd moved the highway and taken a bridge out [that] went over a small river and left the abutments right there. Sid thought it would be great fun to get one or two old cars and run 'em off the abutments. If possible to get it going fast enough so the car would shoot across and hit the abutment on the other side and fall into the river. . . . We rigged up some costumes that would make the thing a little more fun [and] . . . we decided that it would be pretty good fun to drive down a road somewhere and crash into each other a little bit and do a lot of fender bending before we sent the cars off the abutment into the river.[24]

While Bemis recalled filming the movie in spring of 1930 and the date codes on the film also point to a 1930 date, the title indicates that Sidney may not have gotten a chance to edit the film until late 1931 or early 1932. The first intertitle sets the film up as a parody of a melodrama released by MGM in October 1931: "The Motormaulers present Clark Gable and Greta Garbo in 'The Rise and Fall of Susan Lennox [sic].'" The Hollywood version, *Susan Lenox (Her Fall and Rise)*, with its themes of illegitimacy and extramarital sex was considered quite risqué.[25] Much more tame—and with scarcely a plot—the Motormaulers' version featured only one actor: Alan Bemis dressed as a woman taking swigs from a bottle. The stars of the show were the automobiles: a Model T Ford driven by Bemis, and a 1921 Chevy touring car driven by Ned Dane. Sidney filmed the scenes with Crane's Akeley camera fixed in the rear seat of a third car driven by John Marshall. The Model T and the Chevy are seen barreling down the road, hitting trees, electricity poles, and sideswiping each other along the way until the final scene, when the Model T sails off an embankment, tumbling "end over end in great style with a dummy at the wheel." The final intertitle tells us that the "state police closed the 1930 season leaving Clark Gable still at large."

According to Sidney, the police did arrive on the scene and chase him, first on foot through the woods (with Sidney carrying the Akeley) and then by car into town, where Sidney was able to elude the law by parking on a side street, ducking into a barber shop, sliding into a chair, and lathering his face with shaving cream. The cops burst into the shop and "glaringly inspected all the customers," while Sidney calmly read the newspaper awaiting his shave. This "saga" of the Motormaulers' first film has the tone of an oft-repeated story and familiar comedic themes: car chases and crashes, inept policemen, and wily, wacky "criminals."

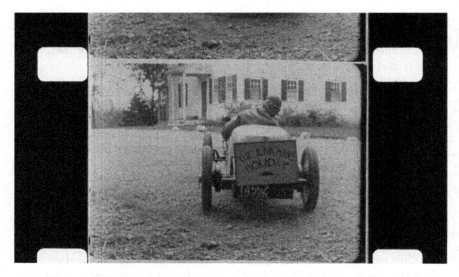

Fig. 7.3 Title scene of *The Junkman's Holiday*, 1932. From 16mm film. Alan Bemis Collection, Northeast Historic Film. [Accession 2313, Reels 11–12]

Sidney and his friends had such a good time with the first Motormauler film they decided to reconvene in 1932—possibly to watch the 1930 final cut as well as carry out another escapade. A flyer decorated with Sidney's drawings of car crashes along the top announced "The Motormaulers 1932 Field Day and Crack-Up, Sunday, Oct. 9, 1932" and invited all to "take part in a most terrific and awe-inspiring spectacle at the Shurcliff proving grounds." This time, the cast expanded to thirteen, including Cornelius Crane appearing as a policeman. "To ensure the perpetration of a soul-satisfying amount of damage, elaborate preparations" were made, including the charge of a "crash tax" of two dollars per participant. The "charter members" all chipped in fifteen dollars to buy the cars, a "Reo sedan and a Studebaker Special Six touring car," but the hope was that the crash tax might permit a refund. The cars were procured from the "junk-man Greenberg in Ipswich [who] was happy to sell us cars for $10.00 provided he could be allowed to haul them back to his yard after the fun. He was made an honorary member immediately."[26]

Energy and enthusiasm for the second installment of the Motormaulers' escapades had begun to build, and more time and thought were being directed toward the mechanics of filmmaking. The Field Day and Crack-Up flyer hinted at the outline of a plot, promising a "thrilling movie scenario involving a running battle between bootleggers and minions of the law," and the opening scenes of *The Junkman's Holiday* signal an increased attention paid to cinematic techniques.

Fig. 7.4 Bootleggers boating through the marsh landscape, *The Junkman's Holiday*. From 16mm film. Alan Bemis Collection, Northeast Historic Film. [Accession 2313, Reels 11–12]

The film begins with the intertitles "The Motormaulers" and "Present" cut in with teaser shots of head-on car crashes. Next, Ned Dane speeds down Argilla Road in his custom-built one-person sports car, the *Enad Special*. The camera follows him in a long panning shot until the car disappears at left. The film then cuts to Dane driving up a gravel drive and skidding the car around to the left. A close-up of Dane spinning the wheel and shielding his eyes from dust then cuts to him backing the car up toward the camera until a placard fixed to the rear of the car, clearly lettered "The Junkman's Holiday," fills the frame. Alan Bemis commented while viewing the reels in the 1980s that they were trying to give the film a big opening in "Cecil B. DeMille style."[27]

Junkman's continues with the intertitle "The Spirit of Spring Comes to Happy Valley," and another close-framed shot of a lettered sign—this time the side of a wooden crate of champagne stamped "Bollinger Brut 1911," (an in-joke because Ned Dane's father was famous for his wine cellar stocked with this favorite champagne). The camera pans up to reveal that the crate sits on the bottom of a small outboard motorboat piloted by two gun-toting, derby-hat-and-false-mustache-wearing bootleggers with neckerchiefs and striped shirts, smoking cigars and pointing off-camera (presumably) to the shore. We know we are in for some tussles with local law enforcement, high-speed car chases, and spectacular smashups.

The Junkman's Holiday does indeed deliver laughs with scenes employing exactly the type of stock characters that appeared in slapstick comedies of the

Fig. 7.5 Cars plunging off cliff, *The Junkman's Holiday*. From 16mm film. Alan Bemis Collection, Northeast Historic Film. [Accession 2313, Reels 11–12]

period: incompetent police, pistol-wielding criminals, hayseed farmers, and a group of oblivious young women picnicking on the edge of a precipitous cliff. In an improvement over the 1930 film, the grand finale this time features three cars plunging to destruction—the bootleggers run into the picnickers' car sending both off the edge followed by the police car (all driverless). But in this film the landscape also plays a leading role. Shot entirely in the neighborhood of Argilla Road, the camera pays homage as much to the environment as to the slapstick. The camera follows the bootleggers and their boat in a long shot as they make their way through a marsh landscape that stretches to the horizon; another long shot takes in a distant view of the ocean across rolling hills and hay fields with a gate and a single rutted car track, and in yet another shot, the picnickers find a picturesque though precarious spot overlooking a broad salt pond. If chaos and disorder are the source of the film's hilarity, it is achieved as much by juxtaposing that anarchy with the stability of the landscape as it is in the antics of automobiles and drivers.

Junkman's Holiday celebrates the natural beauty of the Ipswich marshes, but the Motormaulers' last two productions expanded to include formally designed landscapes that both advanced the cops-and-robbers plots and again provided comedic contrast between idyllic surroundings and automotive mayhem. *Rollo's Revenge or the Last of the Gotrocks* (1933) and *Why do Oysters Perspire?* (1937) featured more complicated plots involving crimes perpetrated on affluent

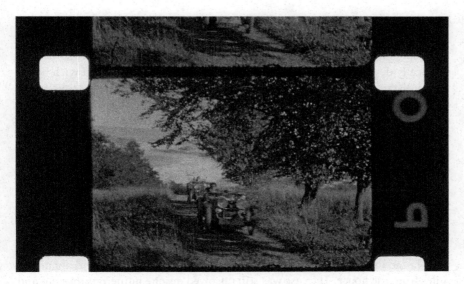

Fig. 7.6 MG race cars on hill overlooking Ipswich beach, *Rollo's Revenge or the Last of the Gotrocks*, 1933. From 16mm film. Alan Bemis Collection, Northeast Historic Film. [Accession 2313, Reels 13–14]

characters—the kidnapping of an affluent family's son, Rollo, in *Rollo's Revenge*, and the theft of jewelry from a wealthy eccentric by her maid and chauffeur in *Oysters*. Country estates with elaborately designed grounds signal the socioeconomic class differences between the Gotrocks or Madame Kohinoor and the criminals. *Rollo's Revenge* opens with an establishing shot of the Cranes' enormous neo-Georgian estate designed by Chicago architect David Adler. The mansion is viewed from the Grand Allée that had been laid out by Arthur Shurcliff in 1913–1915—a broad swath of green flanked by classical statuary and edged with Norway spruce and white pine trees. After these opening scenes, the location changes to the Wayland, Massachusetts, home of Alan Bemis for the rest of the first reel. Here the Motormaulers were again taking their chances with the local police, because many scenes were filmed on Wayland's suburban roads, including the final scene featuring two cars crashing into a gravel pit and bursting into flames (once the actors are seen escaping from the cars). The bonfire scene lasts about a minute and a half, with close-ups of the cars engulfed in flames, and ends when the camera tilts up to follow clouds of black smoke as they dissipate.[28]

Reel two of *Rollo's Revenge* takes us back to the Ipswich marshes with Rollo's nanny, Parkins (played by Sidney in drag), on foot in hot pursuit of the kidnappers. More cars are commandeered (including one driven by a drunken yokel), and they career down country lanes, off the roads, into one another, and into

bridge abutments. The kidnappers are about to get away when, like the cavalry, Mr. Gotrocks's team of MG race cars arrives. Another long shot of the Grand Allée spots the three cars driving straight as arrows in a single line across the classically designed landscape, around a curve with the sweep of Ipswich beach in the distance, to come to a stop filling the frame with drivers getting out in unison. Parkins and Rollo's parents hop into the MGs with the drivers, and they speed off to save the day. One final crash between the kidnappers and a hapless motorist gives Rollo the opportunity to wreak his revenge on his captors and reunite with his family. The final scene is of the Gotrocks family all speeding off down Argilla Road in the MG race cars.

The plots for these last two Motormaulers films involved much more elaborate cops-and-robbers scenarios. *Rollo's Revenge*, in which the boy is kidnapped from his home out from underneath the eyes of his English nanny, was no doubt drawn from recent headlines. On March 1, 1932, news spread that Charles and Anne Morrow Lindbergh's twenty-month-old son had been kidnapped from their home in New Jersey, and on May 12 the boy's body was found about five miles from the house. The case was still unsolved despite numerous theories and leads in early spring 1933, when the Motormaulers gathered for their third film. The Lindbergh story still held the country's attention, however, and although it ended in tragedy, the inability of the police to solve the crime fit well with a plot about incompetent law enforcement. But Sidney Shurcliff could also draw on his own experience with criminal activity and bungling cops. When he was a child, his mother spent a fearful night at the Argilla Road house with twelve-year-old Sidney and his younger siblings, as an intruder tried to break into the house. In later years, while in graduate school, Sidney shot at two thieves absconding with a spare tire from his car parked near Harvard Square. But perhaps the most harrowing experience was that of his client, John P. Wright of Keene, New Hampshire, who was the victim of an extortion scheme that began in 1934 and continued unabated until 1938. Sidney was asked to design landscape features that would hide monitoring equipment installed by the police around the Wright house. The perpetrators went uncaught—the result of law enforcement ineptitude, according to Sidney—but the threats disappeared when some local gangsters were killed in a bank holdup.[29]

The Motormaulers staged their last and most elaborate production in 1937, *Why Do Oysters Perspire?: A Stark Drama of Stolen Pearls and Savage Revenge*. It had a larger cast, more spectators, and a complex plot involving sailboats, airplanes, and a half dozen cars. *Oysters* followed a theme similar to that of *Rollo's Revenge*, centering on extraordinarily wealthy people victimized by crime, but this time the theft of a pearl necklace triggers the mayhem. Madame Tiara Kohinoor (named for the Kohinoor diamond worn by England's consort Queen Elizabeth at her coronation in May, 1937), has her jewels stolen by her maid and

chauffeur.[30] The familiar crazy and chaotic car chases ensue, with the addition of two airplanes performing stunts over Ipswich beach in pursuit of the criminals, and a staged airplane crash. The addition of an airplane not only had the benefit of introducing another kind of vehicle into the chase but also afforded Sidney the ability to take aerial shots. The opening scene of the film is a bird's-eye view of the Crane estate, focusing particularly on the beach and the Grand Allée and labeled in the intertitle "Magnificent Bewdley-on-Baldwin." Reel two as well takes advantage of new plot elements to put the landscape at the forefront. A small wooden sailboat hijacked by the thieves gave Sidney the opportunity to frame some beautiful shots of the boat sailing in the marshes and aerial views of the marsh landscape. Joining the seaplane, a Laird stunt plane takes off down the Ipswich beach with Madame Kohinoor at the wheel. Disorienting shots from the cockpit of the plane showing first land, then clouds, enhance the sense of chaos until the camera again fixes on the sailboat and swoops down. These scenes are crosscut with images of the thieves in the boat enhancing the sense of a chase. Last, a kind of trick shot shows the Laird stunt plane flying through the trees—seemingly at risk of crashing—although the trees are at the marsh edge, and the plane is landing on the beach behind them. The film then cuts to a crashed airplane, echoing the many automobile crashes. Thieves, police, and Madame end up together at the marsh edge where, united with her jewelry, Madame announces, "These are just the imitations of my real ones!" and tosses them in the water. The final scene is of the cast being tossed into the water—leaving just their hats to bob up and down in the ebbing tide.

The Motormauler films brought together a tight group of friends to drive their cars, perform in elaborate screenplays, and laugh in the face of desperate economic times. To be sure, none of the Motormaulers crowd experienced the kind of devastating hardships that faced so many Americans in the early 1930s, but the effects of the Great Depression were impossible to escape. The annual town reports for Ipswich reveal the damage wreaked locally by the national economic disaster: 1931 was called "The hardest year since the Depression began." In 1932, "finding jobs is out of the question. They cannot even be bought." The next year, 1933, was the town's "hardest year yet, banks failing, banks closed, business stagnant and labor unemployed." The Shurcliffs, though, were lucky. From 1928 to 1934, the firm (Sidney became a partner in 1934) worked steadily and tirelessly on the Williamsburg project. After the first phase of restoration was complete in 1934, and work for the project's architecture, engineering, and landscape architecture firms came to a close, Arthur Shurcliff acknowledged that they had "been more fortunate than most offices in having work through the depression."[31]

In addition to providing much-needed distraction from bleak economic times, however, the Motormauler films gave Sidney yet another way to explore

moviemaking. If *Jungle Islands* was an opportunity to venture into documentary and adventure films, maybe the Motormauler films were a way to try his hand at slapstick. The choice of emulating Keystone Kops films brought together his love of photography, his near obsession with all kinds of motor vehicles, and his deep appreciation for the New England landscape.

American boys growing up in the 1910s and 1920s had relatively easy access to images of car chases and crashes, most notably in the films of Mack Sennett's Keystone Film Company, which cast a long shadow over American comedic cinema despite its short duration from 1912 to 1917. As film historian Rob King argues, the company "played *the* key role in securing the revitalization of American screen comedy, modernizing the then-disreputable genre of slapstick and defining it as a comic form attuned to the popular values of America's working class."[32] Keystone emerged during an era when Americans' leisure activities were rapidly changing and expanding. The early decades of the twentieth century saw an explosion in vaudeville, comic strips, amusement parks—all dedicated to making Americans laugh out loud. Despite calls from reformers that comedies were morally suspect, the public's demand for slapstick grew throughout the 1910s, and Mack Sennett led the way. Although we don't know much about Sidney's moviegoing predilections, his journal and the diaries of his father indicate a keen interest in seeing the latest movies, and he undoubtedly took in his share of Keystone and other comedies. Even while on the Crane Expedition, Sidney often went to the movies while in port and was eager to share American popular culture with the people he encountered. A telegraph from the *Illyria* asked the Crane office in Chicago to "send two standard size film Chaplin movie comedies, one Western and one Douglas Fairbanks feature to Fiji." Sidney received the films and staged an elaborate screening for the residents of Timbunke, New Guinea.[33]

After the 1937 filming of *Why Do Oysters Perspire?*, the Motormaulers never reconvened to shoot another film. Perhaps the productions had become too complicated, time consuming, and dangerous. Bemis and Shurcliff wrote that after *Oysters* they were "exhausted and somewhat shaken, we all agreed we had tempted fate too far and . . . [we] put the Motormaulers Club on inactive status forever." Another tragic event, though, may have brought the escapades to an end. Just two years after filming *Oysters*, on Labor Day, Sidney's wife, Kay Shurcliff, was driving along Argilla Road at about 7:00 p.m., when her English roadster flipped over, killing the passenger, her good friend Pamela Barnum Barker. Maybe the film productions had become too onerous for the club members, many of whom were busy working and raising children, but it is also possible that after Pamela Barker's death, what seemed like harmless fun came to be viewed as thoughtless, reckless, and rash.[34]

Sidney continued to screen and make movies in the late 1930s and early 1940s, although he largely turned away from comedy and cars (with one notable exception). From January through March in 1935, and again in 1936, he toured the country lecturing on Colonial Williamsburg (with slides) and showing *Jungle Islands* for which he provided running commentary. To market his film/lecture and manage his engagements, he hired a Boston-based agent, George W. Britt, who booked him with social clubs, nonprofit organizations, garden clubs, and student groups. Brochures produced by Britt billed Sidney as "Explorer, Architect, Moving Picture Photographer." By 1937, Sidney reported that he had given approximately two hundred lectures and clearly found the work rewarding and somewhat profitable.[35] He decided to expand his repertoire and began making color films to promote the growing industry of downhill skiing, featuring ski resorts in the East, Canada, and the West. He describes the origins of this idea in his memoir:

> Having been married in 1935 and finding myself unable to live on three dollars an hour (my father set the rate) in the manner to which I would have liked to become accustomed, I decided to produce a ski travelogue on movie film for public lecturing purposes. This seemed to be a feasible enterprise because I was already lecturing during the winters on the Restoration of Williamsburg and on Jungle Islands of the South Seas, the record of the Crane South Sea Expedition which I had filmed in '28-'29. I owned the necessary camera equipment, was one of the newest members of the White Mountain Ski Runners and had a brother-in-law . . . who would furnish introductions to the other ski instructors and act as a guide to the west.[36]

Ski America First (1938) and *Ski America Second* (1940) showcased glamorous new resort areas as well as expert skiers from the United States and Europe. Sidney did return to comedy with one film, *Dr. Quackenbush Skis the Headwall* (1942), which even featured an old car—though it does not get into a "crack-up." Motormauler charter member John H. Marshall rejoined Sidney in this endeavor and starred as Erasmus B. Quackenbush, a retired African explorer who seems to have very little awareness of his surroundings and is largely out of control when skiing down the mountain. All of Sidney's ski movies depict elegant skiers carving their way down the slopes, along with stunning views of the mountains, but none of them exhibit the same appreciation for the natural beauty of the New England landscape that is so clearly on display in his films of the 1930s.[37]

The Motormauler films were created by the fortuitous confluence of a specific group of people, at a particular place, and during a specific time. They were produced just after Sidney had returned from almost a year filming foreign landscapes in the South Pacific; in a place that had special meaning for his family and friends; at a time when automobiles epitomized modernity and (somewhat

paradoxically) used or junk cars were relatively cheap to own and fix up; during a nationwide economic downturn that left Americans desperate for a laugh; at a moment when amateur filmmaking technology was becoming more affordable and easier to use; and at a point in the lives of a group of good friends when the cares of work and family had not quite overwhelmed the impulse to stage elaborate theatricals. That conjunction of who, what, when, and where could explain the creation of the Motormauler films. But the comedic beauty that draws us to them—the counterpoise of stable landscape and out-of-control machines— derives from a filmmaker's intense engagement with and sensitivity to the landscape of his childhood as well as his ability to translate that deeply rooted sense of place to the flicker of images on a screen.

Technical Notes: Sidney Shurcliff, *The Motormaulers: The Rise and Fall of Susan Lennox* (1930) and *Why Do Oysters Perspire?* (1937)

While most home movie makers shot with equipment produced particularly for the amateur market, some had access to high-quality cameras that were more often used by professionals. The Akeley camera used by Sidney Shurcliff in *The Rise and Fall of Susan Lennox* (1930) was one of the most advanced pieces of motion picture equipment for the time. The circular body featured a 230-degree rotary shutter that resulted in a slower shutter speed and allowed for the passage of more light through the lens. This permitted the Akeley to capture images in lighting situations that other cameras of the time could not. More important, the sturdy design of the camera made it suitable for World War I aerial photography as well as the automobile action sequences of the Motormaulers films.

The Akeley (1915) and the Bell & Howell 2709 (1912) were the only solid-metal professional 35mm cameras; all the others had wooden box housings. The Akeley's compact design made it easy to transport and mount on everything from automobiles to airplanes. It also featured a tripod head as part of the camera body that allowed for easy and fluid pan-and-tilt movements, which are used throughout the Motormaulers footage as the camera follows the automobiles. In addition, the lens and viewfinder were connected via a geared section so that the operator, focusing in the viewfinder, simultaneously focused the lens. This was close to the modern reflex camera, where the operator could look through the actual lens that captured the image on the film.

By the time Shurcliff and the Motormaulers made *Why Do Oysters Perspire?* in 1937, further advancements in amateur camera technology made the small-gauge Bell & Howell Filmo 70-D an acceptable alternative. As one can see from the two-reel *Oysters* film, nothing was sacrificed in the professional look of the work when Shurcliff transitioned entirely to 16mm. In fact, the team increased

the professionalism over their 35mm production by expanding the level of editing in the later films, with *Oysters* featuring close to 150 splices.

The Motormaulers: The Rise and Fall of Susan Lennox, 1930. Alan Bemis and Sidney Shurcliff.
Alan Bemis Collection, Accession 2313, Reel 11.
Gauge: 16mm. Stock: Kodak Safety Positive (B&W print) for first 170 ft. of film, Kodak Safety Film (B&W reversal) for last 30 ft. of film (camera original).
Length: 200 ft. Splices: eight (three tape splices, five cement splices).
Overall reel length: 200 ft.
Date codes: 1932, B&W print/first 170 ft. of film; 1927, B&W reversal (camera original) for last 30 ft. of film.
Camera code: none for B&W print; Bell & Howell Filmo 70-D for B&W reversal.
Other info: Switches to the B&W camera original reversal footage at the scene where the drag car is suddenly driving in snow and then backs into the garage. The first 170 ft. was reduction printed from film originally shot on a 35mm Akeley camera, according to the Motormaulers history by Alan Bemis and Sidney Shurcliff (May 12, 1980) in the Alan Bemis Collection folder. There is no mention of the extra 16mm section at the end.

The Motormaulers: Why Do Oysters Perspire? 1937. Alan Bemis and Sidney Shurcliff.
Alan Bemis Collection, Accession 2313, Reels 15–16.
Gauge: 16mm. Stock: Reel 15, Eastman 50 Safety Film (B&W print) for first title card only; Kodak Safety Positive (B&W print) for all other title cards; Kodak Safety Positive (B&W reversal) for some live action shots at beginning (dupe footage); Kodak Safety Film (B&W reversal) for many live action shots throughout, including aerial views (camera original); Agfa Safety (B&W reversal) for most live action shots (camera original). Reel 16, Kodak Safety Positive (B&W print) for title cards; Kodak Safety Film (B&W reversal) for many live action shots (camera original); Agfa Safety (B&W reversal) for most live action shots (camera original).
Length: Reel 15, 400 ft., Reel 16, 350 ft., Splices: Reel 15, ninety total (tape: three, cement: eighty-seven). Reel 16, fifty cement splices.
Overall reel length: Reel 15, 400 ft., Reel 16, 350 ft.
Date codes: 1979 for Eastman 50 Safety Film/first title card; 1937 for Kodak Safety Positive (print)/title cards; 1938 for Kodak Safety Positive (print)/title cards;

1933 for Kodak Safety Positive (reversal)/dupe; 1936 for Kodak Safety Film (reversal)/camera original. None for Agfa Safety (reversal)/camera original. Camera code: Bell & Howell Filmo 70-D (camera original sections only). Other info: Reel 15 is part 1, and Reel 16 is part 2. Both reels have projector damage near head. The 1934 date comes from label on original cans. Reels 30 and 31 in this collection are dupes of these reels on 1979 stock (same as first title card in Reel 15).

Martha J. McNamara is Director of the New England Arts and Architecture Program in the Department of Art at Wellesley College, where she specializes in vernacular architecture, landscape history, and material culture studies of New England. McNamara is author of *From Tavern to Courthouse: Architecture and Ritual in American Law, 1658–1860*, and editor with Georgia Barnhill of *New Views of New England: Studies in Material and Visual Culture, 1680–1830*.

Notes

1. For assistance with research, my thanks go to Armand Esai at the Field Museum; Susan Hill Dolan, Alison Bassett, and Nicole Lapenta at the Trustees of Reservations; Elizabeth Hope Cushing, Charles Shurcliff, and Virginia-Lee Webb. My thanks also go to Alice Friedman and Karan Sheldon for their thoughtful comments on this essay. Alan Bemis and Sidney Shurcliff, "The Saga of the Motormaulers," May 12, 1980, typescript in collection files, Alan Bemis Collection, Northeast Historic Film, Bucksport, Maine. All four of the extant Motormaulers films are in the collections of Northeast Historic Film and were a gift of Motormauler founding member Alan Bemis. It is not clear how many copies of the movies were made in the 1930s or later, and it is possible that other copies of the films are extant in the hands of other Motormauler descendants. For information on American comedic films of the early twentieth century, see Alan Bilton, *Silent Film Comedy and American Culture* (New York: Palgrave Macmillan, 2013).
2. Rob King, *The Fun Factory: The Keystone Film Company and the Emergence of Mass Culture* (Berkeley: University of California Press, 2009); Bemis and Shurcliff, "The Saga of the Motormaulers," 1. For a discussion of automobiles and traffic regulation in early film, see Kristen Whissel, *Picturing American Modernity: Traffic, Technology, and the Silent Cinema* (Durham, NC: Duke University Press, 2008), especially chapter 4.
3. In 1930, the family changed the spelling of their name from "Shurtleff" to "Shurcliff." For simplicity, "Shurcliff" will be used throughout this essay in both pre- and post-1930 references. Elizabeth Hope Cushing, *Arthur A. Shurcliff: Design, Preservation, and the Creation of the Colonial Williamsburg Landscape* (Amherst: University of Massachusetts Press, 2014), chapters 2–3. Sidney's aunt on his mother's side, Rose Standish Nichols, was also an accomplished landscape architect. See B. June Hutchinson, *At Home on Beacon Hill: Rose Standish Nichols and Her Family* (Boston: Nichols House Museum, 2011).
4. Cushing, *Arthur A. Shurcliff*, 89, 91–92. For a description of the constantly evolving home on Argilla Road, see Cushing, *Arthur A. Shurcliff*, chapter 4, "The Creation of the Ipswich Home"; Joseph E. Garland, *Boston's Gold Coast: The North Shore* (Boston: Little, Brown),

87–107; Sidney Nichols Shurcliff, *Upon the Road Argilla: A Record of the First Quarter Century of a Unique Summer Colony* (Boston: by author, 1958), 89; William A. Shurcliff, memorandum, January 19, 1994, as quoted in Cushing, *Arthur A. Shurcliff*, 124.

5. Not surprisingly, the first structure Sidney built on his Argilla Road lot was a three-car garage; in 1936 he built a house adjoining the garage. William A. Shurcliff, "A Casual History of the Upper Part of Argilla Road, Ipswich, Mass., since 1897," April 1, 1952, typescript at Boston Athenaeum, Boston, MA, 78–79 (house construction), 52–54 (ambivalence about graduate school); Jeffrey Fulford, "Negotiating Postwar Landscape Architecture: The Practice of Sidney Nichols Shurcliff," (master's thesis, University of Massachusetts, Amherst, 2013), 6–7. For a history of Harvard's program, see Melanie L. Simo, *The Coalescing of Different Forces and Ideas: A History of Landscape Architecture at Harvard, 1900–1999* (Cambridge, MA: Harvard University Graduate School of Design, 2000). The majority of the Crane estate is now owned by the Trustees of Reservations and open to the public; the beach, known as Ipswich beach in the 1930s, is now a much-loved Boston-area beach known as Crane Beach. Shurcliff, *Upon the Road Argilla*, 97–99, 99–105; Cushing, *Arthur A. Shurcliff*, 86. In July 1929, for instance, Sidney's younger sister Sarah, while traveling abroad with her mother, received an invitation from the Crane's daughter, Florence, to join them on a cruise through the Mediterranean. Sarah Shurcliff to Helen Shurtleff, July 21, 1929, Box 12, "Trip to Europe, 1929," Nichols Family, Additional Papers, Schlesinger Library, Radcliffe Institute for Advanced Study, Harvard University, Cambridge, MA (hereafter Nichols Additional Papers, SL).

6. Cushing, *Arthur A. Shurcliff*, 4; 96–98 quoting SNS; Sidney N. Shurcliff, Scrapbook "Early drawings made by Sidney also early letters gathered for him by A2S," 1921–1932, Box 30, Folder 4, p. 461, Nichols Additional Papers, SL.

7. Sidney Shurcliff to Margaret and Arthur Shurcliff, January 11, 1928, Nichols Additional Papers, SL.

8. See March 18, 20, October 24, 29, November 5, 1928, "Arthur Shurcliff Diaries, December 31 1927–Jan. 2, 1929," Carton 7, Arthur Asahel Shurcliff Papers, Massachusetts Historical Society, Boston (hereafter AAS Papers, MHS). When it arrived in Boston, Arthur asked his MIT classmate, George Owen, by then a professor of Naval Architecture at MIT to inspect the *Illyria* for seaworthiness. See George Owen to Arthur Shurcliff, November 8, 1928, Folder 4, Box 30, Nichols Additional Papers, SL.

9. Sidney N. Shurcliff, *Jungle Islands: The "Illyria" in the South Seas* (New York: G. P. Putnam, 1930), 5.

10. Document outlining responsibilities of expedition members, Folder 1, June–July 1928, Records of the Cornelius Crane Pacific Expedition, 1928, Archives, Field Museum of Natural History, Chicago, IL (hereafter CPE Papers, Field Museum).

11. SNS to Rose Standish Nichols, June 2, 1921, Box 5, F. 91, Nichols-Shurtleff Family Papers 1780–1953, Schlesinger Library, Radcliffe Institute for Advanced Study, Harvard University, Cambridge, MA.

12. Marlene Salon, foreword to *The Day it Rained Fish*, by Sidney Nichols Shurcliff (1978; reprint Gloucester, MA: Pressroom, 1991), viii. Possibly Leon E. Dadmun, an architectural photographer whose photographs illustrated an article by Shurcliff published in 1910 (*Country Life*) and who later turned to filmmaking. Arthur Shurcliff to Sidney Shurcliff, August 19, 1927, Folder 4, Box 30, Nichols Additional Papers, SL. *The Boston Register and Business Directory*, vol. 86 (Boston: Sampson & Murdock, 1922), 714.

13. Rarely a day went by on the expedition without Sidney making some reference in his journal to photography and/or camera equipment. The entry for February 12, 1929, for instance, describes underwater photography in the Marquesas. Journal, "Vol. 2 Jan. 7–Mar.

14, 1929," Folder 1, Sidney Nichols Shurcliff Papers, 1928–1929, Phillips Library, Peabody Essex Museum, Salem, MA (hereafter SNS Journals). For a discussion of the still photographs produced by members of the expedition, see Virgina-Lee Webb, "Official/Unofficial Images: Photographs From The Crane Pacific Expedition, 1928–1929," *Pacific Studies*, Vol. 20, No. 4 (December 1997): 103–24; Mark Alvey, "Motion Pictures as Taxidermy: Carl Akeley and His Camera," *In the Field: the Bulletin of the Field Museum of Natural History*, Vol. 71 (2000): 10–11.

14. "Cornelius Crane, Plumbing Heir, Dies at 57; Lived at Ipswich," *Boston Globe*, July 10, 1962. *Harvard Class of 1928 Twenty-fifth Report* (Cambridge, MA: Harvard University, 1953), 331–32 (Fairbank), 832–39 (Peavy); *Harvard Class of 1928 Fiftieth Report* (Cambridge, MA: Harvard University, 1978), 207–8 (Fairbank).

15. SNS Journals, Folder 1, "Vol. 2 Jan. 7–Mar. 14, 1929," January 25, 1929.

16. *Harvard Class of 1927 Fiftieth Report* (Cambridge, MA: Harvard University, 1977), 654–57.

17. Alice W. Shurcliff to Virginia-Lee Webb, personal correspondence, June 27, 1986, as quoted in Webb, "Official/Unofficial Images," 103–24; *Moving Picture World*, January 8, 1916, 270; "Local Amateur Movie Actors Pay Real Money to Toil Like Trojans," *Boston Globe*, July 18, 1926; *Moving Picture World*, July 20, 1918 (comedies); *Exhibitors Trade Review*, June 13, 1925 (*The Pearl of Love*, 1924); *Exhibitors Trade Review*, October 15, 1921 (scientific and educational films).

18. SNS Journals, Folder 1, "Vol. 2 Jan. 7–Mar. 14, 1929," December 12 and 16, 1928 (Panama); February 29, 1929 (Tahiti); Correspondence regarding film shipments to Crane Co., Chicago in Folder "13/18 April–June 1929," CPE Papers, Field Museum. See also Webb, "Official/Unofficial Images," 111. Crane Pacific Expedition films, DVD "Rolls 1, 2, 3, 5 and 6," Film/Video Box 1, Castle Hill Collection, Trustees of Reservations, Archives and Research Center, Sharon, MA.

19. Crane Pacific Expedition films, Trustees of Reservations, Archives and Research Center; Shurcliff, *Jungle Islands*, 243–5; SNS Journals, Folder 1, "Vol. 2 Jan. 7–Mar. 14, 1929," February 12, 1929.

20. SNS to AAS, June 28, 1929, and AAS to SNS September 24, 1929, Nichols Additional Papers, SL; *Boston Globe*, May 4, 1930, A62.

21. Sidney N. Shurcliff, *Roughing it at Roughwood* (Weston, MA: Nob Hill, 1979), 2–3. The Speakers Club occupied a building at 43 Mt. Auburn Street in Harvard Square. "Bodie" has not been identified.

22. Ibid., 3.

23. Shurcliff, *The Day it Rained Fish*, 27–30; Cushing, *Arthur A. Shurcliff*, 187–89, 197–98; "Autobiography of Arthur A. Shurcliff," 35A, Carton 1, AAS Papers, MHS; J. K. Prentice [secretary to R. T. Crane] to Arthur A. Shurcliff (telegraph) February 5, 1931; Arthur A. Shurcliff to Marian Nichols, March 17, 1931, Nichols Additional Papers, SL. A copy of the film *Jungle Islands* (two reels) survives in the CPE Papers, Field Museum and is accessible at https://archive.org/details/JungleIslands19281929Reel1 and https://archive.org/details/JungleIslands19281929Reel2 (accessed August 2, 2015).

24. "Alan Bemis Commentary on Motormaulers," Reel 48, Alan Bemis Collection, Northeast Historic Film. Although subsequent Motormauler movies included women (wives, sisters, and friends) as actors, it seems clear that the films were primarily an activity carried out by the men of the group. The cameramen were Sidney Shurcliff, Blaney Dane, and Brenton H. Dickson; the cars (and planes in *Oysters*) were all driven by men, and all the main characters are male or played by men. Though not quite a "men's club," the Motormauler films were primarily about young men and their machines.

25. The film ran into particular trouble in Britain, where it had to be cut and retitled *The Rise of Helga* in order to make it past the censors. David Bret, *Clark Gable: Tormented Star* (Boston: Da Capo, 2008), 38–39.

26. Ibid., 3.

27. "The Motormaulers 1932 Field Day and Crack-up, Sunday Oct. 9, 1932," flyer in Alan Bemis Collection Files, Northeast Historic Film; Shurcliff, *Roughing it at Roughwood*, 19–20; "Alan Bemis Commentary on Motormaulers," Reel 48, Alan Bemis Collection, Northeast Historic Film.

28. April Austin, "A Grand Undertaking: Restoring the Crane Estate Allée to its Original Design," *Special Places Magazine* [Trustees of Reservations] 18, no. 1 (Spring 2010): 7–10. Bemis and Shurcliff, "Saga of the Motormaulers," 4. Bemis notes that a neighbor notified the fire department, which was not too happy to find the fire was the work of amateur filmmakers. "Alan Bemis Commentary on Motormaulers," Reel 48, Alan Bemis Collection, Northeast Historic Film.

29. "Richard T. Cahill, Jr., *Hauptmann's Ladder: A Step-by-Step Analysis of the Lindbergh Kidnapping* (Kent, OH: Kent State University Press, 2004); Margaret Homer Shurcliff, *Lively Days: Some Memoirs* (reprint; Boston: Nichols House Museum Board of Governors, 2011), 107–8; "Harvard Man fires three Shots at Tire Thieves," news clipping, November 26, 1927, Box 30, F. 4 Vol: "Early Drawings Made by Sidney" Nichols Additional Papers, SL. Shurcliff, *The Day it Rained Fish*, 55–60.

30. William Shawcross, *Queen Elizabeth the Queen Mother: the Official Biography* (New York: Macmillan, 2012).

31. One Argilla Road neighbor, Adele "Kitty" Crockett Robertson, recorded her futile attempts to keep her family's orchard in production during the 1930s in *The Orchard: A Memoir* (New York: Henry Holt, 1995). Town reports quoted in Betsy Robertson Cramer, foreword to Robertson, *The Orchard*, 1995. Despite the end of the major phase of Colonial Williamsburg work, Shurcliff remained chief landscape architect until 1941 and worked as a consultant for Williamsburg after retirement until just before his death in 1957. Arthur Shurcliff to Arthur F. Perkins, December 15, 1933, as quoted in Cushing, *Arthur A. Shurcliff*, 231; 243–44.

32. King, *The Fun Factory*, 5.

33. John Kasson, *Amusing the Million: Coney Island at the Turn of the Century* (New York: Hill and Wang, 1978); Eileen Bowser, *The Transformation of Cinema, 1907–1915: Vol. 2, History of the American Cinema* (New York: Charles Scribner's, 1990), 179–185. See, for example, entries for Dec. 14–23, 1928, SNS Journals, Folder 1, "Vol. 1, Nov. 16 1928–Jan. 6 1929) and Arthur Shurcliff Diaries, Oct. 1, 1928, AAS Papers, MHS. Cornelius Crane to J. K. Prentice, Telegraph, February 10–11, 1929, Folder 10, "18 Jan.–March 1929," CPE Papers, Field Museum; Shurcliff, *Jungle Islands*, 246–48.

34. Bemis and Shurcliff, "Saga of the Motormaulers," 6; Anon., "Labor Day, Sept. 6th 1939," typescript, Box 30, Folder 3, Nichols Additional Papers, SL; "Society Wife Crash Victim," *Boston Herald*, Sept. 4, 1939.

35. Brochure advertising *Jungle Islands*, Box 30, Folder 3, Nichols Additional Papers, SL; Sidney Nichols Shurcliff, *Harvard Class of 1927 Tenth Report* (Cambridge, MA: Harvard University, 1937), 287.

36. Shurcliff, *The Day it Rained Fish*, 76.

37. Correspondence related to SNS's lecture tours can be found in the Arthur A. Shurcliff and Sidney N. Shurcliff Papers, Series G (Correspondence/Personal Papers Sidney Shurcliff), Special Collections, Frances Loeb Library, Harvard Design School, Harvard University, Cambridge, MA; promotional materials for Sidney's ski movies can be found in Box 30, folders 2–3, Nichols Additional Papers, SL.

Everyday Lives: Home and Work in Amateur Film

2 Perspectives on the Home Movies of Charles Norman Shay, Penobscot Elder

Jennifer Neptune

ON A COLD, rainy day in June 2013, I had the pleasure of sitting with Penobscot tribal elder Charles Norman Shay at his home on Indian Island in Maine to watch 8mm home movie footage he had shot with his Bell & Howell camera between 1955 and 1972. Shay's home movies are both artistic and remarkable: spanning seventeen years and two continents, recording everything from glimpses of tribal history to his years in the US Air Force in Cold War-era Europe, as well as the celebrations and ordinary moments of his everyday life.

Charles Shay's footage, shot all those years ago, is important for its historical, ethnographic, and aesthetic qualities. While made to preserve memories for himself and his family, he also recorded moments from a truly amazing life that was filled with the love of family, travels, and adventures. He crossed oceans and cultures and shattered commonly held stereotypes of what a Native American man could achieve.

Born in June 1924, Charles was the eighth child of Leo and Florence (Nicolar) Shay. He spent the first four years of his life in Bristol, Connecticut, until lack of work resulting from the stock market crash of 1929 forced his parents to return home to the Penobscot Indian Reservation on Indian Island.

Charles was drafted into the US Army in April 1943, and trained as a surgical technician. Assigned to the First Infantry Division, his first combat experience as a newly trained medic would be on the shores of Omaha Beach on June 6, 1944—D-Day. He earned a Silver Star for his bravery and courage that day, treating countless injured and dying men while under heavy fire. In the spring of 1945, he was captured by the German army and spent a few weeks in a prisoner-of-war camp before being released and returning to the United States.

Discharged from the army in October of 1945, Charles worked briefly in Boston before heading home to Indian Island. Like many other Native American men and women returning to the reservation after World War II, Charles found the oppression, discrimination, and lack of opportunity intolerable. After his honorable service in the war, finding himself unemployed and being denied the

right to vote in state or federal elections because he was Native American was too much injustice to bear.

By 1946, Charles had reenlisted in the army and found himself stationed in the beautiful but devastated city of Vienna, Austria. Here he learned the German language and met the love of his life—Lilli Bollarth, a local Austrian woman. Married in the spring of 1950, they would share fifty-seven years together. Just four months after their wedding, Charles received orders to return to the United States to prepare for deployment to the war in Korea, where he served eleven months on the front lines as a combat medic in North and South Korea. Discharged from the army in 1952, Charles could not find work in Vienna and reenlisted in the US Air Force.

After several assignments in New York, Massachusetts, Florida, Oklahoma, and the South Pacific islands, Charles found himself at Mitchell Air Force Base, Long Island, New York, where, encouraged by a friend who was an amateur filmmaker, Charles purchased a Bell & Howell camera, spools of 8mm film, and a Keystone projector. His camera was fairly small and portable and came with a turret mount, allowing Charles to choose among three lenses attached to the camera. Like most 8mm cameras of that time, it recorded motion but not sound, with each spool recording approximately four minutes of color footage.

During our meeting in 2013, Charles explained that he had been interested in capturing memories for himself and sharing the movies with family and friends. He recalled how exciting it was getting the films back from the developer, setting up the screen and projector, and inviting people over to watch. In 2009, Northeast Historic Film, in Bucksport, Maine, transferred his 8mm film reels to DVD. Almost sixty years after he recorded his first home movie, I set up my laptop computer for us to view them together.

The very first reel we viewed brought tribal history to life in way I had never experienced. Charles was born to a very influential Penobscot family. His mother, Florence Nicolar Shay (1884–1960), and his aunt, Lucy Nicolar Poolaw (1882–1969), worked hard to improve social conditions on the Indian Island reservation, fighting for improvements in education, pushing for the right of tribal members to vote in state elections, and advocating tirelessly for a bridge connecting Indian Island to the mainland in Old Town. That bridge was eventually built in 1950, and I was able to drive across the Penobscot River from Old Town to Charles's home on Indian Island because of their hard work. As a tribal member, basketmaker, and anthropologist, I had heard stories about Florence and Lucy and had seen photographs, but to see them and their personalities brought to life on film was a gift I will long remember.

Among the most memorable moments in Charles's footage is a piece of Penobscot history that has almost completely disappeared. Penobscot and Passamaquoddy basketmakers had a long tradition of traveling to coastal resort areas for

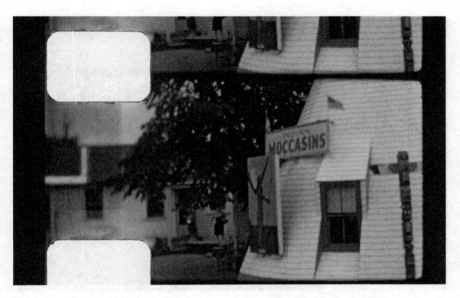

Fig. R2.1 House and teepee, home and shop of Lucy and Bruce Poolaw, Indian Island, Maine, 1955. From 8mm film. Charles Norman Shay Collection, Northeast Historic Film. [Accession 2515, Reel 1]

the summer to sell ash and sweet grass baskets along with other handcrafts. In 1955, Charles, accompanied by Lilli and her mother, filmed a visit to his family while they were in Lincolnville selling baskets during the summer. Charles's parents, Leo and Florence, set up their basket shop in a large canvas tent along Route One across from Lincolnville Beach. Their shop was one of the last remaining traditional basket tents, and it is memorialized in Charles's 8mm films.

On this same visit, Charles, his parents, sister, wife, and mother-in-law traveled to Indian Island to visit his aunt Lucy and her husband, Bruce Poolaw. Lucy and Bruce, a Kiowa from Oklahoma, met as entertainers on the vaudeville circuit. They built a two-story teepee next to their home and sold baskets made by weavers on Indian Island. They also organized Indian pageants and hired dancers from the community to put on shows throughout the state of Maine. The teepee is still standing on Indian Island; their home was purchased and lovingly restored by Charles and Lilli when he retired in 1988. In Charles's film we see the house and the teepee as they looked in the summer of 1955. His family smiles and laughs as they visit; Lilli walks up to the camera and looks into the lens. She circles around him as he follows with the camera, never averting her gaze. It is a powerful moment, beautifully capturing both the love between them and an important historical landmark for our tribe—the teepee.

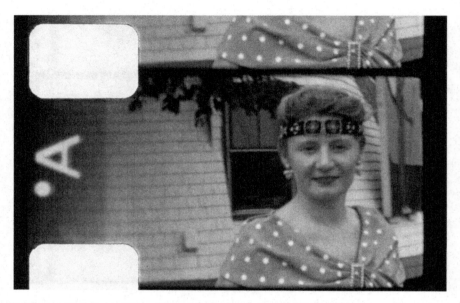

Fig. R2.2 Lilli Bollarth Shay, Indian Island, Maine, 1955. From 8mm film. Charles Norman Shay Collection, Northeast Historic Film. [Accession 2515, Reel 1]

Other than splicing spools of film together, Charles did not edit his films. Instead, he was mindful of setting up his shots ahead of time and thinking of how they would flow together as he was shooting. A good example of this is an afternoon cookout with Lilli and their son, Jonny, filmed while he was stationed in Colorado. Charles explained that they would often take drives together to see the scenery in their Volkswagen Beetle. In this segment, the scenes flow seamlessly from the landscape to an idyllic picnic spot beside the car with Lilli and Jonny in the background, to steaks cooking on the grill, to Lilli seated in a folded chair with the camera following as Jonny brings her a bouquet of wildflowers, to the family eating together.

Charles's films also document his life living, working, and traveling in post–World War II Europe. Like other home movie makers, he captures celebrations—birthdays, Christmas, New Year's parties—as well as the visits, beloved pets, childhood milestones, and everyday moments that make up a life. What makes these films special is the extraordinary life he has led as a Native American from a tiny reservation in Maine, making a life for himself throughout the United States and Europe. In a time when there were very few educational and employment options for Native people, Charles was successful in making a good life for himself and his family. His life and films effectively counteract negative stereotypes of Native American men. His films capture Native culture and life through the

Fig. R2.3 Lilli and Jonny Shay picnic near Colorado Springs, Colorado, circa 1962. From 8mm film. Charles Norman Shay Collection, Northeast Historic Film. [Accession 2515, Reel 9]

eyes of an insider—we see the love and laughter in our community and among our families that is so often overlooked by nonnatives who have photographed and filmed our community.

It is inspiring to see both the adventures and everyday moments of Charles's life in his films. Charles and Lilli spent summers fixing up their home, the teepee, and other property that had once belonged to his aunt. Sadly, in spring of 2003, Charles and Lilli returned to make this their permanent home, but Lilli passed away that same fall. Charles restored the teepee into a beautiful museum and shrine to his family. The family portraits painted on the teepee walls are the same faces that laugh, smile, and come to life in his films.

By the end of that rainy day in 2013, I had seen our tribal history come to life. I looked out the window of Charles and Lilli's first transatlantic flight; watched in fascination as Cold War–era Germany and Austria rolled past; and took a grand tour of Europe: the Alps, the Rhine, the Black Forest, Switzerland, the beaches of Italy, even catching a rare glimpse of the Soviet side of Berlin.

Sitting with Charles, two weeks before his eighty-ninth birthday, and watching his home movies, his memories, on that stormy June day revealed the power embedded in the moving images of an extraordinary life. We sat cozily in the living room of his home—the same home that had belonged to his aunt Lucy, the home that had been filmed by him fifty-eight years ago—surrounded by the beautiful things Charles and Lilli had collected during their lives together. As the

reels went by, his collection of authentic cuckoo clocks called out the hours. We laughed, cried, and often sat in silence together as his loved ones smiled, raised a toast, and waved good-bye from the screen.

Charles Shay is an inspiring example of living with courage, strength, and respect for himself and others. He has been able to walk gracefully in many worlds while maintaining traditional Penobscot values. His films are a gift, a legacy that has the power to inspire us and future generations. They link us, in a moving and personal way, to tribal history; they are a reminder of what a short and precious gift life is.

Technical Notes: Charles Norman Shay, Indian Island (1955) and Colorado Picnic (circa 1962)

Charles Norman Shay's 8mm movies exemplify both the changes in home movie technology and the changing nature of amateur filmmaking. As Neptune points out, Shay was not particularly interested in creating highly crafted, carefully edited films like many earlier amateurs. He clearly enjoyed capturing moments in a celebration of the 8mm camera's capabilities. Indian Island, from 1955, introduces subjects and follows them closely to create individual, very personal portraits. These shots were captured in a fairly typical shaky, handheld manner and were technically easy to film because of the small size and simplicity of the camera.

It is possible that Shay was using a Bell & Howell Model 172 8mm camera with film loaded in a magazine (instead of on a reel) and a three-lens turret. Colorado Picnic zealously uses the camera's zoom lens, then a new technological advance. In 1959, Kodak had released the film camera in the United States capable of a zoom, the Kodak Zoom 8. Zoom technology for 16mm came later, probably because the smaller format's popularity made 8mm a more profitable product. Shay remembers using a Bell & Howell camera, so it is a safe guess that Colorado Picnic was shot using the 1960 Bell & Howell Zoomatic 8 camera. Abraham Zapruder used a Bell & Howell 8mm Zoomatic when he filmed the assassination of President John F. Kennedy in 1963, but unlike Shay, who repeatedly zoomed in close and then out again, Zapruder stayed on the maximum close-up setting.

At first, zoom features were operated manually by pushing down or up on a lever sticking off the side of the lens. In later models, pushing a button generated an automatic zoom. The combination of a spring-loaded motor and automatic exposures made this an extremely easy camera to use and would have fit perfectly with Shay's desire to capture moments of time without becoming a highly technical filmmaker. Such advances made filmmaking so easy for the average user that sales of 8mm skyrocketed through the 1950s and into the 1960s.

One other important note regarding Colorado Picnic is the use of Kodachrome II color reversal film stock, which had just been released in 1961. Although

Kodachrome had been around for nearly thirty years, this new version was much faster, so it could be used in darker conditions. Kodachrome II reduced grain and contrast while increasing color saturation, which is why so many old color home movies look vibrant to this day. When watching the two Charles Norman Shay reels together, the color differences are unmistakable.

Indian Island, circa 1955. Charles Norman Shay.
Charles Norman Shay Collection, Accession 2515, Reel 1.
Gauge: 8mm. Stock: Kodak Safety Film (Kodachrome).
Length: 35 ft. Splices: Six within selection. Many more in overall reel.
Appears to mostly be splices to connect 50 ft. rolls, with the usual middle splice at 25 ft., plus a few repair splices where damaged frames were cut out.
Overall reel length: 450 ft.
Date code: 1955.
Camera code: Magazine Ciné-Kodak Eight Model 90? (some shots). Other shots on same continuous unspliced film have the picture extending nearly to the edge of the film, which could be many cameras (Bell & Howell Filmo Auto-8, Revere "60" Turret, Revere "70," Siemens-Halske Double Eight Magazine). None of the films in the collection arrived in Kodak mailer boxes, so it's unknown if he was using magazine film or not.
Other info: Overall reel has 1955 and 1956 date codes. All Kodachrome.

Colorado Picnic, circa 1962. Charles Norman Shay.
Charles Norman Shay Collection, Accession 2515, Reel 9.
Gauge: 8mm. Stock: Kodak Safety Film (Kodachrome II).
Length: 30 ft. Splices: one. This is the usual middle splice at 25 ft. in a 50 ft. regular 8mm reel. More splices in overall reel.
Overall Reel Length: 400 ft.
Date code: 1961.
Camera code: None visible. The thickness of the frame lines and borders look about the same as Reel 1, so this may just be a different exposure setting that has no identification mark.
Other info: 1962 date comes from note in original film can.

Jennifer Neptune is a member of the Penobscot Nation and Executive Director for the Maine Indian Basketmakers Alliance. She is an accomplished ash and sweetgrass basketmaker, beadworker, writer, herbalist, and Registered Maine Guide. She has worked in the field of cultural preservation for over twenty-five years. Neptune curated the exhibit Spirit of the Basket Tree: Wabanaki Ash Splint Baskets from Maine at the Hood Museum of Art, Dartmouth College.

8 Not-at-Home Movies

Christopher Castiglia & Christopher Reed

WES ANDERSON'S 2012 feature film *Moonrise Kingdom* won over critics and audiences with its quirky presentation of life on the islets and inlets of New England. This coming-of-age story struck a balance between aspirations to normality and appreciation of quirkiness, as between Down East hominess and cosmopolitan sophistication (signaled musically by the characters' fascination with Benjamin Britten and French pop music). Certain images in Anderson's film—maps animated with advancing dotted lines to plot the protagonists' trajectory, bouncing views from the windows of airplanes and the bows of motorboats, loving looks at the domestic architecture of the New England seacoast—combined the intimacy of nostalgia with the distance of self-conscious aestheticizing.

Some of the same images work to similar effect in the extraordinary amateur films made in the late 1930s by Cyrus Pinkham. Anderson and Pinkham, three quarters of a century apart and approaching filmmaking from very different trajectories, arrived at similar territory: a place between home movies and Hollywood cinema that we would be tempted to call a no-man's land if it were not so concerned with the fraught transition of boys to men. This essay takes up Pinkham's films to explore these issues in relation to the genre of home movies, the invocation of place, and the emotions associated with the aestheticization of time.

Part 1. Genre

Our claims for Pinkham's films seem far removed from the sites and feelings usually associated with home movies, often thought of as an unselfconsciously transparent genre of visual culture. The interest of home movies usually lies in what's in front of the lens. Any camera turned on that scene, in anyone's hand, it seems, would have captured the same moment. Along with transparency of the genre, we expect home movies to offer easy identification with the family histories and domestic rituals they typically depict.

But Pinkham's films are not ordinary home movies. Writing about amateur films of the 1939 World's Fair, Caitlin McGrath singles out Pinkham's version as "markedly different" in its attention to aesthetics. Unlike other amateurs,

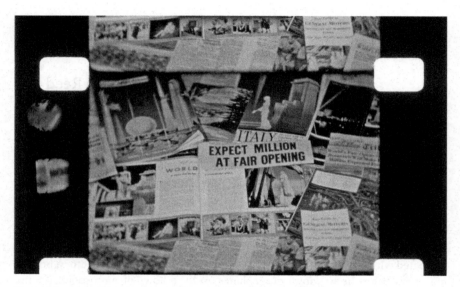

Fig. 8.1 Montage of New York World's Fair publications, 1939. From 16mm film. Cyrus Pinkham Collection, Northeast Historic Film. [Accession 2463, Reel 13]

who began filming when they arrived at the fair, Pinkham planned introductory sequences featuring a montage of fair publications and an establishing shot of the Queens fairgrounds from the vantage point of the Empire State Building. And where other amateur films of the World's Fair comprise eight to fifteen splices, McGrath reports, Pinkham's editing resulted in ninety-six. Pinkham took to heart the advice in how-to guides published by Kodak and the Amateur Cinema League for filming the World's Fair. These echoed the ideas Patricia Zimmermann has identified in industry-sponsored books and magazines for home filmmakers throughout the 1930s, which advocated the adoption of the "professional" styles of direction, photography, and editing seen in Hollywood films. Both McGrath's analysis of World's Fair footage and Zimmermann's broader study of home movies conclude, however, that most amateur filmmakers ignored this advice, simply turning on the camera, recording what they wanted to see, and presenting the result with little or no editing. Although McGrath interviewed Pinkham's surviving friends and family members, and they reported "he had no formal training as a filmmaker, did not belong to a cine-club, and did not subscribe to any filmmaking publications," she rightly observes that he "thoroughly absorbed classical Hollywood style and editing techniques and used them extensively."[1] Pinkham's accomplishment within the constraints of the 16mm (silent) home movie camera and splicing equipment of the 1930s registers his powerful fascination with cinematic language and technique, a perspective

Fig. 8.2 Margaret Pinkham, 1937. From 16mm film. Cyrus Pinkham Collection, Northeast Historic Film. [Accession 2463, Reel 2]

that returns us to issues of aesthetics. His films cherish the folksy family ways the camera records, but from an aesthetic distance informed by an identification with the glamour of Hollywood.

From the start—the first film on the first reel of his movies—Pinkham complicates the transparency of both "home" and "movies" by introducing Hollywood style into what an intertitle announces as "PICTURES of the FAMILY." The first "picture," intertitled "Margaret," features Pinkham's sister, who was twenty in 1937. Far from looking like a kid sister, however, Margaret looks like a movie star as she glides across the lawn in a long dress, poses for dramatically lit profile and full-face close-ups, and reclines, languorously blowing cigarette smoke in uncanny anticipation of Bette Davis in *Now, Voyager* (1942). A second intertitle introduces "Cyrus," who emerges from the house looking dapper in a blazer. Where Margaret exemplifies glamorous cinematic femininity, Cyrus takes an equally cinematic, but comic, approach to masculinity. Recalling Buster Keaton or Charlie Chaplin, he next appears as a scrawny figure falling off a high-dive board, then inching along it backward only to fall off again. Footage follows in which he wears glasses and theatrical makeup reminiscent of the comic silent-film star Harold Lloyd. The last scene shows him setting up theatrical lighting in the family dining room. Cyrus moves self-consciously here from slapstick actor to the star as seen off-stage and then to filmmaker. His footage does not so much document Pinkham's family and friends as "star"

Fig. 8.3 Cyrus Pinkham setting up lighting in the family dining room. From 16mm film. Cyrus Pinkham Collection, Northeast Historic Film. [Accession 2463, Reel 2]

them in films "produced by Cyrus Pinkham" (to take the vocabulary of other intertitles) and characterized by dramatic framing, close-ups, stagecraft, and lighting.

Cinematic artifice pervades scenes of Pinkham's family. An apparently mundane event—Margaret, eating at the kitchen table and getting up to give an affectionate welcome to her father, who then joins her at the table—is filmed from several angles, ending with a dramatic shot of the two filmed down a hallway, and preceded with the intertitle "Dad and Margaret do a scene 10/38." A more poignant episode of "Grandma" picking flowers, then arriving at a cemetery where she puts them on a gravestone marked "MOTHER," is clearly staged. Its elderly star repeats her mourning for different takes from different angles, ending with a dramatic shot of her walking away silhouetted against the sky.[2] Such cinematic effects run throughout Pinkham's films, with the many scenes of boat rides invariably shot both from the boat and from onshore. And although Pinkham's films document birthdays, Christmases, and family outings, these scenes are framed within other cinematic conventions. In the Christmas film, hand-turned calendar pages indicate the approach of December 25. When they visit the beach, Pinkham's cast cavorts like Hollywood actors, leaping over the camera as they run onto the sand, for instance, or the girls all turning in unison to sun their behinds like so many extras in a synchronized swimming extravaganza.[3]

Epitomizing this tendency to portray the mundane as cinematic is one of Pinkham's longer films, the eight-minute *A Day in a Young Boy's Life*. A double-exposed title sequence, in which the young star's face appears behind his name, presents Charles Stewart Jr., who grins infectiously through a day staged from crawling into his parents' bed in the morning, through a scrub in the tub, walks to and from school, a game of pickup football on the street with older kids, his father's return from the office, dinner, a boxing match with his dad, reading the "funnies" with his mother, to finally a sleepy yawn as he falls asleep in front of the fireplace. In addition to intertitles offering scraps of dialog, the self-consciously filmic gestures enlivening this narrative include the hands of a clock turning to mark the school day and a roller skating sequence in which freedom of play is registered by footage of the speeding skaters run both forward and backward (the same trick conveys the fun of summer on Boothbay Harbor in another film, where a motor boat rushes past, then seems to dance backward, consuming its own wake).

Hollywood and home movies fuse differently in footage Pinkham shot at New York City's Rockefeller Center on the day silent-film stars Mary Pickford and Buddy Rogers opened the rooftop gardens. Lacking the directorial control he exerted over friends and family, Pinkham here achieved a result more like typical home movies: with the stars in middle distance unsure what to do next, Pickford clutches her hat to keep it from blowing away in the wind. Pinkham's footage in the Rainbow Room at Rockefeller Center was made on a day when a professional crew, with its tall stage lights and giant cameras on dollies, was shooting. The effect here is familial: Pinkham, his camera, and his film take on a little-brother status in their depiction of the big boys at work. This domestication of Hollywood glamour complements Pinkham's glamorization of the domestic, in which Hollywood style distances his films from the usual immediacy of home movies and conferring familial intimacy on Hollywood stars.

One result of these cinematic references is that Pinkham's films never make viewers feel they are spying on—or bored by—someone else's private memories. These films were made for an audience, as we see in footage of his friends and family trooping down the stairs to his *Opening Night at Theater in Cellar* and arranging themselves as an audience before his camera.[4] Another effect of such self-conscious theatricality is that we do not slip into the visual complacency that the coherent artifice associated with Hollywood movies allows. Pinkham keeps stepping out from behind the camera or making the instruments of his craft—lights, cameras, intertitles—visible. His home movies are less films about his specific family than films about films about families. Such self-reflexivity reveals usually naturalized concepts like home and family to be far more staged than is usually acknowledged. Showing his family watching itself playing a family, Pinkham makes visible how films teach us to be ourselves, especially in the case

of "home movies," which prompt families to see a simpler, happier, fun-loving version of themselves, even while the distance of film and spectator puts an unhomey distance at the heart of that viewing experience. This self-consciousness about the proximity of affection and detachment, nature and artificiality, resonates with *Moonrise Kingdom*, as Pinkham's films delicately balance the competing claims of home and movies.

Part 2. Location

If home and family are cultural constructs often misperceived as natural, so too is region, especially when it is signified by a distinctive geography. Recent scholarship shows that by the late 1930s Maine was central to discourses of regionalism. Images of Maine filled publications like *Yankee* magazine (founded in 1935) and were widely distributed in advertising by railroads, the state tourist office, and businesses like L. L. Bean. The "Vacationland" slogan that first appeared on Maine license plates in 1927 is clearly visible in Cyrus's full-frame shot of the plate on the honeymoon car leaving Margaret's wedding in 1937.[5]

Pinkham's films endorse the Vacationland ideal. One offers a tour of a local attraction, beginning with its sign: "You are about to enter the Desert of Maine. You will never forget it." This freakish landscape opened as a tourist spot in 1925, a counterpoint to the nearby bays and beaches that are the setting of Pinkham's other Maine films. In one titled *A Vacation*, a young woman (Margaret) visits a friend in Wiscasset. Here, framed with such self-consciously cinematic devices as calendar pages turning to indicate the passage of time, vignettes show the friends enjoying a paradigmatic Down East holiday. They row in the harbor, meet friends in the quaint downtown, and take the ferry to Capitol Island. Many of Pinkham's films seem motivated to convey a sense of place. His reel of family pictures includes—as the intertitle puts it—"FAMILIAR PLACES." Short intertitled footage follows: "Grandma's House," "Dad's Old Home," and so on. But Pinkham's range expands the usual sites of "home movies," which conventionally fall into two categories of setting: the domestic for holidays and birthdays or, for family vacations, an extraordinary undomestic—even antidomestic—geography. Pinkham's films collapse this opposition, dwelling on the Maine landscape with an attention that conveys familiarity, lingering over the faces of unnamed locals with an affection like that shown for Grandma and Aunt Fan.

At the same time that they relish an idyllic image of Maine, Pinkham's films suggest that nature becomes "region" through selective framing. Maine is literally signed: his camera pauses on signs at railway stations ("Wiscasset"), docks ("Capitol" [Island]), and post offices ("Pemaquid Beach, Me."). It is also framed by the conventions of the picturesque: myriad shots of the coastline, often seen over the shoulder of someone taking in the view. Created at a moment when Maine was establishing itself as a tourist destination, these "home movies"

became indistinguishable from promotional photos in travel magazines. This conflation renders the natural artificial, displacing the familiar—and familial—into the realm of mass-mediated imagery. At the same time, the viewers within the frame suggest a self-consciousness about seeing, as the direct view is blocked by awareness of other, prior viewers.

It is easy to denounce the corruption of the authentic into the touristic—easy but illogical. The pastoral is an urban genre. The "authenticity" of "unspoiled" nature is a perception produced from the urban perspective, which understands the rural as reprieve. Pinkham's films engage both sides of this equation. Reels of leisure on the Maine coast contrast with two of Pinkham's most striking films, both documenting sites of cosmopolitanism in 1939: the World's Fair and the brand new Rockefeller Center. Both films are set in New York and both thematize a broader ideal of travel. Scenes of the rooftop Gardens of the Nations at Rockefeller Center and of the World's Fair's Court of States and national pavilions propose an ersatz global tour.

If Pinkham's Maine films take a visitor's perspective to aestheticize Maine as Vacationland, his urban films adopt the wide-eyed awe of the tourist to aestheticize the city. His camera slowly pans up the infinitely windowed sides of skyscrapers or focuses down on the legions of varied feet climbing stairs at Rockefeller Center. At the World's Fair, Pinkham casts himself in a vignette of the exhausted visitor throwing his worn-out shoes into the trash. Where McGrath notes that other amateur films of the World's Fair evince an interest in dirty puddles, maintenance workers, and "undecorated service entrances," revealing the artifice behind the gleaming spectacle, Pinkham celebrates the shiny white surfaces of the modernist facades, documenting rather than exposing the illusion.

The same is true at Rockefeller Center. Although Pinkham worked there as a tour guide, his camera never goes backstage.[6] We stand among the visitors buying tickets for a tour. The intertitles rehearse the official spiel, starting with "Rockefeller Center is the largest building project ever undertaken by private capital, consisting of fourteen buildings." The Rockettes dance in perfect unison. What unites Pinkham's images of Vacationland and his depictions of New York is his willingness to be enchanted by the mystique of place matched with his desire to convey that enchantment to his viewers.

Part 3. Nostalgia

Much of the enchantment of Pinkham's films lies in their nostalgic evocation of the acting styles and cinematography, the dream sequences and romance plots of already-outdated silent films. Another focus of nostalgia is suggested when his camera lingers over the craggy faces of Mainers on tiny ferryboats or the wide porches of old seaside houses. Even at the futuristic World's Fair, Pinkham attends to the past. Describing typical amateur films of the World's Fair, McGrath

Fig. 8.4 Family members on a boat trip, circa 1937. From 16mm film. Cyrus Pinkham Collection, Northeast Historic Film. [Accession 2463, Reel 11]

says, "Home-movie makers in 1939 did not view the World of Tomorrow with nostalgia; rather, they were intent on capturing and asserting their presence in its vision of the future." In contrast, for Pinkham the future frames the past. His camera lingers over entertainers in nineteenth-century costumes, the "Old New York" dance review, the family farm, the steam locomotive, and a parade of antique cars. What is explicit in Pinkham's World's Fair footage—that the past is nostalgic only from the perspective of the self-consciously modern—is implicit in the films of Maine. Returning to the sites of his childhood, Pinkham's Maine films often make child's play their subject, but more generally assume the view-point of a child trailing the elders (there are no scenes of adults-only venues, such as workplaces or late-night parties).[7] Here the medium provides the juxtaposition of modernity necessary for nostalgia. The cinematic technology emphasized by the intertitles and reverse motion creates an aesthetic frame for the sparkling waves seen through trees, the prow of a rowboat rising up above a camera placed at the roots of grasses on shore, figures silhouetted against the sunset or framed by architecture. This framing continually reminds us that what we see is representation: a timeless past figured in the modern present.

Pinkham's stylization anticipates the effects of *Moonrise Kingdom,* with its evocations of childhood—both the specific childhood of Wes Anderson and the idea of childhood in general.[8] As reviewers pointed out, the "obvious and worn on the surface" artifice of Anderson's film is key to its "distinctly adult perspective."[9]

It is a disquieting perspective for those who take their normativity straight. There are "those who accuse Anderson of precious or pretentious postmodern poseurness," says critic Andrew O'Hehir, though they "are missing the fundamental sincerity that lies beneath his view of movies and the world."[10] Something similar could be said about Pinkham's aesthetic, which seems genuinely nostalgic not so much for a lost innocence but for a lost sense of belonging, at the same time that it asserts the power of modern technology and sensibility to render that past. What Pinkham's—and Anderson's—movies show is that innocence, simplicity, and transparency take a lot of skill to produce. Both filmmakers demonstrate a certain pride in rendering a past that is too perfect to be anything but the self-conscious creation of someone who has moved on.

Conclusion: Camping in Maine

It's hard to think of Maine vacations without thinking of camps, the local term for summer houses. By the time Pinkham got to New York in the 1930s, however, "Camp" had another meaning, the "unmistakably modern . . . variant of sophistication" that, as Susan Sontag famously theorized, "goes by the cult name of 'Camp.'"[11] Camp, as Sontag says, is a "sensibility," a mode of perceiving: "It is one way of seeing the world as an aesthetic phenomenon." We invoke the double meaning of camp not just as a bad pun, but to suggest how a single frame—linguistic or cinematic—can pull together urban and rural, surface and depth, strange and familiar, past and present.

"Most campy objects are urban," Sontag says, but there is also "Rural Camp." What links the two is "a serenity—or a naiveté—which is the equivalent of pastoral." One way to look at Pinkham's films is as regional Camp: a stylized restaging of the land of "camps" as it was being conventionalized and commodified for urban audiences. It is a perspective that treasures the look of Maine—"Camp is a tender feeling," says Sontag—by aestheticizing it in ways both self-conscious and nostalgic. Explaining "why so many of the objects prized by Camp taste are old-fashioned, out-of-date, démodé," Sontag says, "Time may enhance what seems simply dogged or lacking in fantasy now because we are too close to it, because it resembles too closely our own everyday fantasies, the fantastic nature of which we don't perceive." Pinkham's assertions of time passing—the flipping calendar pages and turning hands of the clock—take part in this aesthetic of temporal distance.

Listing things that exemplify Camp, Sontag foregrounds old movies. "Warner Brothers musicals of the early thirties" are Camp, according to Sontag, and "the best examples" of Camp "are movie stars." Evocations of old movies and movie stars contribute to the campy effect of Pinkham's films, and the intervening years have undoubtedly increased their nostalgic charge. The years have also made us more attuned to—and less reticent about—the primary association of Camp

with gay identity. Sontag acknowledged this connection in her 1964 essay, which briefly considered the "peculiar affinity and overlap" between Camp and "homosexual taste," noting, "Homosexuals, by and large, constitute the vanguard—and the most articulate audience—of Camp." Since then, other critics have deepened that analysis, emphasizing Camp's exposure of artifice inherent in naturalized gender and sexual norms.[12]

Our knowledge that Pinkham turned out to be gay informs our willingness to see a Camp sensibility in the films he made when he was in his early twenties. We want to identify with his apparent pleasure in tagging along with his sister and her girlfriends, or what seems like his sly insinuation of a lingering shot of two handsome men, clearly together, smiling delightedly at one another in the crowds at the World's Fair. We are happy to read his homegrown Camp as proof of an organic connection between the situation of gay men in twentieth-century, middle-class culture and the ironic take on that culture that by the 1960s was being commercialized in the art world by Pop artists like Andy Warhol, and by the century's end had achieved widespread appeal in the films of John Waters and Wes Anderson. We want to see Pinkham as part of a legacy of gay aesthetic inventiveness that both drew from and contributed to the visual and thematic vocabulary of popular film.

Elements of self-conscious Camp in one of Pinkham's late films seem to confirm our analysis. When Pinkham picked up a movie camera again in the late 1970s after putting it down four decades before, he produced *Birth of a Bag*, a slapstick narrative involving a Rolls Royce, a dithering chauffeur (played by Pinkham himself), a badly behaved dog, and a demanding matron. These characters enliven straightforward documentary footage of workers in the small Maine factory where Cyrus and his sister (until her premature death in the 1950s) produced purses and hats for boutiques and upscale department stores.[13] In the end, the dog eats the newly made purse and the matron swoons. Shot in color, *Birth of a Bag* nevertheless evokes old silent films—and old Pinkham home movies—with its intertitles introducing the cast. Its self-conscious Camp comes at some cost to the charm and affection that characterized Pinkham's youthful films, yet that self-consciousness highlights a sensibility incipient in them.

The campiest of Pinkham's early films is also the most narrative. Opening with intertitles including "CYRUS PINKHAM presents" and "PEGGY SMITH in BE BEAUTIFUL?" (his sister using her married name) with further intertitles crediting the "screen play" and "titles," this short film about the norms of femininity opens with a bespectacled maid who, exhausted by dusting, drowses over a magazine advertisement headed, "Is it any wonder she's attractive to men now!" She dreams that she is the ad's stylish woman, who primps before the mirror, gets phone calls, and goes on dates (some of the glamour footage from the "Margaret" reel reappears here). The years 1934 and 1935 appear, she has a baby, and

more years flash by. Now it is 1939. She steps from her house to stop her children from throwing snowballs, but they ignore her. In frustration, she throws down her package and runs inside. The dream ends, the fancy clothes revert one by one to the maid's outfit, she wakes up and goes back to dusting. The nominal punch line—the maid is happier because she is not a pretty and affluent mom—competes with the more pointed suggestion that high- or lowborn, all women labor in frustration to produce the home life that looks so natural.

If *Be Beautiful?*, with its twin strands of humor and social commentary, is Pinkham's contribution to the canons of Camp, it exemplifies both the potential and the limits of that aesthetic. *Be Beautiful?* was clearly intended to amuse and was probably a lot of fun to make. But the exaggerated frumpiness of the maid with her ripped stockings feels condescending today, while the funnier scenes now are those most invested in the ideals of midcentury bourgeois femininity: Margaret, all dressed up, talking to the camera as if it were her date; the nightclub, awkwardly staged with spliced footage of different couples at the same little table; the chanteuse, more enthusiastic than glamorous, whom the audience applauds by tapping little mallets on the table. *Be Beautiful?* seems to demonstrate one of Sontag's axioms: "One must distinguish between naïve and deliberate Camp. Pure Camp is always naïve. Camp which knows itself to be Camp ("camping") is usually less satisfying." Sontag's conclusion problematically privileges the connoisseur over the creator, the critic over the producer, denying Camp's powerful potential when deployed as an affirmation of gay community. But her distinction says something useful about this film, where the Camp is naïve. There is an earnestness, at once exasperating and touching, to the premise that Peggy Pinkham Smith's conventional femininity is an ideal to be realized in accession to motherhood, no matter how theatrically exasperated.

In contrast to this gender-normativity, what is counternormative about Pinkham's films is their extraordinary stylization—their determination to wrench the maximum beauty from the tools available to home movie maker. Perhaps his aesthetic legacy should be traced not just to Warhol or Waters, therefore, but to Jonathan Caouette's controversial 2003 *Tarnation*, beautifully constructed from Super 8 footage Caouette had been shooting since he was eleven years old. Caouette's exploitation of the range of visual possibilities available in the iMovie editing software that came with home computers of his era echoes Pinkham's use of the home movie equipment of his day, even as the nostalgic wholesomeness of Pinkham's representations of family are as different from Caouette's horrifying depictions of his dysfunctional family as wistfulness is from rage. Despite their differences, the distance imposed by Pinkham's aestheticizing reflects a sentiment articulated by Caouette: "Being young and gay, you're already detached from your surroundings because no one knows what you're really like."[14]

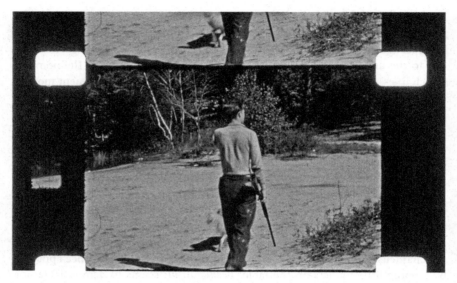

Fig. 8.5 *Hunting*, 1937. "Boy," played by Winthrop Rolfe. From 16mm film. Cyrus Pinkham Collection, Northeast Historic Film. [Accession 2463, Reel 6]

This sense of alienation is in poignant tension with a desire to connect in what may be Pinkham's most beautiful film, which takes as its subject neither family nor New York, but a maimed boy almost exactly Pinkham's age.[15] *Hunting*, "Produced by Cyrus Pinkham" and "Filmed around North Conway, N. H.," according to the intertitles, had a cast of two: "Boy," played by Winthrop Rolfe, and "Dog," played by Teddy. Boy, who has lost an arm, emerges from a shack carrying a rifle; framed in various artful compositions involving leaves and dappled light, he walks with Dog through the forested mountainside, gazes at views over the valley, drinks water from a rushing stream, and kneels to shoot at birds. A desire for kinship with a loner whose difference is visually marked animates this footage. A similar impulse undoubtedly colors the pleasure we take in Pinkham's films. As we gaze back nostalgically at his already-nostalgic imagery, we are aware that we are constructing Pinkham in the image of the alienated aesthete as surely as he was constructing Maine in the image of Vacationland. But these acts of construction-as-recognition express shared sensibilities that are the outcome of shared experiences and serve a purpose in creating identities based on region or sexuality or anything else. In a queer way, Pinkham's not-at-home home movies, with their campy relation to time and place, become our home movies, a source of pleasure in the here and now.

Technical Notes: Cyrus Pinkham, *New York World's Fair* (1939) and *Hunting* (1937)

Of the films discussed in this volume, the work of Cyrus Pinkham stands out as some of the most deliberately edited examples of amateur movie making. Virtually none of the shots in his World's Fair film was in-camera edits, so he would shoot a scene and then choose only a portion of it to construct his narrative. Pinkham used a 16mm Ciné-Kodak Model K camera, which featured a spring-wound motor. Kodak released the Model K in two versions: one with a f/3.5 lens and the other with a more expensive and faster f/1.9 lens. When measuring lens speed, one might think of it as less is more, meaning that the lower the number, the more light the lens allows in. For instance, an f/1.9 aperture could be used indoors, whereas f/3.5 would need brighter light. The Model K has nine aperture settings from f/1.9 to f/16 marked on the outside of the camera, indicating to the user how to adjust the amount of light coming through the lens. Setting the aperture also permitted the filmmaker to control depth of field. The wider the aperture, the smaller the f-stop number, and the shallower the depth of field.

Pinkham was one of a number of amateur filmmakers trying to shoot movies that mirrored traditional Hollywood editing by hiding his intrusions and exploiting the strengths of his equipment to create a seamless narrative.

At the time of their digital transfer, both Pinkham films exhibited a form of deterioration known as "vinegar syndrome" in which the acetate film base breaks down, becoming brittle and shrunken. The deterioration releases an acetic acid that is chemically similar to vinegar and emits a comparable odor. Vinegar syndrome is generally caused by poor storage conditions such as high heat or humidity levels and can spread to other films stored nearby.

New York World's Fair, 1939. Cyrus Pinkham.
Cyrus Pinkham Collection, Accession 2463, Reel 13.
Gauge: 16mm. Stock: Macy Safety (B&W reversal) for live action, Kodak Safety Film (B&W negative) for end title card.
Length: 330 ft. Splices: ninety-eight. Most appear to be original edits, some may be midscene repairs.
Overall reel length: 330 ft.
Date codes: none for live action; 1937 for end title card.
Camera code: Ciné-Kodak Model K f-1.9 or f-3.5.
Other info: Vinegar syndrome.

Hunting, 1937. Cyrus Pinkham.
Cyrus Pinkham Collection, Accession 2463, Reel 6.

Gauge: 16mm. Stock: Macy Safety (B&W reversal) for live action, Kodak
Safety Positive (B&W print) for intertitles.
Length: 125 ft. Splices: eight within section. Additional splices in first part
of overall reel.
Overall reel length: 225 ft.
Date codes: none for live action, 1937 for intertitles.
Camera code: Ciné-Kodak Model K f-1.9 or f-3.5.
Other info: Intertitles appear to be homemade and have the same camera
code as the rest of the film. Reel 6 first section contains footage of the
Desert of Maine and "Mother flying" separated by leader from *Hunting*
section. Vinegar syndrome.

Christopher Castiglia is Distinguished Professor of English and Women's, Gen-
der, and Sexuality Studies at Pennsylvania State University. He is author of sev-
eral books on nineteenth-century American literature, including *Bound and
Determined: Captivity, Culture Crossing, and White Womanhood from Mary
Rowlandson to Patty Hearst*, and author with Christopher Reed of *If Memory
Serves: Gay Men, AIDS, and the Promise of the Queer Past.*

Christopher Reed is Liberal Arts Research Professor of English and Visual Cul-
ture at Pennsylvania State University. In addition to his publications about the
Bloomsbury group and about Japanism, he is author of *Art and Homosexuality: A
History of Ideas*, and author with Christopher Castiglia of *If Memory Serves: Gay
Men, AIDS, and the Promise of the Queer Past.*

Notes

1. Caitlin McGrath, "'I Have Seen the Future': Home Movies of the 1939 New York World's
Fair," *The Moving Image* 13.2 (Fall 2013): 74–76. Patricia R. Zimmermann, *Reel Families: A
Social History of Amateur Film* (Bloomington: University of Indiana Press, 1995), 65–72.
2. An alternative explanation is that these films were shot from different angles at the
same time using two different cameras—an equally cinematic approach to home movie mak-
ing. This seems less likely, however, given that there are no shots of anyone using a movie cam-
era, a subject that would have suited Pinkham's predilection for reflexivity, as demonstrated by
the footage of projecting the films.
3. Pinkham's film follows the kind of advice offered in journals like *American Cinematog-
rapher*, as quoted by Zimmermann: "Pick a picture that has beach shots in it. Look them over
and see what the professional did to make his shots effective" (Zimmermann, *Reel Families*,
67). Pinkham's adherence to Hollywood styles here and elsewhere cast some doubt on the
accuracy of reports by friends who knew him later that he did not read such sources.
4. This short film, *Opening Night at Theater in Cellar* (1938), can be viewed at oldfilm.org
/collection/index.php/Detail/Collection/Show/collection_id/471

5. Donna M. Cassidy, *Marsden Hartley: Race, Region, and Nation* (Lebanon, NH: University Press of New England, 2005), 20, 37, 66–67.

6. On Pinkham's biography, see "Biographical/Historical Notes," Cyrus Pinkham Collection, Northeast Historic Film, accessed at oldfilm.org/collection/index.php/Detail/Collection/Show/collection_id/471

7. Pinkham was born in Rockland, Maine, in 1915, and his family was still living there at the time of the 1930 census. He attended high school in Maryland, and by the time he was making these films his parents were living on Long Island.

8. Anderson performed with his brother in a children's theater production of Benjamin Britten's *Noye's Fludde*, which is what the community is staging in *Moonrise Kingdom*. Andrew O'Hehir, "Wes Anderson on *Moonrise Kingdom*" [interview], *Salon*, June 1, 2012, accessed at http://www.salon.com/2012/06/01/wes_anderson_on_moonrise_kingdom_im_trying_to_make_something_unfamiliar/.

9. Andrew O'Hehir, "*Moonrise Kingdom*: Wes Anderson's mid-'60s love story," *Salon*, May 23, 2012, accessed at http://www.salon.com/2012/05/23/moonrise_kingdom_wes_andersons_mid_60s_love_story/.

10. Andrew O'Hehir, "Wes Anderson on *Moonrise Kingdom*."

11. Susan Sontag's 1964 "Notes on Camp" was anthologized in her *Against Interpretation and Other Essays* (New York: Farrar, Straus Giroux, 1966), 275–92, and is widely republished in both print sources and on the Internet. The *Oxford English Dictionary* dates this use of "camp" to 1909.

12. See, for example, Fabio Cleto, ed., *Camp: Queer Aesthetics and the Performing Subject* (Ann Arbor: University of Michigan Press, 1999); Moe Meyer, ed., *The Politics and Poetics of Camp* (London: Routledge, 1994).

13. See "Biographical/Historical Notes" cited at note 6. An article, "Maine Housewife's Pin-Money Job Turns into Big Business" in the *Lewiston Evening Journal*, March 10, 1951, reports: "In May, 1949, Mrs. Smith, on her sewing machine in her Randolph home, turned out her first 'Margaret Smith' handbag. That handbag has ballooned into a business that weekly ships out an average of 1500 handbags from the Gardiner post-office to major stores all over the United States, Puerto Rico, the Virgin Islands and Bermuda . . . 'I went into business,' readily admits the very attractive, red-headed Mrs. Smith, 'because I hate housework.'" The article credits Cyrus, "who for fifteen years had been an advertising man with a top flight New York hat concern," with helping his sister rapidly develop a market. A picture shows Margaret, Cyrus, and Bill Waters. An account on a vintage clothing blog adds that "her bags were sold in women's specialty shops and in the 50s/60s were carried by Bonwit Teller. Margaret Smith Inc. dropped its clothing line in 2005 and closed completely in 2008" (forums.vintagefashionguild.org).

14. Quoted in Gareth McLean, "My Life, The Horror Movie," *The Guardian*, accessed at www.guardian.co.uk/film/2005/apr/16/features.weekend.

15. Winthrop Rolfe was born in 1916, Pinkham in 1915.

9 The Boss's Film: Expert Amateurs and Industrial Culture

Brian R. Jacobson

AMATEUR FILMS POSE unique interpretive challenges to modern viewers and historians. They encourage speculative readings based more on contemporary ideas about their subjects than the historical realities—often unknown, always incomplete—of their production, distribution, exhibition, and reception. We read them—as much as, if not more so, than other kinds of films—through the lens of the present, mediated by both our distance from the past and our preconceptions about it. This lens shapes, no less, the very choice of the objects we examine. With amateur films, the historian and archivist face what might seem like an undifferentiated mass of often quotidian footage: hunting trips, beach scenes, train rides, plane flights, children playing, dogs barking, horses jumping, people running. How does one choose what deserves further consideration? To what degree and in what ways can the historian illuminate both the chosen content and the choice of it? And what kinds of unexpected insights can even the most orthodox of choices produce?

This essay poses these questions about a small selection of films taken from two moving image collections at Northeast Historic Film in Bucksport, Maine. Its title—"The Boss's Film"—already suggests why these particular films have been selected and one interpretive lens through which they might be analyzed. Two come from a collection of films made between 1926 and 1941 by Henry Sturgis Dennison (1877–1952), the "boss" of paper products company Dennison Manufacturing in Framingham, Massachusetts. Dennison's films include footage—much of it skillfully captured—of family trips to Martha's Vineyard, Niagara Falls, and Yellowstone National Park; holidays spent at the family's lodge near Springfield, Maine; scenes of leisure time at the family home; hunting, hiking, and river trips; and sporting events. Several films, though, focus on Dennison's working life. The first, most likely shot in late 1927, presents workers leaving the Dennison factory in Framingham. One sequence captures a long stream of workers who pass the filmmaker as they depart from the factory, which is visible on the opposite corner. A second sequence includes departing workers carrying gifts, and the factory, here seen from several vantage points, decorated for

the holiday season with garlands looping around the building's colonnade and a large wrapped present on the front lawn. A second film, shot in 1936, features the boss on his own lawn, sitting, talking, and pacing in the sun with economist John Kenneth Galbraith.

The final film comes from a collection made by Charles B. Hinds (1881–1958), the owner of a hand cream company in Portland, Maine. Like Dennison, Hinds used film to record both his working and family lives, including travel, leisure, and public events. And like Dennison, he made his employees film subjects. But rather than capturing them leaving their work, Hinds put his camera in the midst of it. His 1925 factory film documents the company's production process at length, from the initial preparation of their trademark cream, to successive stages of bottling, labeling, packing, and shipping.

Why these films? What do Dennison and Hinds—and their respective films—have in common? What can they tell us about amateur filmmaking? About the aesthetics of home movies? About bosses and workers in the first half of the twentieth century? Or about today's interest in yesterday's amateurs, experts, and celebrities? This essay uses such questions about the Dennison and Hinds films to challenge the assumptions that have guided their selection. It argues that these films likely meant something rather different at the time of their production than the assumed meanings that attract us to them now. It also uses them to explore both the changing meaning of amateurism and the early development of industrial film as a form of advertising in cinema's late silent period.

Dennison's factory films, for instance, evoke the kind of enlightened paternalism often associated with nineteenth-century bosses like the Lumière brothers. The Lumières' factory gate film—*La sortie de l'usine Lumière à Lyon* (*Workers Leaving the Lumière Factory*, 1895)—helped inspire other filmmakers and factory owners to do something similar. Its importance as one of the world's first films continues to make similar films like Dennison's interesting for historians. But while they may share similarities, we should not assume that these films are all the same. Indeed, Dennison's film presents a very different idea about workers, one rooted in a new conception of management and labor relations for the changing business world that he hoped to create. Below the surface of what we see today, Dennison's "workers leaving the factory" was about a new way of managing employees—a business strategy that became a corporate policy. Similarly, his home movie of John Kenneth Galbraith—which might appeal to today's audiences for its behind-the-scenes look at an internationally recognized public figure—was nothing of the sort at the time. Galbraith was still a relatively unknown young academic. Rather, the film documents Dennison's efforts to turn his management policy into an influential business idea that might, with the help of an eager economist, become an economic theory. It, too, is a film about labor—intellectual labor—and the work of thinking that businessmen like

Dennison thought could transform Depression-era economies and save American capitalism from itself.

Together with Hinds's depiction of his company's manufacturing process, these films offer a fascinating visual survey of factory life—as the owners saw it—in New England during the decade divided by the Wall Street crash of 1929. They present a world shaped by efficient processes that produced, for a time, progress and prosperity, but left even the most well-to-do in a state of uncertain reflection. In the decades to come, film would become a critical and widely used component of business strategy. These films offer one way of understanding, at a micro level, how an idea of film's importance for industry took root in the quotidian practices of individual bosses.

They do so only if we treat them not simply as windows into the past but rather as documents of the historical processes from which they emerged. These films teach us about industrial life at two New England factories, about the interests of their bosses, and about the aesthetics of amateur filmmaking in its early years. But beyond what we can read *from* them, Dennison and Hinds's films also offer an opportunity to read *through* and *around* them to understand the context that shaped their creation and that they, in turn, helped to shape. Looking back from a world in which moving images are central to advertising-driven capitalist consumer culture, these films demand that we cast aside our assumptions about film's integral role in industry and ask what motivated bosses to pick up cameras in the first place.[1] What, we should ask, must they have thought they were getting into? And what kinds of assumptions and expectations shaped their films and filmmaking practices?

Process and Efficiency: An Expert Amateur Films the Factory, 1925

By the time Charles Hinds made his factory film in 1925, the idea of capturing industry on film was nothing new. Films about industrial life had become common and had a long history dating to the earliest days of cinema.[2] The Lumière operators, for instance, brought industrial life to the screen not only in well-known films such as *Workers Leaving the Lumière Factory* and *The Arrival of a Train at La Ciotat* (*L'arrivée d'un train en gare de La Ciotat*, 1895), but also in numerous other films about train and steamship arrivals, building construction and demolition projects, and the coal, oil, and metal industries.

In the United States, the Edison Company and American Mutoscope and Biograph had long produced industrial subjects. As a young man, Hinds might have seen Edison films about the Union Iron Works (1898), Biograph's Westinghouse Works series (1904), or films with titles such as *Loading Sugar Cane* (Biograph, 1902) or *Logging in Maine* (Biograph, 1906). Such films were a common feature of film catalogs, where they were grouped in categories including the "machinery film" and "industrials." During the 1910s, numerous production

companies continued to produce industrial films, while in-house production began at corporations such as the Ford Motor Company, which created its film unit in 1913.³ Such developments may have inspired Hinds by demonstrating the value and appeal that industrial films might have for both bosses and their workers. In sum, film was already on its way to becoming one of the boss's many concerns.

In another sense, however, Hinds's film was both exceptional and, arguably, ahead of its time. At the very least, Hinds was an early adopter. While film companies and major corporations like Ford could devote time and resources to film production in the 1910s, it would take the development of cheaper, easier-to-use small-gauge film equipment in the 1920s to allow—or, in some cases, convince—amateurs and small-scale industrialists and business owners (not to mention many larger corporations) to see film as an accessible leisure accessory or useful tool. The standardization of 16mm film stock in 1923 and the efforts of three companies—Eastman Kodak, Bell & Howell, and Victor Animatograph—to promote 16mm cameras and projectors to consumers beginning around 1923 created America's first widely used amateur film gauge.⁴ By 1926, the year after Hinds made his factory film, the idea of bosses making amateur industrial films had entered industry discourse. Bell & Howell president Joseph McNabb, for instance, promoted the idea in the consumer magazine *Amateur Movie Makers* in a December 1926 article entitled "The Amateur Turns a Penny."⁵

Hinds's film suggests that he had either seen earlier industrial films and sought to reproduce their basic form, or that he shared earlier filmmakers' intuitive sense of film's ability to match the character of factory production. In particular, Hinds produced a version of the common industrial film form that we might term "the procedural aesthetic"—a scene-by-scene structure that follows the step-by-step process of factory production. Jennifer Peterson has described this technique of using "one shot per action"—which she reads in earlier films such as the Kalem Company's *The Concrete Industry* (1913)—as the formal response to Taylorist production. Just as Taylorism sought to boost manufacturing productivity by breaking it down "into a series of discrete tasks," so, she argues, filmmakers developed efficient ways of narrating those efficient processes.⁶

The Hinds factory film uses this procedural aesthetic to sketch out the factory's production process in just over five minutes. The film begins in a room with large, steaming metal vats, where production of the company's almond hand cream also begins (figure 9.1).⁷ A man in suit and tie, shot from the waist up, enters from the left smoking a cigarette. The camera pans smoothly right to follow him and pauses momentarily in a medium-long shot framed by a column in the left foreground and windows that reach beyond the top of the frame some dozen feet in the distance. The man stirs vats with two workers—including one in a white shirt and apron who smiles gleefully at the camera—then surveys

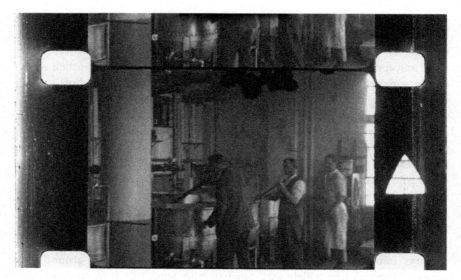

Fig. 9.1 Stirring vats at the A. S. Hinds factory, Portland, Maine (1925). From 16mm film. Charles B. Hinds Collection, Northeast Historic Film. [Accession 2426, Reel 10]

the room while the workers continue stirring. The camera vacillates somewhat uncertainly between the three men—as if Hinds was frustrated by his inability to contain all three in a single frame—before cutting away, satisfied, we might assume, with having recorded step one.

The next scene begins with a striking composition. A woman, shot from behind, appears framed between a bottling machine on her left and a column like the one in the previous scene in the middle distance. The camera pans slowly right to follow a line of empty bottles that move, slightly more slowly, in the same direction. Both pause in front of a machine that fills empty bottles with hand cream before the camera continues its pan, now following full bottles before the shot ends with a second woman seated before yet another machine. A cut shifts to a closer view of bottles being raised and filled. With that process completed, the film cuts again—one shot for one task—to a close-up view of a different rotating machine that directs filled and capped bottles to the seated woman from the previous shot. As she guides them along their path, the camera again follows, panning left to right past the woman and down the line. The next cut jumps forward with the bottles to the next station and another woman, who is again shot from behind but who sneaks a stealthy look at the camera while overseeing a labeling machine. A cut to a close-up of the latter confirms a consistent pattern— overview, close-up, pan to the next step—that underscores Hinds's adoption of the procedural aesthetic's iterative form.

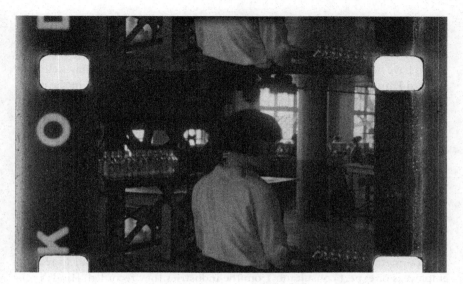

Fig. 9.2 Hinds focuses on successive stages of the production process and individual workers. From 16mm film. Charles B. Hinds Collection, Northeast Historic Film. [Accession 2426, Reel 10]

The next cut shifts to a new scene and the final phase of production: packing and shipping. The procedural formula initially remains in place. This time we see a man who looks over his shoulder at the camera as he prepares to load a machine to his right. The camera pauses to wait for him, then pans, again left to right, to follow the bottles, now in boxes, as they glide farther along. At this point, the end of the line signals the end of the pattern. A new series of shots shifts between workers building boxes—images of rapid efficiency that evoke the motion studies of industrial engineer Frank Gilbreth—then tables of women who appear to be processing orders or recording production data. The film concludes with a series of shots at the loading dock. A rapid pan from left to right and back shows large boxes waiting to be delivered. An exterior shot—what one might expect to be the film's conclusion—captures a loaded A. S. Hinds Co. delivery truck pulling away. But three more shots follow: two record men passing boxes from the loading bay to the dock, and in the final shot, a smiling man sorts through what appear to be stencils used to label boxes for shipping.

Although generally well shot and organized, the film at times betrays the amateur behind the camera. It contains a number of "mistakes" commonly cited in popular industry-dictated discourses about amateur filmmaking. The kind of uncertain panning seen in the first vat-room scene, for instance, would come to be mocked by critics who created the term "firehosing" to describe the

more extreme versions of this tendency to move the camera without sufficient motivation.[8] Similarly, some of the panning shots of women recording shipping information, and especially the back-and-forth pan in the first loading dock shot, would have been criticized for moving too rapidly. Finally, critics may well have accused Hinds of poorly planning the film shoot, thereby resulting in the peculiar ordering of shots in the final sequence.

Hinds may have agreed. Indeed, there is evidence to suggest that he was not entirely satisfied with this series of footage. Later on in the same reel, new scenes in the factory capture similar locations from different angles. Most notably, he seems to have made an effort in these additional shots to record more workers and their faces, as if attempting to correct for the tendency to shoot workers only from behind in many of the earlier scenes.

Whatever its intended purpose, this additional footage points to the film's compelling mix of amateurism and expertise. Hinds may have been an amateur when it came to filmmaking, but he was, after all, an expert in the factory's production methods. In contrast to industrial film producers who had to rely on employees or expert consultants from the industries they recorded, Hinds's role was all encompassing—amateur filmmaker, expert boss. This expert amateurism defines the mix of amateur "mistakes" and Hinds's skillful deployment of the procedural aesthetic to match the factory processes he knew so well.

Putting aside judgments about his film's quality, one is left to wonder about Hinds's motivation for making it, how it would have been used, and what effect it might have had on its viewers. Did Hinds intend to "turn a penny" by using his amateur industrial film in the way Bell & Howell's president imagined? Was it a home movie that he hoped to share with family and friends interested in his work? Would it have been shown to the employees themselves? Such questions are difficult to answer with certainty. Hinds's decision to capture the entire step-by-step process resulted in a film that might have satisfied any of these potential uses. And one can easily imagine him narrating the production process and reveling in the efficiency that his film makes legible through careful framing and panning from step to step and in its formal adherence to the factory's procedures.

That emphasis suggests just how important it was to Hinds not only that his factory be efficient but also that its efficiency be instantly recognizable. This was not a unique goal. For American manufacturers in the 1920s, the influential theories of scientific management, developed by Frederick Winslow Taylor beginning in the 1880s, had made efficiency and productivity dominant ideals.[9] Industrial films offered bosses a way to demonstrate their efficiency, and many cannily recognized that film offered formal means to reveal and even enhance it on the screen. On the other hand, assuming that all bosses used film in this way ignores other important uses for film as a representation of industry and the range of ideas that it presented. The factory film made by Henry Sturgis Dennison in 1927

illustrates one such possibility as well as the importance of historical context for interpreting these kinds of films.

Progress and Prosperity: Workers Leaving the Factory, 1927

That Dennison used film to capture and share images of his working life is no surprise—he was an eager amateur filmmaker. He produced striking images of domestic life and family vacations. He experimented with Kodacolor, Kodak's early color stock. He and his son-in-law even produced a sponsored film in 1929. John Kenneth Galbraith later noted that, when it came to his many interests, Dennison refused to be a dilettante, and film seems to have been no exception.[10]

Unlike Charles Hinds, Dennison does not seem to have produced any footage of his factory floor. Instead, he opted for a "factory gate" film in the tradition of the Lumières and other early film companies such as the English firm Mitchell & Kenyon.[11] Rather than making an image of productivity and efficiency in the factory, Dennison chose to show his workers liberated from it. His choice raises a number of questions: Why not record footage in the factory? Did Dennison ever consider making industrial films about his company? What purpose did he hope his factory film might serve? What kind of image of work and workers is this?

The film itself offers only limited evidence with which to respond. It captures the workers' end-of-day departure, likely on different days. Lacking a single factory gate on which to focus, Dennison opted for a series of views that offer various perspectives of the factory and its workers. In the first sequence, the camera begins a few hundred feet down the block so that the factory still dominates the background, but groups of workers can also be seen approaching in a line from the distant right and entering from a side street in the left middle ground. From this position, Dennison creates a dynamic visual field—a kind of camera funnel that directs workers entering from left and right to the same rear exit.

After several minutes, Dennison moves slightly closer to the factory and uses frequent pans to focus briefly on selected workers before moving, finally, to a position just adjacent to the factory itself for closer footage of workers passing in single file. After a brief close-up shot of a single man, new footage commences, perhaps on a different day, with shorter shots that shift among several locations. Many of the workers carry packages, and shots of the decorated factory façade suggest that these are holiday gifts.

On the surface, the film presents a paternalistic view of the factory and its workers, who are shown to be happy, well treated, and not working. They are the beneficiaries of an enlightened owner who decorates their workplace and shows his appreciation for their labor not simply by paying them but also through special seasonal gifts. Rather than showing the workers at work—whether to valorize

Fig. 9.3 Dennison creates an impression of abundance in his factory film (1927). From 16mm film. Henry Sturgis Dennison Collection, Northeast Historic Film. [Accession 2177, Reel 76]

their labor, treat them as efficient cogs in a corporate machine, or to ignore them in favor of real machines—this boss's film leaves that work hidden behind the factory façade and the smiling faces of workers in a moment of postwork pleasure. This somewhat cynical interpretation of the film may be precisely what Dennison had in mind. But it also ignores the more complex view of labor and factory management that shaped Dennison's decisions as factory boss and, arguably, as amateur factory filmmaker.

Dennison's approach to his company and his ideas for reforming American business suggest a different reading of the film. If Hinds's amateur industrial film was about demonstrating the efficiency and productivity of the work itself, Dennison's factory gate film was about the progress and prosperity that might result if it was done well. For Dennison, doing it well involved new approaches to managing and treating the kinds of workers he filmed leaving his factory. His ideas were the product of the same concerns with efficiency and productivity that influenced Hinds, but they developed in different ways.

Like Hinds, Dennison valued—indeed, championed—efficiency and had long embraced the principles of scientific management. After graduating from Harvard in 1899, he entered his family's business, which manufactured stationary goods, shipping labels, and jewelry boxes.[12] Although initially employed as a low-level manager, Dennison quickly promoted reforms based on his growing

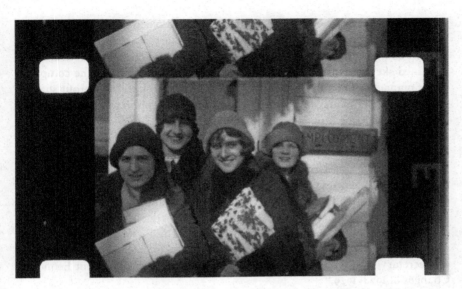

Fig. 9.4 Dennison's image of smiling workers standing in front of an employment sign with holiday gifts evokes both paternalism and sound management practice. From 16mm film. Henry Sturgis Dennison Collection, Northeast Historic Film. [Accession 2177, Reel 76]

awareness of the scientific management approaches being implemented at businesses such as the National Cash Register Company (NCR) in Dayton, Ohio, which he visited in 1901. His earliest reforms—modeled on NCR policies—included employee bonus and suggestion systems, and the company soon added new worker facilities including a clinic, cafeteria, library, and other amenities such as a social club and savings bank.[13]

These kinds of reforms were consistent with contemporary practices of welfare capitalism. During the Progressive Era, many American businessmen sought to counter growing reform movements by promoting good worker relations that still maintained the capitalist's best interests. Dennison initially followed this pattern, but in the early 1910s he began to develop a different program that would set him apart from many of his contemporaries. He initially focused on reforming his company's corporate structure. In particular, Dennison sought to end absentee management by revoking voting power from stockholders not involved in the day-to-day activities of running the company. The company, he argued, needed on-site expert managers to implement ultimate efficiency.[14]

Dennison's interest in scientific management and his association with key figures in the movement, including Mary Parker Follet and Henry P. Kendall, continued to shape his approach to management practice and employee relations in the mid-1910s. Concerned about losses associated with employee turnover, he

implemented new systems for hiring, training, and placing workers; instituted better planning practices designed to avoid layoffs due to work shortages; and created the country's first corporate unemployment insurance program.[15] Dennison remained skeptical of the average worker's ability to understand the complexities of management policies—rejecting, for instance, proposals for profit-sharing programs for nonmanagement employees—but his attention to creating positive labor relations made him an unusual boss in the 1910s.

After World War I, Dennison's approach became more liberal under the influence of Woodrow Wilson, for whom he served on the planning and statistics section of the War Industries Board and as a representative to the President's First Industrial Conference in 1919.[16] Dennison became an advocate of collective bargaining. He instituted work councils in Framingham and agreed to profit sharing with blue-collar workers after 1920.[17] During the next decade, he promoted these policies in a variety of forums, including as head of the Taylor Society (1919–1921), the organization created in 1915 to promote scientific management methods, and on Secretary of Commerce Herbert Hoover's Committee on Recent Economic Changes of 1928–1929.[18]

What can these activities and ideas tell us about Dennison's factory gate film of 1927? At the very least, they complicate any surface-level analysis that would suggest a resolutely paternalistic boss's gaze. By 1927, Dennison was far removed from even his own paternalistic form of welfare capitalism, which had always been mild in comparison with his contemporaries. In his most recent role as director of welfare work for the US Post Office's Service Relations Division (1921–1927), Dennison had overseen the creation of worker councils, credit unions, and programs like those implemented at his own factory during the previous decade.[19] Such initiatives and their benefits for workers could not have been far from his mind when he trained his camera on his own employees outside the Framingham plant in late 1927.

Read from this perspective, the film looks somewhat different. Dennison fills the frame with his workers, creating an image of employee vitality. In the opening sequence, for instance, he repeatedly stops and restarts the camera, perhaps simply to save film during periods in which few workers approach but also, one might argue, to create an impression of plenitude—abundant images of workers for an image of progressive abundance at the Framingham factory (figure 9.3). And yet this is not an image of an undifferentiated worker mass. Dennison singles out individuals with pans or short close-ups. The combination of crowds and individual figures balances Dennison's recognition of the working collective's importance for corporate prosperity and his emphasis on the need to have groups of management experts on the ground, present to make things run efficiently (and we might speculate that the film emphasizes these specific workers' presence in its few close-ups).

Dennison had a number of reasons to believe that this kind of image of his workers would serve a greater purpose than a procedural factory floor film like the one made by Hinds. As head of the Taylor Society, he would have been familiar with Frank Gilbreth's motion study work and aware of its potential contributions to worker efficiency. But as Scott Curtis has described, many Taylorists staunchly opposed Gilbreth's use of film, which they saw as a form of competitive differentiation from their own preferred techniques, and whatever his view on Gilbreth may have been, Dennison's focus on management expertise over worker efficiency may have limited his interest in film's use for optimizing labor.[20]

On the other hand, Dennison was also keenly aware of film's potential use as an advertising tool. During 1927, the year he made his factory gate film, the Dennison Manufacturing Company spent more on advertising than ever before.[21] And in 1929 he even produced a sponsored film called *Strike Salmon Strike* (with his son-in-law, Edward Smith) for *National Sportsman* magazine. But Dennison discounted film's practical value, as he described in a 1929 Taylor Society publication: "The public is so used to the million-dollar productions from Hollywood that an industrial picture produced for an advertiser suffers very often by comparison. It is difficult, also, to obtain showings for an industrial film where it will be viewed under the right conditions by home consumer prospects. A film for use in a portable projector by salesmen in selling business consumers is often of considerable value. [But] there are special distribution difficulties to be overcome before motion pictures can become media of major importance."[22]

Given his own amateur film work, Dennison had good reason to know about the potential pitfalls that awaited those who might rush too readily into industrial film production. While he could be sure that "the right conditions" would be created for viewing his own films, he knew that those conditions could not be taken for granted elsewhere. In the meantime, his factory gate film would have allowed him to share, on a small scale, an image of the well-managed, well-functioning system he had created in Framingham. Under his leadership, new business practices had become corporate policies. Framed in this way, the amateur factory film would have illustrated the prosperity that came with his model of progressive reform.

That prosperity would soon be shattered, but Dennison continued to promote his ideals and used his company as a model for broader reforms. During the Great Depression, he aspired to use the policies implemented in Framingham as the basis for transforming American capitalism. To do so, he forged partnerships with other reform-minded business owners, and he sought intellectual support from a young economist whom he hoped might help turn his local corporate policies into national ones. In 1936, he made a home movie about this process that brought a different labor—the intellectual kind—to his home screen and remains

today a remarkable early document of one of the most influential economists of the twentieth century.

Reflection and Uncertainty: At Home with John Kenneth Galbraith, 1936

Dennison's efforts to maximize capitalist productivity by promoting efficiency and positive worker relations took on new valence and found a larger audience during the Great Depression. His public role increased after the 1929 market crash, and he often served alongside members of the big business elite despite the comparatively small size of his own company. In 1930, for instance, Dennison was recruited for an advisory commission in the National Recovery Administration, where he served with capitalists including Walter C. Teagle of Standard Oil of New Jersey, Louis Kirstein of the Filene Stores, and General Electric president Gerard Swope.[23] In this capacity, Dennison used his experiences in Framingham to advocate for policy reforms such as worker councils that might quell broader labor conflict by granting workers an acceptable degree of power. Soon, however, Dennison's brand of labor negotiation and the Roosevelt administration's welfare programs fell out of favor with many of his big business colleagues. In response, Dennison worked to rally like-minded leaders with whom he hoped to develop a recovery plan that emphasized government intervention as essential not simply for the nation's recovery from the Great Depression but also as a means of saving capitalism, even if it meant accepting long-term forms of state regulation that might prevent future crises.

Among the means through which he hoped to disseminate this reformist program was a book project that he began preparing in 1936 with long-term allies from small businesses and the Taylor Society. The group hoped to outline a vision of capitalist reform based on their own experience as bosses. They lacked, however, the academic training in classical economics that would be necessary to turn their specific experiences into more abstract principles. Never the dilettante, Dennison sought to resolve this problem by hiring an academic to educate him about current economic theories. That academic was a young lecturer from Harvard named John Kenneth Galbraith.

Galbraith had taken up his post at Harvard in 1934 after graduating from the University of California, Berkeley, and serving at the Department of Agriculture. During the summer of 1936, he lived at Dennison's house outside Framingham. Galbraith later described the home, known as Juniper Hill, as "a large, low-slung structure with deep sleeping porches . . . and with a view all the way to Boston and the Bay." The home was, he imagined, "the most civilized place of abode in all of New England."[24] During his stay, Galbraith worked in the house's library and gave Dennison economics lessons that often became heated debates about capitalism. By the end of the summer, Galbraith's work and these debates had

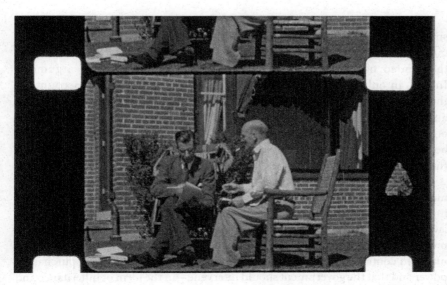

Fig. 9.5 Dennison and John Kenneth Galbraith debate Keynes (1936). From 16mm film. Henry Sturgis Dennison Collection, Northeast Historic Film. [Accession 2177, Reel 20]

become the basis for a coauthored book—Galbraith's first—published by Oxford University Press in 1938 as *Modern Competition and Business Policy*.[25] By all accounts, the book's development was a highly animated intellectual struggle between stubborn, adversarial collaborators: one initially devoted to classical economic theories; the other calling for reforms that seemed to reject those theories altogether.

The 1936 home movie offers one sense of what that struggle might have looked like. The film appears to document an afternoon discussion on the Juniper Hill lawn. Dennison and Galbraith initially appear seated in two chairs surrounded by books, framed in medium shot with the house in the background. The two men talk and smoke while Galbraith makes notes. A close-up briefly shows the covers of two books—Mordecai Ezekiel's *$2500 a Year; From Scarcity to Abundance* and John Maynard Keynes's *The General Theory of Employment, Interest, and Money*, both published in 1936—before cutting to a long shot from across the lawn. At this point, the men stand up, walk toward the camera, then return to the chairs, all while arguing in spirited, almost exaggerated fashion. The film concludes with two shots, both from the same long vantage point, in which Dennison and Galbraith, now seemingly reconciled, pace calmly to and from the camera, occasionally passing just in front of the lens.

On the surface, the film presents itself as an objective document of one small slice of Dennison and Galbraith's summer-long collaboration. Read more closely, however, it offers every reason to believe that Dennison staged the film to narrate the events that led to the book's ultimate argument. Indeed, in only a few short scenes, the film reproduces standard accounts of the book's development. The first shot establishes its initial stages: Dennison and Galbraith's early discussions and Galbraith's role as advisor and teacher on Dennison's collaborative book project. The shots of Ezekiel and Keynes's books and the subsequent argument reflect the next, more conflicted stage of the collaboration.

Dennison's proposals often flew in the face of accepted economic theories, much to Galbraith's horror. In particular, Dennison's belief that the unspent savings of the wealthy were sapping productivity from the market contradicted Say's law of markets, a widely accepted component of classical economic theory, which proposed that supply and demand always necessarily remained in balance. Dennison, in contrast, argued that the money being saved was reducing purchasing power and that the government should intervene—in the form of inheritance and capital gains taxes—to stimulate the economy.[26] As Galbraith later explained, "To anyone properly learned in economics, it would be hard to imagine a more horrifying idea. . . . In 1936, it was not only wrong but professionally unwise to reject Say's Law. It was litmus by which the reputable economist was separated from the crackpot. . . . Since I took seriously my reputation as well as my commitment to economic truth, my dilemma, given Dennison's heretical vision, was a difficult one."[27]

The film illustrates the fierce debates that ensued, debates that become so animated in the film as to suggest that Dennison and Galbraith were performing for the camera. The two close-ups of book covers illustrate the source of the men's eventual détente. Keynes's work, in particular, helped convince Galbraith that Dennison's ideas had a basis in emerging economic theory. Much to Galbraith's surprise, "Keynes," he later wrote, "was with Dennison and not with me. His explanation of oversaving was much more sophisticated than Dennison's but in practical consequences precisely the same."[28]

The remainder of the film illustrates their reconciliation and foreshadows the long-term friendship that the two men developed. Their calm back-and-forth stroll across the lawn—made visually striking by the fact that the 6′ 8″ Galbraith towers over Dennison—suggests the mutual respect that made their resulting book possible. This scene stands in for the final writing process that followed after Galbraith, thanks to Keynes, accepted Dennison's "heretical" ideas.

Galbraith narrated the story somewhat differently in his memoirs. There, he describes Dennison's economics lessons taking place "under a pine tree just

west of the house" and a final discussion about Keynes that happened "one night over old-fashioneds."[29] That the two men felt compelled to record this story in their own way underscores both the value that each placed in it and the fallibility of any historical account, however realistic. The differences between the two versions of the story suggest that Dennison may indeed have staged the film as a way of defining the book's origins and narrating it to friends and colleagues. One can imagine how much he would have enjoyed recounting his triumph over a Harvard economist!

More importantly, however, if he hoped to win over American capitalists— those who, if he succeeded in selling the plan for moderate reform articulated in the book, would be subject to new taxes and government oversight—he would need support. What better tool than visual evidence of how he had convinced even the most skeptical economist? In this sense, the film may have been a hopeful parable about the more fraught process that Dennison knew was yet to come.[30] If his factory gate film was about the progress and profit that came from making business strategy corporate policy, the Galbraith film was about the kind of struggle it would take to turn that policy into economic theory or government prerogative.

Dennison continued to advocate for such policies from high posts, including as a Roosevelt-appointed member of the National Resources Committee beginning in January 1936 and on the National Resources Planning Board from its inception in 1939 until it was dissolved in 1943.[31] And he remained a strong advocate of New Deal policies and moderate welfare reforms even into the 1950s. But the death of his wife in 1936 and successive severe heart attacks in 1937 and 1941 effectively ended Dennison's career. The book he coauthored with Galbraith was, as one historian has put it, his "last major statement regarding capitalist reform."[32]

Although Dennison continued to make films until at least 1940, the film about that book would be his last document of work or industry. A charming sequence of Dennison on the lawn playing with the family dogs comes just after it on the reel. There would also be more scenes of hunting, fishing, and family. But for all of his interest in selling the nation on business reform, Dennison seems never to have fully embraced film's potential for selling ideas about business and industry. Indeed, Dennison's work films—like Hinds's factory procedural—may have been more of an aberration than a representation of what film meant to these bosses and many others like them. That view was soon to change. Film wouldn't stop meaning leisure—whether in amateur footage or Hollywood spectacle—but by the 1950s few bosses would be able to think about film without also thinking about what it might mean for their business.

Conclusion: Reading the Present through the Past

> For my own part, I believe that there is social and psychological justification for significant inequalities of incomes and wealth, but not for such large disparities as exist to-day.
>
> —John Maynard Keynes, *The General Theory of Employment, Interest and Money* (1936)

It is hard to watch Dennison and Galbraith debate Keynes without considering the troubling parallels between their moment and our own. In a letter written the previous year, Dennison had expressed his concerns about a return to the laissez-faire norms of the 1920s. "If the old system comes back," Dennison wrote, "I'll bet a thousand to one that it might succeed for a year but would go into a worse tailspin than '32 ever thought of being, and would end in a revolution."[33] If Dennison's films were a small part—or at least a reflection—of his efforts to avoid such an outcome, the same could not be said for those of his contemporaries.

In the next decade, the boss's film would take on a character more like Hinds's factory procedural but with higher production values and clearer messages. Film promised to help business right itself and address the consuming public of a laissez-faire world. As an article in the first issue of *Business Screen*—a magazine founded in 1938 to promote industrial and corporate filmmaking—enthused, "The motion picture competes with no other medium of expression—it excels all of them as the most perfect medium for advertising and selling yet known to business."[34] To film would be to sell.

We've ended up somewhere in between. Film still often means selling. But in the hands of the amateur, it also means leisure, spectacle, art, and activism. For every corporate YouTube channel that uses bosses' films to define corporate identities and project business ideals, there are many more filled with cute kids, cat videos, experimental shorts, and protest footage. Scenes of everyday life at work and at home have become a normal part of our daily moving image repertoire. In this sense, the Dennison and Hinds films look incredibly familiar, as if the two bosses had simply pulled out their iPhones for a quick stroll through the factory or to document the holidays.

But we also need to flip the script. If the Dennison and Hinds films look familiar, they should also remind us both how much and how little has changed. Amateur moviemaking is no longer restricted entirely to the wealthiest few—the bosses—who can afford it. But extremes of inequality continue to define our world, our screen worlds, and our approach to amateurism. In the 1930s, amateur filmmaking became dominated by industry-driven efforts to make amateur aesthetics unacceptable if not professional, in part as a way to sell amateurs on new products that would allow them to achieve professional quality.[35] Today,

once again, new amateur movie technologies like the latest iPhone promise to give all amateurs access to professional standards. This profit-driven approach to amateurism threatens to reinforce artificial distinctions between the wealthy few who can afford "amateur" technologies and those who will be disregarded as too amateur to count.

For all of their importance as documents of working life in New England in the 1920s and 1930s, films like those made by Dennison and Hinds should remind us of what it means if only a select few can create those documents. What about the workers they filmed? What was their view of working life and leisure? Amateur films might be able to tell us, but only if they can be made and only if they are saved. We should be grateful for the films we have, but we should also remember the ones we don't.

Technical Notes: Henry S. Dennison, Factory Gate Excerpt (1927) and Galbraith and Dennison Excerpt (1936)

Both Charles B. Hinds and Henry Sturgis Dennison used Bell & Howell Filmo cameras, which featured a spring-wound motor for film movement. This allowed the amateur to operate the camera by winding the motor and pressing a button to expose the film. This was an advance over earlier hand-cranked cameras because the filmmaker could hold the camera with both hands, didn't need a tripod, and could more easily pan and follow subjects. An unintended drawback was that a spring-wound motor would yield at most a forty-five-second shot before the film movement stopped. In contrast, cranking by hand one could spend the entire roll on a single, uninterrupted shot. Both the first scene of the tour of the A. S. Hinds hand cream factory and the Dennison films illustrate this limitation of spring-wound motors—each use maximum shots of just under forty-five seconds.

While the Filmo camera did not require a tripod, filmmakers could choose to use one to avoid the overall unsteadiness of handheld filming such as that seen in the initial shot of the Hinds film. Dennison's factory film seems to have been shot using a tripod, whereas in the garden film with John Kenneth Galbraith it appears as though the camera was handheld, producing some shakiness and uneven movement when tracking the two men as they walk back and forth.

By looking at Dennison's two films side by side, one can examine the advancements in film stock used by amateurs in the early days of 16mm. Dennison's 1927 Factory Gate film was shot using an early orthochromatic film. This black-and-white film was sensitive only to blue and green and not to yellow, orange, or red values. The effect was a slight distortion of color values: red would appear much darker than it actually was, and a blue sky would look lighter. Professional films of the time would employ costume choices and makeup to compensate for these

distortions. The 1936 film featuring Dennison and John Kenneth Galbraith was shot using panchromatic film, which had replaced orthochromatic around 1930. The newer film had a much greater sensitivity to all the colors of the spectrum. Running the two films side by side reveals the greater depth of detail available in the 1936 film stock.

> Factory Gate Excerpt, 1927. Henry S. Dennison.
> Henry Sturgis Dennison Collection, Accession 2177, Reel 76.
> Gauge: 16mm. Stock: Kodak Safety Film (B&W reversal).
> Length: 270 ft. (for entire factory/worker footage section). Splices: four within factory/worker section. More splices after that in other half of reel. Splices appear to mostly be original, mainly splices to connect full rolls.
> Overall Reel Length: 500 ft.
> Date code: 1927.
> Camera code: Bell & Howell Filmo 70-D.
> Other info: This is "Dennison Mfg. Co., Framingham, Ma" at Christmas time, according to donor notes. Second half of overall reel is hunting/ nature trip footage.

> Galbraith and Dennison Excerpt, 1936. Henry S. Dennison.
> Henry Sturgis Dennison Collection, Accession 2177, Reel 20.
> Gauge: 16mm. Stock: Kodak Safety Film (B&W reversal).
> Length: 90 ft. Splices: zero within Galbraith/Dennison footage. A few splices in earlier sections, which appear to be splices to connect full rolls.
> Overall Reel Length: 500 ft.
> Date code: 1936. Overall reel contains 1934, 1940, and 1935 date codes, all B&W reversal.
> Camera code: Bell & Howell Filmo 70-D.
> Other info: This is at the Dennison home called Juniper Hill, Framingham, Mass., according to donor notes. Reel 17 in Dennison Collection contains a Kodak reversal dupe of the Galbraith/Dennison footage.

Brian R. Jacobson is Assistant Professor of Cinema Studies and History at the University of Toronto and author of *Studios Before the System: Architecture, Technology, and the Emergence of Cinematic Space*.

Notes

1. For more about the origins of film's role in business and industry, see the essays in *Films that Work: Industrial Film and the Productivity of Media*, eds. Vinzenz Hediger and Patrick

Vonderau (Amsterdam: Amsterdam University Press, 2009) and *Useful Cinema*, eds. Charles R. Acland and Haidee Wasson (Durham, NC: Duke University Press, 2011).

2. On industrial films in early cinema, see Jennifer Peterson, "Industrial Films," in *The Encyclopedia of Early Cinema*, ed. Richard Abel (New York: Routledge, 2005), 320–23.

3. Lee Grieveson, "The Work of Film in the Age of Fordist Mechanization," *Cinema Journal* 51, no. 3 (Spring 2012): 27.

4. See Patricia R. Zimmermann, *Reel Families: A Social History of Amateur Film* (Bloomington: Indiana University Press, 1995), chap. 3.

5. See J. H. McNabb, "The Amateur Turns a Penny," *Amateur Movie Makers*, December 1926, 19. Cited in ibid., 62. As Heather Norris Nicholson has described, in the United Kingdom, industry was quickly "promoted as legitimate subject matter for cine enthusiasts." Heather Norris Nicholson, "'As If by Magic': Authority, Aesthetics, and Visions of the Workplace in Home Movies, circa 1931–1949," in *Mining the Home Movie: Excavations in Histories and Memories*, eds. Karen L. Ishizuka and Patricia R. Zimmermann (Berkeley: University of California Press, 2008), 214.

6. Jennifer Peterson, "Workers Leaving the Factory: Witnessing Industry in the Digital Age," in *The Oxford Handbook of Sound and Image in Digital Media*, eds. Carol Vernallis, Amy Herzog, and John Richardson (New York: Oxford University Press, 2013), 602.

7. Assessing where this film starts and the previous one, shot on the same reel, ends is tricky. It is hard to read the cuts that separate one scene from another. Here, I define the film's beginning as the first scene on a factory floor, but one might rightly ask if the preceding footage—scenes of two men in suits working at desks, one sorting mail, taking out a cigarette, and talking toward the camera; the other writing notes and referring to a small card catalog—is part of the factory film or something else. One might read these scenes of white-collar work as part of the factory process, but without their maker to comment on them (as Hinds probably did when showing his films), it is impossible to know for sure how he wanted viewers to see them.

8. For more about these kinds of "mistakes" and how Hollywood style became the standard against which amateur filmmaking was judged, see Zimmermann, *Reel Families: A Social History of Amateur Film*, 68.

9. See Frederick Winslow Taylor, *The Principles of Scientific Management* (New York: Harper and Brothers, 1911).

10. John Kenneth Galbraith, *A Life in Our Times: Memoirs* (New York: Ballantine, 1982), 61. Galbraith explains that "when some new subject captured [Dennison's] imagination, he regularly hired someone of professional competence to give him instruction," but it is unclear if this was the case for his interest in filmmaking.

11. On Mitchell & Kenyon's factory films, see Vanessa Toulmin, *Mitchell and Kenyon* (London: British Film Institute, 2002).

12. Patrick D. Reagan, *Designing a New America: The Origins of New Deal Planning, 1890–1943* (Amherst: University of Massachusetts Press, 1999), 113. A number of historians have recounted Dennison's life and work. Much of what follows comes from Kim McQuaid, "Henry S. Dennison and the 'Science' of Industrial Reform, 1900–1950," *American Journal of Economics and Sociology* 36, no. 1 (January 1977): 79–98 and Reagan, *Designing a New America*, chap. 5. See also Kyle Donovan Bruce, "Activist Management: The Institutional Economics of Henry S. Dennison" (PhD thesis, Department of Economics, University of Wollongong, 1999).

13. McQuaid, "Henry S. Dennison and the 'Science' of Industrial Reform," 80.

14. Ibid., 81–82. McQuaid notes that Dennison's policy "helped to create an industrial program which closely approximated what, a decade later, liberal economist Thorstein Veblen would term a 'Soviet of Technicians.'"

15. Ibid., 83.

16. Reagan, *Designing a New America*, 117–19; McQuaid, "Henry S. Dennison and the 'Science' of Industrial Reform, 1900–1950," 85.

17. McQuaid, "Henry S. Dennison and the 'Science' of Industrial Reform, 1900–1950," 86.

18. Reagan, *Designing a New America*, 121.

19. McQuaid, "Henry S. Dennison and the 'Science' of Industrial Reform, 1900–1950," 87. McQuaid notes that Dennison was also involved in the National Bureau of Economic Research, the Social Science Research Council, and the Unemployment Commission established by President Harding in 1921.

20. Scott Curtis, "Images of Efficiency: The Films of Frank B. Gilbreth," in *Films That Work*, 88.

21. John S. Keir and Henry S. Dennison, "Control of Sales Operations," in *Scientific Management in American Industry*, by the Taylor Society, ed. H. S. Person (New York: Harper and Brothers, 1929), 303.

22. Ibid., 305.

23. McQuaid, "Henry S. Dennison and the 'Science' of Industrial Reform, 1900–1950," 90.

24. Galbraith, *A Life in Our Times: Memoirs*, 61.

25. Henry S. Dennison and John Kenneth Galbraith, *Modern Competition and Business Policy* (New York: Oxford University Press, 1938).

26. McQuaid, "Henry S. Dennison and the 'Science' of Industrial Reform, 1900–1950," 91.

27. Galbraith, *A Life in Our Times: Memoirs*, 64–65.

28. Ibid., 65.

29. Ibid., 63–66. For all of his fond memories of the book's production, Galbraith later renounced it as "a bad book that should never have been printed." On the other hand, he also emphasized his contributions to the collaborative book project that later appeared as Henry S. Dennison et al., *Toward Full Employment* (New York: Whittlesey House, McGraw-Hill, 1938).

30. As Reagan describes, "Dennison advocated moderate reform often based on the corporate models of his own experience as the only way out of the Depression and its possible concomitants of reaction or revolution." For more about Dennison's planning strategies in the 1930s, see Reagan, *Designing a New America: The Origins of New Deal Planning, 1890–1943*, 137–9.

31. Ibid., 138; McQuaid, "Henry S. Dennison and the 'Science' of Industrial Reform," 93.

32. McQuaid, "Henry S. Dennison and the 'Science' of Industrial Reform," 93.

33. Quoted in Reagan, *Designing a New America*, 139.

34. "The Power of Films to Sell," *Business Screen* 1.1 (August 1938), 13.

35. See Zimmermann, *Reel Families: A Social History of Amateur Film*, chapter 3.

FAMILIES: PRIVATE AND PUBLIC

3 "The Ring of Time" in the E. B. White Home Movies

Martha White

IN THE SPRING of 1956, my grandfather, E. B. White (1899–1985), wrote an essay called "The Ring of Time" (*Essays of E. B. White*, Harper & Row, 1977) in which he attempted to record a moment in Sarasota, Florida, where a mother and daughter rehearse a circus act, the girl riding bareback as her mother guides the horse around the ring. Another of his much-reprinted essays, "Once More to the Lake" (*Essays of E. B. White*, 1977), recalls returning to one of the Belgrade Lakes with his son, as he had once done with his own father. This theme, both of time passing and timelessness as viewed through the generations, was a common one in my grandfather's work.

"I have always felt charged with the safekeeping of all unexpected items of worldly or unworldly enchantment," my grandfather wrote in "The Ring of Time," "as if I might be held personally responsible if even a small one were to be lost."

In the home movies he filmed, this same attempt to communicate his appreciation of the small, commonplace yet precious moments of the day is clear. Further, like the rider and her mother in that circus ring, the connections between past, present, and future are unmistakable. Viewed over eighty years after the first scenes were filmed, it is remarkable how much has stayed the same, even as time has marched on.

These home movies were filmed almost exclusively by my paternal grandfather (except for a few rare moments when he allows the camera to be turned on him) and span a period from approximately 1929 or 1930 to the early 1960s. They go from black-and-white to color; from New York City to the coast of Maine; from the early days of his marriage to Katharine Sergeant (Angell) White to his stepparenthood of her two children, Nancy (Angell) Stableford and Roger Angell; and to the birth in 1930 of his only (and Katharine's third) child, my father, Joel McCoun White. In E. B. White's own life, his appearances in public or on camera were exceedingly rare. At his memorial service in 1985, as an example, my grandfather's stepson Roger made the observation to the assembled crowd that "if E. B. White could have been here today, he wouldn't have been here." Likewise, in these

films, his appearances are tiny cameos and, always, he appears self-conscious in front of the camera.

Over time, three spouses are introduced on film: Nancy's husband, Louis Stableford (playing croquet); Roger's first wife, Evelyn (and her St. Bernard, Tunney); and my mother, Allene Messer White, seated on the doorstop of our house on the Benjamin River in Maine. Nancy is seen as a young girl on a horse and later sailing a Brutal Beast catboat off the Center Harbor Yacht Club. Roger Angell, as a boy, sports a bow and arrow and is also filmed in a Gluyas Williams cartoon spoof of "Portrait of a Small Boy Reading," as he spins 360 degrees in his overstuffed chair on the porch, while purportedly reading a book. (More on this later.) My father is recorded being given a bath by a brusque nurse, taking his first steps, trying to row, training his dog, Raffles, to tow a berry basket, picking a flower for his mother, feeding a lamb a bottle, helping with the haying, and other bucolic moments of my grandfather's choosing. Grandchildren naturally follow, including the youngest of us (on film): my older brother and me (seen chucking firewood off the truck at the end of the films), and our younger brother, seen crawling after a croquet ball and trying to catch a free-ranging chicken in the backyard.

What overshadows the various family members, however, are two things. One is the various creatures on the Whites' salt water farm in Maine, including not only chickens, geese, turkeys, lambs, sheep, cattle, and horses, but even a close-up of a spider in her web (filmed long after *Charlotte's Web* was published in 1952), and also a great many dogs (read *E. B. White on Dogs*, 2013, for more of them). Many of these creatures also show up in my grandfather's essays and poems, of course, most notably in *One Man's Meat* (Tilbury House, 1997). Second of the overriding themes is the great many boats, including E. B. White's own *Astrid* and *Fern*, and the flat-bottomed scow named *Flounder*, which he built for my father, Joel, in about 1940 from plans in *The American Boy's Handy Book* (D. C. Beard, 1882). My father was about ten at the time, and he later—by then an MIT-trained naval architect himself—repeated the gesture for his own children, building *Sea Dragon* from the same plan when my younger brother (now a lobsterman) was learning to row.

Viewed from my perspective, roughly fifty to eighty years after they were filmed, I am tempted to title these home movies, "How to Build a Boatbuilder" or "The Man Who Launched a Thousand Ships." They chronicle for me the myriad ways my grandfather passed along his passion for beautiful wooden boats, especially sailing yachts, first to my father, who grew up to become a boatbuilder and designer, founding the Brooklin Boat Yard (which my older brother now runs), but also to my husband, who worked with my father briefly (and whose own father was also a boatyard owner at Rockport Marine, Inc.), and now to our three sons, all of whom seem to be headed into boats in one form or another. Among them—my father, my brother, my husband, and now my sons—they have launched literally thousands of boats and built a good many of them, and we now

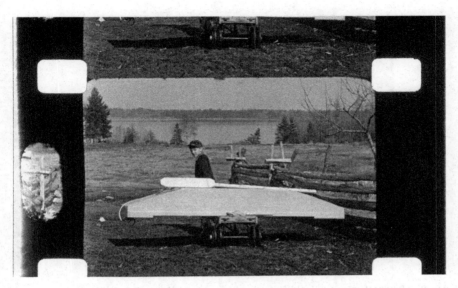

Fig. R3.1 Joel White prepares to launch the scow named *Flounder*, circa 1940. From 16mm film. E. B. White Collection, Northeast Historic Film. [Accession 1197, Reel 2]

have a third Maine boatyard in the family as well. It is easy to trace the origins of these nautical interests to E. B. White. If you were to edit out the farm shots in the films, most of what remains would be the Brutal Beast catboat races on Eggemoggin Reach; the old steamships and schooners plying their trades along Blue Hill Bay and Penobscot Bay; my father as a toddler clambering into a rowboat in his first lifejacket, then attempting to row; my father's first launching of the scow *Flounder*; various family cruises aboard *Astrid*; and the launching of the Aage Nielsen–designed *Fern*, no doubt paid for by the early proceeds from *Charlotte's Web*. Years later, when my father bought his first yacht for family use, it was another Aage Nielsen yacht he chose, *Northern Crown*, now owned by my husband and me. Likewise, *Fern* has been brought back into our family, recently sold to us for restoration by the family who originally bought it from my grandfather. Imagine us hauling this boat into our boat shed, even as I am writing about my grandfather first launching her from his, and you will get a feel for the circle of time that we continue to live within.

When I first viewed these family films, as a young girl, I naively thought the nine-year-old boy driving the hay truck with his dog was my older brother. In fact that boy was my father, Joel, but I was too young to realize I might be viewing my own father's childhood. The resemblance was strong, however, as you can see from the end of the film where my brother helps me chuck wood off another truck, this one owned by my father, not his father. ("The Ring of Time" circus horse takes

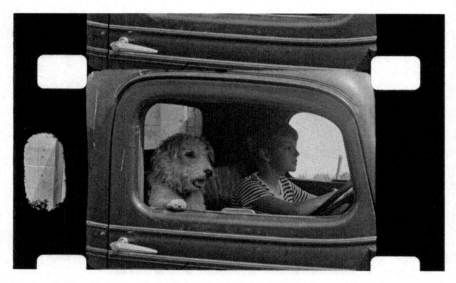

Fig. R3.2 Raffles the dog and Joel White, 1941. From 16mm film. E. B. White Collection, Northeast Historic Film. [Accession 1197, Reel 2]

another lap.) Nearly a half century since my first viewing, it is far easier for me to recognize who is whom, but the family resemblances remain strong and extend now down through the generations, not only in facial similarities but perhaps even stronger in body language and gestures. My father, about to take his first steps in an apartment in New York City, looks uncannily like my firstborn at that age. My grandmother, Katharine, aboard the boat and smiling self-consciously at the camera, looks surprisingly like my college-aged daughter, right down to the dimpled cheek and hair so fine and thick that it resists being caught up in a knot at the nape of the neck. The cock of a head or placement of a hand can take my breath away for the resemblances they evoke, and I wonder how many of our future generations will continue to recognize these similarities, so unmistakable that I now think of them as visits between those who have passed on and those as of yet unborn.

Fortunately for our family, my grandfather's book, *Letters of E. B. White* (Harper Collins, 1996), and his various essay collections help to date many of the sequences here, and identify players otherwise possibly lost. There is footage of the 1932 Olympic Winter Games in Lake Placid, for example—the ski jump, the speed skaters, my grandmother, Katharine, in a raccoon coat. My grandfather was sent to write about it for the *New Yorker* that winter, and the "Notes and Comment" pieces can still be found in that magazine's archives.

Likewise, a sequence with Gluyas Williams (1888–1982) and his wife, Margaret, appears, and I know from the letters that Gluyas was a frequent cartoon

Fig. R3.3 Roger Angell, after a Gluyas Williams cartoon sequence, "Portrait of a Small Boy Reading," circa 1930. From 16mm film. E. B. White Collection, Northeast Historic Film. [Accession 1197, Reel 1]

contributor for the *New Yorker* and many other publications. My uncle, Roger Angell—who at ninety-six still writes for the *New Yorker* and summers in Maine—appears as a ten-year-old in the film, in a spoof of a cartoon drawing found in *The Gluyas Williams Book* (Doubleday, Doran, 1930), a sequence titled "Portrait of a Small Boy Reading." Gluyas and Margaret summered in Maine in the 1930s, on Sylvester's Cove in nearby Deer Isle, and the Whites and the Williams families visited back and forth. (Gluyas was also an avid sailor.) A 1936 Martin Sheridan newspaper article titled "Creator of 'Family Album' Got Start as Free-Lancer" shows a photograph of Williams, at age forty-eight, looking much as he does in the E. B. White home movies: bald-headed, with perfectly round tortoise-shell eyeglasses, and his eyebrows as expressive as his line-drawn caricatures. I am guessing, from letters and Roger's apparent age in the film, that the spoof might have been filmed in the early 1930s and was probably screened for the unsuspecting cartoonist, by my grandfather, on one of those visits.

"It has been ambitious and plucky of me to attempt to describe what is indescribable, and I have failed, as I knew I would," wrote my grandfather. "But I have discharged my duty to my society, and besides, a writer, like an acrobat, must occasionally try a stunt that is too much for him."

My grandfather was by far a better writer than filmmaker, but his themes were the same. Of his writing, he once said, "All that I hope to say in books, all I

Portrait of a small boy reading

Fig. R3.4 Gluyas Williams drawing, "Portrait of a Small Boy Reading," circa 1930. Courtesy Joyce Williams, Estate of Gluyas Williams.

ever hope to say, is that I love the world." Whether in his writing or in his films, it doesn't take much digging to find that.

Technical Notes: E. B. White, *Boy Reading* (circa 1930) and Brooklin, Maine, Excerpt (1941)

The films of E. B. White prove that sometimes the simple things provide greatest enjoyment. White did not make flashy films with titles or effects, or even much editing. He simply turned on his camera. White used the second model of Ciné-Kodak 16mm cameras, the Model B, an excellent tool for the unskilled amateur. The Model B's simplicity helped make small-format filmmaking popular. Had the technology been too complex, it is possible that users such as White may

never have picked up a movie camera. White has made simple point-and-shoot films with in-camera edits.

The Model B provided information on aperture settings and focal distance. A small metal plate screwed to the front of the camera gave simple instructions for adjusting aperture. For the setting f/8 the text reads, "For Average Subjects and Scenes in Direct Sunlight." For more challenging lighting conditions (f/1.2, f/1.9, and f/16), the chart helpfully reads, "See Manual." The lens barrel was marked in feet indicating the distance to the subject. If the user knew how far the camera was from the subject, he or she simply dialed that number on the lens (e.g., four feet or ten feet) to ensure that the subject was in focus.

The practice of focusing based on distance was important in the early days of filmmaking before the invention of the reflex camera. Reflex cameras, developed for Hollywood in the late 1940s and for amateurs in the mid-1950s, allowed the operator to look directly through the same lens that was being used for filming. If the image looked in focus through your eyepiece, then it would be captured in focus on the film.

Boy Reading, circa 1930. E. B. White.
E. B. White Collection, Accession 1197, Reel 1.
Gauge: 16mm. Stock: Kodak Safety Film (B&W reversal).
Length: 20 ft. Splices: zero within sequence. Many throughout overall reel.
Overall reel length: 1,650 ft.
Date code: 1930.
Camera code: Ciné-Kodak Model B f-1.9
Other info: Entire reel has multiple date codes, not necessarily in chronological order—1934 date code stock directly precedes this sequence; 1935 stock follows it.

Brooklin, Maine, Excerpt, 1936, 1941. E. B. White.
E. B. White Collection, Accession 1197, Reel 2.
Gauge: 16mm. Stock: Kodak Safety Film (B&W reversal).
Length: 160 ft. Splices: eight. Some original cement splices, some later repair tape splices. Many more splices throughout overall reel.
Overall Reel Length: 1,500 ft.
Date codes: 1941 for beginning to boy with dog and wagon, 1936 for chickens to end.
Camera code: Ciné-Kodak Model B f-1.9.
Other info: Entire reel has multiple date codes, not necessarily in chronological order.

Martha White is a writer and editor whose works include *Traditional Home Remedies*, *Letters of E. B. White*, *In the Words of E. B. White*, and *E. B. White on Dogs*.

10 Opening the Can: Home Movies in the Public Sphere

Melissa Dollman

> I had an argument with someone a few years ago about whether or not the dead have a right to privacy. In making the film I decided that they don't, really. Who is protected by that? By selling all her papers to a public institution before her death, Sontag already violated her own right to privacy. As did her son by publishing her diaries, even though he edited them.
>
> —Interview with Nancy Kateson on her film, *Regarding Susan Sontag* (2014)

Getting Personal about Privacy

Famous or not, your likeness has probably been captured in photographs or a home movie—your family's, a family friend's, a stranger's, a passerby's. Moreover, it is possible that on whatever medium your likeness was captured, it may be preserved by an archive or library and open to researchers, sold at auction, displayed online, or make its way to a stock-footage provider where it could be purchased and used in someone else's artwork or film. If you are a celebrity or otherwise notable, you may have an estate manager or lawyer monitoring the use of your image. If you are mentally ill in the United States, there are additional protective measures regarding your medical records—including images and video—such as the Health Insurance Portability and Accountability Act. And as of 2014, a citizen of the European Union has the "right to be forgotten," under certain circumstances, from search engines in perpetuity.[1]

What about the rest of us? What rights do we have upon discovering that our likenesses have been repurposed or exhibited without permission or compensation? In the days before digital images, it was easy to "delete" unwanted representations of oneself by ransacking the family picture album for embarrassing prints, cleanly snipping out a section of 8mm film, or erasing a videotape. If you partake in social media and are concerned about appearing in often easily distributed, seemingly ephemeral, digital photos, whether it be for professional

reasons, out of shyness, or even vanity, alleged safeguards are in place that allow you to vet or delete those images. At least, in social media parlance, you can ask a friend to "untag" you.[2]

We live in a surveillance culture, and there are numerous locations where your image can be captured or disseminated without your knowledge or explicit consent. Imagine the less sinister scenarios where you might incidentally find your own photo or that of a family member: in a shoebox at a thrift store, in an old "On the Street" fashion spread by the late photographer Bill Cunningham for the *New York Times*, or in *Found* magazine. What a shock, though, to discover yourself in someone else's video art piece, as stock footage on Getty Images, or in the Internet Archive. How would you react to this once personal artifact now completely and utterly out of context? For some, any representation is positive. Others prefer (and believe they have a right to) anonymity. And some countries, (not the United States) allow citizens the "right to be forgotten," to have digital images, or unfavorable online references, deleted so they can return to anonymity. Ultimately, you might question the feasibility of protecting your image after death, as your privacy rights extend only that far anyway. However, as the epigraph for this essay indicates, if you are famous, your rights may still be hotly contested once you are out of the picture.

Both ethical and legal issues come into play when deciding how to use moving images of anyone who comes before the camera, as intellectual property expert and copyright attorney Eric J. Schwartz points out:

> The legal obligations come in three flavors: (1) a right of privacy which we all, in theory, have, to prevent an unflattering portrayal without permission whether on analog or digital film or still photographs (as well as libel and defamation laws which govern intentional misrepresentations); (2) a right of publicity, limited to the famous (and infamous) when their portrayal, including their image in any medium, is linked to a commercial use; and (3) copyright which dictates the ownership and use of the film or other medium by the filmmaker (and to some extent also the "performers"—the subjects in the film), as well as any exceptions thereto.

But the law does not provide a complete guide through the challenging ethical issues that can arise when working with moving images.[3]

This essay explores the potential ethical implications of presenting home movies—moving images produced by amateur filmmakers capturing personally relevant content that is typically intended only for private viewing—in a public context without the explicit consent of either the filmmaker or the subjects whose images are captured. Predictably, there does not exist a clear, incontrovertible set of policies, best practices, or procedures to guide the archivist, collector, curator, or exhibitor of home movies. Instead, the wide range of practitioners, working in diverse settings, who present this material approach the ethical questions that

Fig. 10.1 Author's collection of found vintage photographs, 2015. Photograph by Melissa Dollman.

arise in an ad hoc fashion. In order to move toward an understanding of the ethical complexities of home movies, then, and to honor the existence of any privacy rights, discussions about the ethics of viewing must embrace a multivocal and necessarily subjective assessment of the specific contexts in which home movies are screened. In short, it is a "can of worms" that can be fully understood only by opening the can and evaluating each reel on its own merits and within the intended rescreening context.

A considered and evenhanded approach to privacy of the individual requires input from a variety of commentators. Thus, for this essay, I am coupling my personal experience as an archivist and researcher—with experience in both restricting archival materials due to privacy concerns and discovering decontextualized photographs and moving images for documentary filmmakers—with the thoughts and experiences of colleagues currently engaged in curating, collecting, safeguarding, cataloging, screening, lecturing on, repurposing, or donating home movies. The goal here is to mimic the process by which archival, curatorial, and artistic practice overlays the intent of a donor, a creator, or a subject often in his or her absence. Various guidelines drafted by professional

associations, advocacy groups, copyright and privacy lawyers, and the United States government can provide a guide to privacy, publicity, and copyright law. Still, the array of people who screen or describe the content of home movies cannot help but make subjective decisions as to how these images are portrayed or exhibited to the public. They often end up speaking or conjecturing—coming to very different conclusions at times—on behalf of the people on screen eating birthday cake, showing off a new car or a new baby, drinking cocktails, frolicking at the beach, engaging in illicit behavior, or trying to avoid the camera.

To collocate the multiplicity of voices on this subject, I gave a questionnaire to colleagues in the archival, academic, and filmmaking fields. Their answers, woven through this essay, create a conversation about privacy as it relates to home movies and demonstrate the diversity of opinions that emerge when a group of people chimes in to evaluate a stranger's personal film and discusses its privacy implications. Interviewees watched, with a limited amount of background data, a home movie clip and offered their assessment. Assembling these voices, and attempting to work through the complexities they raise, underscores the potential dilemmas that emerge when *personal* materials appear in *public* contexts.

A Multiplicity of Voices—Part 1

A diverse group of professional practitioners who engage with home movies from creation to repurposing to exhibition participated in this exercise. First, Ariel Dougherty, an independent filmmaker, teacher, cofounder of Women Make Movies, and advocate for feminist filmmakers provided her perspective as a donor. She also responded to privacy issues as a creator who reuses her own home movies. Dougherty received her first camera, a Super 8 Canon, as a Christmas gift in 1968, and by the next year was filming events including a sit-in at Sarah Lawrence College. Next, founder of Oddball Film, media archivist, image-maker, and curator Stephen Parr helms a nonprofit media archive that collects, preserves, and screens home movies and licenses stock footage for documentaries and feature films. He also collects home movies for use in his own montage works and sees no reason why he would restrict his own or his family's films, had they been donated to an archive.

Albert Steg is a freelance archivist and film collector living in Cambridge, Massachusetts. He holds master's degrees in philosophy (Edinburgh University) and English (Boston University). After completing the L. Jeffrey Selznick School of Film Preservation at George Eastman House in 2005, he spent years sharing his own collection through public screenings and at film conferences like the Northeast Historic Film Symposium. He also joined the board of the Center for Home Movies (CHM), a home movie advocacy group and repository that originated International Home Movie Day events. Steg noted that he has not personally deposited a family film with an archive, but he would only consider donating

materials that could be used without restriction, in the hope that the recipient archive would make appropriate choices as to their possible use or exhibition. Cofounder of CHM and an archivist specializing in amateur film, Dwight Swanson is a curator, collector, advocate, lecturer, writer, and preservationist. He has publicly screened some of his own personal films (moving images of his wedding, for instance) in order to gauge his reaction to showing personal moments publicly and to "understand what the people who I have been dealing with at Home Movie Day screenings have gone through."

Devin Orgeron, director and associate professor of film studies at North Carolina State University, has collected others' home movies since the late 1990s, included the home movie/amateur film genre in class curricula, presented on them publicly at the Orphan Film Symposium and elsewhere, and explored his own collection in an essay written for *The Moving Image*. Although neither he nor his family have donated their home movies to a repository, he hopes, should they ever make their way to a collector, archive, or public exhibition, that they are "used purposefully," and he advocates for "fair, thoughtful use" of anyone's family films. Dan Streible is an associate professor in New York University's cinema studies department, director of the Moving Image Archiving and Preservation program, author, and organizer of the biennial Orphan Film Symposium. Streible first became engaged with home movies shown as repurposed footage incorporated into works by attending filmmakers Alan Berliner and Carolyn Faber at an Orphan Film Symposium. Streible argues that home movies held (and continue to hold) a long-standing place in special-interest documentary circles, noting the frequency with which other "collector-cinephiles showed each other found home movies." Though he has not donated any moving images to an archive, he has shown his parents' 8mm films at Home Movie Day. He finds them all-too-tame to restrict, except when a family member was "simply self-conscious about the way they looked." Kim Andersen is an audio visual materials archivist in the Special Collections Section at the State Archives of North Carolina. She collects home movies for the state archives and focuses particularly on those moving images that "document the history, culture, and people of North Carolina, and that supplement or complement the public records of the state." Her family has no home movies. Finally, David S. Weiss, cofounder and former executive director of Northeast Historic Film (NHF), has spent most of his professional life working with personal film: "I started taking home movies in high school and have sporadically taken them ever since. Shortly after forming NHF it became clear to us that home movies were perhaps the key building block of a regional film archives . . . Since then I have worked with home movies, made other films out of them, stood on stage and talked about them, sold them to producers for use in broadcast documentaries, news programs, feature films, commercials, and exhibits." Weiss has donated his films to NHF and does not recall any restrictions

placed on their use. However, he cheerfully concedes that some uses of his films might be embarrassing because they vary in degrees of successful execution.[4]

The Many Homes of Home Movies

Home movies did not always stay at home; the context for screening home movies has always been mutable. Not all home movies were shot *at home*, and small-gauge cameras and projectors have been easily portable, so no doubt some filmmakers showed their films in other people's houses. Moreover, in *Home Movies: A History of The American Industry, 1897–1979*, historian Alan Kattelle dedicates a chapter to cine-clubs, organizations whose members shared and screened amateur films and home movies in the United States and abroad. Kattelle and film historian Patricia Zimmermann both suggest that members of organizations such as the Amateur Cinema League screened personal films outside the home in contests and via lending libraries as early as the 1930s. Some families donated home movies to archives and libraries, but, of course, like many inherited possessions, family films also made their way into thrift stores, estate sales, garage sales, and even dumpsters, where they were obtained by collectors, filmmakers, and lovers of small-gauge film and/or old things more broadly. Discovering a "rescued" reel often meant opening the can or a small cardboard box and holding the strip of tiny images up to a light source for inspection. At that enchanting moment, the content was essentially exposed to the public—at least one member of the public—either for the first time, or after many years of dormancy.[5]

To varying degrees, home movies have been in the wider public sphere for decades. The public has grown accustomed to viewing these images in museum exhibits, both in person and online, and repurposed in feature films or television programs. Abraham Zapruder's extraordinary 8mm film capturing President John F. Kennedy's assassination in Dallas is perhaps the most widely studied home movie. Frances Guerin discusses the home movies of Eva Braun, Adolph Hitler's mistress, in *Through Amateur Eyes: Film and Photography in Nazi Germany*. Brian L. Frye and Penny Lane's *Our Nixon* (2013) disclosed previously confiscated footage of the president shot by his most personal confidants and aides. Television has been a disseminator of these documentaries to an ever-broader audience, with the advantage of returning this kind of footage to a more intimate setting, the living room. Two examples come to mind: Stanley Nelson's *A Place of Our Own* (2004), and *In the Matter of Cha Jung Hee* (2010), by Deann Borshay Liem.[6]

And while the screening methods may differ, home movies are permanently exhibited in a variety of museums including the Andy Warhol Museum, the John F. Kennedy Presidential Library and Museum (and other presidential libraries), and the United States Holocaust Memorial Museum. There have been numerous temporary exhibits featuring this material such as "Jim Campbell: Home Movies" (2008) at Berkeley Art Museum and Pacific Film Archive, and the Museum

of the City of New York's "Letters to Afar: By Péter Forgács, music by the Klezmatics" (2015). Personal films are screened live at special events held for the wider community by such organizers as Oddball Films, Outfest, Home Movie Day, film and university archives, and libraries.[7]

Moving image archives and libraries have increasingly offered online access to selections from their collections, and the decision about what to screen seems to rest with their perceived popularity with a general audience: particularly noteworthy family films, or films containing the images of historically significant events or people, seem to get top priority. The Library of Congress's website hosts clips from home movies featuring Carl Sagan and Danny Kaye; the National Archives and Records Administration's streams the film of an army engineer stationed in Papua New Guinea during World War II. Other repositories promote more quotidian home movies such as Rick Prelinger's vast collection on the Internet Archive, the Texas Archive of the Moving Image, the National Film Preservation Foundation, and this volume's online component featuring selections from Northeast Historic Film.[8]

Reuse of home movie footage as part of artistic practice moves original home movies into another domain, as viewers of the new work are reliant on (although encouraged to question the "authority" of) the artist to contextualize the film. Juxtaposition of other footage gives it new meaning, and a meaning that is more closely allied with the artist repurposing the film than the original creator's. The same could be said for home movies screened and contextualized by a scholar, an archivist, or a curator. Questioning privacy and public viewing, Indiana University Libraries Moving Image Archive archivist Andy Uhrich wonders, "Are they still 'home' movies when they're screened in a theater or viewed online?"[9]

Opening (and Closing) the Can

Collectors, archivists, donors, filmmakers, privacy and copyright lawyers, scholars, and curators engaged with home movies are a diverse bunch with equally divergent points of view regarding questions of copyright, donors' (and subjects') right to privacy, and accessibility. For instance, the first home movie collection I organized and described contained reels shot by a Hollywood director, in which actors and other famous people smiled at or playacted for a handheld camera on and off movie sets. "Intimate" sprang to mind before "private," perhaps because of their celebrity. And this intimacy was part of the films' allure. In her 2001 essay "Family in a Can: The Presentation and Preservation of Home Movies in Museums," Snowden Becker emphasizes that an institution use "good judgment and careful planning" in its treatment of family films in the same way it would consider other potentially revealing documents such as diaries and personal correspondence by communicating with donors. Patricia Zimmermann takes an overtly and intriguingly political angle when she argues, "I don't believe in

privacy issues because I also don't believe in authorship and I don't believe in copyright . . . the major goal we have in a democracy is to take that which is private and make it public. Because those who decide what gets made public are generally those who are officials in power." Karan Sheldon, cofounder of NHF, tempers her concern about donors' privacy with a wish that there was more public recognition of home movies as historical resources: "Some days I get cranky about producers using home movies as visual wallpaper. I resent educators who insist on slick documentaries for the classroom, rather than exploring unedited original footage of people, places and events." Archivist, collector, and scholar Rick Prelinger warmly encourages patrons of the Prelinger Archives to "download, use and reproduce" copies of films in his collection, including thousands of home movies, "in whole or in part, in any medium or market throughout the world . . . to share, exchange, redistribute, transfer and copy these films, and especially encouraged to do so for free."[10]

The same year that "Family in a Can" was published, Northeast Historic Film held its second annual film symposium on the topic of home movies and privacy. Eric J. Schwartz presented on legal issues facing three parties with potential interest(s) in a home movie: the copyright owner; a collector or donor of film material to an archive; and a user of such material for commercial or noncommercial purposes. According to Schwartz, the person behind the camera (or persons, if different family members take the device) is first and foremost *protected* as "author(s)" of the film. The law provides a filmmaker of an unpublished home movie with "exclusive rights of reproduction, distribution, adaptation, public display and public performance as well as the right to authorize others to exercise these rights" until he or she dies and 70 years pass. If the death date is unknown, protection equates to a similar length of time: 120 years from date of creation. The films then fall into the public domain except for those home movies intentionally registered for copyright (reportedly few were); these are restricted for much longer. There are, of course, exceptions to those rights, most notably the doctrine of fair use, which allows the material to be used without permission or payment in certain circumstances.[11]

The second category of copyright holder Schwartz considers is the collector and/or donor who wishes to deposit or permanently gift a home movie collection to an institution and is given a choice to share legal rights with, or relinquish them to, their new guardians, as well as negotiate a mutually beneficial agreement. These rights include the rights in the physical material (films themselves) and, if the donors have them, the intangible property rights in copyright. Ideally, any institutional or cultural repository will review a site-specific checklist at the time of acquisition, whereby the donor and the repository's representative can record expectations and potential restrictions in a document called a donor agreement (a contract between the donor and the receiving institution).

What is deemed "mutually beneficial" takes extensive communication between the two parties, starting, for instance, with a donor's initial understanding regarding access and copyright if the donor can even grant such rights, which is often not the case for home movies acquired by the donor at auctions or other third-party sites.[12]

As Kim Andersen explains, "Often a donor will want certain restrictions concerning the use of their donation and/or want to make sure the filmmaker/artist/photographer/creator is properly credited when the donated material is used. Wherever possible we strive . . . to satisfy those requests. That said, we draw the line at accepting materials that will have any permanent restrictions." These requests can be made whether or not a donor owns the copyright, but in the case of home movies, Andersen tells donors immediately that their films will be state property, and anything they do not want to share publicly should be edited out prior to donation. There are ways of redacting sensitive material after donation that do not entail destruction of artifacts, but only an explicit clause in a donor agreement can guarantee that sensitive materials remain closed to the public. Other interviewees echoed this sentiment pertaining to permanent restrictions. Dwight Swanson admits that CHM tries "to be as clear as possible that it is always our intention to put as many home movies as possible online with no restrictions." Stephen Parr mentions that unless requested in writing in the deed of gift, donors are informed that their films are going to be made public and may be used as stock footage. Rarely, he says, have donors rejected this stipulation, but in those cases they were referred to another archive. Speaking in the role of a private collector and not as a CHM representative, Albert Steg neither has particular policies in place, nor does he anticipate privacy issues due to the orphaned (no identifiable owner) nature of his collection. He elaborates, "I have never been in a position where a living human being objected to . . . the home movie I was making use of." He adds that if surviving relatives of a filmmaker who were not aware of a film's existence, but encountered this footage in a public forum were to object, he would take those complaints seriously and "explore repatriating the films to the family."[13]

In the role of filmmaker and donor, Dougherty offers a unique perspective from both sides of the camera, admitting that even when shooting home movies, the setting dictated her approach to privacy issues:

> There are three different kinds of situations in which I have filmed people: one is familial or friendly social gatherings where a certain amount of commonality or trust exists; the second are public gatherings where there is some level of understanding that the camera is a vehicle to enlarge the audience and preserve the discussion/event; and third, are enacted scenes in mostly non-scripted movies. Technically, one should secure releases . . . for formal films, but in the past not for these more informal familial and or public event

gatherings . . . In the shooting of "home movie" footage I tried to be sensitive to the situation. To some extent as a participant in the event having the whir of the camera "observe" the occasion seemed natural and okay. There were other times when I felt it would be obtrusive and I did not film.[14]

Orgeron, Steg, and Streible appear to be, in some ways, the outliers in their points of view on the donor's (or his subjects') right to privacy. First, Steg, as a collector, does not find home movies to be any different from other "cultural artifacts" like diaries that have passed into the "realm of historical evidence" and are written about or displayed as primary documents. He finds that abstract concerns about what defines the "personal," and therefore privacy concerns, are essentially moot once a person is deceased but should be addressed directly when you have an actual complainant standing before you. In a similar vein, Streible admits considering the issue "only indirectly" and names screenings in venues such as "chamber cinemas, living rooms, hotel rooms, and conference gatherings" as perfectly suitable environments to "share the revelations rather than hide them for the sake of some possible (and not likely) privacy concern."[15] Conversely, Orgeron confesses that although he is always, as an academic, representing his university, he is not equivocal: "My own code of ethics . . . is fairly liberal if I believe the material in question has value (aesthetic, industrial, historical, or theoretical) beyond the personal or, more problematically, the comedic. And, while I appreciate the fact that differences of opinion abound, I find the largely decontextualized or speciously contextualized exhibition of these materials highly problematic. At the very least, I wonder if our work in this area loses a bit of its footing if this material is shown over drinks or as fodder for jokes?"[16]

Andersen and Weiss represent institutions, state-funded and incorporated nonprofit respectively, and thus present a glimpse into the quandaries that arise when public perception of their enterprises is a consideration. Weiss indicates that NHF has adopted a donor agreement but admits that rules can be mutable. As an example, he mentions an animal-rights group searching for footage of animal abuse for use in an advertising campaign. While what they sought may well have existed in the collection, it still seemed to him like a betrayal of donor trust to provide the footage they might have found. This incident forced NHF to reevaluate its position regarding use restrictions. NHF, in other words, recognizes the fact that, while they may have the *legal* right to provide potentially sensitive material for a variety of uses, there are a number of factors that might compel them, or a similar institution, not to exercise that right. A few questions may help uncover the inappropriate, racist, culturally insensitive, or homophobic intent of a patron. From her position within a state archive, Kim Andersen offers an analogous case: "I have had the opportunity to question the wisdom of publicly screening and/or putting online certain home movies we have in our collection, films that wonderfully document real events in the state's history, but

that present problems without proper context and prefacing. Specifically we have a film documenting a Ku Klux Klan rally in eastern North Carolina. Randomly showing that footage without benefit of good introductory material is at best in poor taste and could reflect poorly on the State Archives. So the choice was made to not put that footage online yet." From these examples, it is clear that understanding the intent of the user and providing adequate context as part of the screening are important strategies for coping with complex privacy issues.[17]

It is significant that in these scenarios Weiss's and Andersen's institutions have the legal rights to license a donor's footage because they obtained the copyright to the material. However, a more oblique intersection arises when a subject's right to privacy is violated by the donor or filmmaker's choice to repurpose material. Whether prominently displayed or not, there are often statements available to patrons or researchers on a collection's finding aid or as a "Rights and Permissions" policy on a repository's website that summarize the institution's declaration of rights, such as this one from Harvard University's Schlesinger Library: "Copyright in the audiovisual material created by Ariel Dougherty is held by [her] during her lifetime, and will revert to the President and Fellows of Harvard College for the Schlesinger Library upon her death. Copyright in other materials in the collection may be held by their authors, or the authors' heirs or assigns. Researchers must obtain the written permission of the holder(s) of copyright and the director of the Schlesinger Library before publishing excerpts from materials in the collection."[18]

Theoretically then, even if primarily protecting the donor or filmmaker, a statement such as this can be the first line of defense against a potential invasion of privacy—using copyright as that vehicle—for those subjects whose likenesses are found in a collection's personal films. Copyright law is federal law and is therefore uniform nationwide, but, additionally, there are state laws governing privacy rights (to prevent unflattering depictions) and commercial publicity rights. According to Schwartz, these laws protect the privacy of home movie subjects or filmmakers, and their rights of publicity. This "right of publicity" can potentially shield that person from "unauthorized commercial use of one's name or likeness"; and a "personal right" of privacy, while applied on a state-by-state basis, may also protect all subjects from injurious representations leading to a public degradation of reputation and "mental distress or harm to one's dignity or esteem."[19]

Schwartz points out another potential safeguard for filmed *subjects* in "Depositing Films with Archives: A Guide to the Legal Issues," an online checklist of issues designed to encourage the donations of films, including home movies, to archives. He writes, "The individuals appearing on-screen may not have signed employment or consent forms and may never have expected the footage to be shown in public. If an archive intends to publicly exhibit such material, it

should consider requesting releases from the on-screen individuals if the donor can obtain such releases." Consequently, his statement addresses mainly those people who were willingly filmed, whether for public exhibition or not. Home movie making and "employment or consent forms" have not historically gone hand in hand, however, so releases may be hard to come by long after creation of the footage. Since getting permission may be difficult, particularly when the films are "orphans" (the origins of the films or filmmakers are unknown), Congress has been working to amend the copyright law to allow much greater leniency for the use of orphan films after a due diligent search for the rights holders of the films. This "orphan works" legislation, in 2015, has been supported by the United States Copyright Office and many other interested parties and may, eventually, be enacted into law, which would greatly simplify the use of materials such as home movies.[20]

The Library of Congress policies for use primarily address legal protection for the patron who wishes to reuse footage, touching on monetary compensation for a subject (who knowingly posed) if his or her likeness is commercialized without permission. Although referring to photographs rather than home movies, the Library of Congress offers this example on its information page dealing with the legalities of privacy and publicity:

> An advertiser wishes to use a photograph for a print advertisement. The advertiser approaches the photographer, who holds the copyright in the photograph, and negotiates a license to use the photograph. The advertiser also is required to determine the relationship between the photographer and the subject of the photograph. If no formal relationship (e.g., a release form signed by the subject) exists that permits the photographer to license the use of the photograph for all uses or otherwise waives the subject's, sitter's or model's rights, then the advertiser must seek permission from the subject of the photograph because the subject has retained both privacy and publicity rights in the use of their likeness. The publicity right of the subject is that their image may not be commercially exploited without his/her consent and potentially compensation.[21]

In their discussion of copyright, the Center for Home Movies echoes the Library of Congress' copyright/privacy statement but also attempts to address those third party passersby and accidental subjects. They write, "The risk of copyright infringement is not the only consideration for users of home movie footage. Individuals who appear in the films—either as active participants or bystanders—have rights of personal privacy and publicity that should be weighed as well. . . . In the United States rights of privacy are only applicable during one's lifetime, so using 50-year-old footage of elderly people is less risky than scenes of children or young adults."[22] Both the Library of Congress and CHM seem to be concerned primarily with giving objective advice for reuse and exhibition, and risk-protection for the user. Dwight Swanson elaborates on this idea by pointing

to two different positions CHM took regarding material considered a violation of privacy—one deemed so by the donor herself and one where the film's owner and subjects had not been identified. In the former case, the donor requested that no names accompany the online showcasing of her family's home movies; in the latter, CHM made a decision to screen the more explicit film, in a symposium setting, with the intention of publicly questioning the more obvious privacy issues.[23]

The variety of approaches to self-regulation by private entities or public institutions, as described above, does not come out of thin air. Rather, it is a result of an unavoidably ad hoc process based on trusted best practices guidelines and decades of experience (even longer outside the United States). Archives, libraries, museums, and private collectors look to professional organizations' recommendations and governmental restrictions, and counter with suggestions that keep codes up-to-date and culturally relevant. While it is difficult to pinpoint from which direction it comes, as we have seen, more emphasis is placed on copyright ownership than on the rights of privacy for subjects of home movies, especially for commercially valuable or high-profile materials not covered by the doctrine of fair use. The Association of Moving Image Archivists' (AMIA) code of ethics does not respond to the topic of privacy beyond encouraging repositories to "provide access to content, as much as possible, without infringing on current copyright or intellectual property rights laws." The International Federation of Film Archives (FIAF) advocates that archives recognize that "materials in their care represent commercial as well as artistic property, and fully respect the owners of copyright and other commercial interests. Archives will not themselves engage in activities which violate or diminish those rights and will try to prevent others from doing so. . . . Archives will not intentionally be party to transactions (whether relating to screenings, to acquisitions or of any kind to any other use) which infringe the rights of others."[24]

The Association of College & Research Libraries, an arm of the American Library Association (ALA), in its "Guidelines: Competencies for Special Collections Professionals," advises its members to develop and maintain "knowledge of intellectual property rights, copyright, rights management, patron and donor privacy, and other legal issues, especially as they apply to primary materials in various formats." The phrase "other legal issues . . . various formats" seems to acknowledge vaguely the complexity of privacy and publicity rights (governed by state statute or common law) in regard to non-paper-based documents, but the focus remains on the creator and/or donor. In adjacent fields, the American Alliance of Museums' "Code of Ethics for Museums" promotes regulated access to the collections and related information and addresses concerns regarding "competing claims of ownership" and associated "dignity of all parties involved." An interpretation of the latter could, perhaps, be stretched to include subjects of contested works. The Society of American Archivists (SAA), like AMIA and FIAF,

asserts that archivists should honor copyright privileges while maintaining an overwhelmingly open access policy, including unpublished home movies (which they deem documents worthy of preservation). Although it does not directly refer to moving images, SAA's Code of Ethics is far less ambiguous in asserting that the voiceless may have viable stakes in their own privacy. They assert, "As appropriate, archivists place access restrictions on collections to ensure that privacy and confidentiality are maintained, particularly for individuals and groups who have no voice or role in collections' creation, retention, or public use."[25]

Institutional regulations, copyright statutes, and state laws regarding publicity rights and privacy rights only skim the surface of a deep set of issues. In 1993, the Committee for Preservation and Public Access, whose members included "motion picture screenwriters, directors, producers, distributors, historians, and journalists," went on record before the National Film Preservation Board of the Library of Congress with a statement entitled "Preservation without Access Is Pointless," and that title has become a maxim that motivates many moving image archivists. What is clear is that all laws, copyright included, generally permit public institutions to preserve film materials, including changing the format of the film to stable archival copies. The laws, however, usually come into play when those institutions or their patrons want to make the material widely available to the public. The privacy of individuals, then, often remains up for interpretation on a case-by-case basis. For help making such decisions, repositories can turn to codes of ethics that define parameters and guidebooks by organizations like the Duke Center for the Study of the Public Domain and Cornell University's Copyright Information Center. Conversations with copyright and privacy lawyers and a clearly written donor agreement can also help with intuitive and sometimes on-the-spot decisions.[26]

"Can We Watch This Together?"

Essays, articles, and personal perspectives extolling the praises of home movies regardless of how much we know about the filmmakers, subjects, or bystanders, exist alongside and intermingle theoretically with those that emphasize the significance of the firsthand account and the importance of the "witness." Decontextualized home movies are historical documents and are sometimes, as Roger Odin describes, "the only records of some racial, ethnic, cultural, social communities marginalized by the official version of history." Nico de Klerk further stresses that while only people participating in a given home movie can comprehend its full meaning, the content need not "remain obscure" to nonparticipants. Some scenes may be understood by nonfamily members as artistic flourish, or as Devin Orgeron has pointed out, a discovery of something homely in a foreign locale.[27]

Returning to Snowden Becker's essay, for those who are fascinated by "meeting" the family inside the can, she lays out a best-case scenario for capturing data—the narrative and people, places, and things—while simultaneously making "universal" someone else's home movie:

> The ideal scenario might include a special viewing of the home movie, with curatorial or collections staff and the family of the filmmaker present, in a room with a tape recorder. Commentary from the audience should be encouraged, especially identification of people, places, or activities, and the museum staff present should be able to make follow-up inquiries after the film is over ... Museums that conduct such screenings would be effectively borrowing from the practice of film collections like Northeast Historic Film, which screened a recent acquisition several times for local audiences in order to identify individuals depicted in the historic footage.[28]

A home movie preserved as such in the museum or library environment, Becker proposes, and supplemented with an audio recording of the narrative or oral history during its exhibition, may invite the public to feel like "part of the family" in perpetuity.[29]

Demonstrations of recorded conversations with a filmmaker or someone else with intimate knowledge of the film's original context are increasingly accessible online: *Disneyland Dream* (1956), in which Robbins Barstow gives the backstory to his family winning a trip to Disneyland; *The Last Reel* (1986), where Arthur H. Smith and Blanche Smith discuss their move to a mobile-home retirement community in California; *Think Of Me First As A Person* (1960s) containing an intimate and frank narration by Dwight Core Sr. about his son, who has Down syndrome; featured on the CHM website, Phil and Peter Mork home movies (1959–1970), with commentary by Peter Mork; and Manuel Reyes Family home movies (1978–1979), which include Verónica Reyes-Escudero in conversation with Jennifer Jenkins of the University of Arizona. "Home movies potentially provide a candid, evocative look at individual lives and endeavors at an identifiable point in time [and] give rise to serious questions about ethics, contextualization, and the very idea of true narrative," says Becker. What truer narrative, even if colored by the rosy hue of hindsight, or the subjectivity of personal experience, than that of the first person?[30]

A Multiplicity of Voices—Part 2

The creator and subjects are those best situated to illuminate privacy issues inhering in a film document. However, to elucidate the range of concerns among archivists, I invited interviewees to view a single home movie clip in order to elicit their opinions on the privacy issues that arise in screening the particular work in public. This exercise is meant to exemplify three things: first, despite the

Fig. 10.2 Archie Stewart in a motorboat during a hunting trip in Maine, 1930. From 16mm film. Archie Stewart Collection, Northeast Historic Film. [Accession 1108, Reel 20]

accompanying documentation about the film itself and the filmmaker/donor, we still know little about the subjects in the clip; second, exhibiting this clip on the Internet and discussing it in a public forum adds to the multiplicity of voices speaking on the subjects' behalf and speculating about these strangers' lives; and third, despite their varying opinions, each interviewee's response is *personal* and therefore subjective.

The interviewees watched an approximately four-minute clip from a home movie by Thomas Archibald Stewart in the Archie Stewart Collection at NHF. They were given a link to the clip, the link to Stewart's online finding aid, and the following information obtained from NHF's Karan Sheldon: "Stewart is the man in the checked shirt/jacket steering the outboard motor on the canoe. Howard Kendall, the man in the black coat and cap who we first see in the canoe with Stewart, apparently guided the hunting trip. He [Kendall] was assisted by the young man who appears in the sequence outside the home. The homestead is presumably Kendall's or the young man's."[31]

To situate the reader, the following attempt at a neutral and unbiased shot list of the clip might prove useful: Stewart readies his cap and camera bag; he and Kendall on the lake in a canoe; Kendall and another older man inspecting a freshly killed deer strapped to the front of a vehicle; a young man physically struggling with a young woman, and then with an older woman, in front of a homestead; the Kendall family (presumably) and Stewart posing; Kendall

Fig. 10.3 Archie Stewart filmed his visit to a homestead while on hunting trip in Maine, 1930. From 16mm film. Archie Stewart Collection, Northeast Historic Film. [Accession 1108, Reel 20]

securing a canoe to the top of the car; followed by a trip to a gas station and seeing Stewart off at a train station.[32] It is intriguing to think about the relative impossibility of *objectivity* in describing the action. Values and assumptions creep into what is meant to be merely illustrative language, and this is the crux of the issue. Excerpts from the interviewees' responses (in alphabetical order) reveal the range of opinions regarding a stranger's film from professionals engaged with home movies:

> If the women are, in order of their appearance, the young man's sister and perhaps his mother or an aunt or other older family member, the behavior is a lot less disturbing than if the women are spouses or hired help or prostitutes. Either way, I didn't find the clip to be overly disturbing or controversial but do see where it is not the most appropriate film for all audiences. (Kim Andersen)
>
> Here is a young hunting guide whose own sister (?) seems put off—to my eyes—by looking at the deer strapped to the front of the car . . . We know that the young man and Kendall make at least part of their living as guides, thus Archie Stewart is their employer in this case. I wonder if her actions do not somehow embarrass them momentarily, whether she does not want to be filmed or look at the deer, as the man with the camera is their employer. (Melissa Dollman)
>
> The women in the Stewart clip are definitely not willing partners in the performance. There are no close ups of their faces. The women seem to be hiding or running away from the camera. They have no direct gaze at the camera,

as the men have had. The only shot where they seem to be slightly engaged is the sequence with the five of them as they stand in a row like a bow at the end of their performance. Maybe they are "relieved" their "parts" are over. (Ariel Dougherty)

I have no objection to this clip whatsoever. The fact that the details are left open to interpretation (What are the relationships? Is this play or cruelty? Is the displeasure on the girl's face the result of the dead deer she's being forced to confront or something else?) might present us with some potentially cavernous ethical questions . . . Were it being used in an exhibit, for example, on New England economies (tourism or sport), I think a thoughtful curator could provide adequate context and also indicate to potential visitors the ambiguities at play. (Devin Orgeron)

It's difficult to say whether what is happening outside the home is forced physical contact between the male and female. (Stephen Parr)

Well, first of all I guess I would ask whether all of the people captured on film are deceased? If so, I don't see any real privacy issues here, because no person exists whose privacy is being violated. Now, what if, say, there is a son or daughter of one of the persons in the film, and that this living person feels that their relative is being exposed in an unflattering light—or "knows" that this person would not have wanted his or her image to be seen by strangers. Such a complaint should be taken seriously, and certainly not dismissed out of hand. (Albert Steg)

I watched it, but without more context I don't know what to say. (Dan Streible)

The clip really brings out the limitations of silent film, since if we could hear the voices of the participants the mood of the moment would be much more clear . . . This is one of the dangers of dislocating a private film from the producers and participants and their historical setting. Can we really trust our own impressions of the scene without knowing the participants? It is easy, after all, to wildly misinterpret a stranger's intentions. Or can it possibly be true that we, as spectators, are allowed a privileged view because of our objectivity? (Dwight Swanson)

I found the clip disturbing. On the face of it, it looks like highly inappropriate behavior. I am a little cautious though as I have seen examples where footage viewed without context is quite misleading. (David Weiss)

In this case, the participants already knew more about some of the subjects' relationships to the filmmaker than is typical for many home movies that have been collected. Moreover, their viewing was informed (as was the rest of the questionnaire) by the request that the interviewees identify any inherent privacy concerns. Still, the personal responses to this clip reveal that even if all caretakers of home movies and stock footage clients approached the rights of strangers and their respective likenesses according to the Society of American Archivists

suggestion—considering the sensitive nature of a film "particularly for individuals and groups who have no voice or role in collections' creation, retention, or public use"—a "best practices" guideline would be best employed when combined with empathy.

"The Last Word"

Ariel Dougherty's thoughts regarding the complexities of the archive/collector/user/donor relationship are enlightening. When asked if she had occasion to consider privacy issues and home movies, we see above that as a filmmaker she has thought about the role of the *camera* in a given situation, such as when release forms are necessary or not. But what about as a *donor* of such films? Dougherty writes:

> Ironically, the footage in my collection at Schlesinger [Library] that holds my largest privacy concerns is not the footage of bare-breasted women (restricted), but the wedding footage of my oldest and best friends from elementary and junior high (not currently restricted). Not even a decade has passed since my audiovisual collection was archived. But it has been many more years since I have viewed almost all of the material . . . I might re-consider some aspects of the restrictions. First, my understanding is the restricted footage is based upon my death plus so many years. But really the restrictions have to do with the subjects in the films more than myself as the camerawoman. Realistically, there is no way an archive can know when such subjects die or not. This poses a challenge . . . I have to say from the initial donation it never occurred to me to restrict certain footage or material. I simply did not think about it. The archivist raised the issue.[33]

What do Dougherty's words tell us? Can only the first-person narrative of a donor, or perhaps another person otherwise intimately connected to a home movie's content, offer context and nip speculation in the bud? Certainly, it seems to be the sole means of identifying what in a film is particularly personal *to her*. In retrospect, what the archivist identified as potentially a reason for restriction (bare breasts—not the donor's—of extant women) turns out to be not nearly as worthy of consideration as her best friends' wedding. So there you go.

This essay presents for the reader a number of personal perspectives, though by no means exhaustive, in an attempt to shed a light on a murky subject. The interviewees volunteered varying points of view but agreed wholeheartedly and sometimes passionately about the importance of these "little" films. Moreover, as each focused on a different aspect of the issue at hand—rights to privacy for subjects in these films—there emerged a common thread: context. They discussed context of the original filming, the context of the original exhibition, and perhaps most critically, the context of our contemporary use of these materials. Insufficient information about the first two, it would appear, can be compensated for if the final element is adequately compelling, and if much of that original context

is unknowable, this is where archival best practices would appear to converge context with consent. As Karen Benedict writes in *Ethics and the Archival Profession*, "Privacy and confidentiality are the areas of law that most affect archival decision making. Though they are matters of law, privacy and confidentiality also are treated as ethical concerns."[34] Sometimes, however, the "last word" on any ethical or legal concerns regarding audiovisual materials rests in the hands of individuals who may be wholly disconnected from a given film's origins except for any paperwork that came in the box.

Home movies are important historical records, are examples of amateur filmmaking techniques, serve the study of familial dynamics, and are a window into the aesthetics of bygone eras. In the case of materials that are otherwise "useful" in some contemporary context (a museum exhibition or as stock footage), elements that raise moral, ethical, or privacy flags sit more comfortably if those ambiguities and potential concerns are openly and critically addressed rather than ignored or speculated upon. Home movies are difficult objects, more veiled than transparent. Our continued critical thinking about these issues contributes to a greater understanding of the importance of unfettered access to these materials and promotes our collective mission to better understand our culture and ourselves.

Technical Notes: Archie Stewart, Excerpt from Reel 20, Stewart Collection (1930)

From the time Archie Stewart started making movies in 1926 to his last home video, he was constantly upgrading his equipment to try out new technology as it became available and make the overall look of his films more professional. This mark of true enthusiasm is also signaled by his use of the Amateur Cinema League leader at the start of his films.

For this excerpt, Stewart used a Ciné-Kodak Model B. The Ciné-Kodak was a popular and continually evolving camera with multiple models sold over the years. Kodak produced the Model A in 1923 when it first introduced 16mm film. The Model B, which was more of a specialty camera, appeared in 1925. These were shortly followed by the more affordable and simplified models BB, K, and M. In 1933 Kodak made its next real design improvement with the Ciné-Kodak Special, which came equipped with a lens turret. The turret fixed multiple lenses to the front of a camera, giving the filmmaker easy access to different lenses. For Stewart this meant he could film his friends hunting in a wide shot and then quickly turn the turret to change lenses for a close-up.

These reels also show that Stewart continued to edit his films but began to use less-noticeable straight splices rather than diagonal ones.

Excerpt from Reel 20, 1930. Archie Stewart.
Archie Stewart Collection, Accession 1108, Reel 20.

Gauge: 16mm. Stock: Kodak Safety Film (B&W reversal) for live action, Agfa Nonflam Safety (B&W print) for ACL leader, Kodak Safety Positive (B&W print) for ACL leader.
Length: 107 ft.
Overall reel length: 220 ft. Splices: seven.
Date code: 1930
Camera code: Ciné-Kodak Model B f-1.9
Other info: ACL leader has a splice in the middle of it where it changes from Agfa to Kodak stock. Perhaps it became damaged and Archie sent away for replacement.

Melissa Dollman is a PhD student in American Studies at the University of North Carolina, Chapel Hill. She has worked as an audiovisual archivist for Harvard University, the Academy Film Archive, the UCLA Film and Television Archive, and Women In Film Foundation. As a consultant, she has cotaught a graduate seminar on film archives and research at North Carolina State University, conducted archival material research for documentaries, and presented at numerous conferences and symposia.

Notes

1. I am beholden to the questionnaire respondents, whom I have referred to as "interviewees" in this essay. I would also like to thank Greg Pierce (The Orgone Archive) and Skip Elsheimer (A/V Geeks), who contributed ideas through conversation. A special thank you to Martha McNamara, Karan Sheldon, and Eric Schwartz for reviewing the essay and for their invaluable assistance. The epigraph can be found at http://www.hbo.com/documentaries/regarding-susan-sontag/interview/nancy-kates.html, accessed on July 16, 2015. Jeffrey Toobin, "The Solace of Oblivion," *New Yorker*, September 29, 2014, accessed March 7, 2015, http://www.newyorker.com/magazine/2014/09/29/solace-oblivion. European Court of Justice, "Factsheet on the 'Right to be Forgotten' ruling (C-131/12)," March 6, 2014, accessed March 7, 2015, http://ec.europa.eu/justice/data-protection/files/factsheets/factsheet_data_protection_en.pdf.

2. David K. Li, "Professor Finds Long-Lost Home Movies Playing in NYC Museum," *New York Post*, January 15, 2015, accessed March 7, 2015, http://nypost.com/2015/01/12/professor-finds-long-lost-home-movies-playing-at-nyc-museum/.

3. Eric J. Schwartz, e-mail message to author, June 21, 2015.

4. Ariel Dougherty, Stephen Parr, Albert Steg, Dwight Swanson, Devin Orgeron, Dan Streible, Kim Anderson, David Weiss, e-mails to author, November 17–December 6, 2014. The questions presented were "1. Could you give your bio and affiliation? 2. And in that role, what historically has been your relationship to home movies (e.g., collect or otherwise acquire them; curate and screen them; have appeared in them; teach, write, or present on them as a genre; make them or otherwise incorporate their content artistically?) 3. What rules in place in your institution, your business, or personal code of ethics specifically observe a donor's privacy (or not)? 4. Have you had occasion to consider privacy issues related to home movies? (e.g., Direct interaction with donors or their estates—or lack thereof?; forced to question the ethical

implication of a public presentation of a home movie or a scholarly investigation thereof? Or reuse of footage?). 5. Have you or your family donated home movies to an archive or similar repository? What, if any, stipulations were included as to restricted use? If not donated, how would you feel if your home movies were screened publicly? What, if any, footage would you personally restrict? 6. I have included a link to a 4+ min. video. As part of my overall discussion regarding privacy and public viewing of home movies, I would appreciate your reactions to this clip. I am particularly interested in your reaction to the part that takes place in front of the home."

5. Alan Kattelle, *Home Movies: A History of the American Industry, 1897–1979* (Nashua, NH: Transition, 2000), 265. Philip Sterling, "Sowing the 16mm Field," *New York Times*, July 25, 1937, quoted in Patricia R. Zimmermann, *Reel Families* (Bloomington: Indiana University Press), 71.

6. The original Zapruder 8mm film is at the National Archives in College Park, Maryland, while the copyright for the film is owned by the Sixth Floor Museum in Dallas, Texas. See "JFK Assassination Records," US National Archives and Records Administration accessed July 14, 2015, http://www.archives.gov/research/jfk/faqs.html#film; Frances Guerin, *Through Amateur Eyes: Film and Photography in Nazi Germany* (Minneapolis: University of Minnesota Press, 2012); Eva Braun Private Motion Pictures, Steven Spielberg Film and Video Archive, United States Holocaust Memorial Museum, accessed July 14, 2015, http://www.ushmm.org/online /film/search/result.php?titles=Eva+Braun+private+motion+pictures; Penny Lane and Brian L. Frye, *Our Nixon* (2014), accessed March 7, 2015, http://www.ournixon.com/; Stanley Nelson, *A Place of Our Own* (Firelight Media, 2004); Deann Borshay Liem, *In the Matter of Cha Jung Hee* (New Day Films, 2010). See also "Home Movie Movies," Center for Home Movies, accessed March 7, 2015, http://www.centerforhomemovies.org/homemoviemovies/.

7. The National Film Preservation Foundation has provided funding for film-to-film copying of amateur films and home movies, accessed July 16, 2015, http://www.filmpreservation.org /nfpf-grants/overview.

8. "Carl Sagan Home Movies of Childhood," Library of Congress, http://www.loc.gov /item/cosmos000112; "Danny Kaye—Africa and Asia," Library of Congress, http://www.loc .gov/item/ihas.200198135/; "Home Movies from the War Front: The First Fighters in New Guinea," National Archives and Records Administration, http://unwritten-record.blogs .archives.gov/2014/11/03/home-movies-from-the-war-front-the-first-fighters-in-new-guinea/; Prelinger Archives, https://archive.org/details/prelinger; Texas Archive of the Moving Image; http://www.texasarchive.org/; Center for Home Movies, "Amateur Night: Home Movies from American Archives," http://centerforhomemovies.org/amateurnight/screenings/; Oddball Films, http://oddballfilms.blogspot.com/; The Outfest Legacy Project for LGBT Film Preservation, http://www.outfest.org/legacy-project-film-gallery, all accessed March 7, 2015.

9. Andy Uhrich, "The Private and Public Viewings of Home Movies," *In Media Res: A Media Project*, October 15, 2012, accessed March 7, 2015, http://mediacommons.futureofthe-book.org/imr/2012/10/15/private-and-public-viewings-home-movies.

10. Snowden Becker, "Family in a Can: The Presentation and Preservation of Home Movies in Museums," *The Moving Image* 1, no. 2 (Fall 2001): 89–106; Patricia R. Zimmermann, "Morphing History Into Histories," Northeast Historic Film, July 2001, accessed March 7, 2015, http:// oldfilm.org/content/morphing-history-histories; Karan Sheldon, "Home Movies," Northeast Historic Film, accessed March 7, 2015, http://oldfilm.org/content/home-movies; Rick Prelinger, "Rights," Internet Archive, accessed March 7, 2015, https://archive.org/details/prelinger.

11. Eric J. Schwartz, "Intellectual Property Law and Rights of Privacy in Relation to Home Movies," Northeast Historic Film, July 2001, accessed March 7, 2015, http://oldfilm.org /content/intellectual-property-law-and-rights-privacy-relation-home-movies; Peter B. Hirtle,

"Copyright Term and the Public Domain in the United States: 1 January 2015," Cornell Copyright Information Center, accessed March 7, 2015, http://copyright.cornell.edu/resources/publicdomain.cfm.

12. See also David Pierce, "Copyright, Preservation, and Archives: An Interview with Eric Schwartz," *The Moving Image* 9, no. 2 (2009): 105–48; Keith Aoki and James Boyle, "Bound By Law?," Duke University's Center for the Study of the Public Domain, http://web.law.duke.edu/cspd/comics/digital.php/; Rick Prelinger, "Orphan Works talk for 4/12/2012," http://www.law.berkeley.edu/files/Orphan_Works_Talk.pdf; "Charts and Tools," Stanford University Libraries, Copyright and Fair Use, http://fairuse.stanford.edu/charts-and-tools/, all accessed March 7, 2015.

13. Anderson, Swanson, Parr, Steg, e-mails to author, November 17, December 2, 2014.

14. Dougherty, e-mail to author, November 26, 2014.

15. Steg, Streible, e-mails to author, December 2, 6, 2014.

16. Orgeron, e-mail to author, December 1, 2014.

17. Weiss, Andersen e-mails to author, November 24, 2014.

18. Ariel Dougherty Audiovisual Collection, 1952–1992; Vt-146, MP-48, Phon-41, DVD-9, or T-349. Schlesinger Library, Radcliffe Institute, Harvard University, Cambridge, MA.

19. Eric J. Schwartz, "Intellectual Property Law and Rights of Privacy in Relation to Home Movies," Northeast Historic Film, July 2001, accessed July 18, 2015, http://oldfilm.org/content/intellectual-property-law-and-rights-privacy-relation-home-movies.

20. Eric J. Schwartz and Scott Martin, "Depositing Films with Archives: A Guide to the Legal Issues," Library of Congress, accessed March 7, 2015, http://www.loc.gov/programs/national-film-preservation-board/preservation-research/film-preservation-plan/depositing-films-with-archives/.

21. "Privacy and Publicity Rights," Library of Congress, accessed March 7, 2015, http://www.loc.gov/legal#privacy_publicity.

22. "Copyright," Center for Home Movies, accessed March 7, 2015, http://www.centerforhomemovies.org/copyright/.

23. Swanson, e-mail to author, November 28, 2014.

24. "Code of Ethics," Association of Moving Image Archivists, accessed March 7, 2015, http://www.amianet.org/about/code-of-ethics; "Code of Ethics," Fédération Internationale des Archives du Film/International Federation of Film Archives, accessed March 7, 2015, http://www.fiafnet.org/uk/members/ethics.html.

25. "Guidelines: Competencies for Special Collections Professionals," American Library Association/Association of College & Research Libraries, http://www.ala.org/acrl/standards/comp4specollect; "Code of Ethics for Museums," American Alliance of Museums, http://www.aam-us.org/resources/ethics-standards-and-best-practices/code-of-ethics; "Donating Your Personal or Family Records to a Repository," Society of American Archivists, http://www2.archivists.org/publications/brochures/donating-familyrecs; "SAA Core Values Statement and Code of Ethics," Society of American Archivists, http://www2.archivists.org/statements/saa-core-values-statement-and-code-of-ethics, all accessed March 7, 2105.

26. "'Preservation Without Access is Pointless': Statement by The Committee For Film Preservation and Public Access before The National Film Preservation Board of the Library of Congress, Los Angeles, California February 12, 1993," The Committee For Film Preservation and Public Access, http://www.loc.gov/programs/static/national-film-preservation-board/documents/fcmtefilmprespubaccess.pdf, accessed July 17, 2015.

27. Roger Odin, "Reflections on the Family Home Movie as Document: A Semio-Pragmatic Approach," in *Mining the Home Movie: Excavations in Histories and Memories*, eds. Karen L. Ishizuka and Patricia R. Zimmermann (Berkeley: University of California Press, 2008), 263;

Nico de Klerk, "Home Away from Home," in *Mining the Home Movie*, 149; Devin Orgeron, "Mobile Home Movies: Travel and le Politique des Amateurs," *The Moving Image* 6, no. 2 (Fall 2006): 78.

28. Becker, "Family in a Can," 2001, 98.

29. Ibid.

30. Becker, "Family in a Can," 2001, 91; *Disneyland Dream*, https://archive.org/details /barstow_disneyland_dream_1956; *The Last Reel* (excerpt), http://mediacommons.future-ofthebook.org/imr/2012/10/15/private-and-public-viewings-home-movies; *Think of Me First as a Person*, http://www.thinkofmefirstasaperson.com/; Phil and Peter Mork, 4th of July 1959, http://www.centerforhomemovies.org/phil-and-peter-mork-mork-home-movies/; Reyes Family Movies, Manuel Reyes, http://www.centerforhomemovies.org/manuel-reyes-reyes-family -home-movies/, all accessed March 7, 2015.

31. The Archie Stewart Collection finding aid, Northeast Historic Film, accessed March 7, 2015, http://oldfilm.org/collection/index.php/Detail/Collection/Show/collection_id/170.

32. The reader is invited to participate in this exercise by accessing the film available on the volume's accompanying website.

33. Dougherty, e-mail to author, November 26, 2014. I am the archivist to whom she is referring. I processed the audiovisual components of her collections donated to the Schlesinger Library at Harvard University in 2011.

34. Karen Benedict, *Ethics and the Archival Profession: Introduction and Case Studies* (Chicago: The Society of American Archivists, 2003), 16.

11 Layers of Vision in Amateur Film

Mark Neumann and Janna Jones

Since the early decades of the twentieth century, amateur filmmakers have worked in the shadows of a commercial film industry that has both inspired and frustrated them. Fearful of being regarded as clumsy and incompetent in comparison to professional filmmakers, amateurs have looked to cinema clubs, amateur movie making magazines, and guidebooks for advice and techniques. Such efforts have only highlighted the ways that amateur filmmakers have been viewed as second rate. During much of the twentieth century, the distance between amateur films and commercial ones seemed insurmountable.

Amateur films are at once wild and uncontained by the conventions of cinema and, at the same time, aspire to mimic those conventions. The term "amateur" surely distinguishes such films from commercial films, but it is not a difference that tends to get us very far in trying to make sense of them. When we keep our focus only on the ways that amateur filmmakers do not measure up to their professional counterparts, their rich cultural, social, and psychological meanings are easily overlooked. In fact, amateur films are a significant cultural resource that document both the constraints and possibilities of social and cultural life, past and present. They also have the potential to reveal the amateur filmmaker's personal flashes of imagination and creativity.

To make sense of some of the tensions between the lived realities that serve as the basis of experience for making films and the cinematic dreams constructed by amateur filmmakers, this essay focuses on scenes from two collections of family films that are part of the Northeast Historic Film archives. These films are historical documents that reveal the impact of various cultural and aesthetic forces, as well as traces of an idealized and imaginary sense of life and experience. The transformations wrought in America by increasing industrialization and urbanization in the late decades of the nineteenth century and early decades of the twentieth century prompted many Americans to seek out the world of nature as an aesthetic and redemptive experience. In *No Place of Grace*, Jackson Lears notes that Americans facing the "marriage of material and spiritual progress" in modern America, particularly eastern cities, experienced a moral void of culture that "lost sight of the larger frameworks of meaning." Many members of an educated bourgeoisie expressed an antimodern spirit that left them longing for a life

in places that felt authentic. Many turned to leisure and aesthetic experiences that oriented them toward nature and rustic modes of life as a source of leisure and aesthetic experience.[1]

In this essay, we specifically examine films made by Elizabeth Woodman Wright and Thomas Archibald ("Archie") Stewart.[2] Wright and Stewart both began making amateur films in the 1920s, and their films capture numerous scenes of family life, culture, and travel. We focus our attention on the films by Wright and Stewart that concern themselves with rural life and nature as leisure experience.

The Wright family lived in Cambridge, Massachusetts, and the Stewart family lived in Newburgh, New York. As both filmmakers resided in urban areas, the films they made about their excursions into rural life and nature offer a number of ways to consider various dimensions of amateur filmmaking. Given the period in which these films were made, they have historic value in that they document ways of life, objects, dress, landscapes, and technologies from the 1920s. In this way, the films offer an experience of "time travel" that shows us how places and people were directly recorded by the camera decades ago. They offer moving images of other times documented with an immediacy that opens a window to the past, an inherent value of nearly any amateur film.

On another level, however, their films reveal how amateur filmmaking provided a mode for documenting life that illuminated, in part, the contradictory dimensions of modern experience. As the larger forces of modernization and progress began to overthrow traditions and usher in new technologies as well as new forms of social structure and experience, they also spawned a sense of loss and longing. As Marshall Berman notes, the forces of modernization are characterized by a dialectic of destruction and renewal, and it is in the experience of modernity that we find people "striving to make a place for themselves in the modern world, a place where they can feel at home."[3] In part, this sense of "feeling at home" meant leaving one's home in search of experiences where one could seek out life that felt more "real" and "authentic" in comparison to the comforts and securities of modern urban life.

Against the broad backdrop of modern experience, the amateur film camera appears as a technology that sometimes captured the drama of modern life in a manner expressing modes of revelation and self-consciousness. In the films discussed below, Wright and Stewart's work reveals how the camera mediated experience and captured images that both documented and idealized life at a distance from home, and also suggested how people tried to "be at home" and belong to the ways of life found in rural and natural settings. These films show some of the ways rural life and the experience of nature offered a temporary alternative to the alienating features of modern urban life.

For both of these amateur filmmakers, it was the world of rural life and nature found in Maine that captured their imagination. Since the mid-nineteenth

century, artists and writers had constructed an image of the natural and rural regions of Maine as an attractive travel destination. For instance, Pamela Belanger's study of artists such as Thomas Cole, Frederic Church, and Sanford Gifford shows how their art constructed an image of Maine that appealed to visitors who sought out the transcendent virtues of natural wilderness and land-scapes.[4] These images, along with the work of writers, poets, tourist guidebook authors, and printers helped to establish Maine and northern New England as a retreat from urban life. As Dona Brown observes, in contrast to "city land-scapes [that were] dominated by huge brick factories," late nineteenth-century Americans sought out "isolated and remote parts of New England, looking for an imagined world of pastoral beauty, rural independence, virtuous simplicity, and religious and ethnic homogeneity." In short, "New England came to mean an escape from the condition of modern urban industrial life," writes Brown. "When late nineteenth-century consumers grew uneasy with the world they had helped make, tourism offered an escape from that world."[5] Her observations point to the dialectical tensions of modern life and the antimodernist impulse to temporarily vacate urban life for the supposed virtues of the rural and of nature. In the early twentieth century, people like Wright and Stewart went to Maine to find such relief, and they did so against a backdrop of images and ideas about the place that had been culturally constructed since the middle of the nineteenth century.

Wright and Stewart were motivated—like anyone who frames an image and exposes film—by an intentionality and attitude toward their subjects. In this case, they have created films that depict a hazy cultural space of fact and fiction, real-ity and imagination, and a conspicuous sense of desire. For Wright, filming her family during their annual summer retreat to their farm in rural Maine appears as a self-conscious effort to reaffirm the values of work and physical labor associ-ated with a "rustic" lifestyle. At face value, her films seem to be a compilation of images depicting the family during their summer vacation and their association with locals in and near Paris, Maine. Yet, as we discuss below, Wright's films also reveal an active pursuit of the merits of rural life. For Stewart, an excursion into the Maine woods to hunt provides a context for fabricating a cinematic story that is a mix of fact and fiction, offering him an opportunity to gather images he will compose as a tale of masculine adventure.

At least since the middle of the nineteenth century and the early decades of the twentieth, the alienating qualities of modern urban experience prompted many to look to nature, rural life, and the great outdoors as a place of leisure and recreation. Escaping the routines of the city for the country farm or a hunt in the woods were, in part, efforts not just to "get away" from the routines of life but to move toward a world that held the promises and possibilities for making a different kind of identity. Such pursuits were not new for people like Elizabeth Woodman Wright or Archie Stewart. What was new, particularly in the 1920s,

was the presence of the amateur movie camera, which enabled the filmmakers to record and animate those places and document their attempts to experience a distinctly nonmodern world.

Making the Rural Scene: Elizabeth Woodman Wright at Windy Ledge

Against the steel gray sky, they are silhouettes. Men are heaving hay high onto a flat wagon. Three men with pitchforks work the field, lifting the loose bundles up to three other men who stand on top of the piled hay that is already filling the wagon. One working in the front of the wagon does double duty, switching between a pitchfork and the reins that control two draft horses. The horses slowly advance the wagon to follow the windrow, while the field workers scramble to gather the crop and lift it to those atop the hay. Even though we have never seen these 1929 moving images before, there is a moment of recognition. It feels familiar and somehow sentimental. Even in the immediate moment of exposing this footage there is a sense of composition and an attitude toward the subjects that suggests an attempt to recuperate a simpler life from an earlier time. It may be 1929, but these images are reminiscent of an earlier century.

Elizabeth Woodman Wright was forty-three years old when she purchased a 16mm Kodak amateur movie camera in 1928. Wright, at Windy Ledge, made most of her family's films. They document their activities on the farm, the work of rural life, and their children, family and friends. Wright, who was married to Charles Henry Conrad Wright, a professor of French language and literature at Harvard University, lived in Cambridge, Massachusetts. They spent summers at Windy Ledge, a farm in Paris, Maine, that Charles bought in 1903. They had three sons, Walter Woodman, Charles Conrad, and Brooks.

The hay wagon is now parked in front of the barn clad in cedar shingles. Like many New England farmhouses, the barn is connected to the house with a small addition that allows passage from the main living area into the barn without going outside.[6] Three men with pitchforks stand atop the pile of harvested hay. Their sleeves are rolled up, two of them wear brimmed hats, and their trousers are held up with suspenders. The wagon, horses, and workers fill the frame. The black-and-white film lends great contrast to the white horse, harnessed and still, as the men begin to unload. One of them climbs through the window on the upper side of the barn, which opens onto a hayloft. The other two use their pitchforks to shovel the hay through the window to the man inside, who is now out of view and presumably moving the hay to the storage area of the barn.

These scenes evoke the realism of Jean-François Millet's peasants during a harvest. Wright's silent black-and-white scenes are like a painting coming to life. Her films "sketched her family's summer farm with the eye of a landscape artist," Scott Simmon notes. "Her films speak with a fluid pace that suits her pastoral subject."[7] Other scenes convey a similar rich sense of aesthetic sensitivity

Fig. 11.1 Bringing in the hay at Windy Ledge, Paris, Maine, circa 1929. From 16mm film. Walter Woodman Wright Collection, Northeast Historic Film. [Accession 0996, Reel 1]

toward the land and the people who lived there. We see country roads, stone walls, and meadows leading to a western view of the White Mountains. There is more harvesting of hay, picnic lunches on blankets in the fields, winter frolicking on a horse-drawn sleigh, and the end-of-summer county fair. Such scenes share an attitude toward composition and subject matter that enchant the pastoral life and landscapes of southwestern Maine. Wright framed her landscape scenes in a manner equated with aesthetic conventions often brought to landscape paintings in the nineteenth century and earlier. There is nothing inherent in a landscape that makes it enchanting or unsettling. In landscape painting, however, there is a pervasive pastoral aesthetic that constructs a feeling toward the land using particular depictions of light, a sense of harmony, and the portrayal of rural subjects as living simply and with integrity. This pastoral tradition has strong associations with the ideals and virtues of labor and of spirituality. Such conventions seem to have exerted a strong influence on Wright as she composed her scenes. Yet Wright's eye was not entirely focused on conveying an aesthetic appreciation for the region. The films she made at Windy Ledge are also filled with images of her family, visitors, pets, and visions of rural life that were both performative and celebratory.

Since the beginning of the twentieth century, Kodak advertisements depicted women using their still photography cameras, and in the 1920s, the company made an effort to market their amateur movie cameras specifically to women, promoting the idea that they capture scenes of family and nature.[8] "The technical

aura of moviemaking might place this activity in the masculine sphere," notes Richard Fung, but the "domestic role of producing family" opened filmmaking to an "arena of the feminine."[9] Wright's films reveal how a woman filmmaker engaged and extended the notion of the "family album" that was typically reserved for photographs. In one scene, her family is gathered together to install a wooden sign in front of a stone wall. The sign, mounted on two wooden posts, reads "Windy Ledge." The family works together to set the posts and secure it with rocks, and then gathers around it to pose for a family portrait. The scene carries a dual function. Posting the sign is a way of marking the territory, a planting of the proverbial flag. At the same time, it provides a setting for the family who owns the farm and uses it as their summer playground.

Wright's films reveal a glimpse of how amateur filmmaking intersected with other cultural conventions for experiencing rural life as both a mode of leisure and an aesthetic pursuit. Despite her bucolic settings and scenes, a modern tension between rural and urban life is embedded in Wright's moving images. Windy Ledge was a place at a distance from the world of Cambridge and Boston where the Wrights lived most of the year. The rural world of Paris, Maine, at least as it appears in Wright's films, served as a stage for a fantasy of rural life that existed outside of the familiar routines of the city. Wright's films emphasize a fantasy of rural existence, for Windy Ledge was an arena where a temporary engagement with rural life could be practiced, performed, and filmed in numerous scenes of fascination.

Wright's camera calls attention to the tension between the rural and the urban, even if she did not realize it. Wright documented and dramatized rural life, and in these films, as we have argued elsewhere, the "rural appears as an imaginary site, a cinematic space where depictions of rural life are a product of the filmmaker's relationship to [her] subjects." Wright's films, like those of many other amateur filmmakers, attend to and compensate for the growing forces of modern life and progress as they render "a fantasy of the small town and the folk as a retreat from such forces."[10]

In many amateur films, it is difficult to provide a definitive identification of people and locations, but in Wright's case various sources provide some contextual information about her films.[11] Here we focus on one of Wright's films that appears to document "a day in the life" at the farm. Such films depicting "a day in the life" offered a narrative structure for some amateur filmmakers that allowed them to convey a sense of place and identity for their subjects, often in an effort to create an interesting and entertaining film.[12] Wright's seventeen-minute film is a compilation of scenes that she edited by stopping and starting the camera. There are no descriptive intertitles. Her film is loosely structured, and the following description of the film's scenes will enable us to analyze more closely the nature of the events and experiences she recorded.

The film begins with two of her sons hoisting an American flag up a flagpole fixed in one of the meadows. As the boys attach the flag to the rope and pull it high, we can we see the White Mountains in the distance. Wright lingers on the flag flapping in a stiff breeze before cutting to a scene of brush clearing. The boys use axes to chop saplings. A wood-paneled station wagon drives up with a young girl and boy seated on the tailgate. They are there to load the brush and move it elsewhere. The camera cuts to an elderly man, Ellsworth Thayer, a neighbor the Wright family called Uncle El, sharpening a scythe in a field. A German shepherd dog stands close by and then lies down in the grass, as Uncle El demonstrates how to cut the hay with the tool.

This scene is followed by several shots showing a horse-drawn hay mower cutting a field. The mower is a simple design, with a seat mounted over two wheels and a threshing bar extending on the right side to cut the field. The two horses, Hat and Minnie, are harnessed to the mower.[13] They methodically walk through the field cutting the grass. One of the boys rakes the cut hay into piles.

The next shot is another family portrait of the boys and two women gathered on a stone wall. Rusty, their Irish Setter, bounds into the scene. They try to get the dog to settle down as if they were posing for a photograph.

Then we see more work. This time Hat and Minnie are pulling a plow that is furrowing the field. Children follow behind the plow, picking out rocks and throwing them to the side. In a series of shots we watch as the boys and other children, perhaps neighbors, clear away sod and remove a large boulder. Wright films this endeavor from different angles, taking the time to record the boys using pry bars and shovels to get leverage and successfully extract the rock. Next, the horses are hooked to a large shovel that is clearing away dirt. Their efforts create a large rectangular and flattened space in the field.

There is a brief interlude away from the work in the field, but the film quickly returns to it. This time Hat and Minnie are harnessed to a wagon and hauling a load of firewood. A man is driving the team while the children follow behind. He deftly backs the wagon to the barn door, and one of the boys stacks the pile inside. The empty wagon exits through the drive between the stone walls, with two children riding on the open back as the German shepherd tags along behind.

Other scenes reveal a man in overalls sawing limbs from a tree, a birthday party for an elderly neighbor, the cedar shingling of the barn, a performing fiddler, and a picnic. The film then jumps to a man unloading neatly cut logs, each approximately four feet in length, from a wagon. He works with a steady rhythm, not looking up at the camera, and uses a hook to grab the logs and pull them off the pile. Wright then cuts to him driving a team of horses hauling a wagon full of wood down a country road. Again, we see him unloading more wood in a different location. Wright lets the film roll to capture the man's methodical work.

As we reach the end of the reel, Wright films a slow pan of sunset looking west toward the White Mountains. In the foreground we see the fields of Windy Ledge. The descending sun finds its way through the cloudy sky as the camera pans across the scene. A final shot shows the flag descending from the pole as the day comes to an end.

We offer this extended example because it shows how much value Wright placed on scenes of work at the farm. Although the bookend images of the flag going up the pole in the morning and coming down at sunset suggest the film captures a single day, it is likely that this composition of accumulated images took place over several days or a week. The considerable attention Wright gives to filming these scenes and providing these details, as well as the composition of the images (often shot with the camera on a tripod), conveys her desire to capture the varied dimensions of Windy Ledge as a life of retreat and an escape—a world quite different from her urban home and daily life in Cambridge. We can see the antimodern impulse in the family's efforts to *belong* to this world, albeit temporarily, and in Wright's commitment to representing those efforts. The film is both a documentation of events and a narrative that expresses the Wrights' desire to be at home in this environment.

Windy Ledge and its necessary labor provided the Wright family a mode of leisure experience, but Wright's aesthetically pleasing scenes also helped to validate a work ethic of physical labor and tangible results. The barn is shingled. The wood is stacked. The field is mowed and the hay is harvested. This is all work that needs to be done. Of course, the many scenes depicting Uncle El suggest that he and some of the neighboring workers may have provided a good bit of the labor, but the family is engaged as well. In scene after scene, Wright's images suggest that their work helps them to connect with their Maine home, and she makes a point of including numerous scenes of the family at work.

For example, Wright filmed a scene of one of her sons carrying two small milk canisters out of the house. The boy puts a yoked boom across his shoulders with a canister hanging from each end of the boom. He balances the boom, picks up the house cat, and proceeds to walk down the drive. It is a scene of a technique and a form of work that is being "tried on." This is a small experiment with a lifestyle, a brief moment of experiential education and folly that finds its energy because of its difference from their life at home. It is also a performance that takes place because Wright is filming it. The boy puts on the yoke to demonstrate it for the camera. This brief moment on film is emblematic of the many scenes of work in the fields, at the barn, clearing brush, raking hay, and burning brush and rubbish that all simultaneously served as real work but also play.

In contrast to the daily lives of the full-time residents of Paris, Maine, where physical labor was a way of life, Wright's films render a complex portrait of a family from a different world, one marked by the virtues of formal education

Fig. 11.2 Boys shingle the barn at Windy Ledge, Paris, Maine, circa 1930. From 16mm film. Walter Woodman Wright Collection, Northeast Historic Film. [Accession 0996, Reel 2]

and economic security. Coming from the urban setting of Cambridge, with a father and husband who was a well-traveled and respected professor at Harvard, the Wrights enjoyed a very different relationship to the land and people of Paris. In several instances, Wright places the camera on a tripod and rotates it as she attempts to film a panoramic scene. She films butterflies, flowers, ferns, and waterfalls. Such images reflect a view of nature as site of contemplation, study, and, potentially, spiritual sustenance. Her view seems to be an attempt to grasp rural life as a set of images.

Wright's films also suggest that the family engaged in leisure activities that were more familiar to their station in life. Wright films the family playing croquet on the lawn, a game of chess being played on the porch, and family and friends watching a tennis match on a makeshift court in a field. We see the spectators' heads moving side to side, following the volleys. A large roller to flatten and firm the earthy plot is visible at courtside. It is the same field where the family was at work, cutting grass, removing sod, and creating a level plot, not to plant, but to erect an outdoor tennis court.[14]

If viewing Wright's films today evoke a sense of nostalgia for rural life, it is likely because even in 1929 they carried strains of distance and disjuncture, the retrieval of old ways and a slower time. In the nineteenth century, "some thought that the modern metropolis would provide enough excitement and stimuli to quell people's longings for the rustic life," writes Svetlana Boym. "Yet this did

Fig. 11.3 At the tennis court, Windy Ledge, Paris, Maine, circa 1931. From 16mm film. Walter Woodman Wright Collection, Northeast Historic Film. [Accession 0996, Reel 3]

not come to pass. Instead, nostalgia accompanied each new stage of modernization, taking on different genres and forms, playing tricks with the timetables."[15] Wright's films of life at Windy Ledge are one instance of how the home movie camera served as a technology that mediated and made tangible the retreat from modern urban experience into a culture of rural imagination.

This is not to argue that these films were intentionally scripted performances seeking to create an idealization of the rural world. Instead, Wright's camera documented the family's excursion into that world. These are films that show an intense desire to take hold of rural life, participate in it, and belong to it. Wright's films are endowed with the virtues of physical labor and simplicity, and a compensation for something not available in the routines of everyday urban experience.

Perhaps this "quest" is captured most prominently in Wright's images of her children embracing and performing the qualities of a rural childhood. "Modern notions of childhood were also romantic constructions," writes Owain Jones, "with nature at their core. Inevitably, then, notions of childhood and the rural were in harmony. The specialness, purity and naturalness of childhood merited a special, pure natural place to be in—the countryside."[16] Wright's images of her children working the farm, interacting with the locals, perched atop Hat the horse, or on the back of a wagon reaffirmed broader cultural narratives fusing childhood purity with rural wholesomeness. As she documented the many

scenes of life in rural Paris, Maine, and the daily events and people who moved through Windy Ledge, Wright's films also captured nostalgic desire to incorporate all of these qualities into her family. Windy Ledge, of course, was a real summer retreat for her family, and over the years they had developed a network of local friends and neighbors, anchoring them to that world, at least during the summer.

Wright's films, however, also reveal how that world was a stage where she could show all of these scenes as they were practiced, performed, and integrated into the fabric of her family. Wright filmed her home at Windy Ledge with the eye of a documentarian; her films reveal a curiosity about and an enchantment with a world that drastically differed from her life in the city. In our next example, we see how rural Maine—specifically in the context of a hunting trip—becomes a stage for a self-conscious construction of identity. Here the journey from the city into the northeastern woods of Maine becomes a stage for Archie Stewart's construction of a narrative of masculine adventure, demonstrating the skills needed for life in the woods and a celebration of trophies of the hunt.

Making the Self: Archie Stewart's Hunting Trip

The vast collection of amateur films made by Archie Stewart (Thomas Archibald Stewart) offer a chronicle of his life, his family, and an array of events he witnessed in his work and travels from the 1920s through the 1990s. The Stewarts operated a Buick dealership in Newburgh, New York. He and his family traveled throughout the United States and made regular trips to Maine for hunting and fishing. He became interested in amateur film in the 1920s and was an enthusiastic early adopter of its various technologies—lenses, editing techniques, early synchronized sound. Later in life, in the 1970s, he switched from 16mm film to videotape. If his films offer any index of his interests, he seemed interested in everything. Taken together, his archive of moving images offers a visual history of his life and family that extends over eight decades.

Like many amateur filmmakers, Stewart recorded his share of family holidays and milestone events. But his camera also followed a circuitous path documenting a range of subjects and aspects of everyday life that captured his attention. He filmed automobiles, boats, trains, airplanes, and their passengers. He made a movie about the construction of a garage and techniques for harvesting ice. During a snowstorm in Newburgh, he covered the event as if he were a news reporter. He experimented with sound recording in his living room by having friends tell jokes while he filmed them. He filmed street scenes and people hanging laundry.

In other words, Stewart was fascinated by both the extraordinary and the mundane, and his camera created a catalog of how he saw the world. As an amateur documentarian, Stewart edited together various pieces of footage in much the same way that people paste images into a family album. He created what he

called a "Moving Image Scrapbook," an edited collection of moving images that accounted for notable events during a particular time period.

There are numerous scenes where Stewart also appears in the frame, having handed the camera off. He was not camera shy and was determined to record his presence in the world. A member of the Amateur Cinema League, he was also interested in the capacity of the camera to tell stories, often using intertitles to provide a structure to the narrative. In the remainder of this section, we focus on one film that Stewart made about a hunting trip to Maine. It is an interesting film because it reveals the blurry boundaries between actual events and ability of the amateur filmmaker to fictionalize and fabricate a narrative from those events.

In 1926, Archie Stewart made a thirty-minute silent film about a hunting trip in eastern Maine. Stewart likely took his title for the film, *The Deerslayers*, from one of James Fenimore Cooper's Leatherstocking Tales.[17] He may have envisioned a parody of himself as a modern day Natty Bumppo. His own "acting" in the film carries a self-conscious playfulness, but the film really has no narrative parallel with Cooper's novel, except the name.

Combining a personal vacation film and a travelogue, the hunting trip in *The Deerslayers* serves as a stage for the twenty-four-year-old Stewart to dramatize the rigors of life in the Maine woods and the men with whom he associated during his time there.

The Deerslayers begins with an introduction of the two primary characters. Maine guide, Howard Kendall, stands at the Perry, Maine, train depot, grinning at the camera. An intertitle describes Kendall as the one "who killed the game." Archie, the other main character, stands looking at the camera, presumably at the same depot, fixing his hair and rubbing his scrabble of a beard. An intertitle describes Archie as the one "who took the credit." This prologue suggests that the story that is about to unfold is a yarn, but it is cobbled together from scenes filmed during Stewart's actual trip.

Another intertitle begins the story: "From New York to Maine." It is followed by scenes of Archie walking out of the front door of his home in Newburgh, New York, carrying his hunting gear, the train leaving the Newburgh depot, his wife and daughter waving good-bye, the train creeping its way out of the city, and an interior shot inside the passenger car. Two men dressed in suits smile as Stewart films them.

The next intertitle signals that Archie has arrived in Perry, Maine, and Howard has met him at the station in "his trusty fliver [*sic*]," a name for a Model T Ford or a jalopy. Stewart films Howard cranking up the engine and getting behind the wheel. They run into another Maine guide, Rob Golding, and Archie—still dressed in his suit and bow tie from his rail journey—and Golding appear on camera talking to each other. Behind them we see a muddy, unpaved road and a white clapboard farmhouse. The two spend the night in Perry and set out for the

"Big Woods" the next morning in a heavy fog. The scene shows Howard loading gear into his automobile. Next, Archie stands next to the vehicle, strapping a belt of ammunition around his waist. He turns around for the camera, and we see that the belt holds a sheathed hunting knife, a hatchet, and a still photography camera. Archie takes out the camera, unfolds the bellows, aims at his movie camera, and snaps a picture.

In these first few minutes of *The Deerslayers*, we see two sides of Stewart's experience of hunting in Maine and the film he makes about hunting in Maine. On the one hand, he actually makes the journey to the Maine woods to go hunting with Howard. On the other hand, he is ambitiously filming scenes along the way that are aimed at creating a story of the hunting trip afterward. This latter agenda requires that he enlist his family and friends in the process of getting images that he will later edit into a story. Stewart embarks on a journey that he continually interrupts with his desire to tell a story once he returns home. His experience is regularly divided between the hunting expedition and some imagined future moment that depicts the hunting trip on film.

Stewart's film required a considerable amount of time and effort devoted to setting up the equipment and enlisting the assistance of others to achieve continuity in his film. Rather than seeing the journey through Stewart's eyes as he filmed the experience, Stewart was attempting to create a film where the viewer would witness him taking the trip. It was a complicated effort aimed at achieving the effect that Stewart was playing a character in a film made by someone else. For instance, in filming his departure he first had to set up his camera on a tripod on the front porch, go back inside of the house, signal to his wife (or someone else) to begin rolling film through the camera, and then exit the house through the front door. At the depot, his wife and young daughter were clearly complicit in Stewart's filming efforts. They do not merely give him a good-bye kiss on the platform. Instead, they pretend to wave good-bye while Stewart films them. Considering that Stewart could not simultaneously be on the train and film it leaving the station or rolling out of Newburgh, he had to shoot scenes of another train leaving the station. In Perry, Howard becomes another character, playing himself while Stewart directs him from behind the camera. Later, Howard operates the camera while Archie chats with Rob Golding and again when Archie starts to gear up on that foggy morning before they drive to Grand Lake Stream, where they take a boat and then a canoe to the hunting camp on Sysladobsis Lake.

In *The Deerslayers*, Stewart assembles a series of scenes that include a portage from Grand Lake Stream to Sysladobsis Lake. Howard and he take turns filming each other paddling the canoe. Howard, seemingly uncomfortable when the camera is aimed at him, looks into the lens and grins. Archie, on the other hand, is cagey. He paddles the canoe, his head darting side to side, looking out for any sign of danger on the calm lake. Later, when they are at the hunting camp,

Archie appears to have coached Howard in his acting. The two men take turns standing on the shore of Sysladobsis Lake, inspecting their rifles. Howard tries not to look into the camera, but he still glances up to eye the lens. Howard's self-consciousness goes against the grain of what Stewart seems to be trying to accomplish: a seamless account of the trip where the camera is merely an observational device. Instead, these scenes continually call attention to how much effort is going into filmmaking. *The Deerslayers* is a set of contrived scenes that call attention to the ways the camera serves as a wedge that splits experience. On the stony shore of Sysladobsis Lake, Stewart experiences the present moment of the lake and the future of his film as he gathers the images for the film he will screen for friends and family back in Newburgh.

The scenes of the men hunting, perhaps, epitomize the lengths Stewart goes to tell his tale. His introduction to *The Deerslayers* has already given away the ruse of the film: Howard bagged the game, and Archie took the credit. Stewart stages several scenes depicting the deer hunt. Howard walks carefully and quietly through the patch of birch and pine, on the lookout for deer. He spies something, raises his rifle, and fires off two rounds, and runs to the left out of the frame. The next shot shows him running to a deer lying on the ground. He pulls out his knife and field dresses the animal. The next shot moves in for a closer look at Howard wiping off his blade and dragging the buck by the antlers through an opening in the trees.

An intertitle reads "Archie on the Trail." Archie walks through the woods with his rifle, pausing to look left and right. An intertitle reads "What Was That?" We see a tighter shot of Archie firing three rounds from his carbine, and running out of the frame. "A Buck," reads the intertitle, and Archie then runs to his fallen deer. A tighter shot shows Archie brushing his hand over the deer's coat.

Obviously, these scenes depict the main objective of the hunting trip and bring home the title of the film. What is notable here is that Stewart has lugged the camera and tripod into the woods along with his rifle. Although Stewart made his film years earlier, an article in the September 1931 issue of the Amateur Cinema League's journal *Movie Makers* warns against trying to create the kind of film they were creating. "Just as a man cannot well serve two masters, he cannot successfully handle two kinds of shooting apparatus," wrote Townsend Godsey in his article about tips for hunting films. "As the sportsman makes more and more successful films, he will be more likely to choose to operate the movie camera and let hunting companions make the kills."[18]

Godsey's article underscores the difficulty and complexity of what Stewart accomplished in *The Deerslayers*. Howard and he stage these scenes with a level of shot variation and narrative construction that ultimately betrays any sense that they are actually hunting. What they are doing is acting like they are hunting. Given what we see in the scenes, at this point in the trip, Howard, the Maine

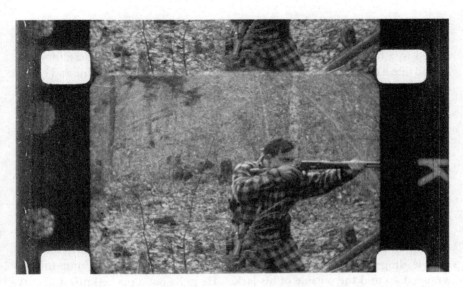

Fig. 11.4 Archie Stewart firing rifle, *The Deerslayers*, 1926. From 16mm film. Archie Stewart Collection, Northeast Historic Film. [Accession 1108, Reels 4/5]

guide, is as complicit as Archie in creating a narrative. He no longer looks at the camera but acts out the scenes. Most likely, the buck that Howard bags is the same buck that Archie also lifts by the antlers. In a later scene that shows the men carrying their trophies out of the woods, Howard carries the buck across his shoulders while Archie carries a doe. It's not clear who shot which deer or if Archie shot any of them at all. At this point in the film it matters little, as the scenes document the labor necessary to get the game back home.

Howard single-handedly bends down a sapling and attaches the doe to it. He uses the leverage afforded by the bent tree and two other poles to raise the sapling and hang the deer so it can bleed out. The two men take turns standing next to the hoisted doe, inspecting it—a bullet went through its ear—and stroking its hide. An intertitle reads, "When Work Is Done," and an edited scene cuts back and forth between Archie and Howard seated on the trunk of a fallen tree, apparently discussing the hunt, with their rifles in their hands. Again, this is not an actual conversation because they have taken turns operating the camera while one pretends to be talking to the other. The splices on the film show that Stewart has edited the footage to make it appear as if they are in conversation, but this is merely a product of the editing.

The final ten minutes of *The Deerslayers* reverses the journey back from the woods. Stewart spends some time showing the deer hanging from bent saplings. Two other men, possibly guides or other hunters at the camp, take the deer down

from the saplings. Archie assists in this effort. The men lift the deer over their shoulders. The head of one deer has been cut off. A horse named Dobbin harnessed to a flat wagon helps to transport the kill to the dock, where they are loaded into a canoe. Another staged scene shows a silhouette of Archie and Howard paddling the canoe on the lake. The dead deer are visible in the middle section of the canoe.

Once they return to Grand Lake Stream, the two men spend the rest of their time at Howard's camp, a small, saltbox-style, shingled shack. Archie comments on the small quarters in an intertitle, "One Room Indoors and Plenty of Room Outdoors." He films a scene of Howard walking out the front (and only) door to empty dirty water out of a skillet. Howard shakes out the water and walks back inside without looking at the camera. He has become accustomed to playing a scene.

Stewart inserts another intertitle, "Chalking Them Up, Count 'Em," which is followed by a shot of him walking into the frame, taking a seat on a set of steps leading to a porch. He is dressed in his hunting gear, a belt of ammunition wrapped around the outside of his jacket. He pulls out a pocketknife and cuts three notches into the stock of a rifle. He looks at the camera (that Howard is likely operating) and holds up three fingers. He then picks up another rifle and carves another notch in its stock. The notches, of course, mark the number of deer killed by the weapons. But given what we have seen in the previous scenes, it remains unclear who shot how many deer during the hunt.

After a few brief shots of trees—probably Christmas trees—being loaded onto a flatbed rail car, Stewart inserts an intertitle: "Goodbye To Maine For 1926." The next scene shows Archie walking into the frame, in front of the Perry railroad depot, carrying his luggage. He is dressed in a coat, vest, bowtie, and hat. He puts down his luggage, looks up at the sign that says "Perry," and takes off his hat. His hands cover his eyes, and he bends over melodramatically, in grief over his departure. He pulls out a handkerchief, weeps into it, wrings out the tears, and returns it to his pocket. This is followed by a shot of Archie standing on the platform, looking at the camera. He takes off his hat and brushes his hair back, puts his hat back on, and walks into the depot. A shot shows the train pulling out of Perry. Then another shot shows Howard standing on the platform. He, too, is dressed in a coat, vest, and tie. He takes off his cap and waves it in the air, a good-bye to the departing train and his hunting partner, and walks back into the depot. A final intertitle appears: "Finis."

Archie and Howard must have arrived early at the depot in order to compose this final sequence depicting the departure back to Newburgh. Again they have taken turns operating the camera and acting out their parts. In these final few minutes, Stewart's editing constructs a cohesive ending to *The Deerslayers*. As with everything that preceded this scene, it is a moment when the actual events

Fig. 11.5 Howard Kendall waves good-bye from train station platform, Perry, Maine, *The Deerslayers*, 1926. From 16mm film. Archie Stewart Collection, Northeast Historic Film. [Accession 1108, Reels 4/5]

have been experientially divided between what was happening and gathering the footage for the future, the moment when the completed film was realized. In a way, it is the camera that divides the immediacy of the hunting trip from the story of the hunting trip that appears in the film. The camera reveals a trip that took place, and the light and shadows on the screen also tell us that this is not entirely an accurate account of what happened. Instead, it hides the filmmaking process and conceals the effort required to stage so many of these scenes for the benefit of a story.

Apart from the cooperation Howard offers in running the camera and acting out his scenes, *The Deerslayers* is really Stewart's film. And it is really not a story about hunting as much as it is about how the journey and the pursuit of a trophy becomes a stage for performing a particular identity. The hunt serves as a vehicle for telling a story about masculinity, the journey of a city man to the faraway woods, his association with the men who live there, his endurance of the elements in order to kill a deer and carry it through the forest, and his return to civilization. But Stewart does not take himself too seriously in any of it. If anything, he is a comic actor. Against Howard's confidence, know-how, and sense of humility and purpose, Archie plays an eager and enthusiastic apprentice who follows Howard's lead.

Stories of journeys are less about destinations than how the self is revealed along the way. In this story, Archie is transformed from the bow-tied, suit-wearing Buick dealer from the city into the flannel-jacket-wearing, gun-toting woodsman who, with his companion, looks to feel at home in the outdoors. It is a tongue-in-cheek tale of this quest. Because Stewart actually did go to Maine to hunt with Howard, there is a truth to all of this, and Archie is entitled to claim all the values and credibility that come with such a trip. What the film also reveals, however, is how the camera provided a mechanism for imagining this alternate sense of self and experience. *The Deerslayers* is a film that at once says, "Don't take this too seriously" but remember, "I did all of these things." Here, nature serves as the backdrop for not only having the capacity and interest to embark on such an adventure but also for creating an alternate screen self who could tell that story.

Conclusion

Wright and Stewart's films give us a glimpse at an interior set of desires about self, identity, and family. They are personal films that show how people moved through landscapes that are simultaneously real and imaginary. The movie camera allows them to give shape and meaning to each in a manner that reveals different dimensions of culture, discourse, and desire. Lears notes that "all anti-modernists sensed (however dimly or fleetingly) that they somehow had to choose between a life of authentic experience and the false comforts of modernity." This was not a hard and fast dichotomy as much as the polarities of modern life where people found themselves simultaneously pulled by oppositional forces of culture. As Lears observes, the "active side of antimodernism resurfaces in the persistent desire to test oneself physically by confronting the natural world—whether on a homestead in Vermont or a hiking trail in Montana."[19] In their different ways, the films of Wright and Stewart show how people sought to satisfy such desires by venturing into the rural and natural world of Maine. More importantly, they carried movie cameras to record their pursuits of such desires and create a cinematic record of their escapes from urban life.

As Wright and Stewart created amateur narratives about their retreats into rural life and nature, we also recognize that neither made their life in those worlds. Instead, their films depict these places as endowed with the possibilities for an imagined life. For Wright, the family farm becomes a stage for culturally imagining rural life as a place of purity, physical labor, community, and tradition. While her films are a composition of self-evident features and experiences of that world, they also invite a critical reading of a culturally constructed rural life, particularly of those who sought out the rural as a place of virtue. Stewart's film, on the other hand, reveals how a journey into nature could serve as a context for creating a fictional self and story with the amateur camera. His film is an attempt to narrate a story of self and experience that emerges from the real and

the imagined. Both filmmakers' amateur films show how the camera offered an avenue to an imagined life that existed at a distance from the places they called home. The camera was a device for mediating and overcoming that distance, at least temporarily, and allowed each to express a kind of desire for how to belong to the world differently . . . at least on film.

Technical Notes: Elizabeth Woodman Wright, Paris, Maine Excerpts (circa 1930) and Archie Stewart, *The Deerslayers* (1926)

The films of Archie Stewart and Elizabeth Woodman Wright show physical evidence of the equipment used for filming, and these evidentiary marks affect the overall aesthetics of the constructed narratives. Stewart shot *The Deerslayers*, a rural narrative, in 1926 using a Ciné-Kodak Model A camera, the first 16mm camera offered for sale in 1923. The Model A had its drawbacks, most notably the hand-cranked shutter, which meant that Stewart always had to shoot using the camera mounted on a tripod for stability. Hand cranking also posed problems for stopping the shutter. Depending on where in the cranking rotation Stewart finished, the shutter could stop in either the closed or the open position. Stopping a shot with the shutter open would overexpose that frame of film, leaving what was called a flash frame. This was most apparent in scenes where the hunters are traveling downriver: each new scene ended with a burst of white light. These conspicuous transitions between scenes were compounded by Stewart's decision to use a diagonal cement splicer to edit the film, a choice that made every one of the roughly 150 scene changes extremely noticeable. Cement splicers came in two basic designs, horizontal and diagonal, and were the only way to splice amateur films for many years. The diagonal splice was thought to pass more easily through a projector than a standard horizontal splice. One has to wonder why Stewart made so many cement splices but did not edit out the flash frames. It is possible he knew that both would be noticeable, and it was less work to leave the flash frames.

In contrast to Stewart, Elizabeth Wright constructed her rural narrative using very few splices, instead opting for more than fifty in-camera edits. Wright benefited from the new Ciné-Kodak Model B camera, which had a regulated shutter controlled by a spring-wound (rather than hand-cranked) motor. When the filmmaker wanted to finish a shot, he or she just stopped pressing the button and the shutter finished its cycle in the closed position, avoiding a flash frame.

> Paris, Maine, Excerpt, circa 1929–1930. Elizabeth Woodman Wright.
> Walter Woodman Wright Collection, Accession 0996, Reel 2.
> Gauge: 16mm. Stock: Kodak Safety Film (B&W reversal).
> Length: 425 ft. Splices: thirteen. Many appear to be original, a few are repair splices midshot probably to cut out damaged frames, and a few are newer replacements.

Overall Reel Length: 425 ft.
Date codes: 1929, 1930.
Camera code: Ciné-Kodak Model B f-1.9.

The Deerslayers, 1926. Archie Stewart.
Archie Stewart Collection, Accession 1108, Reels 4 and 5.
Gauge: 16mm. Stock: Kodak Safety Film (B&W reversal).
Length: 640 ft. Splices: 103. Mostly original diagonal.
Overall Reel Length: 640 ft.
Date code: 1926.
Camera code: Ciné-Kodak Model A f-3.5 or f-1.9.
Other info: Reels 4 and 5 were spliced together when NHF processed them
in the 1990s, so it is not clear where the original break was.

Mark Neumann is Professor of Creative Media and Film in the School of Communication at Northern Arizona University. He is author of *On The Rim: Looking for the Grand Canyon* and coauthor of *Recording Culture: Audio Documentary and the Ethnographic Experience*.

Janna Jones is Professor of Creative Media and Film in the School of Communication at Northern Arizona University. She is author of *The Southern Movie Palace: Rise, Fall, and Resurrection* and *The Past is a Moving Picture: Preserving the Twentieth Century on Film*.

Notes

1. T. J. Jackson Lears, *No Place of Grace: Antimodernism and the Transformation of American Culture, 1880–1920* (New York: Pantheon, 1981), 4–58.

2. Respectively, the films are found in the Walter Woodman Wright Collection and the Archie Stewart Collection at Northeast Historic Film, Bucksport, Maine. Also, please note that throughout this essay, we will use the name *Archie* when we write of the character in the film. When we write about the filmmaker, we will use the name *Stewart*.

3. Marshall Berman, *All That Is Solid Melts into Air: The Experience of Modernity* (New York: Penguin, 1988), 11.

4. Pamela J. Belanger, *Inventing Acadia: Artists and Tourists at Mount Desert* (Rockland, ME: Farnsworth, 1999).

5. Dona Brown, *Inventing New England: Regional Tourism in the Nineteenth Century* (Washington, DC: Smithsonian, 1997), 9. See also, Joseph Conforti, *Imagining New England: Explorations of Regional Identity from the Pilgrims to the Mid-20th Century* (Chapel Hill, NC: University of North Carolina Press, 2001).

6. For a discussion of the emergence of this building type in western Maine during the nineteenth century, see Thomas Hubka, *Big House, Little House, Back House, Barn: The*

Connected Farm Buildings of New England (Hanover, NH: University Press of New England, 1984).

7. Scott Simmon, "Film Notes for Rural Life in Maine," National Film Preservation Foundation, accessed January 26, 2015, http://www.filmpreservation.org/dvds-and-books/clips/rural-life-in-maine-ca-1930-clip.

8. Patricia Holland, "History, Memory and the Family Album," in *Family Snaps: The Meanings of Domestic Photography*, eds. Jo Spence and Patricia Holland (London: Virago, 1991), 7; Simmon, "Film Notes from Rural Life in Maine."

9. Richard Fung, "Remaking Home Movies," in *Mining the Home Movie: Excavations in Histories and Memories*, eds. Karen L. Ishizuka and Patricia R. Zimmermann (Berkeley: University of California Press, 2008), 31.

10. Mark Neumann and Janna Jones, "Amateur Film and the Rural Imagination," in *Cinematic Countrysides*, ed. Robert Fish (Manchester: Manchester University Press, 2007), 233.

11. For example, Northeast Historic Film has notes that identify various people and locations in Wright's films through correspondence with Aagot Horn Wright, the wife of Walter Woodman Wright, eldest son of C. H. C. Wright and Elizabeth Woodman Wright. In addition, the Wright Family Papers are held by the Massachusetts Historical Society: http://www.masshist.org/collection-guides/view/fa0136#.

12. For instance, amateur filmmaker Olin Potter Geer's essay, "Suburban Scenario" appeared in the September 1933 issue of the Amateur Cinema League's journal, *Movie Makers*. Geer found the "day in the life" structure a useful approach for creating interesting family films. Geer suggested the compression of multiple days and events into a storyline that would be represented as a typical day. Such a narrative structure "is based on a summary of the activities of many days compressed into one, which tells the story of a family's life from dawn to midnight," he wrote (p. 371). Geer's film, *Poem of Montclair*, about a day in the life of his family in Montclair, New Jersey, was the basis for the article. It is housed in the collections of Northeast Historic Film. Similarly, Wallace Kelly, a journalist from Lebanon, Kentucky, shot a twelve-minute film entitled *Our Day* that depicts small-town southern life during the Depression. Kelly's 16mm film has been included in the National Film Registry.

13. We were able to identify the horses by their appearance in other films by Wright where she used intertitles and referred to the horses by name.

14. The information about the tennis court construction comes from the oral history provided by Aagot Wright (ca. 1990). Wright commented on the scenes found in the films, and her recollections are on file in the collections at Northeast Historic Film.

15. Svetlana Boym, *The Future of Nostalgia* (New York: Basic Books, 2001), 346.

16. Owain Jones, "Idylls and Otherness: Childhood and Rurality in film," in *Cinematic Countrysides*, 178.

17. *The Deerslayer* was the first in a series of five novels known as the Leatherstocking Tales. James Fenimore Cooper, *The Deerslayer: Or, The First War-Path. A Tale* (Philadelphia: Lea and Blanchard, 1841).

18. Townsend Godsey, "Hints for Huntsmen," *Movie Makers* (September 1931), 492.

19. Lears, *No Place of Grace*, 300–305.

Selected Bibliography

Abel, Richard, ed. *French Film Theory and Criticism, vol. 1: 1907–1929*. Princeton, NJ: Princeton University Press, 1988.

Acland, Charles R., and Haidee Wasson, eds. *Useful Cinema*. Durham, NC: Duke University Press, 2011.

Alvey, Mark. "Motion Pictures as Taxidermy: Carl Akeley and His Camera." *In the Field: the Bulletin of the Field Museum of Natural History* 71, no. 5 (September/October 2000): 10–11.

Aoki, Keith, James Boyle, and Jennifer Jenkins. *Bound By Law?: Tales from the Public Domain*. Durham, NC: Center for the Study of the Public Domain, Duke University Press, 2008.

Auer, Michel, and Michèle Ory. *Histoire de la caméra ciné amateur*. Paris: Les Editions de l'Amateur, 1979.

Batchen, Geoffrey. *Each Wild Idea: Writing, Photography, History*. Cambridge, MA: MIT Press, 2002.

Becker, Snowden. "Family in a Can: The Presentation and Preservation of Home Movies in Museums," *The Moving Image* 1, no. 2 (Fall 2001): 89–106.

Belanger, Pamela J. *Inventing Acadia: Artists and Tourists at Mount Desert*. Rockland, ME: Farnsworth, 1999.

Berman, Marshall. *All That Is Solid Melts into Air: The Experience of Modernity*. New York: Penguin, 1988.

Bigourdan, Jean-Louis, Liz Coffey, Dwight Swanson, Bob Brodsky, Toni Treadway, David Cleveland, and Robin Williams, eds., *Film Forever: The Home Film Preservation Guide*, Chapter 2, "Film Specifics: Stocks and Soundtracks." accessed May 26, 2015, http://www.filmforever.org/chap2.html.

Bilton, Alan. *Silent Film Comedy and American Culture*. New York: Palgrave Macmillan, 2013.

Bourdieu, Pierre. *The Field of Cultural Production*. New York: Columbia University Press, 1993.

Bowser, Eileen. *The Transformation of Cinema, 1907–1915*: vol. 2, *History of the American Cinema*. New York: Charles Scribner's, 1990.

Boym, Svetlana. *The Future of Nostalgia*. New York: Basic Books, 2001.

Brown, Dona. *Inventing New England: Regional Tourism in the Nineteenth Century*. Washington, DC: Smithsonian Institution Press, 1995.

Camper, Fred. "Some Notes on the Home Movie," *Journal of Film and Video* 38, no. 3/4 (1986): 9–14.

Cassidy, Donna M. *Marsden Hartley: Race, Region, and Nation*. Lebanon, NH: University Press of New England, 2005.

The Center for Home Movies 2010 Digitization and Access Summit Final Report, January 2011, accessed May 26, 2015, www.centerforhomemovies.org/Home_Movie _Summit_Final_Report.pdf.

Cahan, Richard, and Michael Williams. *Vivian Maier: Out of the Shadows*. Chicago: CityFiles, 2012.

Chalfen, Richard. *Snapshot Versions of Life*. Bowling Green, OH: Bowling Green State University Popular Press, 1987.

Cleto, Fabio, ed. *Camp: Queer Aesthetics and the Performing Subject*. Ann Arbor: University of Michigan Press, 1999.

Coe, Brian. *The History of Movie Photography*. Westfield, NJ: Eastview Editions, 1981.

Condon, Richard H. "Living in Two Worlds: Rural Maine in 1930." *Maine Historical Society Quarterly* 25, no. 2 (Fall 1985): 58–87.

Conforti, Joseph A. *Imagining New England: Explorations of Regional Identity from the Pilgrims to the Mid-Twentieth Century*. Chapel Hill, NC: University of North Carolina Press, 2001.

Cotton, Raymond C. *Hog Reaves, Field Drivers, and Tything Men: The Birth Pains of the Town of Hiram*. Hiram, ME: Hiram Historical Society, 1983.

Craven, Ian, ed. *Movies on Home Ground: Explorations in Home Cinema*. Newcastle upon Tyne: Cambridge Scholars Publishing, 2009.

Curtis, Scott. "Images of Efficiency: The Films of Frank B. Gilbreth." In *Films That Work: Industrial Film and the Productivity of Media*, edited by Patrick Vonderau and Vinzenz Hediger, 85–100. Amsterdam: Amsterdam University Press, 2009.

Cutshaw, Stacey McCarroll, and Ross Barrett. *In the Vernacular: Photography of the Everyday*. Boston: Boston University Art Gallery, 2008.

Dixon, Robert. *Photography, Early Cinema and Colonial Modernity: Frank Hurley's Synchronized Lecture Entertainments*. London, New York: Anthem, 2012.

Doane, Mary Ann. *The Emergence of Cinematic Time: Modernity, Contingency, the Archive*. Cambridge, MA: Harvard University Press, 2002.

Dulac, Germaine. "From 'Visual and Anti-Visual Films,'" (1928) In *The Avant-Garde Film*, edited by P. Adams Sitney, 31–48. New York: Anthology Film Archives, 1987.

Erens, Patricia. "The Galler Home Movies: A Case Study." *Journal of Film and Video* 38, no. 3/4 (1986): 15–24.

Fish, Robert, ed. *Cinematic Countrysides*. Manchester: Manchester University Press, 2007.

Fossati, Giovanna. *From Grain to Pixel: The Archival Life of Film in Transition*. Amsterdam: Amsterdam University Press, 2009.

Frick, Caroline. *Saving Cinema: The Politics of Preservation*. New York: Oxford University Press, 2010.

Gans, Herbert Julius. *Popular Culture and High Culture: An Analysis and Evaluation of Taste*. Rev. ed. New York: Basic Books, 1999.

Gordon, Marsha. "Lenticular Spectacles: Kodacolor's Fit in the Amateur Arsenal." *Film History* 25, no. 4 (2013): 36–61.

Gracy, Karen F. *Film Preservation: Competing Definition of Value, Use, and Practice*. Chicago: Society of American Archivists, 2007.

Greenough, Sarah, Diane Waggoner, Sarah Kennel, and Matthew S. Witkovsky, eds. *The Art of the American Snapshot, 1888–1978: From the Collection of Robert E. Jackson*. Washington, DC: National Gallery of Art, 2007.

Grieveson, Lee. "The Work of Film in the Age of Fordist Mechanization." *Cinema Journal* 51, no. 3 (Spring 2012): 25–51.

Guerin, Frances. *Through Amateur Eyes: Film and Photography in Nazi Germany.* Minneapolis: University of Minnesota Press, 2012.

Harrison, Blake, and Richard Judd, eds. *A Landscape History of New England.* Cambridge, MA: MIT Press, 2011.

Holland, Patricia. "History, Memory and the Family Album." In *Family Snaps: The Meanings of Domestic Photography*, edited by Jo Spence and Patricia Holland. London: Virago, 1991.

Horak, Jan-Christopher, ed. *Lovers of Cinema: The First American Film Avant-Garde, 1919–1945.* Madison: University of Wisconsin Press, 1995.

Imperato, Pascal James, and Eleanor M. Imperato. *They Married Adventure: The Wandering Lives of Martin and Osa Johnson.* New Brunswick, NJ: Rutgers University Press, 1992.

Ishizuka, Karen L., and Patricia R. Zimmermann, eds. *Mining the Home Movie: Excavations in Histories and Memories.* Berkeley: University of California Press, 2008.

Jones, Janna. *The Past is a Moving Picture: Preserving the Twentieth Century on Film.* Gainesville: University Press of Florida, 2012.

Judd, Richard, and Joel Eastman, eds. *Maine: The Pine Tree State from Pre-history to the Present.* Orono: University of Maine Press, 1995.

Kattelle, Alan D. *Home Movies: A History of the American Industry, 1897–1979.* Nashua, NH: Transition, 2000.

Kasson, John F. *Amusing the Million: Coney Island at the Turn of the Century.* New York: Hill and Wang, 1978.

King, Rob. *The Fun Factory: The Keystone Film Company and the Emergence of Mass Culture.* Berkeley: University of California Press, 2009.

Kleinhans, Chuck. "My Aunt Alice's Home Movies," *Journal of Film and Video* 38, no. 3/4 (1986): 25–35.

Kmec, Sonja, and Viviane Thill, eds. *Private Eyes and the Public Gaze: The Manipulation and Valorisation of Amateur Images.* Trier, Germany: Kliomedia, 2009.

———. *Tourists & Nomads: Amateur Images of Migration.* Marburg, Germany: Jonas, 2012.

Lears, T. J. Jackson. *No Place of Grace: Antimodernism and the Transformation of American Culture, 1880–1920.* New York: Pantheon, 1981.

Lewis, George H. "The Maine That Never Was: The Construction of Popular Myth in Regional Culture," *Journal of American Culture* 16, no. 2 (June 1993): 91–99.

McGrath, Caitlin. "'I Have Seen the Future': Home Movies of the 1939 New York World's Fair," *The Moving Image* 13, no. 2 (Fall 2013): 56–80.

McQuire, Scott. *Visions of Modernity: Representation, Memory, Time and Space in the Age of the Camera.* London: Sage, 1998.

Maher, Neil M. *Nature's New Deal: The Civilian Conservation Corps and the Roots of the American Environmental Movement.* Oxford, UK: Oxford University Press, 2008.

Maloof, John, ed. *Vivian Maier: Street Photographer.* Brooklyn, NY: Power House Books, 2011.

Mattl, Siegfried, Carina Lesky, Vrääth Öhner, and Ingo Zechner, eds. *Abenteuer Alltag: Zür Archäologie des Amateurfilms.* Vienna: Austrian Film Museum; New York: Columbia University Press, 2015.

Mebold, Anke, and Charles Tepperman. "Resurrecting the Lost History of 28mm Film in North America," *Film History* 15, no. 2 (2003): 137–151.

Meyer, Moe, ed. *The Politics and Poetics of Camp*. London: Routledge, 1994.

Nicholson, Heather Norris. *Amateur Film: Meaning and Practice, 1927–1977*. Manchester, UK: Manchester University Press, 2012.

———. "'As If by Magic': Authority, Aesthetics, and Visions of the Workplace in Home Movies, circa 1931–1949." In *Mining the Home Movie: Excavations in Histories and Memories*, edited by Karen L. Ishizuka and Patricia R. Zimmermann, 214–30. Berkeley: University of California Press, 2008.

Norfleet, Barbara P. *The Champion Pig: Great Moments in Everyday Life*. Boston: D. R. Godine, 1979.

Odin, Roger, ed. "Le cinéma en amateur." Special issue of *Communications*, no. 68 (1999).

O'Hehir, Andrew. "Wes Anderson on 'Moonrise Kingdom'" [interview]. *Salon*, June 1, 2012. http://www.salon.com/2012/06/01/wes_anderson_on_moonrise_kingdom _im_trying_to_make_something_unfamiliar/.

Paton, Priscilla. *Abandoned New England: Landscape in the Works of Homer, Frost, Hopper, Wyeth, and Bishop*. Hanover, NH: University Press of New England, 2003.

Pereira, Arthur, ed. *Manual of Narrow-Gauge Cinematography*. London: Fountain, 1952.

Peterson, Jennifer. "Industrial Films." In *The Encyclopedia of Early Cinema*, edited by Richard Abel, 320–23. New York: Routledge, 2005.

———. "Workers Leaving the Factory: Witnessing Industry in the Digital Age." In *The Oxford Handbook of Sound and Image in Digital Media*, edited by Carol Vernallis, Amy Herzog, and John Richardson, 598–619. New York: Oxford University Press, 2013.

Pierce, David. "Copyright, Preservation, and Archives: An Interview with Eric Schwartz." *The Moving Image* 9, no. 2 (Fall 2009): 105–148.

Prosser, Jay. *Light in the Dark Room: Photography and Loss*. Minneapolis: University of Minnesota Press, 2005.

Rodowick, David Norman. *The Virtual Life of Film*. Cambridge, MA: Harvard University Press, 2007.

Rosenbaum, Julia B. *Visions of Belonging: New England Art and the Making of American Identity*. Ithaca, NY: Cornell University Press, 2006.

Rascaroli, Laura, Gwenda Young, Barry Monahan, eds. *Amateur Filmmaking: The Home Movie, the Archive, the Web*. London: Bloomsbury Academic, 2014.

Schlenker, Jon A. *In the Public Interest: The Civilian Conservation Corps in Maine*. Augusta: University of Maine at Augusta Press, 1988.

Schumacher, Alice Clink. *Hiram Percy Maxim*. Greenville, NH: Ham Radio Publishing Group, 1970.

Shand, Ryan. "Theorizing Amateur Cinema: Limitations and Possibilities" *The Moving Image* 8, no. 2 (Fall 2008): 36–60.

Shand, Ryan and Ian Craven, eds. *Small-Gauge Storytelling: Discovering the Amateur Fiction Film*. Edinburgh: Edinburgh University Press, 2013.

Shand, Ryan and Karen Lury, eds., *Show and Tell: Children and Amateur Media*. Edinburgh: Edinburgh University Press, forthcoming, 2016.

Slide, Anthony. *Before Video: A History of the Non-Theatrical Film*. New York: Greenwood, 1992.

Sontag, Susan. *Against Interpretation and Other Essays*. New York: Farrar, Straus Giroux, 1966.

Stilgoe, John. *Landscape and Images*. Charlottesville: University of Virginia Press, 2005.

Swanson, Dwight. "Inventing Amateur Film: Marion Norris Gleason, Eastman Kodak and the Rochester Scene, 1921–1932." *Film History* 15, no. 2 (2003): 126–136.

Tepperman, Charles. *Amateur Cinema: The Rise of North American Moviemaking, 1923–1960*. Berkeley: University of California Press, 2015.

———. "Uncovering Canada's Amateur Film Tradition: Leslie Thatcher's Films and Contexts." In *Cinephemera: Archives, Ephemeral Cinema, and New Screen Histories in Canada*, edited by Zoë Druick and Gerda Cammaer, 39–58. Montreal: McGill-Queen's University Press, 2014.

Thompson, Kristin. "The Limits of Experimentation in Hollywood." In *Lovers of Cinema: The First American Film Avant-Garde, 1919–1945*, edited by Jan-Christopher Horak, 67–93. Madison: University of Wisconsin Press, 1995.

Wasson, Haidee. *Museum Movies: The Museum of Modern Art and the Birth of Art Cinema*. Berkeley: University of California Press, 2005.

———. "Electric Homes! Automatic Movies! Efficient Entertainment!: 16mm and Cinema's Domestication in the 1920s," *Cinema Journal* 48, no. 4 (Summer 2009): 1–21.

Wescott, Richard, and David Vail. "The Transformation of Farming in Maine, 1940–1985." *Maine Historical Society Quarterly* 28, no. 2 (1988): 66–84.

Whissel, Kristen. *Picturing American Modernity: Traffic, Technology, and the Silent Cinema*. Durham, NC: Duke University Press, 2008.

Williams, Raymond. *The Long Revolution*. Peterborough, ON: Broadview, 2001.

Wisniewski, Timothy. "Framers of the Kept: Against the Grain Appraisal of Ephemeral Moving Images," *The Moving Image* 7, no. 2 (Fall 2007): 1–24.

Yee, Martha. *Moving Image Materials: Genre Terms*. Washington, DC: Cataloging Distribution Service, Library of Congress, 1988.

Zimmermann, Patricia R. *Reel Families: A Social History of Amateur Film*. Bloomington: University of Indiana Press, 1995.

———. "Cinéma amateur et démocratie." *Communications*, 68, no. 1 (1999): 281–292.

Zuromskis, Catherine. *Snapshot Photography: The Lives of Images*. Cambridge, MA: MIT Press, 2013.

Bibliographic Note on Technology Sources

Consult the Media History Digital Library, a searchable online repository of media periodicals, for *Movie Makers*, the magazine of the Amateur Cinema League's monthly, *Filmo Topics*, and other twentieth-century publications for home movie makers. http://mediahistoryproject.org/nontheatrical/.

Collections of cameras, projectors, and editing equipment, with their accompanying manuals and other ephemera, reside at the George Eastman Museum in Rochester, New York (the Technology Collection); the Hugh M. Hefner Motion Picture Archive, USC School of Cinematic Arts at the University of Southern California, in Los Angeles (the Herbert E. Farmer Motion Picture Technology Archive); and at Northeast Historic Film in Bucksport, Maine (the Alan and Natalie Kattelle Technology Collection).

An online database with images of cameras and projectors held at museums in Germany, Filmtechnik in Museen, can be found at https://www .kameradatenbank.de/. The collaborative database, in German only, includes photographs and descriptive details and may be searched and browsed by manufacturer (and manufacturer location), object type, film gauge, and decade.

Index

Italicized page numbers indicate pages where an image appears.

CPSIA information can be obtained
at www.ICGtesting.com
Printed in the USA
LVOW06*2031130717
R12428700001B/R124287PG541241LVX1B/1/P